Princes as Patrons

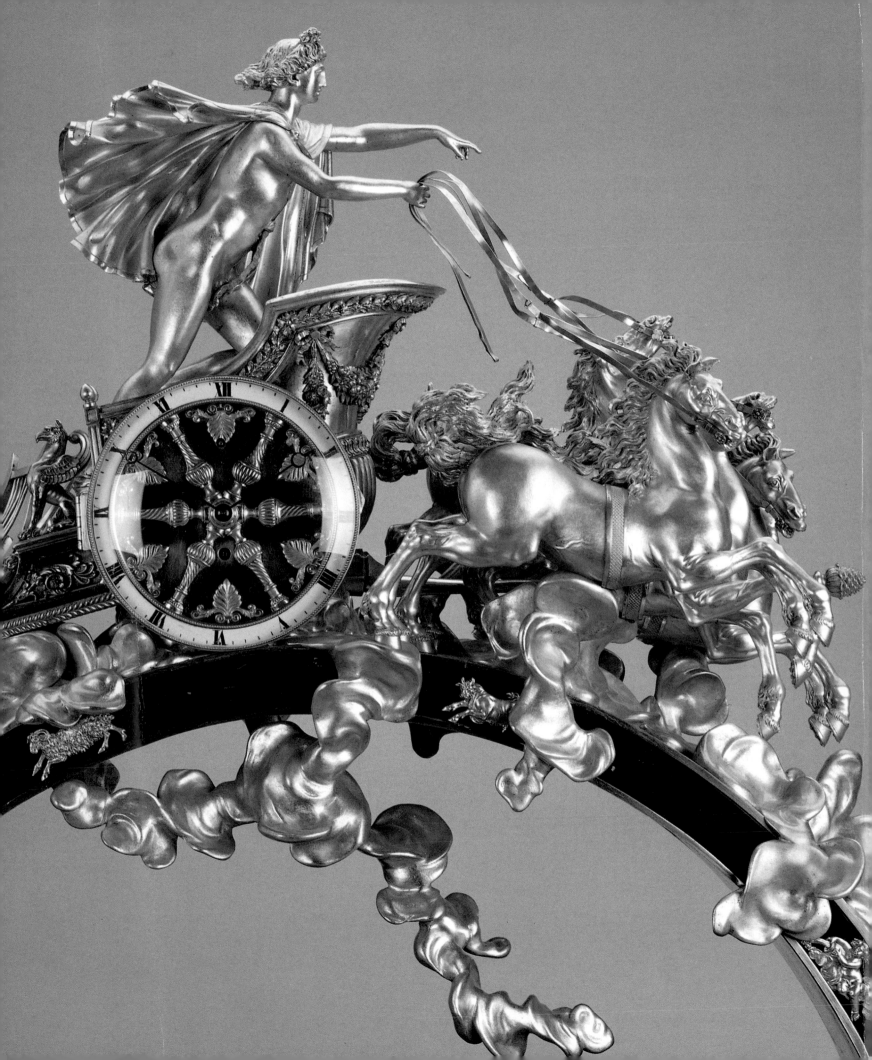

Princes as Patrons

THE ART COLLECTIONS OF THE PRINCES OF WALES

FROM THE RENAISSANCE TO THE PRESENT DAY

AN EXHIBITION FROM THE ROYAL COLLECTION

Foreword by HRH The Prince of Wales

Introduction by Oliver Millar

Edited by Mark Evans

MERRELL HOLBERTON

PUBLISHERS LONDON

in association with

NATIONAL MUSEUMS & GALLERIES OF WALES

AND THE ROYAL COLLECTION

This book accompanies the exhibition 'Princes as Patrons. The Art Collections of the Princes of Wales from the Renaissance to the Present Day' at The National Museum & Gallery, Cardiff, 25 July–8 November 1998
An exhibition from the Royal Collection

Coutts & Co and Legal & General are award winners under the Pairing Scheme for their support of the 'Princes as Patrons' exhibition at the National Museums & Galleries of Wales. The Pairing Scheme is a Government Scheme managed by ABSA (Association for Business Sponsorship of the Arts).

Other photographs are acknowledged as follows:
Fig. 1 Courtauld Institute of Art, London (Conway Library); fig. 2 Trustees of the Chatsworth Settlement; fig. 4 Royal Albert Memorial Museum and Art Gallery, Exeter; fig. 6 National Maritime Museum, Greenwich, London; fig. 9 The Scottish National Portrait Gallery; figs. 10 and 24 The British Library (Newspaper Library); fig. 11 Parham Park Ltd

First published in 1998 by
Merrell Holberton Publishers Ltd
Willcox House, 42 Southwark Street, London SE1 1UN

British Library Cataloguing in Publication Data
Evans, Mark L.
Princes as patrons : the art collections of the Princes of
Wales from the Renaissance to the present day
1 . Great Britain - Kings and rulers - Art collections
I . Title
708.2

ISBN 1 85894 054 0

Designed by Roger Davies
Produced by Merrell Holberton Publishers
Printed and bound in Italy

Front jacket/cover: Robert Peake the Elder, *Henry, Prince of Wales with Robert Devereux, 3rd Earl of Essex, in the hunting field*, ca. 1604 (cat. 1)
Back jacket/cover: Julian Bannerman and Isabel Bannerman, *'Sun' garden bench*, 1996 (cat. 252)
Half-title: Unknown maker, *Circular table*, mid 19th century, detail (cat. 147)
Frontispiece: Pierre-Philippe Thomire, *Gilt bronze mantel clock*, ca. 1805, detail (cat. 93)

Contents

The idea for an exhibition on Princes of Wales as collectors was first proposed at a meeting of the Trustees of The Royal Collection Trust in 1993. As Chairman of The Trust, I have been keen to ensure that every possible opportunity be taken for the collection to be seen and enjoyed, and I am delighted that the largest and most varied exhibition from the Royal Collection yet assembled should be shown in Wales at the National Museum and Gallery.

More than five million visitors enjoy seeing parts of the Royal Collection each year at Windsor Castle, Buckingham Palace, Hampton Court Palace, Kensington Palace and elsewhere. By bringing together works of art from several palaces, exhibitions can draw attention to themes in the history of the Collection that cannot easily be appreciated in the course of such visits and, in this instance, the theme has for me a very particular fascination. I am also very pleased that it has been possible to include exhibits from Sandringham and from Highgrove, as well as from the great palaces.

In the first four sections the collections of those of my predecessors who were most active as patrons and collectors have been, in part, reassembled. I hasten to point out that the final section, containing works from my own young, but rapidly-growing collection, is not intended to compete with the preceding four in any meaningful sense. It is a mere glimpse of a continuing process. But I do share with my four predecessors the passion and excitement of discovering the work of artists and craftsmen, and the further enormous pleasure of enabling young artists to address unfamiliar subjects and settings in the course of my overseas tours. I hope that visitors to the exhibition will be as intrigued as I have been to see the paintings and watercolours produced in much the same way for Prince Albert Edward.

With its great diversity of materials and media, "Princes as Patrons" also allows us to appreciate some of the interests of Princes of Wales outside the visual arts, whether the martial exercises of which Prince Henry was a precocious exponent, the passion for racing which was certainly common to Prince George and Prince Albert Edward, or (in the two paintings by John Wootton and Philip Mercier which normally hang at Highgrove), Prince Frederick's passion for music and for the arts of the chase.

In 1990, sixty paintings from Windsor Castle were exhibited at the National Museum and Gallery and it is thanks to the excellent relationship established at that time with the Director and curators at the Museum that we have been able to build on that foundation with "Princes as Patrons".

Charles

Preface

The role of the Prince of Wales has changed greatly over the four hundred years from the Renaissance to the present day. Princes frequently collected works of art and employed artists and craftsmen independently of the monarch of the day. Some have made a major contribution to the inheritance of paintings and other works of art now forming the Royal Collection. This exhibition focusses on the collections of five Princes, and is a fascinating illustration of how the scope and nature of princely collecting has changed over time.

This enterprise brings together many of the finest works in the Royal Collection, some of them unfamiliar to the public. As well as paintings and sculpture, it includes books, photographs, furniture, silver, porcelain and arms and armour. This exhibition is unique in its scope and the way it addresses the special nature of princely patronage. The National Museums & Galleries of Wales rarely have the opportunity to present an exhibition of this scale.

The National Museums & Galleries have proud links with the monarchy since the opening of the National Museum by George V in 1927. Our collections benefit from the generosity of the Royal Family in the loan of spectacular items, such as the Dolgellau Paten and Chalice. The display of paintings from Windsor Castle in 1990/91 sowed the seeds of the present ambitious project and it is a source of sadness that the death of our previous President, C.R.T. Edwards, means he will not see a project for which he had such enthusiasm reach fruition. We are grateful to all who have worked to realise this exhibition and ensure its success, and above all to HM The Queen and HRH The Prince of Wales for agreeing the number and splendour of the loans which make this the largest exhibition ever mounted from the Royal Collection.

MATHEW PRICHARD, *President*, National Museums & Galleries of Wales

Coutts

SUPPORTING THE ARTS THROUGHOUT THE AGES

There can be few banks with a record so long, rich and varied as that of Coutts. Ever since Scottish goldsmith banker John Campbell founded the Bank "at the sign of the Three Crowns in the Strand" over three hundred years ago, a fascinating array of people have been clients of the bank, from kings, royal princes and great statesmen to playwrights, musicians, writers and artists.

In our own archives there are racks upon racks of great ledgers, box upon box of letters, memorabilia and relics of the past, all illustrating our rich history. We are proud of this heritage and recognize the importance of preserving the past for future generations to appreciate. This is one of the reasons why we are delighted to be a founder sponsor of the 'Princes as Patrons' exhibition.

This display of over 250 paintings, sculpture, silver, ceramics and furniture collected by the Princes of Wales over the last four hundred years offers an insight into the lives of these art-loving princes, each with their own style and tastes. Three out of the five Princes of Wales featured in the exhibition have been banking clients of Coutts and it must be said they were just as individual in their dealings with their personal finances as with their art collections.

Coutts has always been a great patron of the arts. The first Coutts, Thomas, had a discerning eye for real talent and was a supporter of painters such as Reynolds, Lawrence, Haydon and Fuseli and of the sculptor Joseph Nollekens. Angela Burdett, Thomas's granddaughter, continued his tradition by building one of the major art collections of the nineteenth century. The sale of her collection in 1922 lasted over a week and today many of these works can be seen in the collections of the world's major art galleries.

Coutts links with the arts remain as strong today. The Coutts Contemporary Arts Foundation set up in 1992 aims to benefit artists in the forefront of development in the visual arts just as Thomas Coutts nurtured the talent of Fuseli over two hundred years ago. Among our 70,000 clients worldwide, we have many artists, designers, film directors, writers and musicians who have made their mark in the world of arts.

Coutts wants to participate in the growth of the Welsh economy, with Cardiff now a major centre for financial services. We have been delighted to be able to forge close links with the National Museums & Galleries of Wales. We were one of the first companies to sign up to the Corporate Membership Scheme and we chose the Museum as the launch-site of our first branch in Cardiff two years ago. This sponsorship of the 'Princes as Patrons' exhibition underlines our commitment to Wales and its heritage.

We wish the National Museums & Galleries of Wales every success with the 'Princes as Patrons' exhibition and I am sure you will enjoy discovering the many treasures on display from the art collections of the Princes of Wales as much as I will.

SIR EWEN FERGUSSON, *Chairman*, Coutts & Co

Legal & General

PART OF THE COMMUNITY

Although Legal & General has only recently established its call centre in Cardiff there is a strong feeling of belonging to the Welsh community. As a local boy brought up in the South Wales valleys, I am particularly pleased that we are achieving everything we hoped for from our presence in Cardiff. To be involved as sponsor of the 'Princes as Patrons' exhibition allows us to thank Cardiff for the support and help we have had in establishing our office.

The collections of the five Princes featured in this exhibition are a fascinating illustration of the changing scope and purpose of princely collecting over time. This exhibition addresses the special nature of princely patronage. It promises to be both complex and rewarding for the scholar and the art lover, the historian and the curious.

Very rarely has the Royal Collection been able to display such a range of treasures outside a Royal Palace and for the National Museums & Galleries of Wales it is a special opportunity to realise an exhibition of this scale. It has taken enormous enthusiasm and commitment over five years by Colin Ford, Director of the National Museums and Galleries of Wales, and Hugh Roberts, Director of the Royal Collection, and their staff to bring the dream to fruition and we congratulate everyone involved in creating such a wonderful exhibition.

Legal & General believes that it has a responsibility to support the communities in which it works and we are particularly pleased to have helped realise the dream of the 'Princes as Patrons' exhibition. We wish the exhibition every success and hope it is seen by the largest possible audience.

DAVID PROSSER, *Group Chief Executive,* Legal & General Group Plc

Introduction

BY OLIVER MILLAR

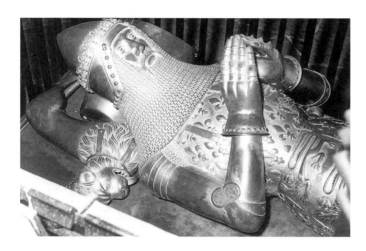

Fig. 1 Funerary effigy of Edward, the Black Prince (1330–1376), in Canterbury Cathedral, cast and partly gilt copper, *ca.* 1377–80

In the masque *Tethys's Festival*, devised by Inigo Jones and Ben Jonson to celebrate the creation of Prince Henry as Prince of Wales, and performed on 5 June 1610, Henry is hailed as "Prince of th' Isles, the hope and the delight/ Of all the northern nations".[1] Born in 1594, he was the first Prince of the newly united Great Britain. With his delight in outdoor pursuits, his love of martial exercise and the chase, he embodied the chivalric virtues so often associated with his legendary forbear, "that young Mars of men", Edward the Black Prince (1330–1376), eldest son of Edward III (fig. 1). Henry's younger brother Charles I actually commissioned in the 1630s a life-size full-length portrait of the Black Prince, and there were later re-incarnations: Frederick, eldest son of George II, commissioned from Rysbrack busts of both the Black Prince and King Alfred. Similarly, George IV, when Prince of Wales, indulged in medieval fantasies in his Gothic rooms and Armoury at Carlton House, and commissioned an elaborate piece of plate decorated with warlike trophies and bearing the arms of the Black Prince. He employed Peter Stroehling to paint him as the Black Prince, dressed in full armour and surrounded by all the appropriate attributes.[2] There was more than a trace of this neo-medievalism, a desire to evoke the pageantry of the Middle Ages, in the ceremonies organized in modern times at Caernarfon Castle.

This symbolic continuity cannot disguise the fundamental changes in the role and circumstances of the Prince of Wales, the title borne by the eldest son of the reigning monarch, during the four centuries covered by this exhibition. The one constant factor has been the need to provide the heir to the throne on his coming of age with his own establishment and household, from which arises the opportunity for independent patronage and collecting. This exhibition allows us to consider how the scope and purpose of princely collecting, and the means to exercise it, have changed in relation to the changing times.

It has never been easy to be a Prince of Wales. During the time – in some cases a very long time – that has elapsed before the famous feathers of the Prince could be exchanged for the crown of the King, individual princes have reacted in varied ways to the different, and frequently trying, circumstances in which their lives have developed. They have often found themselves at odds

with their parents. Some, of course, have been affectionate and dutiful; others, such as the Black Prince himself, were responsible enough to be entrusted with the reins of government; but at least one of those who feature in the exhibition, Frederick, so infuriated his parents that they openly wished he were dead. The worst disagreements have usually arisen over money, and the annals of Parliament are strewn with debates over princely allowances.

Relations between a Prince of Wales and his father were not predictable. Prince Henry was unlike his father, James I, in many ways, and was frequently painted in armour while his father had a horror of edged weapons. By the time of his tragic early death in 1612, he had become something of a legend as the ideal Renaissance prince (fig. 2). An active champion of Protestantism and deeply serious in all that he planned and achieved as patron of the arts and learning, he was the only truly intellectual Prince of Wales, the patron and inspiration of writers, and possessed of a magnificent library and a large scholarly collection of coins and medals, as well as a promising collection of northern and Venetian paintings and an exceptional group of Florentine bronzes (see cat. 20).[3]

The tastes and pursuits of a Prince of Wales were to a large extent formed by the men and women who formed his circle. Prince Henry was fortunate to be surrounded by men of the highest calibre, Sir Thomas Chaloner, for example, Sir Henry Danvers, Sir Edward Cecil and the Earl of Arundel. His was a court truly "fit for a Maecenas".[4] Prince Henry would have found the standard of painting at his parents' court undistinguished, but he failed in his attempt to attract Van Miereveld to come over from Delft to work for him. With similar aims, however, the patronage of his younger brother, Prince Charles, was to attract a succession of good and, indeed, great painters to London. Prince Charles's relations with his father were excellent. They shared a devotion to the Duke of Buckingham, who chiefly fostered the Prince's love of the arts. Buckingham and the Prince were together on the trip to Madrid in 1623, an experience which opened the Prince's eyes to the beauty of Venetian painting. In the same year he bought Raphael's Sistine Chapel cartoons; and before his accession acquired the superb *Self-portrait* (fig. 3) by Rubens, who described him as "the

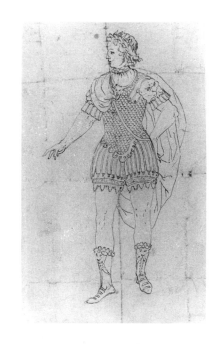

Fig. 2 Inigo Jones, *Prince Henry as Oberon*; costume design for *Oberon, The Faery Prince*, pen and ink, 1610 (Devonshire Collection, Chatsworth)

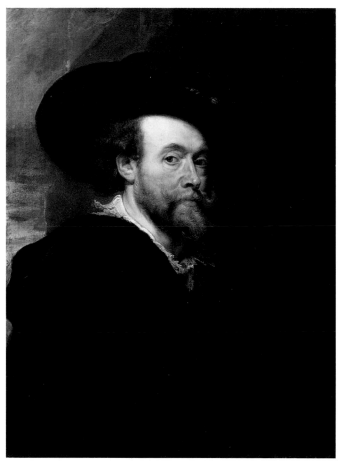

Fig. 3 Peter Paul Rubens, *Self-portrait*, oil on canvas, 1622 (The Royal Collection)

Fig. 4 Francis Hayman, *Allegorical study: Artists presenting a plan for an academy to Frederick, Prince of Wales*, oil on canvas, *ca.* 1750
(Royal Albert Memorial Museum, Exeter)

greatest amateur of painting among the princes of the world".

Frederick, Prince of Wales, and his grandson, the Prince Regent and future George IV, also moved in civilized, cosmopolitan circles and met artists, fellow collectors and *habitués* of the London art world. In doing so they mixed with men and women of whom their parents disapproved, especially after they had moved into separate establishments. The furious row in 1737 between Prince Frederick and his parents led to his banishment from St James's Palace and his retreat to Carlton House, where he could embark on a programme of redecoration, garden design and the acquisition of works of art in defiance of a father who boasted that he loathed painters. George III and Queen Charlotte, prudent and practical in their approach to buying works of art and to embarking on building projects, must have disapproved of everything that went on at Carlton House after it had been given to their eldest son when he came of age in August 1783: the luxury, the wild extravagance, the constant and wasteful changes in the decoration of the rooms, the enormous expenditure and the inevitable mountain of debt. They would have loathed even more the prominent display of portraits of their son's friends: portraits by Hoppner, for example, of such leading Whigs as the Duke of Bedford and Lord Hastings, and the bust by Nollekens of Charles James Fox (cat. 67), whom George III abhorred.

In dealings with artists, in a desire to build, to design gardens, to collect fine works of art and to commission pictures, the more enlightened Princes of Wales were to some extent making gestures of independence. George II, for instance, had entrusted his likeness principally to Kneller, nearing the end of a long career, and to Charles Jervas. This was not good enough for Prince Frederick. He was painted in a fairly conventional manner by such painters as Richardson or Hudson, but also sat to Highmore and Amigoni, who worked in a livelier, more Rococo vein. Frederick was also the first English royal patron to commission pictures, usually on a small scale, of himself and his family engaged in various activities. Mercier, for instance, painted him playing the violoncello with his sisters (cat. 22), and Wootton painted him, in a number of spirited canvases, hunting (cat. 23) and enjoying with his children the country round Henley.

The Prince, although incurably tiresome in many ways, appears in a most sympathetic light when he was taking George Vertue round his works in the gardens at Kew or showing him his pictures at Leicester House.[5] He had talked to Vertue about establishing an academy and Francis Hayman had actually painted a small sketch (fig. 4) of the artists presenting to the Prince a plan for such a body.[6]

George IV when Prince of Wales could equally be charming to the artists who worked for him, while George III was irascible or unpredictable with them. The Prince was on excellent terms with Gainsborough, whom his parents liked, and with Reynolds, whom they could not bear. Reynolds's niece, in fact, gave him her uncle's *Self-portrait* in recognition of the "kind sentiments Your Royal Highness was pleased to express for my late uncle: his patron (and may I presume to say his friend)".[7] The Prince appointed as his Principal Painter John Hoppner, with whom the King had quarrelled in 1795; and it was Hoppner who produced the portrait (fig. 5) of his patron which perhaps most vividly evokes his charm when he was in his prime. The Prince regularly attended the annual dinner of the Royal Academy where, as early as 1785, the artists, in Reynolds's words, "were all mightily pleased with him"; he was always an active supporter of the British Institution, an exhibition space founded by a group of noblemen and gentlemen in 1806. At the end of his reign Sir Robert Peel stated that he was "universally admitted to be the greatest patron the arts had ever had in this country".[8]

Both Princes, Frederick and George, showed a sense of style and a natural and lively good taste in the works they bought or commissioned. In the history of the Royal Collection they stand beside Charles I, in whom as a collector Prince Frederick was seriously interested. Carlton House can be seen as a watershed in the history of royal taste in this country: acquired in 1732 from Lady Burlington by Prince Frederick, altered for him under the auspices of William Kent, it was enriched with a garden laid out by Kent to provide an impression of "beautiful nature". In the gardens Kent built an octagon temple in which busts of King Alfred and the Black Prince made a political statement on behalf of the Prince as one who would eventually, it was hoped, "preserve the Liberties of our ancient Constitution".[9] Nothing as fine as Prince

Fig. 5 John Hoppner, *George IV when Prince of Wales*, oil on canvas, 1796 (The Royal Collection)

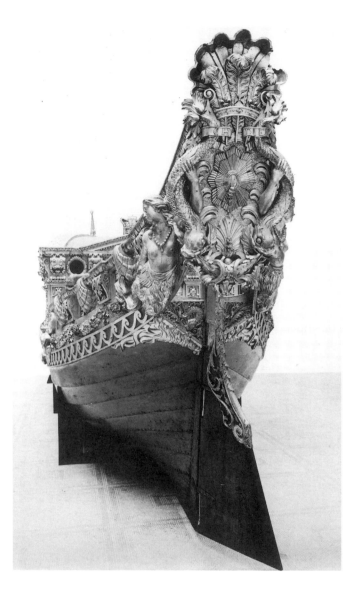

Fig. 6 Stern view of the state barge of Frederick, Prince of Wales, designed by William Kent, showing the Prince's feathers and garter star carved by James Richards and gilded by Paul Petit, 1732 (National Maritime Museum, Greenwich, on loan from Her Majesty The Queen)

Frederick's collection of pictures, hanging mainly in rooms at Kew and Leicester House and set off by picture frames, mirrors and gilt furniture by such craftsmen as Paul Petit, John Boson and Benjamin Goodison, had been acquired since the time of Charles I. The cream of the collection ("no bad pictures many very excellent and well chosen" in Vertue's opinion) is conspicuous for its beautiful quality: *A Flemish fair* by Jan Breughel (cat. 27), for example, *Cleopatra* by Guido Reni (cat. 28), a self-portrait by Murillo, the heroic *St Martin* by Van Dyck and his portrait of Thomas Killigrew with a companion (cat. 29). A fine group of miniatures contained, among masterpieces by Isaac Oliver, the most celebrated miniature (cat. 33) in the Royal Collection today. The stylishness and fine craftsmanship which the Prince encouraged can be seen, on an unusual scale, in the magnificent state barge (fig. 6) designed for him by William Kent.

After the death of Prince Frederick's widow Augusta, Carlton House passed to their grandson, the future George IV. He transformed the house, employing his architects (Henry Holland, James Wyatt, Thomas Hopper, John Nash) and interior decorators (chiefly Guillaume Gilbert, Dominique Daguerre and Walsh Porter) to create a set of interiors which were of a splendour and variety unsurpassed by any earlier, still less later, royal residences. The demolition of the house, by June 1829, is one of the great tragedies in the history of English architecture. Attitudes towards the arts of the past inevitably change, but it is ironic that Sir Lionel Cust, who as a friend of Edward VII would have been familiar with the clutter of Marlborough House and Sandringham, described Carlton House as a "monument of ostentatious bad taste".

The future George IV inherited Prince Frederick's sense of quality but, in a much longer life, was able to deploy on a far grander scale his huge collection of splendid and lustrous works of art in a setting of great richness and variety. He shared Frederick's liking for fine Dutch, Flemish and French painting; but in some ways his tastes were more limited. He showed no interest in Italian painting, in the pictures, for example, which came to Britain with the Orléans collection. The arrangement of works of art in his principal rooms was old-fashioned in that he imitated the habits of earlier French collectors who had combined Dutch and Flemish pictures with

contemporary French furniture and works of art. He had a special liking for the arts of the age of Louis XIV; and one of the first pictures he bought was a view of the building of Versailles[10]. The rooms at Carlton House, of which we are given an invaluable glimpse in the watercolours of Charles Wild (fig. 7), published by Pyne in 1819,[11] were decorated in a range of styles, classical, Chinese and Gothic. They were continually being re-arranged, the hangings, curtains and carpets constantly renewed, the colour schemes endlessly altered: blue and gold, red and gold, scarlet, pale yellow, salmon, lemon or green. So carefully were the individual pieces arranged in harmony together that at any given moment more than two hundred pictures might have to be put in store. In 1816, for instance, the pictures in store included the series of canvases which Stubbs had painted for the Prince, presumably at first to hang in one of his hunting-boxes. In 1819, even such beautiful pictures as Gainsborough's exquisite *Diana and Actaeon*, bought by the Prince at the sale of Gainsborough Dupont's possessions in 1797, or the large oval of his uncle and aunt, the Duke and Duchess of Cumberland walking in a glade, were in store.

The pictures were carefully placed in the rooms in relation to pieces from the Prince's superb collection of furniture, both English and (predominantly) French. Like many of his contemporaries, the Prince was able to profit from the flood of fine works of art that poured across the Channel during the French Revolution and the ensuing wars on the Continent. His French furniture and works of art made up a collection never surpassed in this country and only rivalled today in Waddesdon Manor or the Wallace Collection. Almost as soon as he had stepped into Carlton House the Prince had begun to buy French furniture, and the rooms were thereafter enriched by a succession of magnificent pieces. He made a particularly fine collection of clocks, appreciating their cabinet work, mounts and sculptural embellishment rather more than their mechanisms, in contrast to his father. These creations by Thomire (cat. 93), Osmond, Breguet and Lépine would frequently have stood in relation to equally sumptuous gilt-bronze candelabra, and the rooms would have gained extra richness from the careful placing of mounted vases in porcelain or marble. His collection of Sèvres is the finest in the world. Apart from the beautiful

Fig. 7 Charles Wild, *The Rose Satin Drawing-room, Carlton House*, watercolour, 1817 (The Royal Library, Windsor Castle)

garnitures placed on the mantelpieces, the collection contains the celebrated Louis XVI service (cat. 111), described as "the most lavish and, item for item, the most costly that was ever made",[12] its production originally carefully planned by the French King himself. The Prince's guests must have been further dazzled by pieces from his collection, much of it supplied at vast expense by Rundell, Bridge & Rundell, of silver, silver-gilt and gold plate (cats. 100–08) and partly kept in the fabulous Plate Closet, where Tipu Sultan's jewelled huma bird sparkled under a "very Elegant and Rich cut Glass Roman Lamp":[13] "a magnificent exhibition of taste and expence".[14]

In addition to portraits of his family, the Prince assembled portraits of the people he admired or loved. Charles I had owned a few portraits of his contemporaries, but the Prince gathered a large personal portrait gallery of "the ministers of his serious business and the companions of his looser hours": actors and actresses, musicians, writers, statesmen, friends and mistresses.[15]

Like many of his family the Prince was passionately interested in every aspect of military life. Neither he nor his grandfather could indulge in such splendid martial exercises as had taken up so much of the energies of Henry, Prince of Wales. The parents of the two Princes

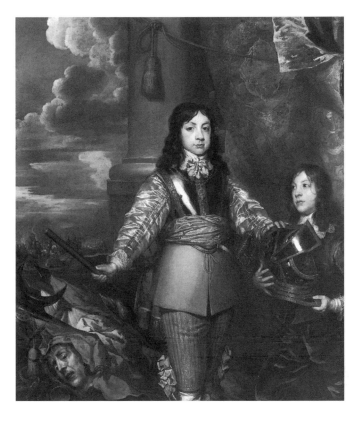

Fig. 8 Jacopo Amigoni, *Frederick, Prince of Wales*, oil on canvas, 1735 (The Royal Collection)

Fig. 9 William Dobson, *Charles II when Prince of Wales*, oil on canvas, 1642 (Scottish National Portrait Gallery, Edinburgh)

had made no secret of their love, in each case, for a younger son; and the younger brothers were able to hold senior command in the army and to gain laurels on active service. There is perhaps a sense of thwarted ambition in Amigoni's portrait (fig. 8) of Frederick, Prince of Wales wearing a military coat over a breastplate, holding a recent translation of Homer and consoling himself with a gesture to the Arts and Sciences. The only post-medieval Prince of Wales who saw active service was the future Charles II who, at the age of twelve, had been pre-pared to charge his father's enemies at the Battle of Edge-hill. William Dobson's superb portrait of him (fig. 9) is the most genuinely martial image of any Prince of Wales since the effigy of the Black Prince (fig. 1) had been made for Canterbury Cathedral, centuries earlier. George, Prince of Wales assembled in the Armoury at Carlton House a huge collection of arms, uniforms and military equipment of all kinds and from many countries: a superb display of rifles, pistols, sabres and swords from

Europe (cats. 114–20) and weapons and equipment from India, China, Persia and North Africa.[16] He himself took great pride in his Colonelcy of the 10th Light Dragoons. He was painted in its uniform (cat. 56) and commissioned Stubbs to include in the series of canvases being painted for him a group of soldiers of the regiment. He venerated the great men of action of the day. Hoppner painted for him full-lengths of Nelson and Lord St Vincent to hang near Reynolds's noble full-lengths of Keppel and Rodney. As early as 1804, the Prince had been in touch with Thomas Lawrence, whose dashing style and rare sensi-tivity to charm and good looks rendered him the ideal painter for the owner of Carlton House. In the State Portrait of the Prince, exhibited by Lawrence in 1818, a brilliantly handled, flamboyant affair, the Prince rests his fingers lightly on the famous *Table des Grands Capi-taines*,[17] which had been commissioned by Napoleon in 1806 and presented to the Prince by the restored Louis XVIII in 1817. By then Lawrence had begun work on the

famous series of sovereigns, statesmen and commanders who had contributed to the final overthrow of the French dictator – the portraits later set up in the Waterloo Chamber at Windsor Castle and dominated by the portrait of Wellington, painted at the same time as a special fête laid on in his honour at Carlton House.

The life led by the Prince at Carlton House – dissolute, improvident, unhappy in a calamitous marriage – was radically different from the quiet, frugal routine followed by his parents and his sisters at Windsor, Frogmore or Kew. Nevertheless, as the King withdrew more and more from the public gaze, Carlton House became the setting for the functions and special occasions over which the Sovereign would normally have presided; and a number of the splendid and hugely expensive entertainments which the Prince laid on at Carlton House enabled him to shine as a generous host and head of state *de facto*. To some extent, therefore, the Prince in his private life and in his presentation of himself in the essentially theatrical, almost kaleidoscopic, setting at Carlton House was making the same form of political statement as his grandfather had put forward more tentatively.

In 1811, before a fête in honour of the French royal family and the Duchess of York, the Prince of Wales had hung in the Blue Velvet Room the greatest picture in his collection, Rembrandt's *Shipbuilder and his wife*, which he had bought for 5000 guineas less than a week before.[18] The Prince owned so many pictures by 1814 that he sent a substantial number to Christie's, probably to make room for the arrival shortly afterwards of no less than eighty-six pictures from the collection of Sir Thomas Baring – an acquisition which transformed the appearance of the collection with its range of exquisite examples of the Dutch and Flemish painters of the Golden Age (cats. 71–78). The qualities the Prince admired in the work of such artists as Rubens, the younger Teniers, Gerard Dou, Adriaen and Willem II van der Velde, Potter, Cuyp, Berchem, Ter Borch, Steen, Wouwermans, Adriaen van Ostade, Jan Both, Van der Heyden, Hobbema and Cornelis van Poelenburch – to name the most important from the Prince's inventories – were beautiful handling, fine condition (the Prince bought on excellent advice and his pictures were well cared for) and an amusing narrative content, qualities he could have also found in the comparatively few French pictures he acquired, for example by Le Nain, Greuze or Vigée-Lebrun (cat. 79).[19] The same story-telling, and perhaps something of the same technical quality, can be seen in the pictures painted for the Prince by David Wilkie (cat. 81) or William Collins, partly in imitation of the great painters of the past whom the Prince and his fellow collectors so much admired. In more florid pastiches of admired painters of the past, Richard Cosway, the miniaturist so lavishly patronized by the Prince, produced sketches of him, trying to look like Charles I, in Van Dyckian costume with a charger and, bringing together many ancient princely threads, as St George.[20]

Albert Edward, the future Edward VII, who went to a famous ball at Marlborough House improbably dressed as Charles I, resembled his great-uncle George IV in his restlessness, his energetic social life, his friendliness, his huge charm, his uninhibited enjoyment of life, his passion for clothes and uniforms and his love of good living and elegant and amusing company. It was his misfortune that so much was expected of him by his parents, who were deeply interested in the arts and devoted so much time to their collections. This Prince of Wales preferred to spend his time and money on other pursuits – field sports, cards, the turf, continental travel and the sea, luxurious living and the company of attractive women – and unlike George IV he could not employ Gainsborough or Cosway to paint the women he loved, or commission Stubbs, Marshall or Gilpin to portray his horses.

Albert Edward had a keen eye and was assiduous both on his trips abroad and in London in visiting exhibitions, galleries and the studios of artists, to whom he was always agreeable (fig. 24, p. 122). When he was in Rome in 1859, he visited Overbeck and Cornelius, spent time in the company of Gibson and Leighton and acquired one of Leighton's pictures of Nanna, his "very handsome model" (cat. 124). He remained a friend of Leighton, looked at the work of such painters as Millais, Poynter, Alma Tadema and Watts, and was especially nice to Landseer, who gave him *The connoisseurs* in July 1867 as an acknowledgement of unvarying "kindness towards an old attached servant".[21] His parents had tried to make him, in isolation, "a moral and intellectual paragon",[22] but, although he would assiduously stock his libraries at Sandringham and Marlborough House

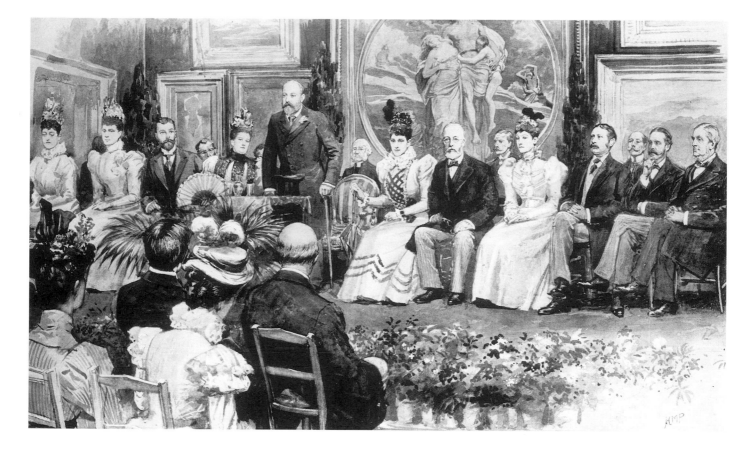

Fig. 10 Albert Edward, Prince of Wales, opening the Tate Gallery, London, 1897 (*The Graphic*, 31 July 1897)

with volumes connected with his foreign tours, there is little evidence that he made much use of them. It is regrettable that, after the death of the Prince Consort in 1861, Albert Edward lacked any informed advice on artistic matters. Consequently, no effort was made to build up a representative collection of works by the leading British artists.

Albert Edward's iconography – the portraiture of his family – is uninspired, though there are among the portraits the occasional eccentric piece like Bastien-Lepage's picture of him in a neo-Titianesque vein (cat. 121) and the freshly painted little variant by Tuxen (cat. 122) of the large conversation piece of the family of the King and Queen of Denmark at one of the annual family reunions at Fredensborg. On a later occasion, the marriage of the Tsar in 1894 (also painted by Tuxen), the Princess of Wales was given by the bridegroom a particularly precious piece of Fabergé. The famous collection of Fabergé (cats. 148–52) had its origin in the links between the two

families and is perhaps the best known and most revealing aspect of the Royal Collection at this time.

The Prince of Wales did, however, acquire a large collection of oil paintings and watercolours to record the places he visited. The most important, by G.L. Brown (cat. 123) and Washington Friend (cats. 130–31) can be associated with his visit to North America in 1860. He commissioned or acquired watercolours from Carl Haag (cats. 127–29) after he had visited the Middle East. He took painters with him on his visits to Egypt and India, where S.P. Hall, as the Special Artist on the tour, produced more than two hundred and fifty watercolours and drawings. Other artists, among them the talented Mihály Zichy (cat. 133), produced drawings of his family, his social life, his horses, yachts and soldiers; and there is a little group of oils of a mildly erotic nature by such painters as Doré (cat. 126) and Gervex.[23]

Gardening and the arts of landscape, in which long years of expectation can be profitably spent, have often

preoccupied Princes of Wales. The present Prince's gardens at Highgrove (see fig. 30) can be compared, in the love and the vision with which they have been created, with those designed by de Caux for Henry, Prince of Wales at Richmond and with those laid out, or planned, by Kent at Carlton House and Kew for Frederick, Prince of Wales. The gardens acquired and developed at Kew by Frederick became the nucleus of one of the great botanical gardens of the world. The gardens at Highgrove have provided the setting for Prince Charles's patronage of young architects, craftsmen and designers, while Highgrove House and St James's Palace accommodate a large collection of watercolours and oil-paintings which The Prince of Wales has commissioned or acquired. It is a collection built up with enthusiasm and discernment, formed by a Prince who enormously enjoys meeting artists and looking at pictures and understands the discipline of painting in watercolour. Many of the subjects are familiar and traditional: well loved or respected people (The Prince's sons, for example, game-keepers, Sir Laurens van der Post and Sir Brinsley Ford); places (especially Sandringham, Balmoral and the gardens at Highgrove); dogs and horses; also some good still lifes, notably by John Napper. The works are generally on a small scale, of necessity given the size of The Prince's residences. Following the precedent of Edward VII, The Prince of Wales has taken young artists on his overseas tours.

The scope of royal patronage and the need for it have, of course, altered fundamentally since the days when support from a royal patron could transform the fortunes of an artist overnight, or when the hope or promise of a royal commission attracted talented painters, sculptors and craftsmen to London. Although the scene has changed and royal patronage has, essentially, done little in hard practical terms for the well-being of the artist since at least 1861, there is today much that can be done. Educational and environmental initiatives, and the encouragement of music and the theatre, have been possible in an age when personal collecting and palace-building on the scale of even the least of those predecessors would have been impossible. In the same way, in his role as Chairman of the Trustees of the Royal Collection, The Prince of Wales is actively seeking ways to promote the wider enjoyment and appreciation of the Royal Collection, an endeavour in which exhibitions such as this form an important part.

NOTES

1. Orgel and Strong 1973, I, p. 194.
2. The portrait is in a private collection in Germany. For the Gothic rooms at Carlton House see London 1991[3].
3. The essential work on Henry, Prince of Wales as collector and patron is T.V. Wilks's D. Phil. thesis, Oxford University 1987. I am profoundly grateful to Dr Wilks for allowing me to read his work. See also his article in the *Journal of the History of Collections*, 1997.
4. Wilks 1987, p. 48.
5. Vertue I/18, pp. 10–14.
6. Allen 1987, p. 122.
7. A convenient summary of the Prince's dealings with contemporary painters is to be found in Millar 1969, pp. xxiii–xxxix.
8. *Ibid.*, pp. xxvi, xxxix.
9. *The Craftsman*, 6 September 1735, quoted Rorschach 1985, p. 139. The best generally available survey of the Prince's activities as patron and collector is the essay by Dr Rorschach in *The Walpole Society*, vol. 55, 1989–90, pp. 1–76 (Rorschach 1989–90).
10. London 1991[3], no. 184.
11. *Ibid.*, pp. 207–27.
12. *Ibid.*, no. 105; see pp. 37–40, 44–47 for a description of the collection of furniture and works of art.
13. *Ibid.*, pp. 44–46.
14. *Farington Diary*, XIII, 1985, p. 4525 (entry for 27 May 1814).
15. For these in more detail, see Millar 1969, p. xxviii.
16. London 1991[3], pp. 47–50, nos. 118–43.
17. *Ibid.*, no. 52.
18. It can be seen in this position in Wild's watercolour, *ibid.*, pp. 219–20.
19. Useful accounts of the Prince's collection of Continental pictures are Millar 1977, pp. 143–59, and White 1982, pp. liv–xxi.
20. Millar 1969, p. xxxi, n. 97. Cosway's work for the Prince as *Primarius Pictor Serenissimi Walliae Principis* is described in detail in Edinburgh 1995, *passim*, and Walker 1992, pp. xvii–xix, nos. 174–204.
21. Millar 1992, no. 416.
22. Magnus 1964, pp. 5–6.
23. The Prince's collection of watercolours and drawings is dealt with exhaustively in D. Millar 1995; see especially I, pp. 16–19.

Henry Frederick

(1594–1612)

CREATED PRINCE OF WALES

4 JUNE 1610, AGED 16; DIED 6 NOVEMBER 1612

The eldest son of James VI of Scotland and his queen Anne of Denmark, Henry was born at Stirling Castle on 19 February 1594. His early upbringing was entrusted to the Earl and Dowager Countess of Mar. On the death of Elizabeth I in 1603, his father acceded to the throne of England as James I, and his later education was supervised by Sir Thomas Chaloner (1563–1615) and the tutor Adam Newton (died 1630). In 1606 the French ambassador characterized the twelve-year old Prince: "None of his pleasures savour the least of a child …. He plays willingly enough at tennis … but always with persons older than himself, as if he despised those of his own age. He studies two hours, and employs the rest of his time in tossing the pike, or leaping, or shooting with the bow…or some other exercise of that kind; and he is never idle" (fig. 14).[1]

On 4 June 1610 Henry was created Earl of Chester and Prince of Wales, and established his own household at St James's Palace (fig. 12). Francis Bacon described his appearance as "strong and erect; his stature of a middle size; his limbs well made; his gait and deportment majestic".[2] The Prince enjoyed a reputation for sobriety, and demonstrated a passion for horsemanship (fig. 11) and a fascination with military and naval affairs. Negotiations took place for marriage alliances with the Infanta of Spain and the Princess of Savoy, but he was more disposed towards a Protestant match. He was a great admirer of the martial reputation and anti-Habsburg policies of his namesake Henri IV, and when the French king was assassinated, reputedly exclaimed, "My second father is dead".[3] Prince

Henry's own death, of typhoid on 6 November 1612, was totally unexpected, and gave rise to profound mourning. A witness observed that his funeral procession "cawsed a fearefull outcrie among the people as if they felt … their owne ruine in that loss".[4]

The brief, two-year duration of his independent court, and the elaborate rhetoric of the elegies and lamentations which accompanied his death, obscure the nature of Prince Henry's patronage. Although his father's interest in the arts was negligible, his mother Anne was fascinated by paintings.[5] Henry's collection was absorbed in part by that of Charles I, and dispersed with it during the Protectorate. Only fragments of it can be identified today.

It has been estimated that in 1610 Prince Henry's total income exceeded £80,000, which compares with a total Exchequer revenue of around £500,000.[6] However, he was required to support a quasi-regal court, comprising over 380 servants.[7] His Surveyor, Inigo Jones, was paid about £55 per annum, while the garden designers Salomon de Caux and Gostantino de' Servi received £100 and £200 respectively, plus gifts and expenses.[8] There was a heavy outgoing on building works, shared between the Office of the King's Works and the Prince's household: the former spent £5206 on work at Richmond Palace (fig. 13) in 1610–12, while the latter contributed £2725 in 1611–12.[9] By comparison, the prince's masque, *Oberon*, written by Ben Jonson, devised by Inigo Jones (fig. 2, p. 11) and performed on 1 January 1611, cost £1092.[10] Prince Henry's most

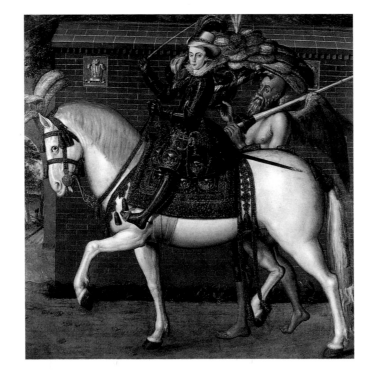

Fig. 11 Robert Peake, *Equestrian portrait of Henry, Prince of Wales*, oil on canvas, *ca.* 1611 (Parham Park)

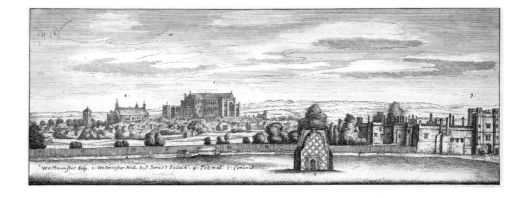

Fig. 12 Richard Sawyer after
Wenceslaus Hollar, *St James's Palace
and part of the City of Westminster*,
etching, published *ca.* 1820 after a
drawing of *ca.* 1660 (The Royal
Library, Windsor Castle)

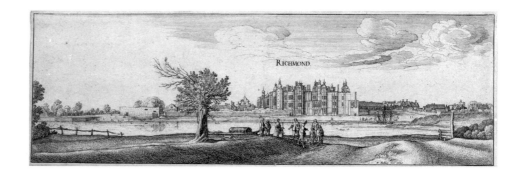

Fig. 13 Wenceslaus Hollar, *Richmond:
the Palace from across the Thames*,
engraving, 1638 (The Royal Library,
Windsor Castle)

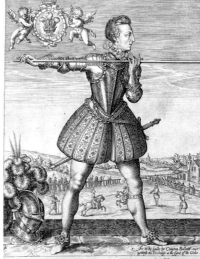

Fig. 14 William Hole
after Isaac Oliver,
The exercise of the pike,
engraving, 1612
(The Royal Library,
Windsor Castle)

expensive art acquisition was the cabinet of gems, coins and
medals assembled by Abraham Gorlaeus of Antwerp, which
he purchased for £2,200 in 1611.[11] Paintings were relatively
inexpensive, ranging from two at £12 or one big picture at £34,
to two "great pictures of the prince in arms", which cost £50
and were provided with frames at £25. 2s. 0d.[12] The major excep-
tion are "the pictures that came from Venice", purchased for
£408. 17s. 4d., probably in 1610, which may have included works
by Palma Giovane, Tintoretto and Bassano.[13]

Following the death of Lord Lumley in 1609, Prince Henry
received the bulk of his library of 3000 volumes, which was sup-
plemented by gift and purchase (cats. 14–18).[14] In January 1610
the Earl of Arundel sent a "great picture" to help furnish St
James's Palace.[15] The Grand Duke of Tuscany dispatched a
painting by Beccafumi and portraits of famous men including
Pico della Mirandola and Machiavelli.[16] Following a hint that
the Prince would appreciate "some paintings by the best
masters in the country", the Dutch government presented
"divers pictures", including a sea-piece by Hendrik Vroom.[17]
In 1612, in response to Prince Henry's request for sculptures
by "worthy men, such as Giovanni Bologna", the Grand Duke
presented a number of small bronzes by Giambologna and
Pietro Tacca (cat. 20).[18] Other princely gifts included suits of

armour (cat. 19).[19] In return, the Prince frequently made gifts of his own portrait (cat. 1).[20]

Lost paintings which belonged to Prince Henry include mythologies, Old Testament subjects, portraits of contemporaries, still lives, sea-pieces and architectural perspectives.[21] Surviving paintings, identifiable by his cypher, include works by Hendrik Goltzius, Vredeman de Vries (cat. 7), Jacques de Backer, Van Miereveld (cat. 8), Holbein, and a handful of Netherlandish and German masters (cats. 5–6 and 9–13).[22]

The mixture of Venetian pictures, Florentine bronzes, coins and medals, and Netherlandish paintings which characterized Prince Henry's collection was quite distinct from earlier Elizabethan collections, which principally comprised portraits;[23] it was, however, typical of contemporary European princely collections. In 1576 Cardinal Granvelle lamented that the great days of the Italian Renaissance were over, and that equally good artists could be found in the Netherlands.[24] This view was shared by the Grand Dukes of Tuscany, who employed Jan van der Straet (1523–1605) as a tapestry designer and Giambologna (1529–1608) as court sculptor. In Prague the Emperor Rudolf II, praised in 1604 as the "greatest art patron of the modern world", assembled an enormous collection, which included numerous bronzes by Giambologna and his student Adriaen de Vries and spectacular holdings of gems, coins, medals and *objets d'art*.[25] Rudolf favoured Italianate Netherlanders as his court painters and, like his nephew Maximilian I of Bavaria, enthusiastically collected pictures by the great past master Albrecht Dürer.[26] The collection of Prince Henry's uncle, Christian IV of Denmark, was not dissimilar.[27]

Prince Henry never travelled abroad, but it is likely that his artistic taste was formed by members of his circle who had.[28] The Prince and his advisers appear to have made a concerted attempt to fashion a modern court culture, by appropriation, gift, acquisition and patronage:[29] even their respect for artists of an earlier generation tends to confirm this. Holbein (cats. 9–13) was a renowned past master of conspicuous skill; Robert Peake (cat. 1) reaffirmed his credentials by seeking inspiration from Dürer and Goltzius, and publishing an edition of Serlio's treatise, to "convay unto my Countrymen ... these Necessarie, Certaine and most readie Helps of Geometrie".[30] In his court miniaturist Isaac Oliver (cats. 2–4), who was born in France and visited Venice and the Netherlands, Henry enjoyed the services of the only British painter of the day whose work was attuned to the exquisite technique and ambitious subject-matter of European Mannerism.

NOTES

1. *Dictionary of National Biography*, IX, 1921–22, p. 558.
2. Strong 1986, p. 12.
3. *Ibid.*, p. 76.
4. Howarth 1997, p. 172.
5. See Wilks 1997 and MacGregor 1989.
6. Wilks 1987, pp. 128–29.
7. *Ibid.*, pp. 274–79.
8. *King's Works*, III, Part 1, 1975, pp. 123, 125.
9. *Ibid.*, p 124.
10. *Ibid.*
11. Strong 1986, pp. 197–200, and Wilks 1987, pp. 183–84, 189–93.
12. Wilks 1987, p. 173.
13. Strong 1986, pp. 189–93, and Wilks 1987, pp. 173, 178–83.
14. Strong, pp. 200–11 and Wilks, pp. 60–71.
15. Strong, p. 188, and Wilks, p. 38.
16. Strong, pp. 190–92, and Wilks, p. 169.
17. Strong, pp. 189–90, and Wilks, p. 168.
18. Strong, pp. 194–97, Wilks, pp. 190, 195–99, and Watson and Avery 1973, pp. 493–507.
19. Strong 1986, pp. 67, 236, no. 199, and Wilks 1987, pp. 207–09.
20. Wilks 1987, pp. 88–90.
21. *Ibid.*, pp. 163–65, and Strong 1986, pp. 191–93.
22. Wilks 1987, p. 166, and Strong 1986, pp. 193–94.
23. London 1995[1], pp. 19, 158.
24. Trevor-Roper 1976, pp. 25–64.
25. *Ibid.*, pp. 104–12, and Prague 1997, pp. 128, 189–208, 412–16, 469–541.
26. *Ibid.*, pp. 95, 104–06, 113–15, and *ibid.*, pp. 20–23, 32–42, 65, 98, 159, 175.
27. Copenhagen 1988, pp. 73–76, 165–79, 301–05, 343–48.
28. Strong 1986, pp. 13, 42–43, 46–47, 81, 139, 195–96, 222–24, and Wilks 1987, pp. 5, 39.
29. Wilks 1987, pp. 177, 184, 214.
30. McClure 1992, pp. 59–72, Strong 1986, p. 114, and Wilks 1987, p. 98.

Robert Peake the Elder (*ca.* 1551–1619)

1. *Henry, Prince of Wales with Robert Devereux, 3rd Earl of Essex in the hunting field*

Oil on canvas, 190.5 × 165.1 cm (75 × 65 in.)

RCIN 405475

PROVENANCE Possibly acquired by Frederick, Prince of Wales; in the collection of George III by *ca.* 1785

REFERENCE London 1935, p. 11; Millar 1963, no. 100; Strong 1969[1], nos. 201, 222; Strong 1969[2], I, pp. 161–65; II, nos. 315–25; Arts Council of Great Britain 1974, p. 7, no. 1; Held 1982, pp. 70–71; Strong 1986, pp. 11, 42–44, 66, 114, 134; Wilks 1987, pp. 28, 88–89, 97, 281; McClure 1992, pp. 59–72; Lloyd 1994, no. 3; London 1995[2], nos. 126–27; Howarth 1997, pp. 132–33

Peake trained as a goldsmith and was active as a portraitist by 1593. Prince Henry's official painter from 1603, he dedicated an edition of Serlio's *Four Books of Architecture* to his master in 1611. Around the same time Peake painted two portraits of the Prince, inspired by engravings by Goltzius and Dürer, which are now in Turin and at Parham Park. In the present work, Henry's pose recalls earlier portraits of Edward VI. Held observed that this innovatory composition depicts English hunting etiquette, as described in Turbevile's *Booke of Hunting*, published in 1575; "the chiefe huntsman (kneeling, if it be to a prince) doth holde the Deare ... whiles the Prince ... cut a slyt ... to see the goodnesse of the flesh". In 1606 the French ambassador observed that Prince Henry "is not fond of hunting; and when he goes to it, it is rather for the pleasure of galloping, than that which the dogs give him".

Robert Devereux (1591–1646) was the son of Elizabeth I's disgraced favourite, and was restored to his father's title as Earl of Essex in 1604. This portrait was probably painted shortly after his rehabilitation. His arms and those of Prince Henry hang from branches above their heads, and an enclosed deer-park appears in the background. Another version of this composition, now in New York, is dated 1603 and depicts John, 2nd Lord Harington of Exton (1592–1614) kneeling before the Prince. Both Harington and Essex were close boyhood friends of Prince Henry, and their inclusion in double portraits with him is clearly indicative of royal favour. However, it is not known whether the present work was commissioned by the Prince or the Earl of Essex. MLE

Isaac Oliver (*ca.* 1565–1617)

2. *Henry, Prince of Wales*

Watercolour on vellum laid on card, 13.2 × 10 cm (5⅛ × 4 in.)

RCIN 420058

PROVENANCE Presumably Henry, Prince of Wales; Charles I and subsequently in the Royal Collection until the reign of William III; recorded by Vertue in an unknown sale in April 1751; purchased by James West; acquired by George IV in 1807; apparently mislaid until recovered by Sir John Cowell, Master of the Household, from a cottage near Windsor in 1863

REFERENCE London 1947, no. 175; Winter 1948, p. 11; London 1953[2], no. 132; London 1972, no. 179; Edinburgh 1975, no. 71; Finsten 1981, II, pp. 98–100, no. 61; London 1983, nos. 257, 258; Strong 1983, pp. 171–73; Edmond 1983, pp. 152–53; Strong 1986, pp. 118–19; London 1988[1], no. 78; Reynolds 1988, p. 24; New York 1996, no. 17; Reynolds (forthcoming), no. 54

2

Isaac Oliver was the son of a goldsmith of Huguenot origin who came to England from France in 1568. He was trained by Nicholas Hilliard (1547–1619), the foremost miniaturist during the reign of Elizabeth I, who retained his position at the court of James I. However, Anne of Denmark (see cat. 3) and Henry, Prince of Wales preferred the work of Oliver, whose style showed wider, more sophisticated terms of reference, particularly to Flemish and Italian Mannerist art. Oliver was formally attached to the household of Henry, Prince of Wales from 1608 to 1612.

One of Oliver's finest miniatures, this work when in the collection of Charles I was described by Abraham van der Doort as "the biggest lim'd Picture that was made" of Henry, Prince of Wales. It served as a definitive portrait on which numerous versions, both large-scale and miniature, were based, including one in the National Museum of Wales. Prince Henry is shown wearing a suit of armour dating from *ca.* 1570 adorned with the riband of the Order of the Garter with the 'Lesser George' attached. This form of dress, and the scene in the right background, allude to the Prince's martial interests. It is difficult to determine whether the background portrays a classical or a medieval encampment, and no specific visual source has yet been found. A connection has been proposed with a court entertainment titled *Barriers*, presented by Ben Jonson and Inigo Jones on 6 January 1610. The emphasis of the *Barriers* on chivalry and its setting at the court of King Arthur accord with the public image which Prince Henry was cultivating before his untimely death. CL

Isaac Oliver

3. *Anne of Denmark*

Watercolour on vellum laid on playing card, 5.3 × 4.2 cm (2⅛ × 1⅝ in.); oval
Inscribed on the back in ink *6 1635*
RCIN 420041
PROVENANCE Probably James I; Charles I; subsequently sold but recovered by Colonel Hawley in 1660–61; Charles II and subsequent royal inventories.
REFERENCE Holmes 1906, pp. 22 and 25; Hind 1955, pls. 64 (b) and 164 (f); Edinburgh 1965, no. 35; London 1968, no. 93; Scarisbrick 1986, p.234; London 1990, no. 144; Reynolds (forthcoming), no. 53

This miniature originally belonged to a group of eight portraits of Charles I's forebears mounted in a single frame. These had apparently increased to ten by the time of the Restoration. The inscription on the back refers to the original framed arrangement which remained intact until the miniatures were separated in the reign of George II. Six remain in the Royal Collection.

Oliver was appointed official limner to Queen Anne in 1605 and he executed some of his most distinguished miniatures for her. Oliver created a whole personal iconography for the Queen, just as he contributed to that of Henry, Prince of Wales. This likeness is closely related to an engraved silver plaque by Simon van de Passe, and exists in several versions. Some of these include the sitter's right hand, a feature which is, in turn, akin to van de Passe's engraving for the book entitled *Baziliwlogia. A Book of Kings* by Thomas Holland (1618).

Anne of Denmark (1574–1619) was the daughter of Frederick II of Denmark, and married James VI of Scotland in 1589. Her upbringing at the Danish court, which parallelled that of Rudolf II at Prague in its emphasis on the arts, may have conditioned the outlook of her children. The jewellery worn here appears in other portraits of the Queen; the crowned 'S' jewel on the left side of the ruff may allude to her mother, Sophie of Mecklenburg, while the crowned 'C4' in monogram in her hair was a gift from her brother, Christian IV of Denmark.
CL

4. *Princess Elizabeth, later Queen of Bohemia*

Watercolour on vellum laid on card, 5.1 × 4.1 cm (2 × 1⅝ in.), oval
Signed on the left in gold *I.O.* (in monogram)
RCIN 420031
PROVENANCE presumably painted for James I, Queen Anne of Denmark, or the sitter; Charles I and therefore sold after the king's death; possibly identifiable with an item recovered by Colonel Hawley in 1660–61; Charles II, but only generally described in royal inventories until the 19th century
REFERENCE London 1947, no. 158; Reynolds 1952–54, p. 25; Auerbach 1961, pp. 249, 330, no. 254; Piper 1963, p. 118; London 1968, no. 90; London 1972, no. 181; Edinburgh 1975, no. 70; London 1977¹, no. 109; Finsten 1981, I, p. 120 and II, pp. 85–86, no. 53; Edmond 1983, p. 171; London 1983, no. 262; London 1988¹, no. 80; New York 1996, no. 18; Reynolds (forthcoming), no. 59

Princess Elizabeth (1596–1662) was younger than Henry, Prince of Wales but four years older than her other brother, Prince Charles, who acceded to the throne in 1625. She married Frederick V, the Elector Palatine, in 1613 as part of a policy to safeguard the Protestant cause. Frederick was crowned King of Bohemia in 1619, but was deposed a year later after his defeat by the Emperor Ferdinand II at the Battle of the White Mountain. Elizabeth thereafter lived in exile, at first in the Netherlands and later in London. Known romantically as the 'Winter Queen', she bore thirteen children including a daughter, Sophia, through whom the Hanoverian Kings of England were descended.

The sitter was depicted by Nicholas Hilliard around 1605 in a miniature now in the Victoria and Albert Museum. The present work, which is of outstanding quality and clearly done from life, dates from *ca.* 1610 and precedes the portrait that Oliver made at the time of her marriage; it is an image which exists in several versions. Oliver's portraits effectively provide the official image of Princess Elizabeth, comparable with those he made of her mother and her brothers. The artist may have accompanied the Princess to Heidelberg in 1613–14, following her marriage.

Van der Doort's description of this miniature in the inventory of Charles I's collection refers to the high hair-style and the multitude of jewels worn by the sitter, details that recur in the painted portraits of her by Robert Peake the Elder, such as that in the National Maritime Museum. The ladies at the court of James I were renowned for being bedizened with fine jewels, and their splendid appearance was often remarked upon by foreign ambassadors. CL

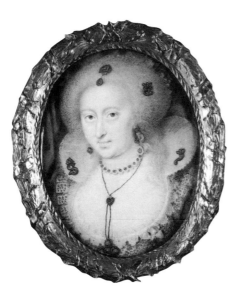

3

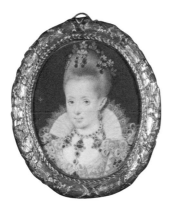

German School, *ca.* 1530

5. *The Battle of Pavia*

Oil on panel, 53.4 × 53.4 cm (23¾ × 23¾ in.)
RCIN 405792
PROVENANCE Henry VIII (?); Henry, Prince of Wales; by descent to Charles I; sold to Richard Marriot, 17 May 1650 (?); James II
REFERENCE Waagen 1854, p. 362; Shaw 1937, p. 47; Manchester 1961, no. 81; Pembroke 1968, p. 74; Millar 1977, p. 27; MacGregor 1983, pp. 297, 302, 318–25; London 1985[1]; Wilks 1987, pp. 163–64, 177; Hale 1990, pp. 145–46, 184–92; London 1991[1], V.2

This painting, probably by a South German artist, is one of numerous representations of the crushing victory of the Imperial army over the French at Pavia in Lombardy on 24 February 1525. It depicts Imperial *Landsknechts* with the flags of Castile, the Empire and the Papal States fighting Swiss pikemen under the fleur-de-lys banner of France. In the middle distance, Imperial artillery bombards French cavalry, and in the far distance are the towers of Pavia.

Although branded with the cypher of Prince Henry, this painting probably belonged earlier to Henry VIII, who had been an ally of the Emperor Charles V in 1525. A "table of the seege of Pavie" at Westminster Palace in 1542 was sold from Hampton Court to Richard Marriot in 1650. Several paintings of this subject were in England at an early date. The large *"vray portrait du siege de Pavie"* at Oxford belonged to John Tradescant (1608–1662), who succeeded his father as keeper of the gardens of Charles I at Oatlands Palace. The small panel after Jörg Breu at Wilton House apparently belonged to Thomas Howard, Earl of Arundel (1585–1646), a member of Prince Henry's circle.

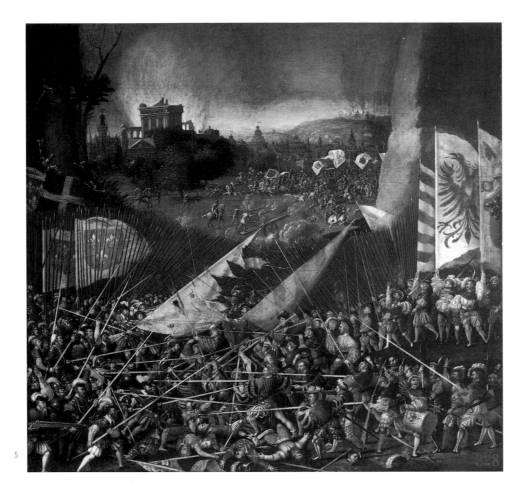

5

When this "old and very beautiful painting" was viewed by the Duke of Saxe-Weimar at St James's Palace in the summer of 1613, shortly after Prince Henry's death, its subject was identified as the French defeat of the Imperial army at Ravenna in 1512. This mis-identification may account for its favour with Prince Henry, who was politically aligned with Henri IV of France against the Habsburgs.
MLE

Netherlandish School, *ca.* 1550–60
6. *Boy looking through a casement*

Oil on panel, 73.8 × 61.6 cm (29¹/₁₆ × 24¼ in.)
RCIN 404972
PROVENANCE Henry, Prince of Wales; Anne of Denmark; by descent to Charles I; sold to Houghton and others, 16 January 1651; recovered at the Restoration; Charles II
REFERENCE Waagen 1854, p. 362; London 1946, no. 243; London 1977¹, no. 12; Millar 1977, pp. 23, 25; Campbell 1985, no. 83; Strong 1986, pp. 193–94; Wilks 1987, pp. 166, 188; Castiglione 1994, p. 87; London 1995², no. 131; Wilks 1997, p. 42

Branded with the cypher of Prince Henry, this painting passed to his mother Anne, and is described in the inventory of her collection at Oatlands Palace in 1616 as "a Buffone lookeing out of a glasse window". There it hung next to "An other of a Buffone in a fooles coate & Coxecombe", which is now lost. In his Kensington Palace inventory of 1750, George Vertue listed this painting as "Holben. Harry Sommers K: Henry 8:th Jester, looking tho' a Window". Although Horace Walpole disputed both the attribution to Hans Holbein and the iden-tification of the sitter as Henry VIII's jester, Will Somers, these remained current until the 19th century.

Lord Lumley had owned a likeness of the "notable fool" Will Somers and a portrait of Anne of Denmark's jester Tom Derry by Marcus Gheeraerts the Younger survives in Edinburgh. However, this picture does not have the air of a portrait. As a self-conscious exercise in illu-sionism, it precedes Dutch paintings such as Samuel van Hoogstraten's *Old man at a window* of 1653, now in Vienna. Its painter was probably familiar with the trompe l'oeil effects of contemporary North Italian artists, such as Parmigianino's *Self-portrait in a round mirror* in Vienna or Veronese's frescos of figures at simulated doorways and balconies at the Villa Barbaro, Maser.

Prince Henry's taste for startling visual effects is confirmed by his ownership of an anonymous Flemish panel of *An old woman blowing*

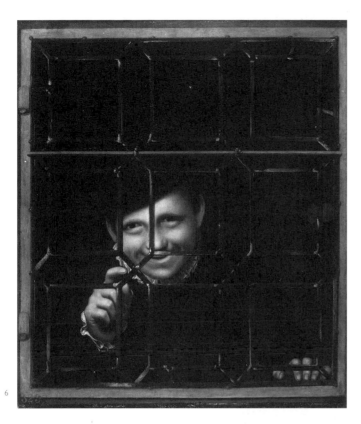

on charcoal, still in the Royal Collection, and a lost painting of a *Booke in perspective*, mentioned in an inventory. Such works demonstrated the "cunning in drawying, and ... knowledge in the very arte of peincting" which Baldassare Castiglione and his translator Thomas Hoby thought that the perfect "Courtyer ought in no wise to leave ... out".
MLE

Hans Vredeman de Vries (1527–1604/09)

7. *Christ in the house of Martha and Mary 1566*

Oil on panel, 79.4 × 109.2 cm (31¼ × 43 in.)
Signed on the step beneath the archway: NS (in monogram) VRIESE 1566
RCIN 405475
PROVENANCE Henry, Prince of Wales; Anne of Denmark; by descent to Charles I; sold to De Critz and others, 18 November 1651; recovered at the Restoration; Charles II
REFERENCE Millar 1960, p. 52; London 1977¹, no. 13; Millar 1977, pp. 22–23; Ehrmann 1979, pp. 16, 19; Campbell 1985, no. 73; Strong 1986, pp. 106–10, 192–94 ; Wilks 1987, pp. 151, 163–64, 166; Wilks 1997, pp. 42–43; Hollstein 1997, XLVII, pp. 9–14; Wells-Cole 1997, pp. 58–88

This painting is described in 1619 in an inventory of Prince Henry's mother as "A small Prospective of Christe Mary and Martha". This story, from the Gospel according to Luke (10: 38–42), favourably contrasts Mary's attention to Christ's words with her sister Martha's preoccupation with household work. Emphasizing the importance of Faith, the subject became popular in the Netherlands during the later 16th century. According to Abraham Van der Doort, writing in the late 1630s, the figures in this "Prospective peece" were painted by the Dutch painter Anthonis Blocklandt (1533/34–1583). X-ray analysis confirms this, revealing that all the foreground figures have been repainted and a large, standing figure of Martha, which dominated the right foreground, has been painted out. These alterations tone down the religious narrative and concentrate attention on the dramatic perspective of the arcade.

The Dutch painter Vredeman de Vries worked principally in Antwerp and specialized in architectural views. His illustrated treatises *Architectura* (1577), *Perspective* (1604–05) and *Architecture* (1606–07) and his numerous engravings provided the principal source of Mannerist designs in Elizabethan and Jacobean Britain. This painting was one of several architectural perspectives in Prince Henry's collection. Others, seen by the Duke of Saxe-Weimar at St James's in 1613, included "A Vaulted House, wherein several are wrestling ... perspectively painted rather than artistically painted" and "Two palaces perspectively painted ... with gardens and people ... very artistically painted in oil colours". This enthusiasm may reflect Prince Henry's own education, as his "Architect" Salomon de Caux (1576–1626) claimed in the introduction to his treatise *La Perspective* (1612) that he had instructed his master in this subject.

MLE

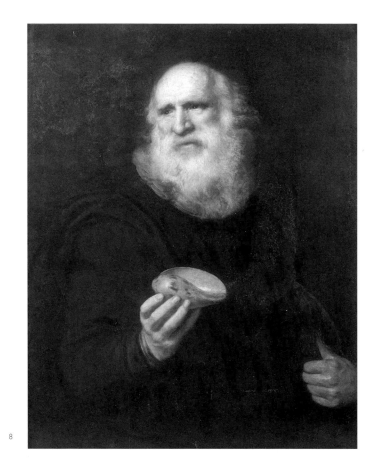

8

Michiel van Miereveld (1567–1641)

8. A bearded old man with a shell

Oil on panel, 87.6 × 67.3 cm (34½ × 26½ in.)
RCIN 403956

PROVENANCE Henry, Prince of Wales; Charles I; sold to Sir Peter Lely, 2 April 1651; recovered at the Restoration; Charles II

REFERENCE Waagen 1854, p. 433; Millar 1960, p. 194; London 1971, pp. 8–9, no. 93; Liverpool 1977, I, pp. 119, 127–28; II, pp. 149, 159; Millar 1977, pp. 25, 27; White 1982, no. 105, pp. xvi–ii; MacGregor 1983, pp. 303–04, 326; Paris 1985, pp. 98–99, pl. 56; Strong 1986, pp. 74, 116–17, 191; Wilks 1987, pp. 86–87, 90–97, 166, 183–84, 190–93; Godfrey 1994, pp. 19–20, 128–29; London 1995², no. 137; Wilks 1997, p. 42

Miereveld was born and worked principally in Delft, but was much patronized as a portrait painter by the Prince of Orange. In 1604 the 'Dutch Vasari' Karel Van Mander praised his portraiture. A close adherent of Prince Henry, Sir Edward Cecil (1572–1658), sat to Miereveld in 1610. At about the same time, the Prince received a Miereveld portrait of Maurice, Prince of Orange. In 1611–12 Henry sought unsuccessfully to secure his services as a court artist, through the agency of Sir Edward Conway, who complained that "the painter of Delft is so fantastical". Although Henry Peacham, who had held a minor position at Prince Henry's court, described Miereveld in 1622 as "the most excellent Painter of all the Low Countries, who sometimes employed a whole year about a picture", his workshop was in fact remarkably prolific.

This portrait bears the cypher of Prince Henry and is documented in the collection of Charles I during the 1630s. Another Miereveld portrait of the same sitter, now in Liverpool, is dated [16]06. The old man has been plausibly identified as the artist's father, the goldsmith Jan Michielsz (1528–1612), who apparently owned a large collection of shells. This portrait is on a reused panel, over a portrait of a woman visible in X-ray. Wilks's identification of the sitter as Abraham Gorlaeus (1549–1609) of Antwerp, whose collection of coins and medals was purchased by Prince Henry, may be disproven by comparison with his portrait engraving of 1601, by Jacques de Gheyn II. This depicts a much younger man with quite different features. The exotic shell is a *melo* from the Indo-Pacific. The leading early British collector of natural history specimens, John Tradescant Senior (1570/75–1638), was the gardener of Prince Henry's mentor, Robert Cecil, Earl of Salisbury.

MLE

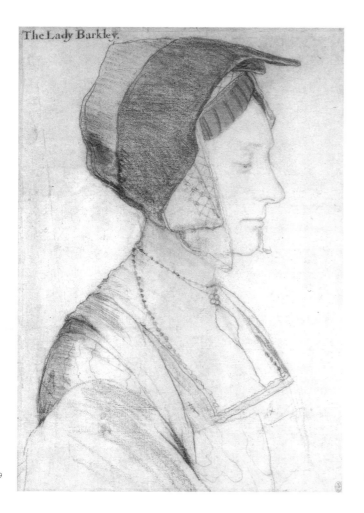

9

10

Hans Holbein (1497/98–1543)

9–13. Five drawings from a book of portraits, mainly of members of the court of Henry VIII

9. *Elizabeth Dauncey (born 1506)*

Black and coloured chalks on paper, 36.8 × 26.1 cm (14½ × 10⁵⁄₁₆ in.)
Inscribed *The Lady Barkley* (top left) and annotated *rot* (red) in the artist's hand (on dress)
RL 12228; Parker, no. 4

This is in fact the second daughter of Sir Thomas More, and wife of William Dauncey, and not Lady Berkeley as inscribed. It is one of a series of detailed chalk drawings of members of Sir Thomas More's family, who appeared in a lost group portrait of 1526–28 which is recorded in an autograph drawing presented to Erasmus, now in Basle.

10. *Unknown man*

Black and coloured chalks with white body colour, reinforced in places with black ink, on pink prepared paper, 27.2 × 19.0 cm (10¾ × 7½ in.)
RL 12260; Parker, no. 44

This study can be dated between 1536 and 1543.

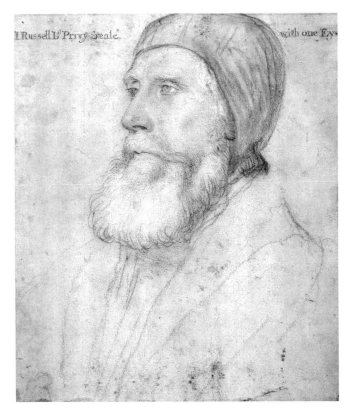

11

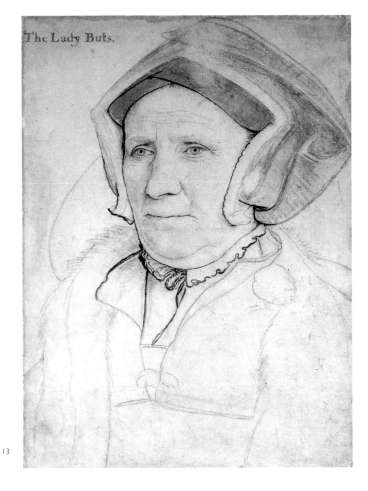

13

11. *John Russell, 1st Earl of Bedford* (ca. 1486–1555)

Black and coloured chalks with white bodycolour on pink prepared paper,
34.8 × 29.4 cm (13¹¹⁄₁₆ × 11⅝ in.)
Inscribed *I Russell Ld Privy Seale / with one Eye* (top)
RL 12239; Parker, no. 69

A favourite of Henry VIII, whom he served as a diplomat and soldier,
John Russell Comptroller of the Royal Household, Lord Admiral and
Lord Privy Seal. He lost his eye at the Battle of Morlaix in 1522 and was
created Earl of Bedford in 1550. This is a study of the late 1530s for a
lost oil portrait.

12. *Katherine, Duchess of Suffolk (ca. 1519–1580)*

Black and coloured chalks, reinforced in places with black ink, on pink
prepared paper, 28.9 × 20.9 cm (11⁷⁄₁₆ × 8¼ in.)
Inscribed *The Dutchess of Suffolk* (top left) and annotated *damast* (damask) and
rot (red) in the artist's hand
RL 12194; Parker, no. 56

This is a study of 1536–43 of the daughter of Baron Willoughby de
Eresby and fourth wife of Charles Brandon, Duke of Suffolk.

13. *Margaret, Lady Butts* (ca. 1485–1547)

Black and coloured chalks, reinforced in places with black ink, and extensive
use of metalpoint, on pink prepared paper, 37.8 × 27.3 cm (14⅞ × 10¾ in.)
Inscribed *The Lady Buts* (top left)
RL 12264; Parker, no. 67

Margaret was the daughter of John Bacon and the wife of Sir William
Butts, physician to Henry VIII. This is a study for the oil portrait which
forms a pair with that of her husband, both now in Boston. As her oil
portrait bears an inscription stating that the sitter was 57 years of age,
the drawing would appear to date from *ca.* 1542.

PROVENANCE Edward VI; Henry Fitzalan, 12th Earl of Arundel; by descent
to John, 12th Lord Lumley; Henry, Prince of Wales; Charles I; by exchange to
Philip Herbert, later 4th Earl of Pembroke; given to Thomas Howard, Earl of
Arundel; Charles II, by 1675
REFERENCE Cust 1918, p. 27; Parker 1945, pp. 8–22; London 1978, pp. 7–24,
nos. 10, 52, 27, 64, 69; Hilliard 1983, pp. 18–19; Foister 1983, pp. 4–12, 16–17,
20–21, 25, 31–33, nos. 4, 69, 44, 56, 67; Rowlands 1985, pp. 69–71, 129–30,
222–24; Strong 1986, pp. 49, 118, 158, 194, 200, 209–11; Wilks 1987, pp. 167, 171,
175, 186; London 1995³, nos. 93, 97, 105

The Dutcheſs of Suffolk.

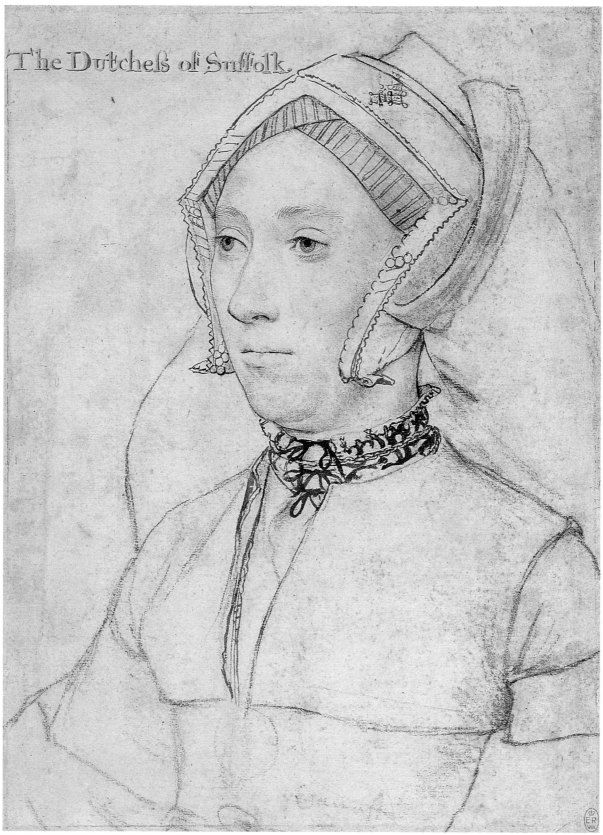

12

33

Born in Augsburg, Holbein first visited London in 1526–28 and returned in 1532. Appointed a court artist of Henry VIII by 1536, he remained almost continuously in London until his death in 1543. The drawings from his first visit, in chalks on white paper, may be distinguished from those made during his second, on paper with a pink priming. Portraiture was quite a new departure in early Tudor England, and Holbein's remarkable skill was highly prized by members of the court. His reputation endured, and in a treatise published in 1598 the English miniaturist Nicholas Hilliard praised him as "the most excelent painter and limner Haunce Holbean, the greatest Master truly in both thosse arts after the liffe that ever was".

These drawings are from a group of eighty-five in the Royal Collection which probably come from the "peynted booke of Mr Hanse Holby" purchased by Edward VI between 1547 and 1553 for £6. In 1590 it is listed with "other pictures and tables" in the inventory of the great bibliophile and portrait collector Lord Lumley as "A great booke of Pictures doone by Haunce Holbyn of certyne Lordes, Ladyes, gentlemen and gentlewomen in King Henry the 8: his tyme". Shortly after Lumley's death, by October 1609, the drawings appear to have accompanied "the librarie whiche his highnes hade of my lord Lumley" into the possession of Prince Henry. Subsequently exchanged by Charles I with the Earl of Pembroke for a painting of St George by Raphael, the volume of drawings re-entered the Royal Collection late in the 17th century; they were unbound and framed for Queen Caroline in 1728.

Prince Henry seems to have had a taste for Holbein, as he also owned Holbein's *Youth riding a horse*, now in Malibu, the two lost monumental canvases of *The Triumph of Poverty* and *The Triumph of Riches*

presented by the London Steelyard in 1610 and, probably, the portrait of *Erasmus writing*, now in the Louvre. Wilks has pointed out that he shared this preference with the Earl of Arundel, who subsequently acquired most of the Holbeins which had belonged to Henry, as the Prince's younger brother Charles I seems not to have cared for this painter. In a court milieu where writers such as Sir John Harington, Michael Drayton and Ben Jonson were prone to compare Prince Henry favourably, but prematurely, with earlier English kings of the same name, it is likely that Holbein's record of the celebrated court of Henry VIII would have been especially appreciated.
MLE

Esther Inglis (1571–1624)

14. Antoine de la Roche Chandieu (1534–1591),

Cinquante octonaires sur la va vanité [sic] et inconstance du monde, dediez à Monseigneur le Prince, pour ses estrennes, de l'an 1607

Open at fol. 3 verso: Self-portrait of the artist, opposite Octonaire I
Calligraphic poems in various scripts, with trophies and botanical decoration in watercolour, highlighted with gold. 54 leaves: ill. Bound in pink velvet (much stained and rebacked); two replacement ties on fore-edge; 12.6 × 16.4 × 1.8 cm (3⅞ × 6⅜ × ¾ in.); width when open 32.5 cm (12¾ in.)
RCIN 1047001

14

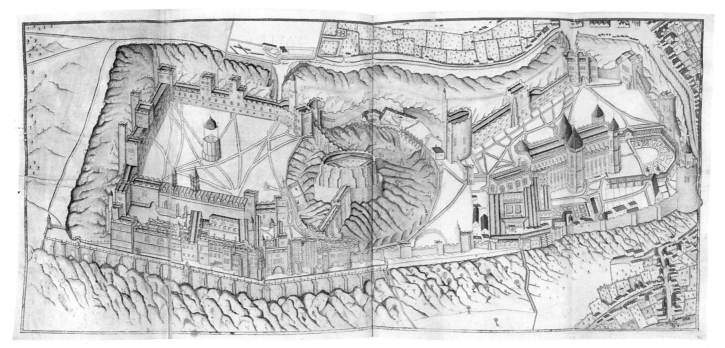

15

PROVENANCE Dedicated to Henry, Prince of Wales, 1607; Lady Jemima Hay, daughter of James, 15th Earl of Erroll, 1805; Miss Armstrong, *ca.* 1900; given by her to Miss R.B. Myrtle; bequeathed to her niece, Miss I.M. Sudlow; presented by her to HM Queen Elizabeth II, 1952
REFERENCE Scott-Elliot and Yeo 1990, no. 27; Royal Collection 1990, p. 48

About fifty manuscripts by the calligrapher Esther Inglis are known, five dedicated to Prince Henry and four to his close associates. The daughter of French Huguenots, Nicholas and Marie Langlois, who fled persecution around 1569 and settled in Edinburgh, she learned calligraphy from her mother, herself a pupil of John de Beauchesne, writing master to Prince Henry. Under the anglicized form of her maiden name, she created exquisite manuscripts dedicated to influential figures in order to obtain patronage for herself and her husband, Bartholomew Kello, an indigent clergyman. Payments to Mrs Kello, for a book of arms in 1609 and for a set of Psalms in 1612, occur in Prince Henry's Privy Purse accounts.

The *Octonaires*, eight-line moral epigrams, a favourite non-biblical text for Inglis, were written by Antoine de la Roche Chandieu, a Protestant theologian, latterly Professor of Hebrew at Geneva, but until 1601 were published anonymously. Inglis presumably never knew their authorship, as none of her nine copies of this text cites it. The self-portrait, showing Inglis pen in hand, is derived from an anonymous portrait of the calligrapher, dated 1595, now in the Scottish National Portrait Gallery. The trophy of armour is perhaps copied from Vredeman de Vries's *Panoplia* (1572). BW

John Norden (1548–1625?)

15. *A Description of the Honor of Windesor ... 1607*

Open at Table I: *Bird's-eye view of Windsor Castle from the north*
Pen detail with transparent and opaque water-colour on vellum. 36 leaves (4 folded) in conjoint pairs: maps, plans. Bound in brown calf (rebacked), tooled in gold and blind; remains of 2 ties on fore-edge; 43.2 × 30 × 3.8 cm (16⅞ × 11¾ × 1¾ in.), width when open 89 cm (35 in.)
RCIN 1142252

PROVENANCE Drawn up and bound for Henry, Prince of Wales, 1607; acquired by the Royal Library probably around 1900 (bookplate of 1898–1901)
REFERENCE Tighe and Davis 1858, I, frontispiece, II, pp. 1–40; Fletcher 1895, pls. 33, 37; Hope 1913, plan VIII; Hobson 1940, nos. 16–18; London 1990, no. 77

Two copies of this pictorial and cartographic survey, showing the Royal demesne around Windsor, were drawn up: the King's copy (British Library, Harl. ms. 3749) and this one, dedicated to Henry, Prince of Wales, with his arms and strapwork corner pieces. The splendid view of the Castle predates Hollar's much better known view from the south by sixty years.

John Norden, Surveyor of Crown Woods in the area from 1600, became also Surveyor of the Duchy of Cornwall in 1605. Among his commissions from Henry, completed after the Prince's death, were written surveys of the Duchy's manors in Cornwall and Somerset, also in the Royal Library.
BW

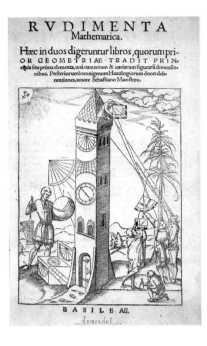

16

16. Sebastian Münster (1489–1552), *Rudimenta mathematica*

Open at title-page
Basle: Henricus Petrus, 1551. [10], 244 p.: ill., diags. Bound in brown calf, tooled in gold; remains of 2 ties on fore-edge; 29.5 × 21 × 2.8 cm (11 × 8 × 1 in.), width when open 40.8 cm (16 in.)
RCIN 1081299
PROVENANCE Arundel; Lumley; Henry, Prince of Wales, 1609; Old Royal Library; British Museum Library 1757; duplicate sale 1769; Revd Philip Furneaux; Coward Trust; sold at Sotheby's to John Hely-Hutchinson, 4 April 1950; bought for the Royal Library at his sale, 13 March 1956 (438).
REFERENCE Holmes 1893, no. 17; Fletcher 1895, pl. 36; Nixon 1953, pl. 2; Strong 1986, pp. 208ff.; Birrell 1987, pp. 30–40; Foot 1993, pp. 310ff.

Münster, formerly a Franciscan, spent his last two decades in Lutheran circles, principally in Basle, teaching mathematics and geography. This work, the last of his prolific writings, combines geometry and horology, and is illustrated with fine woodcuts. Its title-page bears the signatures of the Earl of Arundel and (though mostly cropped) of Lord Lumley. Following its acquisition by Prince Henry, this volume was rebound in his characteristic style, with arms as centrepiece and crowned lions rampant guardant as corner-pieces.

The core of Prince Henry's great library was the Arundel-Lumley library, acquired on the death of John, Lord Lumley (*ca.* 1533–1609). Of Lumley's three thousand books, about a third had previously belonged to his father-in-law, Henry Fitzalan, last Fitzalan Earl of Arundel (1512–1580). After Prince Henry's death, his library was absorbed in the Old Royal Library, given in 1757 to the British Museum, and partly dispersed thence in duplicate sales between 1769 and 1831.

This volume was purchased in 1769 by the Revd Philip Furneaux (1726–1783), a leading Non-Conformist who probably gave it to Coward College library, of which it contains two bookplates. BW

17. Valerius Maximus, *Dictorum factorumque memorabilium libri IX*

Leiden: Franciscus Raphelengium, 1594. [16], 400, 110 p. Bound in olive green goatskin, tooled in gold and silver; gilt edged; remains of 2 ties on fore-edge; 16 × 10.4 × 3.2 cm (6¼ × 4⅛ × 1⅛ in.)
RCIN 1081300
PROVENANCE Binding for Henry, Prince of Wales; presented to George, Prince of Wales in 1778 by Dr Richard Hurd, Bishop of Lichfield and Coventry; presented by George IV in 1826 to Dr Charles Sumner, Bishop of Llandaff; Royal Library by the 1950s
REFERENCE Fletcher 1895, pl. 35; Davenport 1896, fig. 15

This small volume had the distinction of belonging to two Princes of Wales; and was probably chosen for its moral tone. It is a handbook, compiled in the time of Emperor Tiberius, of rhetorical examples of virtues and vices, drawn from history. It was bound for Henry, Prince of Wales in fanfare style, with his initials flanking the Feathers stamp (see also cat. 18). This stamp was perhaps cut before he became Prince of Wales in 1610, since unusually the coronet is a ducal, not a princely, one.

Dr Richard Hurd (1720–1808), Bishop of Lichfield from 1775 and of Worcester from 1781, was appointed Preceptor to George, Prince of Wales, and his brother in 1776. Prince George records this gift from "my much valued Preceptor and Friend". He gave the book to Dr Charles Sumner (1790–1874), his Chaplain and Librarian from 1821, on his appointment as Bishop of Llandaff.
BW

18. *Bible, Prayer Book and Psalms*

Bible, 2 vols., London: Robert Barker [1607]; *The Booke of Common Prayer*, London: Robert Barker, 1607; *The Whole Booke of Psalmes, collected into English meeter*, London: Stationers' Co., 1609.
4 vols. in 1. Bound in brown calf (rebacked) tooled in gold and colours; gilt edged; remains of 2 ties on fore-edge; 33.5 × 23 × 7.5 cm (13 × 9 × 3 in.)
RCIN 1053401
PROVENANCE Binding for Henry, Prince of Wales; Sir Walter Alexander (1572–1637), Gentleman Usher to Prince Henry; Sir Thomas Herbert; his 2nd wife Elizabeth; their grandson Thomas; Revd R. Atkinson by 1800; Benjamin Atkinson Irving; bequeathed by him to King Edward VII, 1905
REFERENCE Fletcher 1895, pl. 35; Davenport 1896, fig. 15

This is a Geneva Bible, known as the 'Breeches' Bible for its translation of Genesis 3:7, "they sewed figge leaves together and made themselves breeches". The version printed in Geneva in 1560, and later in London, was edited by Protestant scholars, many of Calvinist sympathies, and proved popular with the Puritans for its marginal commentary. James I, who opposed the Low Church faction, stipulated that the Authorized Version of 1611 should not have one.

The fanfare-style binding must post-date Henry's creation in June 1610 as Prince of Wales and Earl of Chester. The corners bear the arms of his apanages, Wales, Cornwall, Chester and the Isles. Shaky on heraldry, the binder has put gold and red lions in the wrong quarters for Wales, and ten, not fifteen, bezants for Cornwall.

The Prince added over a thousand volumes to the library which he acquired from Lord Lumley (see cat. 16), expanding particularly the

sciences, but also humanities, such as moral philosophy (see cat. 17), with a strong Northern Protestant bias in both. This dual development reflects the choice of the Greek scholar Patrick Young and the navigator Edward Wright as his librarians.

BW

Greenwich workshop, *ca.* 1608

19. *Armour for barriers, field, tourney and tilt*

Consisting of a close helmet, a cuirass and tassets, a pair of pauldrons, a pair of vambraces and a pair of complete leg harness, all for the field (field gauntlets missing); a right mitten gauntlet, probably for the tourney course; and a second close helmet, a grandguard, a great pasguard and a manifer, all for the tilt

Blued steel, decorated with broad recessed bands, etched in relief with strapwork and arabesques on a fire-gilt ground, and bearing the monograms *HP* and *FHP* below the coronet of the Prince of Wales, and with fleurs-de-lys, Tudor roses and thistles slipped, etched and on a fire-gilt ground; overall height 159 cm (62⅝ in.)

RCIN 72831

PROVENANCE Given to Henry, Prince of Wales by Sir Henry Lee in 1608; thought to have been rescued from Greenwich by Edward Annesley in 1644; at the Tower of London until *ca.* 1679, and again between 1688 and 1692; sent to Windsor Castle before 1742

REFERENCE Public Record Office E 101 433/8, f. 3v.; Laking 1904, no. 678, frontispiece; Millar 1963, no. 142; Strong 1986, pp. 63–70, 141–52; Norman (forthcoming), no. A8

Like the miniature by Isaac Oliver of 1612 (cat. 2) and Hole's engraving after Oliver of the exercise of the pike (fig. 14), this magnificent armour reflects Prince Henry's love of chivalry – the practice of martial exercises. There are several further likenesses of this kind, and in a posthumous portrait of 1636 by Van Dyck the Prince is depicted wearing this very armour.

The armour was delivered in July 1608, when the Prince's Keeper of the Privy Purse recorded a payment of £10 to "Sr. Hary leyes man who presented a Sute of riche armes to his highnes". Sir Henry Lee of Ditchley (1533–1611) served as Master of the Armouries from 1578 until his death. He was largely responsible for initiating and organizing the Accession Day Tilts that took place during Elizabeth's reign on the anniversary of her accession. These tournaments generally comprised a procession in the Tiltyard at Whitehall Palace, and exercises including the barriers, at which two knights fought with sword and pike across a barrier.

When he received his armour the Prince was just fourteen, but his education in the arts of chivalry had begun by 1603, when Henri IV of France had sent his equerry, the Seigneur de St-Antoine, with "a lance and a helmet of gold, enriched with diamonds" to instruct Prince Henry in horsemanship. Armours were also presented to the Prince by the French king and the Prince de Joinville (both 1607, also at Windsor).

The Royal Armouries at Greenwich were established by Henry VIII in 1517; armours were last produced there in the late 1630s or early 1640s.

JM

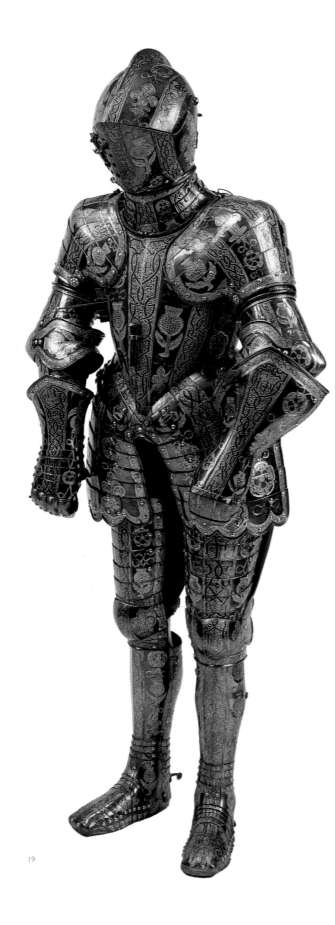

19

20

Pietro Tacca (1577–1640) after Giambologna (1529–1609)

20. Pacing horse

Bronze, 24.2 × 23 × 11.5 cm (9½ × 9¹/16 × 4½ in.)
RCIN 35467
PROVENANCE Henry, Prince of Wales; presumably sold under the
Commonwealth and recovered at the Restoration; at Kensington Palace in 1818
REFERENCE Jutsham I, p. 44 (30 December 1818); Watson and Avery 1973;
Avery and Radcliffe 1978, no. 151

This statuette is the only identified survivor in the Royal Collection of
the fifteen small bronzes cast by Tacca in 1611 from models by
Giambologna as a gift from Grand Duke Ferdinand I of Tuscany to
Henry, Prince of Wales. The gift was part of the diplomatic process
aimed at securing the Prince's betrothal to one of the Grand Duke's
daughters, which was frustrated by Henry's death. It comprised
examples of Giambologna's best known models, including *Nessus and
Deianara*, *Hercules and the Centaur*, a *Bull*, and a *Diana*.

According to one account, when the bronzes were being unpacked
at Richmond Palace the courtier Edward Cecil suggested that the horse
would make a suitable plaything for Henry's younger brother Charles,
but the Prince insisted on retaining the entire group for himself. These
were perhaps the first examples seen in England of 'cabinet' sculp-
tures, intended as an artistic end in themselves rather than serving a
commemorative or architectural purpose. Acquaintance with them
from an early age may have influenced Charles I in his later patron-
age of the bronze sculpture of Hubert Le Sueur and Francesco Fanelli.
JM

Frederick Louis

(1707–1751)

CREATED PRINCE OF WALES

8 JANUARY 1729, AGED 21; DIED 20 MARCH 1751

Frederick Louis was born in Hanover, the eldest son of George II and his wife, Caroline of Ansbach. In Frederick's seventh year his grandfather, the Elector of Hanover, ascended the English throne as George I, the first monarch of the Hanoverian dynasty. His parents moved to England, leaving their son at the Electoral Palace at Herrenhausen. In 1728, the year after the accession of George II, Frederick travelled to England for the first time, having received his early education and formed his artistic taste in Hanover.

Relations between Frederick and his parents were never good. George II was alarmed at his son's involvement in opposition politics. Frederick was named Prince of Wales in 1729; seven years later he married Princess Augusta (1719–1772), the youngest daughter of Frederick II, Duke of Saxe-Gotha-Altenburg. The marriage was a happy one, in spite of the financial constraints imposed by his father and his continuing hostility, which resulted in the banishment of Frederick and Augusta from court in 1737. The eldest of their five sons succeeded as George III, while the eldest of the four daughters was the mother of Princess Caroline of Brunswick, who married her first cousin, the future George IV, in 1795.

In London the Prince cultivated his interests in art, literature, science and politics, and his favourite paintings were kept in his London homes. In addition to his apartments in St James's Palace, in 1733 he acquired Carlton House. With the help of William Kent (1685–1748), appointed architect to the Prince in the previous year, he improved the house and its twelve-acre grounds (fig. 16). He subsequently rented Norfolk House and Leicester House, where he died in 1751.

In 1730 Prince Frederick also acquired the lease of a small house at Kew. This was remodelled by Kent as a Palladian villa and renamed the White House (fig. 15). The Prince may have been inspired to create a landscape garden there after visiting the estate of his friend, Richard Temple, 1st Viscount Cobham, at Stowe in 1737. By 1751 Frederick's enlarged estate at Kew included a lake and buildings in a variety of styles: a classical temple on a mound, to be named Mount Parnassus, and an oriental building known as the House of Confucius (fig. 17). A further building, the Alhambra, was designed "in the old Moorish taste", in 1750 but not built until 1758.[1] Frederick's planting activity was impressive: after his death Peter Collinson wrote that "gardening and planting have lost their best friend and encourager".[2] The Prince's love of hunting and country life led him to rent several other residences: between 1737 and 1751 he leased Cliveden House, on the Thames, and in 1739 he mortgaged Carlton House to finance the acquisition of another Thames-side villa, Park Place. Around the same time he also took the leases of Hedsor House (adjoining Cliveden) and Durdans near Epsom.

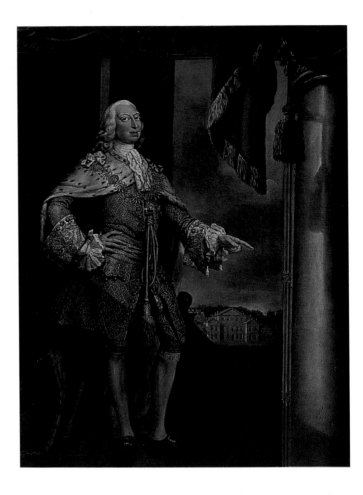

Fig. 15 Detail of George Knapton, *The family of Frederick, Prince of Wales*, oil on canvas, 1751 (The Royal Collection). This posthumous likeness includes a view of the White House at Kew

George I had been active as a patron in Hanover but not in England, and his son, George II, is reported to have stated of poetry and painting that "neither the one nor the other ever did any good".[3] With the exception of Kent's work at Kensington, and for Queen Caroline at Richmond and St. James; architectural projects and additions to the Royal Collection were negligible during the first half of the 18th century. In contrast, the King's eldest son confessed to his friend, the antiquary George Vertue, "I love Arts – and Curiositys". His residences provided the setting for a great new collection, including many works on a heroic scale. Numerous paintings by Old Masters were acquired, and works by contemporary artists and craftsmen were commissioned. The Prince admired the collection of Charles I, and engaged Vertue in 1748 specifically to catalogue its dispersed treasures. He later wrote that "no prince since King Charles the First took so much pleasure nor observations on works of art or artists".

The formation of Frederick's collection is documented only

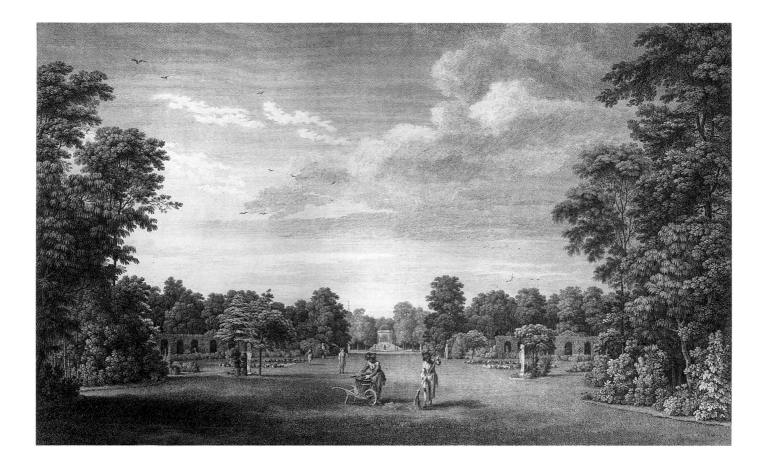

Fig. 16 William Woollett, *View of the gardens at Carlton House: the Palace of HRH the Princess Dowager of Wales*, engraving, 1760 (The Royal Library, Windsor Castle)

in part. His first acquisitions date from soon after 1729, when Philippe Mercier entered his service, to paint (see cat. 22) and to care for his collection and library. From 1733 Joseph Goupy was employed as drawing master, painter and copyist; he gradually superseded Mercier as agent in the acquisition of paintings. Others involved in Frederick's purchases included his friend Lord Baltimore, Major-General John Guise and Sir Luke Schaub. Vertue was invited to complete and arrange his collection, and his notebooks provide vital information on its contents. Seriously concerned that he should be well informed about art, the Prince invited Vertue and George Knapton to instruct him about the treasures at Kensington, Hampton Court and Windsor.

Apart from the extent of his collecting, there was nothing unusual about the Prince's taste for the Italian Renaissance and Baroque and Netherlandish art of the early 17th century (cats. 26–29). However, Frederick also acquired oils and miniatures of royal significance by earlier English artists, and a number of historical portraits came with his house at Kew in 1731.[4] The Prince belonged to the first generation of English collectors to acquire French 17th-century paintings and drawings (cats. 30–32, 38–42). He was also attracted to contemporary French

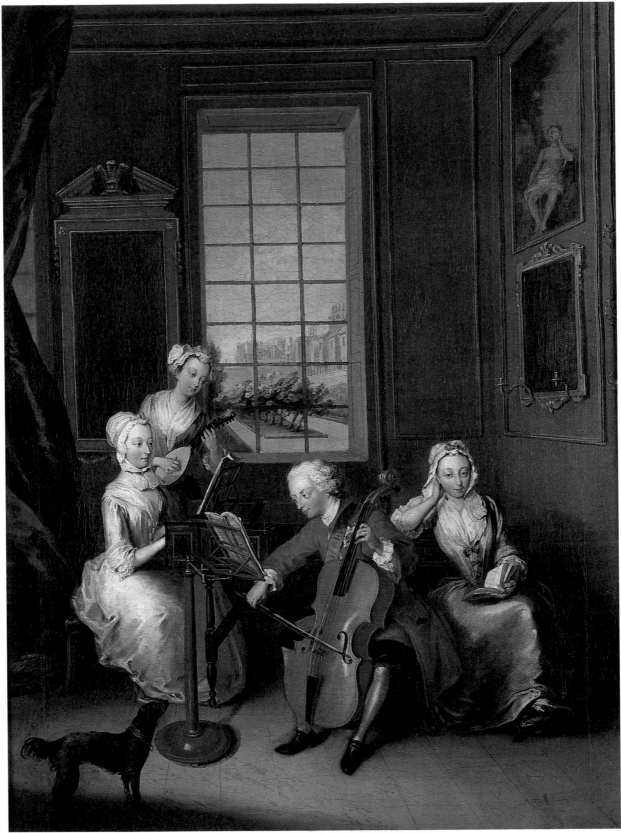

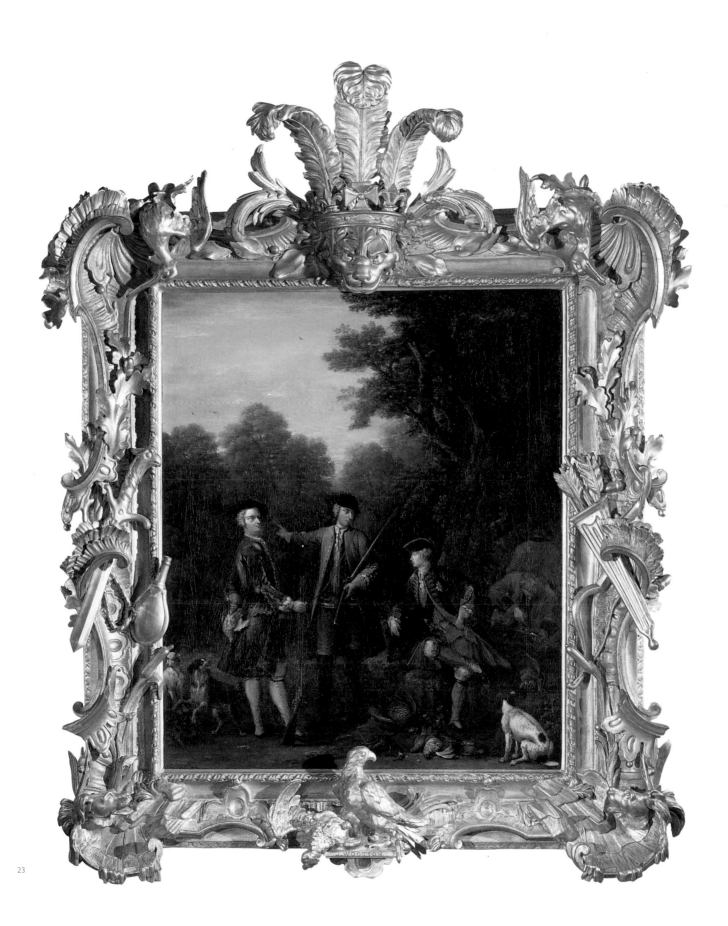

23

Prince Frederick, seated with dead game and a gun dog before him, turns to the Duke of Queensberry (1698–1778), who points to the distance, while John Spencer (1708–1746) stands by. At the left are two dogs, and at the right are grooms in royal livery loading guns. Following a disagreement with George II over John Gay's opera *Polly*, the Duke of Queensberry became a Gentleman of the Bedchamber to Prince Frederick. John Spencer was MP for Woodstock, and succeeded to the inheritance of his grandmother Sarah, Duchess of Marlborough in 1744 on condition that he did not accept any royal "pension or any office of employment" except the rangership of Windsor Great Park.

Wootton, the leading early Georgian painter of sporting and landscape subjects, was visited in his studio by Prince Frederick and his wife in 1738. A second version of this composition, with Windsor Castle in the background, is now at Drumlanrig Castle. The magnificent frame, surmounted by the Prince of Wales's feathers and enriched with game birds, dogs and hunting equipment, is one of several made by Paul Petit (1724–1757) for Prince Frederick. It is probably the "Rich picture frame Carved with birds Richly Ornamented neatley repair'd and Gilt in Burnished Gold to a picture of His Royal Highness painted by Mr Wooton", completed by 6 October 1742, for which Petit received payment of £21.
MLE

24

Charles Frederick Zincke (1683/84–1767)

24. *Frederick, Prince of Wales*

Enamel, 4.4 × 3.7 cm (1¾ × 1½ in.), oval
RCIN 421809
PROVENANCE Frederick, Prince of Wales.
REFERENCE Walker 1992, no. 41, fig. 5

The artist came to England from Dresden in 1706 and was taught the art of enamelling by Charles Boit, who worked for William III and then Queen Anne. He received several commissions from the Royal family from the late 1720s, and was appointed Cabinet Painter to Frederick, Prince of Wales in 1732. Zincke produced several images, with the aid of studio assistants, of the Prince and Princess of Wales, as well as other members of George II's family (cat. 48).

This portrait may be dated on the basis of the uniform, which is prominently decorated with oak leaves, a symbol of military success. The uniform no doubt relates to George II's victory over the French at the Battle of Dettingen in June 1743 – the last occasion when a British sovereign personally led his troops into battle. Frederick, Prince of Wales, held the rank of General, but was never in active command. However, his younger brother, William, Duke of Cumberland, did accompany George II at Dettingen and is shown wearing a similar uniform in Zincke's miniature of him in the National Portrait Gallery.
CL

25

25. *Augusta, Princess of Wales*

Enamel, 4.6 × 3.8 cm (1¾ × 1½ in.), oval
RCIN 421830
PROVENANCE Frederick, Prince of Wales
REFERENCE Walker 1992, no. 46

Princess Augusta of Saxe-Gotha arrived in England in April 1736 and married Frederick, Prince of Wales the day after her arrival. The marriage took place in the Chapel Royal in St James's Palace. Lord Hervey gives a long account of the ceremony in his *Memoirs*.

This enamel was almost certainly commissioned by the Prince of Wales in 1736 and may be one of the items paid for in February 1737/38. The ringlets of hair at the back of the head emulate the preferred hairstyle of Queen Caroline and of her daughters, who were also depicted by Zincke. The lustrous quality of the colour and the stippling enhance the pictorial effect of both cats. 24 and 25. A variant of the present miniature is in the Ashmolean Museum, Oxford.
CL

26

Annibale Carracci (1560–1609)

26. *Head of a man in profile*

Oil on canvas, 44.8 × 32.1 cm (17⅝ × 12⅝ in.)
RCIN 405471
PROVENANCE Probably acquired by Frederick, Prince of Wales, by 1750; George III
REFERENCE Richardson 1725, pp. 166, 206; London 1960, no. 121; Posner 1971, II, pp. 25, 27, pls. 54, 61; Levey 1991, pp. 60–61; Rorschach 1985, pp. 243–44, 354–55; London 1988¹, no. 55; Lloyd 1994, no. 2

This spontaneous portrait, dated between 1582 and 1590, is probably one of "The heads two Carracis by themselves" seen by George Vertue in the collection of Prince Frederick in 1750. Although it does not resemble Annibale's *Self-portrait* in the Uffizi, its bold handling might be suggestive of a self-portrait. It may have been recommended to the Prince by his advisor Major-General John Guise (died 1765), whose collection included major paintings by Annibale Carracci now in Christ Church, Oxford.

With their cousin Lodovico (1555–1619), the Bolognese painters Annibale and Agostino (1557–1602) Carracci revitalized Italian classicism by returning to the heritage of the High Renaissance. In 1725 Jonathan Richardson observed that "Annibale Carracci was rather Great, than Gentile", and noted: "Tis no Objection against a Sketch if it be left Unfinish'd, and with Bold Rough Touches, tho' it be Little, and to be seen Near". In 1769 Reynolds praised the "scrupulous exactness" of Annibale's life sketches, while finding him "often sufficiently licentious in his finished works".
MLE

Jan Brueghel the Elder (1568–1625)

27. *A Flemish fair*, 1600

Oil on copper, 47.6 × 68.6 cm (18¾ × 27 in.)
Signed *BRVEGHEL A 1600*
RCIN 405513
PROVENANCE Probably purchased in Spain by Sir Daniel Arthur; his widow, who married George Bagnall; from whom purchased by Frederick, Prince of Wales, before July 1750
REFERENCE Vertue VI/29, 1938, p. 127; London 1946, no. 275; London 1953¹, no. 353; Gerson and Ter Kuile 1960, p. 58; Manchester 1965, no. 52; Millar 1977, pl. XVIII, p. 100; Ertz 1979, pp. 47–49, 567, no. 60; Brussels 1980, pp. 174, 176, 188, no. 121; Rorschach 1985, pp. 234, 246, 352; Campbell 1985, pp. 13–20; London 1988¹, no. 52; London 1991², no. 35; London 1995, no. 62; London 1996, no. 14

Vertue saw this painting of "a merry makeing or a fair [with] many small figures", together with one of *Adam and Eve*, also now in the Royal Collection, in George Bagnall's collection in 1740. *A Flemish fair* is an exceptionally fine example of the miniaturist technique with which Jan Brueghel re-interpreted at a smaller scale the peasant landscapes of his father Pieter (1525/30–1569), the founder of the Brueghel dynasty of painters. Many of Pieter's paintings found their way into the Habsburg collections, while Jan collaborated with Rubens and enjoyed a distinguished circle of patrons, including the Archduke Albert, Rudolf II, Cardinal Federico Borromeo and Sigismund III of Poland.

The Flemish genre of landscapes peopled with merry-making peasants was introduced to England in 1569–70 by Joris Hoefnagel (1542–1600) with his *Fête at Bermondsey*, now at Hatfield House. Charles I owned numerous paintings by or attributed to Brueghel the Elder, and Charles II owned "a kermiss of Old Brughell" and a "Brugle" of "Dutch Boores making pastime", as well as Pieter's *Massacre of the Innocents*, which remains at Hampton Court. Although 18th-century polite society was not attuned to Pieter Bruegel's realism, Jan's critical reputation remained high on account of his exquisite technique.
MLE

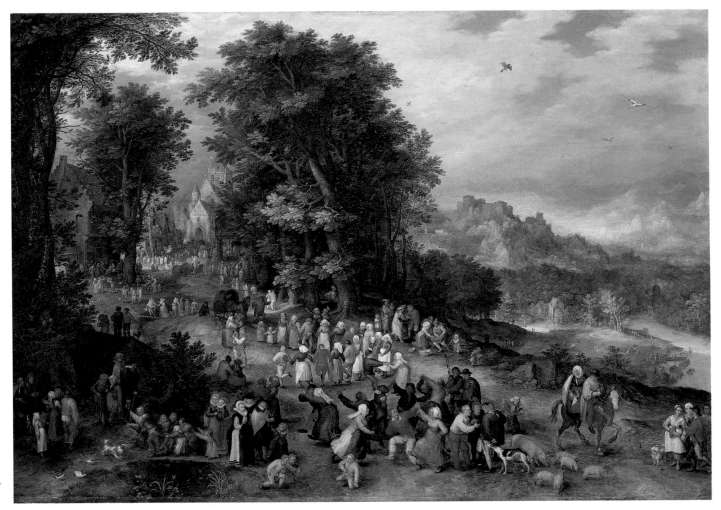

27

Guido Reni (1575–1642)
28. *The death of Cleopatra*

Oil on canvas, 113.7 × 94.9 cm (44¾ × 37⅜ in.)

RCIN 405338

PROVENANCE Boselli, Venice, by 1628 (?); Nicolo Renieri (?); Domenico Fontana (?); acquired by Frederick, Prince of Wales, by 1749

REFERENCE Richardson 1725, pp. 251, 260–61; Waagen 1854, p. 434; Vertue I/18, 1930, pp. 10–11; Levey 1991, pp. 123–24; Spencer (ed.) 1964, pp. 291–93; Pigler II, 1974, pp. 398–403; Reynolds 1975, p. 78; Millar 1977, pp. 98–99; Pepper 1984, pp. 266–67; Altick 1985, pp. 45, 171–72, 319–21; Rorschach 1985, pp. 246, 262, 395; Russell 1987, pp. 526, 529; Frankfurt 1988, no. A.16; London 1988¹, no. 24; MacGregor 1989, pp. 214, 220–22; McGrath II, 1997, pp. 276–78

Cleopatra, Queen of Egypt (69–30 BC) was the ally and mistress of Mark Antony in his war with Octavian. According to Plutarch, they committed suicide after their defeat at the Battle of Actium – Cleopatra by letting an asp bite her arm. Like Shakespeare in *Antony and Cleopatra*, Reni followed the Renaissance pictorial convention of the queen applying the snake to her breast. Shakespeare's play was almost unknown to the London stage during the 18th century, but the story retained its popularity through Dryden's *All for Love*.

This is one of the earliest of several half-length paintings of this subject by the celebrated Bolognese painter Guido Reni. Charles I's fine collection of paintings by Reni was sold after his death, but in 1723 George I bought two large mythologies, now in the National Gallery, London. In 1725 Jonathan Richardson praised Reni as a "sublime" master, comparable even with Raphael and the sculptors of classical antiquity. Prince Frederick included this painting among the works which "I mostly value" in his Closet at Leicester House in 1749. Vertue initially mistook it for a *Death of Lucretia*, but enthusiastically described it as "so beautiful strong clear & Natural. of the finest taste of that skillfullest artist Guido". Although Reynolds found Reni's work wanting for its lack of expression, George III later hung this work with a select group of largely 17th-century Italian paintings at Buckingham House. MLE

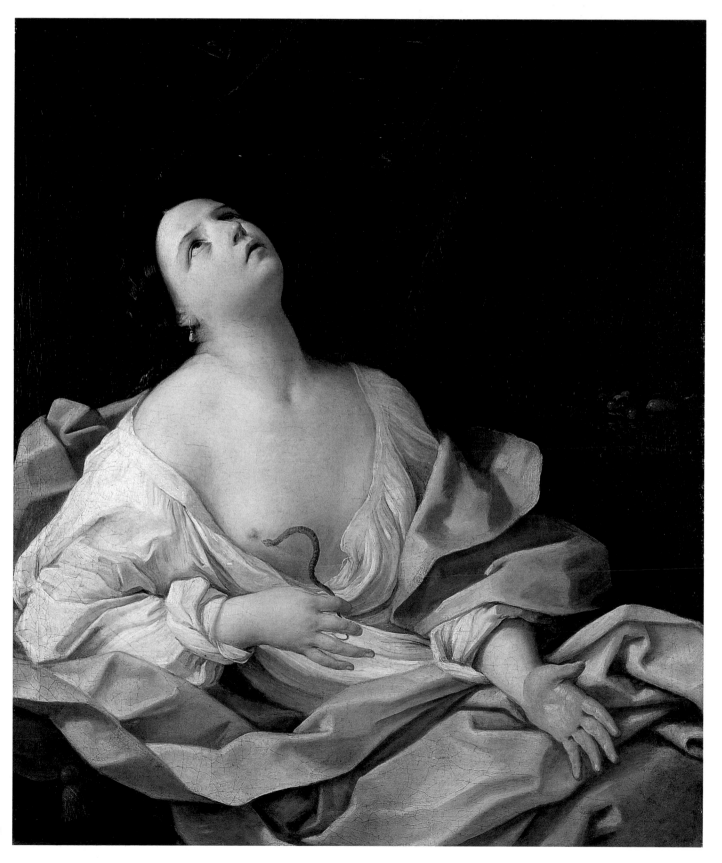

28

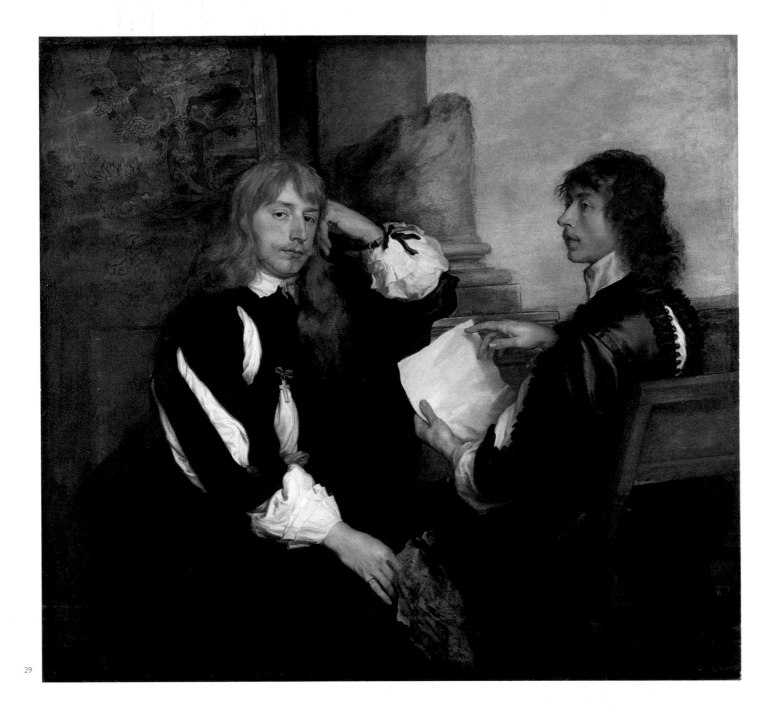

29

30

Sir Anthony van Dyck (1599–1641)

29. *Thomas Killigrew and William, Lord Crofts (?)*, 1638

Oil on canvas, 132.7 × 143.5 cm (52¼ × 56½ in.)
Signed on base of column *A. van, Dyck, 1638*
RCIN 407426

PROVENANCE Reputedly purchased in Spain by Sir Daniel Arthur; his
widow, who married George Bagnall; from whom purchased by Frederick,
Prince of Wales, in 1748

REFERENCE Smith III, 1831, no. 214; Walpole 1849, I, pp. 326–27; Waagen
1854, p. 427; Vertue I/18, p. 11; II/20, p 125; VI/29, p. 127; London 1946, no.
36; Millar 1963, pp. 30, 101; London 1968, no. 14; Millar 1977, pp. 100, 103;
Rorschach 1985, pp. 18, 28–29, 234, 247, 420–21; Larsen 1988, I, p. 368, figs. 406,
407; II, pp. 322, 348, nos. 817, 891; London 1988¹, no. 9

Thomas Killigrew (1612–1683) was a courtier of Charles I and
Charles II. A dramatist, he became a leading figure in the Restoration
theatre. His pose, traditionally associated with melancholy, probably
alludes to the recent death of his wife Cecilia. The broken column in
the background may be an emblem of fortitude. Larsen has suggested
that this work may be a pair to a portrait of *Cecilia Killigrew and Anne,
Lady Dalkeith* at Wilton House. The identity of the second sitter was
uncertain by Vertue's time, and remains conjectural. William, Lord
Crofts, (*ca*. 1611–1677) was Killigrew's brother-in-law. This format, of
two sitters in conversation, derives from Venetian High Renaissance
paintings. The Royal Collection includes numerous works by Van
Dyck, mostly painted for Charles I, and this is one of the artist's most
distinguished portraits.

George Vertue first saw this portrait at George Bagnall's house in
Soho Square in 1740. He and Horace Walpole believed that it portrayed

a dispute on jealousy between Killigrew and Thomas Carew
(1594/95–1640). Carew's poem *Iealousie* was sung at a Whitehall masque
in 1633 and performed in Killigrew's tragi-comedy *Cicilia and Clorinda*,
published in 1664. Prince Frederick was probably aware of these theat-
rical associations, as an observer noted his "particular Liking to our
English Comedies, and the English Actors".
MLE

Claude Gellée, called Le Lorrain (1600–1682)

30. *Harbour at sunset*, 1643

Oil on canvas, 74.3 × 99.4 cm (29¼ × 39⅛ in.)
RCIN 401382

PROVENANCE Probably acquired by Frederick, Prince of Wales

REFERENCE Manwaring 1925, pp. 14–57; Röthlisberger 1961, no. 19; London
1969, pp. 9–10, no. 17; London 1991², no. 42; Rorschach 1989-90, p. 17, no. 59;
Lloyd 1994, no. 12

"Of all the Landskip-painters *Claude Lorrain* has the most Beautiful, and
Pleasing Ideas", wrote Jonathan Richardson in his *Guide to Italy* (1722).
Claude, along with Salvator Rosa and Gaspar Dughet (see cat. 31) were
avidly collected by 18th-century English connoisseurs, inspired by
nostalgia for the Italian Campagna and evocative ruins encountered on
the Grand Tour. By the mid century Claude's Arcadian views were per-
ceived as the epitome of the Picturesque – defined by William Gilpin
as "that kind of beauty which would look well in a picture". Com-
positional elements of Claude's numerous harbour scenes were
appropriated by British artists, particularly John Wootton (see cat. 23).

A related, although not identical, composition appears as no. 19 in

31

Claude's sketch-book, the *Liber Veritatis*. The only firmly identifiable building is the monumental gateway on the right, based on the 3rd-century Arcus Argentarium at San Giorgio in Velabro, Rome. It is depicted in reverse, which suggests that the artist was working from a printed source.

Frederick, Prince of Wales, was one of the first collectors in England to assemble a significant group of French paintings. This may have included as many as four works by Claude – probably including this one – which were seen in his collection by George Vertue.

KB

Gaspar Dughet (1615–1675)

31. *Seascape with Jonah and the Whale*

Oil on canvas, 97.8 × 136.1 cm (38½ × 53⅝ in.)
RCIN 405355
PROVENANCE Marchese Pallavicini; sold to Humphrey Edwin, from whom purchased by Frederick, Prince of Wales, *ca.* 1745
REFERENCE Smith 1837, pp. 24–25; London 1980[1], no. 6; Boisclair 1986, no. 127; Rorschach 1989–90, p. 17, no. 31

The presence of four major paintings by Gaspar Dughet in Prince Frederick's collection is attested to by Vertue, who saw "4 of them large and fine" at Leicester House in 1749. The others, all landscapes, also remain in the Royal Collection.

Horace Walpole recognized that the subject-matter of this painting was unusual for the artist, describing it as "the only Sea-piece, I believe, of that Hand". While Dughet's harmonious landscapes were collected for their Picturesque sensibility, *Jonah and the Whale* was perceived as a dramatic expression of the sublime. This quality, and its royal associations, made this work famous during the 18th century. It was

engraved by F. Vivares in 1748, and at least two extant copies were made directly from the painting.

The painting depicts the moment when Jonah is thrown into the whale's mouth (Jonah 1: 15–17). The composition is based upon a fresco by the Netherlandish painter Paul Bril in the Church of the Scala Santa in Rome, which also inspired Claude's etching, *The tempest*. Dughet has increased the dramatic tension by setting the scene during a thunderstorm. In the 19th century this painting was thought to be by Dughet's brother-in-law Nicolas Poussin (see cats. 37–41), and until recently the figures were attributed to him.

K B

32

Eustache Le Sueur (1626–1655)

32. *Caligula depositing the ashes of his mother and brother in the tomb of his ancestors*, 1647

Oil on canvas, 161.3 × 122.3 cm (63½ × 48⅛ in.)
RCIN 404983
PROVENANCE Acquired by Frederick, Prince of Wales by 1749
REFERENCE London 1946, no. 433; Mérot 1987, no. 77; London 1991², no. 43; Rorschach 1989–90, p. 17, no. 50; Lloyd 1994, no. 12

This is presumably the painting in Leicester House described by Vertue in 1749 as "hung over the chimney, a painting of antient learned men & by Le Seur [*sic*] – a capital picture".

When Prince Frederick arrived in England from Hanover in 1728, he was probably better acquainted with contemporary trends in collecting than most of his father's courtiers, as painting "after the French manner" was – as Vertue noted – "not pleasing to the taste of this nation".

A pupil of Simon Vouet (1590–1649), Le Sueur was profoundly influenced by Raphael and, more immediately, by Poussin. This picture presents the exemplary piety of the Emperor Caligula, who made a dangerous sea journey to retrieve the remains of his mother and brother for interment in the family mausoleum in Rome. The rigid composition, clarity and purity of colour underline the severity of this demonstration of Stoic virtue – a theme also favoured by Poussin. Such didactic expressions of moral themes were much appreciated by later British collectors, notably Prince Frederick's son, George III.

K B

Isaac Oliver (*ca.* 1565?–1617)

33. *Portrait of a melancholy young man*

Watercolour on vellum laid on card. 12.4 × 8.9 cm (5 × 3½ in.)
Signed on the right in gold *I.O.* in monogram
RCIN 420639
PROVENANCE Dr Richard Mead; Frederick, Prince of Wales; George III
REFERENCE Vertue I/18, p. 153; Walpole 1928, I, p. 296; Holmes 1906, p. 26; Long 1929, p. 318; London 1947, no. 124; London 1956, no. 635; Auerbach 1961, pp. 223, 240–41, 328; Strong 1964, pp. 264–69; London 1968, no. 85; Finsten 1981, I, pp. 100–03; II, pp. 18–22, no. 13; Strong 1983, pp. 154–55; London 1983, no. 268; Reynolds 1983, pp. 309, 311; Edmond 1983, pp. 111–12; London 1988¹, no. 76; Rorschach 1989–90, p. 75, no. 177; New York 1996, no. 20; Wells-Cole 1997, p. 80; Reynolds (forthcoming), no. 74

Isaac Oliver occasionally made miniatures on a larger scale that permitted a full-length format and a more elaborate background. Such treatment was almost certainly reserved for particularly significant commissions, and cat. 33 has accordingly been extensively discussed. Its high quality is exemplified by the careful observation of the flowers and the sword hilt. The background view of the building and formal garden is derived from a print by Hans Vredeman de Vries, published in the *Artis Perspectivae* (Antwerp 1568).

Earlier writers convinced themselves that this miniature was a portrait of the Elizabethan poet, Sir Philip Sydney (1554–1586). This can be discounted on chronological grounds, but the costume (note the discarded glove), pose and direct gaze of the sitter suggest 'the

33

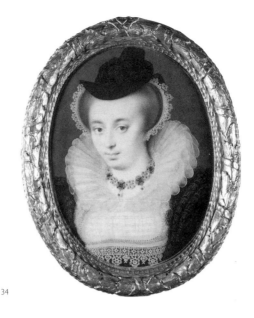

34

Isaac Oliver

34. *Portrait of an unknown woman*

Watercolour on vellum laid on card, 7.8 × 5.9 cm (3 × 2¼ in.), oval
RCIN 420063

PROVENANCE Dr Richard Mead; Frederick, Prince of Wales; George III
REFERENCE Vertue I/18, p. 78 and IV/24, p. 187; Walpole 1928, I, p. 296;
Holmes 1906, p. 26; London 1947, no. 133; Winter 1947, p. 180; London 1956,
no. 636; Edinburgh 1965, no. 32; London 1968, no. 87; Edinburgh 1975, no. 55;
Finsten 1981, I, pp. 112–13 and II, pp. 63–65, no. 38; London 1983, no. 160;
Strong 1983, p. 166; Edmond 1983, pl. 25; Bayne-Powell 1985, pp. 161–62;
Rorschach 1989–90, p. 75, no. 176; London 1988¹, no. 77; New York 1996, no.
22; Reynolds (forthcoming), no. 51

Formerly thought to represent Mary, Queen of Scots, the sitter of this
exceptionally well preserved miniature remains unknown. Her mode
of dress suggests that she was a member of the wealthy gentry, like
many of Oliver's earliest patrons. A slightly smaller miniature by
Oliver, in the Fitzwilliam Museum, Cambridge, may depict the same
sitter.

The style shows an advance on cat. 33. There is no reduction in the
skilful handling of the detail, where the firm modelling and use of
shadow create a sense of corporeality. But the softer treatment of the
flesh tones may indicate a date *ca.* 1596, after Oliver's return from
Venice. Indeed, when due allowance is made for the strong northern
characterization, the portrait shows a certain kinship with Italian art.
The scale is larger than the average head-and-shoulders by the artist,
and the vividness of the blue background is enhanced by the use of
ultramarine instead of the cheaper and more traditional blue bice. The
existence of an enamel copy by C.F. Zincke (for whom see cats. 24 and
25), made while the miniature was in Dr Mead's possession is a reflec-
tion of the status of cat. 34.

CL

Elizabethan malady' of melancholy, associated with the pursuit of
literature and scholarship, and much affected by aristocrats. The neat,
precise style, particularly in the drawing of the face, implies a date of
ca. 1590.

The first recorded owner of the miniature, Dr Richard Mead
(1673–1754), had numerous distinguished patients, including Antoine
Watteau, Sir Isaac Newton, Sir Robert Walpole and George I. He was
appointed Physician to George II in 1727. Mead financed several liter-
ary ventures, and became a Governor of the Foundling Hospital in
London, which commissioned significant works from British artists.
Mead's collection of paintings, sculpture, books, manuscripts, coins,
gems and portrait miniatures was dispersed at his death in 1754.
Frederick, Prince of Wales seems to have acquired some of his choicest
miniatures sometime after 1745.

CL

35

36

Isaac Oliver

35. *Self-portrait*

Watercolour on vellum laid on card, 4.5 × 3.7cm (1¾ × 1½ in.), oval
Signed on the right in gold: *I.O.* in monogram surrounded by four dots
RCIN 420034
PROVENANCE Dr Richard Mead; Frederick, Prince of Wales; George III
REFERENCE Vertue I/18, p. 63 and IV/24, p. 47; Walpole 1928, I, p. 296;
Holmes 1906, p. 22; Long 1929, p. 319; Winter 1948, p. 11; London 1947, no.
136; Edinburgh 1965, no. 21; Edinburgh, 1975, no. 52; Finsten 1981, II, pp.
32–33, no. 18; Murrell 1983, p. 39; London 1983, no. 134; Strong 1983, pp.
151–53; Rorschach 1989–90, p. 75, no. 178; London 1995¹, no. 77; New York
1996, p. 29, fig. 13, no. 23; Reynolds (forthcoming), no. 48

This vivid self-portrait is one of three by the artist. A larger miniature
in the National Portrait Gallery, depicting the sitter hatless with only
an incipient beard, once belonged to Horace Walpole, who wrote
eulogistically about it. This and cat. 35 both date from *ca.* 1590. The third
self-portrait, a much more elaborate composition at three-quarter
length, is only known through an engraving by Hendrick Hondius
datable *ca.* 1610. It shows the artist at a later stage in life and draws
attention to his profession as a miniaturist. The pose of the two earlier
self-portraits owes a great deal to Flemish art, a tradition with which
Oliver was familiar from the start of his career. The tonal qualities and
the taut rhythms of the pose recall the oval engraved portraits of
Hendrick Goltzius (1558–1617).

Cat. 35 provides considerable insight into Oliver's character. The
viewer is made immediately aware of the artist's status and success.
He appears to emphasize his Continental origins through a fashion of
dress which contemporaries apparently mistook for that of a French-
man. Its tiny size provides a striking contrast with the large scale of
cat. 33, and is testimony to Oliver's wide-ranging skills.
CL

Peter Oliver *(ca. 1594–1647)*

36. *Self-portrait*

Watercolour on vellum laid on playing card, 7.6 × 6.1 cm (3 × 2½ in.), oval
RCIN 420034
PROVENANCE Dr Richard Mead; Frederick, Prince of Wales; George III
REFERENCE Walpole 1928, I, p. 296; Holmes 1906, p. 110; London 1956, no.
106; Millar 1963, no. 214; Edinburgh 1965, no. 36; London 1968, no. 103; Strong
1969¹, p. 184; Rorschach 1989–90, p. 75, no. 179; London 1995, no. 103; New
York 1996, no. 30; Reynolds (forthcoming), no. 74

Peter Oliver was the eldest son of Isaac Oliver and worked at first as
his assistant (*ca.* 1610–17). He inherited his father's unfinished works,
and was later employed in his own right by Charles I, Frederick V of
Bohemia and Princess Elizabeth. He received a pension of £200 per
annum from Charles I for the completion of Isaac Oliver's limning of
The Entombment, which is now in the Musée des Beaux-Arts, Angers.
Peter Oliver was frequently commissioned by the king to make
miniature copies of paintings, several of which remain in the Royal
Collection.

Cat. 36, which is unfinished, was thought in the 18th century to
depict the dramatist Ben Jonson. However, the sitter is identifable as
Peter Oliver from other identified representations of him, including a
painting by Adriaen Hanneman in the Royal Collection, a miniature
in the collection of the Duke of Buccleuch, and a drawing (paired with
one of his wife) in the National Portrait Gallery. This self-portrait dates
from the early 1620s. Compared with that of his father, Peter Oliver's
style is broader and softer in pictorial effect. The pose, looking over the
right shoulder, is informal but dynamic. Its origins may lie in portraits
by Titian (such as the *Portrait of a man*, previously known as 'Ariosto',
in the National Gallery, London) or Tintoretto, but it anticipates the
vitality brought to portraiture in the next decade by Van Dyck and later
by Samuel Cooper. CL

37

Nicolas Poussin (1594–1665)

37–41. *Five drawings from an album*

37. *Orpheus in Hades, ca. 1622–23*

Graphite underdrawing, brown ink and grey wash on paper, 18.9 × 32.0 cm
(7⁷⁄₁₆ × 12⁵⁄₈ in.)
RL 11937; Blunt 1945, no. 157

After the death of the dryad Eurydice, according to Ovid, her griev-
ing husband Orpheus descended to Hades, where he persuaded Pluto
by the beauty of his music to allow her to return to Earth. Orpheus is
playing the harp, surrounded by denizens of the Underworld.

38. *Acis transformed into a river-god, ca. 1622–23*

Graphite underdrawing, brown ink, brown and grey washes on paper,
18.9 × 31.9 cm (7⁷⁄₁₆ × 12⁹⁄₁₆ in.)
RL 11939; Blunt 1945, no. 160

Acis, the son of Pan and lover of the sea-nymph Galatea, was crushed
with a rock by the jealous Cyclops Polyphemus. According to the *Meta-
morphoses* of the Roman poet Ovid, Galatea changed the dead youth
into a river-god. Here the transformed Acis emerges, crowned by reeds,
to the consternation of bystanders. This drawing is a pendant to one
of *Polyphemus discovering Acis and Galatea*, also in the Royal Collection.

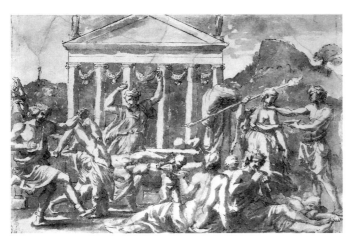

39. *A ritual dance before a temple, ca. 1636–37*

Black chalk underdrawing, brown ink and wash on paper, 20.8 × 31.4 cm
(8³⁄₁₆ × 12³⁄₈ in.)
RL 11910; Blunt 1945, no. 198

This drawing has been torn into fourteen pieces and repaired, prob-
ably during the 17th century for Cardinal Massimi. Although tradi-
tionally identified as a dance in honour of the fertility god Priapus, the
subject-matter is unclear. This and a related drawing in Chantilly are
studies for a lost painting by Poussin, known only through copies.

40. *The Holy Family with the infant St John, ca. 1637–38*

Brown ink and wash on paper, 13.9 × 10.6 cm (5½ × 4³⁄₁₆ in.)
RL 11917; Blunt 1945, no. 208

Drawn on the reverse of a fragment of a draft of a letter written by
Poussin, this sketch may be related to a lost painting mentioned in an
account of 1638. The figures of the Virgin and Child derive from
Raphael's *Madonna della sedia*, and that of St Joseph is a quotation from
the antique painting known as *The Aldobrandini Wedding*.

41. *Ordination*, 1647

Lightly squared in black chalk, slight black chalk underdrawing, brown ink
and wash on paper, 19.6 × 32.6 cm (7¾ × 12¹³⁄₁₆ in.)
RL 11899; Blunt 1945, no. 260

This drawing depicts Christ's charge to St Peter, "thou art Peter, and
upon this rock I will build my church", mentioned in the Gospel accord-
ing to Matthew (16:18–19). It is a study for the oil painting of *Ordina-
tion* from the series of the *Seven Sacraments* from the Sutherland
collection, now in Edinburgh.

PROVENANCE Cardinal Camillo Massimi; by descent; purchased by Dr
Richard Mead in 1739; acquired by Frederick, Prince of Wales by 1750
REFERENCE Friedländer 1929, pp. 253–57, nos. 34, 28, 19, 53, 60; Blunt 1945,
pp. 32–33; Waterhouse 1960, pp. 288–95; Reynolds 1975, p. 87; Blunt 1976, pp.
3–10, nos. 34, 28, 19, 53, 60; Rorschach 1985, pp. 247, 253, 392–93; Reid 1993, I,
pp. 444–45, II, pp. 783, 921–22; Rosenberg and Prat 1994, I, nos. 13, 8, 96, 152,
265; Clayton 1995, pp. 10–11, 20–26, 111–13, 123–26; nos. 7, 4, 38, 43, 58;
Brigstocke 1996, p. 395; Moore 1996, pp. 53, 59, 64, 133, 148–49

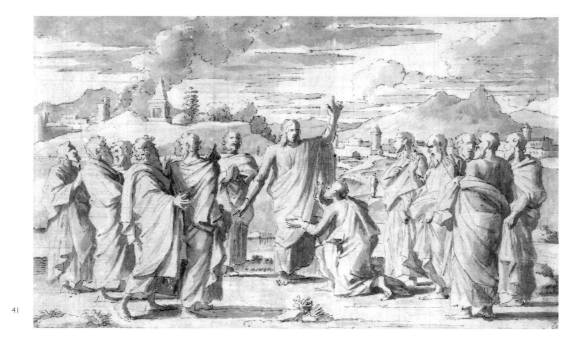

41

Unusually for a 17th-century history painter, Poussin worked with little studio assistance and produced few life studies. In 1741 the French connoisseur Pierre-Jean Mariette observed, "When he was drawing his only aim was to get his ideas down ... with such abundance that a simple theme would stimulate ... an incredible number of different sketches. With a simple line, sometimes with the addition of a few brushstrokes of wash, he was able to express clearly what his imagination had conceived".

The nucleus of the sixty-six drawings from this album, fifteen sheets illustrating Ovid, were apparently made in 1622–23 for Poussin's first known patron, the poet Giovanni Battista Marino (1569–1625). Cardinal Camillo Massimi (1620–1677), who assembled the album, became one of Poussin's most important patrons. Purchased in 1739 by Dr Richard Mead, it was in the collection of Prince Frederick by 21 December 1750, when he showed George Vertue "a book of Drawings by Pousine". The album was broken up and the drawings mounted individually around the beginning of the present century.

In 1717 the painter Sir James Thornhill inaugurated the fashion for Poussin in 18th-century England with his purchase of the painting of *Tancred and Erminia*, now in Birmingham – a work which Jonathan Richardson discussed at length in his *Essay on the Art of Criticism*, published in 1719. One of the greatest collectors of the day, the Prime Minister Sir Robert Walpole (1676–1745) owned eight paintings by or attributed to the master in 1736. Although Walpole's political opponent, Prince Frederick evidently shared his taste. In addition to the Massimi album, he paid £47. 5s. 0d. in 1742 for a painting of *Venus and Cupid* by Poussin, which is no longer identifiable. In 1772 Sir Joshua Reynolds succinctly expressed the classical sensibility which endeared Poussin's work to Georgian conoisseurs: "No works of any modern has so much of the air of Antique Painting as those of Poussin. His best performances have a remarkable dryness of manner, which though by no means to be recommended for imitation, yet seems perfectly correspondent to that ancient simplicity which distinguishes his style".
MLE

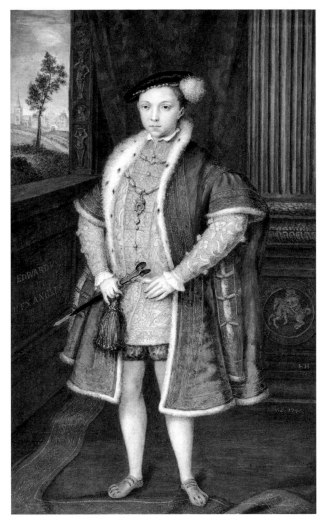

42

George Vertue (1684–1756) after an unidentified 16th-century artist

42. *King Edward VI*

Watercolour on paper, 43 × 25.6 cm (17 × 10¼ in.)
Signed *GV. f. 1745*
RCIN 452476
PROVENANCE Purchased from the artist by Frederick, Prince of Wales, 29 May 1749
REFERENCE Vertue I/18, p. 9, IV/24, pp. 65–66, and V/26, p. 77; Oppé 1950, p. 98, no. 627; Millar 1963, pp. 64–65; Rorschach 1985, p. 423, no. 227

The antiquary and engraver George Vertue was patronised by Edward Harley, 2nd Earl of Oxford, and was a friend and advisor of the Prince of Wales. He is best known for his collection of material for a history of the fine arts in England, utilized after his death in the *Anecdotes of Painting* by Horace Walpole (1717–1797). Vertue produced a few portrait miniatures, and some copies after well known paintings.

This miniature is a copy of an anonymous three-quarter-length oil painting of King Edward VI (1537–1553) in the Royal Collection, which was formerly attributed to Hans Holbein. The painting was enlarged to a full-length by the seventeenth century, but had been returned to its original format by 1813. Vertue saw it at Kensington Palace in 1734: "the picture painted on board of K. Edwd. 6 ... by H. Holben. is most rarely painted. the Face & flesh perfectly. lively and natural the habit furrs. jewells &c. excellently done ... this picture originally was only done to the knees. but since of late added ... at bottom more to make the leggs & feet. but so ill and unjudiciously drawn. that he stands like a cripple".

When the Prince of Wales visited Vertue on 29 May 1749, the antiquary sold him "two limnings I had done, my Self", a picture of Henry V and a "limning (at large) being K Edward 6. standing – a limning I did from the original at Kensington done by Hans Holben". Frederick collected a number of portraits of his predecessors. This "very curious" miniature was noted in the collection of his grandson the Prince Regent at Carlton House in 1816–19. MLE

43. Revd Griffith Hughes (*ca.* 1707–after 1750), *The Natural History of Barbados, in ten books*

Open at pl. IV, the Cabbage tree, inscribed to Frederick, Prince of Wales
London: printed for the author, 1750. [4], xx, 334p., 32 leaves of plates: ill., map. Large-paper copy. Bound in red sheepskin, tooled in gold with dark blue onlays; gilt edged; 42.7 × 27.8 × 5.7 cm (16⅝ × 10⅞ × 2¼ in.), width when open 58.7 cm (22¾ in.)
RCIN 1081286
PROVENANCE Subscription copy bound for Frederick, Prince of Wales; George III's 'Windsor Library'; in the present Royal Library by June 1837
REFERENCE Holmes 1893, no. 62; Smith and Benger 1928, p. 7f.; Young 1937, pp. 166, 186; Nixon 1978, p. 148

Few books in the Royal Library can confidently be traced to the library of Frederick, Prince of Wales, of which the scope and fate remains uncertain. Some of his books clearly passed to his sons, as they bear ownership marks of George III and his brother William, Duke of Gloucester.

43

44

This plate, dedicated to Prince Frederick, is one of several drawn and engraved by Georg Dionysius Ehret, a German botanical artist who was trained by Linnaeus to depict individual parts as well as the whole of plants, and came to England in 1740. His skills were much in demand, and Dr Richard Mead and Sir Hans Sloane, both Fellows of the Royal Society and subscribers to this work, were notable patrons of his. Little is known of the author, the Revd Griffith Hughes, Rector of St Lucy's, Barbados, except that he, too, was a Fellow of the Royal Society from 1748. The binding of this volume, with its characteristic blue onlays on red leather, is almost certainly by John Brindley, bookbinder to the Prince of Wales. Brindley was also an antiquarian bookseller and a publisher of works by Pope and Mead, among others.

Subscription was a common method in the eighteenth century of financing publications. As a friend of poets, such as Alexander Pope and James Thomson, Prince Frederick often appears as dedicatee, or subscriber to their works. He was likewise involved in the scientific avantgarde, intent on systematization and classification, employing the foremost botanical artists, such as Ehret, and engravers like Bickham (see cat. 44). The Prince and Princess of Wales, and Mead, subscribers for large-paper copies of this work, have plates dedicated to them; Sloane, surprisingly, does not.

BW

44. Robert Tailfer, 'Half-pay Officer' (*fl.* 1736), *True and correct tables of time, calculated for the Old Stile, ... and for the New Stile ... 1582 to 2083*

London: G. Bickham, 1736. 12 leaves of engraved plates: ill., tables. Bound in dark-green calf, tooled in gold; gilt edged; 21.8 × 13.6 × 1.2 cm (8½ × 5¼ × ½ in.)
RCIN 1082352
PROVENANCE Binding for Frederick, Prince of Wales; sold Mrs Evelyn Stainton, Sotheby's, 27 February 1951, lot 241; G. Michelmore & Co., catalogue 1953, no. 101; bought for the Royal Library
REFERENCE Hobson 1940, nos. 79–87

These tables show the various methods of calculating both the Old Style Julian calendar and the New Gregorian one. The latter, devised by the Neapolitan astronomer Ghiraldi, to correct the miscalculation of the old Roman leap-year system, was instituted in Catholic countries by Pope Gregory XIII in 1582 and adopted elsewhere at various later dates.

By the 1730s, a campaign was under way in Britain to adopt the Gregorian calendar, and establish 1 January and not 25 March as the start of the calendar year. This culminated in the Act of March 1751, promoted by the Earl of Chesterfield's eloquence and the Earl of Macclesfield's astronomical expertise. It stipulated the excision of eleven days in September 1752, thus bringing the calendar back into step with continental Europe, and was highly unpopular with the bewildered populace. Debate on the Bill and the Prince's death coincided. Like

Prince Frederick, the Earls of Macclesfield and Chesterfield were also subscribers to Hughes's *Natural History of Barbados* (cat. 43).

The elaborate fleuronné binding, although diagnosed by Michelmore as Scottish, shows more characteristics of Irish work, such as the small border-roll. Saltires on the spine, and gold end-papers with embossed coloured flowers, are known from both countries.
BW

Paul Crespin (1694–1770) and Nicholas Sprimont (1716-1771)
45. *The Neptune Centrepiece*, 1741–42

Silver-gilt oval tureen and cover surmounted by a reclining figure of Neptune, the bowl on scrolling bracket supports and dolphins, with four candle-branches; the irregular oval base with two pairs of shell dishes, one pair supported by mer-figures, the other by dragons. Tureen 49.5 × 66 × 47.3 cm

(19½ × 26 × 18⅝ in.); dragon dishes 11.5 × 19.2 × 18.5 cm (4½ × 7⁹/₁₆ × 7⁵/₁₆ in.); mer-figure dishes 6.7 × 21 × 15 cm (2⅝ × 8¼ × 5⅞ in.)
Marks: hallmark for London 1741–42 and maker's mark of Paul Crespin; the shell mount below the body of the tureen with mark of Turin and maker's mark of Andrea Boucheron; the later hippocamp base (not exhibited) with hallmark for London 1826–27 and maker's mark of John Bridge
RCIN 50282.a-n
PROVENANCE Almost certainly made for Frederick, Prince of Wales in 1741–42 and probably supplied by the Prince's goldsmith George Wickes on 24 June 1742
REFERENCE Grimwade 1969; London 1984¹, G17, pp. 113–14 (entry by E. Barr); Barr 1980, pp. 170–72, figs. 106–07; London 1988¹, nos. 114 and 118–19

This quintessential creation of the rococo forms the principal part of a celebrated group of table silver of lively and highly naturalistic marine inspiration, probably made for Prince Frederick in 1741–45. Although the centrepiece bears the mark of Crespin, the presence of Sprimont's

46

mark on the crab and crayfish salts (cat. 47), taken with certain stylistic features, strongly support the theory of Grimwade and Barr that Sprimont was as closely involved in the making of the centrepiece as in the other associated objects with the same provenance. As Sprimont's mark was not registered until 1743, it has been suggested that his associate Crespin marked the centrepiece for him.

A recent detailed examination of the centrepiece (forthcoming publication by C. Garibaldi and K. Jones) has revealed that the process of manufacture involved the re-use of at least two pre-existing elements. The shallow shell in which the bowl of the tureen rests bears the mark of the Turinese court goldsmith Andrea Boucheron (1701–1761); and the tureen and cover, including its tall S-scroll legs (now partially concealed by dolphins) is of slightly earlier date and appears to be of Continental, perhaps French, origin. The explanation for this may be that, like many royal commissions, this highly fashionable object had to be completed very quickly and that the Liègeois Sprimont had ready access to the second-hand elements utilized here.

The further discovery by Garibaldi and Jones that the two pairs of 'salts' with dragon and mer-figure supports – probably entrée dishes for scallops or similar delicacies – were intended to stand on the base and therefore form part of the overall design, places both centrepiece and dishes in a new light. Though a crowded composition, the infelicities noted by Elaine Barr are less pronounced with the dishes in place.

With or without the dishes, the Neptune centrepiece is evidence of Prince Frederick's wide-ranging taste and adventurous patronage; it presents a striking contrast to the other great table decoration made for him about the same date, the spectacular Palladian centrepiece designed by William Kent and supplied by George Wickes in 1745 (fig. 18, p. 42).
HR

Nicholas Sprimont

46. *Two from a set of four silver-gilt sauceboats, stands and ladles*, 1743–44 and 1744–45

The boats supported on dolphins and rock-work, two mounted with a seated nymph and two with a youth; the shaped oval stands and ladles with marine decoration. Sauceboats 22.7 × 23.2 × 13 cm (8^{15}⁄₁₆ × 9⅛ × 5⅛ in.); Stands 28 × 22.4 × 3 cm (11 × 8^{13}⁄₁₆ × 1³⁄₁₆ in.); Ladles 19.9 × 5.9 cm (8 × 2⁵⁄₁₆ in.)
Marks: two sauceboats and four stands hallmarked for London 1743–44, two sauceboats for 1744–45, all with maker's mark of Nicholas Sprimont; ladles unmarked
RCIN 51271.2-.3; 51259.1–.2
PROVENANCE as for cat. 45
REFERENCE (for sauceboats only) London 1984¹, G17, p. 114 (entry by E. Barr); London 1988¹, no. 115; New York 1997, no. 11

Like the dragon and mer-folk dishes (see cat. 45), the sauceboats had long been separated from their stands and have only recently been re-associated (forthcoming publication by C. Garibaldi and K. Jones). As Elaine Barr remarks, the exceptionally fine modelling and elegant posture of the seated figures, recalling Baroque fountain sculpture, place the sauceboats among Sprimont's most accomplished creations.
HR

47. *Two pairs of silver-gilt salts*, 1742–43

One pair cast as a crab with a conch shell between its claws, the second pair with a crayfish crawling over a clam shell, on naturalistic shell-strewn bases; and four spoons with shell bowls and coral handles. Crab salts 8.9 × 17.8 × 11.7 cm (3½ × 7 × 4⅜ in.); crayfish salts 8.7 × 14 × 14.1 cm (3⁷⁄₁₆ × 5½ × 5⁹⁄₁₆ in.); spoons 11 cm long (4⁵⁄₁₆ in.)
Marks: hallmark for London 1742–43 and maker's mark of Nicholas Sprimont; spoons unmarked

47

47

RCIN 51392.1-.2; 51393.1-.2; 51368.1-.4
PROVENANCE as for cat. 45
REFERENCE London 1984¹, G17, p. 114 (entry by E. Barr); London 1988¹, nos. 116–17

The extreme naturalism of the crabs, crayfish and shells, even on unseen surfaces, may be parallelled in the shell dishes accompanying the Neptune Centrepiece (cat. 45). This suggests – as Elaine Barr has pointed out – that Sprimont may have cast some or all of these features from life. HR

English
48. *Gold box, ca.* 1750

Elongated cartouche shape, chased all over with pastoral allegories, classical buildings, ruins, figures, a peacock and a pelican; the arched top chased with Prince of Wales feathers, motto and initials and a crest; inside the lid an enamel miniature portrait of Frederick, Prince of Wales in profile to left by C.F. Zincke; 3.8 × 6.8 × 9 cm (1⁷⁄₁₆ × 2¹¹⁄₁₆ × 3⁹⁄₁₆ in.)
Marks: Prince of Wales feathers and coronet flanked by the initials *F* and *LP* and motto *ICH DIEN*; arms of North below a Baron's coronet; motto *Non Sibi Sed Suis* below a pelican in her piety; otherwise unmarked
RCIN 3926
PROVENANCE Given by Frederick, Prince of Wales to Francis, 7th Lord North (later 1st Earl of Guilford); acquired by Queen Mary and given to King George V on his 49th birthday, 3 June 1914
REFERENCE London 1962, no. 28; (for miniature) Walker 1992, pp. 18, 25, no. 45

This very richly finished box was presented to Lord North, a Lord of the Bedchamber to the Prince of Wales, on his appointment by Prince Frederick as Preceptor to the young Prince George of Wales (later George III), an office which he held from 1749 until shortly after Prince Frederick's death in March 1751. The imagery on the box suggests a symbolic tribute to the Preceptor's selfless role in ploughing the ground in preparation for a rich harvest. Walker dates the miniature, described as "an exceptionally fine example of Zincke's art" to *ca.* 1742, ten years after Zincke's appointment as Cabinet Painter to His Royal Highness.

Prince Frederick's surviving accounts, which contain some payments in the 1730s to jewellers for gold boxes, including one to Jasper Cunst, do not include reference to this or the following two boxes. In the absence of documentation, it can only be surmised that the minutely detailed chasing is likely to be by one of the immigrant Germans who dominated London chasing in the mid-18th century.
HR

English?
49. *Gold box, ca.* 1740

Cartouche shape, the lid chased with Rococo cagework formed of asymmetric scrolls and shell-work incorporating putti with flower garlands on a plain ground, the bombé sides chased with male and female caryatids; the interior of the lid set with enamel miniatures of Frederick and Augusta, Prince and Princess of Wales after C.F. Zincke, below a chased crown; 2.8 × 7.5 × 6 cm (1⅛ × 2¹⁵⁄₁₆ × 2⅜ in.)
Marks: French import mark used from 1 June 1893; scratch inscription either side of thumbpiece *John/hane* (?)
RCIN 73414
PROVENANCE Unknown, but presumably made for presentation following the marriage of the Prince and Princess in 1736; given to Queen Mary by her family, Christmas 1935
REFERENCE Grandjean 1975, pp. 35–37, no. 9; Walker 1992, no. 40

The miniature of Prince Frederick is a variant of the enamel by Zincke commissioned by George II in 1729; that of Augusta is unrecorded. The scratched name *Hane*, possibly that of the maker of the box, has not been traced. A cagework gold and agate box of similar form, also with caryatids around the sides and believed to be English, is in the Rothschild Collection at Waddesdon Manor.
HR

English
50. *Gold box, ca.* 1750

Rectangular, the lid chased with an architectural caprice, obelisk and oval medallion of Prince Frederick below a coronet held by putti, within scrolling symmetrical cartouche, the front with Prince of Wales feathers and motto, the sides with attributes of Plenty, the back with trophy of arms; 2.8 × 6.8 × 5.2 cm (1⅛ × 2¹¹⁄₁₆ × 2¹⁄₁₆ in.)
Marks: unmarked
RCIN 4047
PROVENANCE Early history unknown; Hunt and Roskell, 1862; presented to Queen Mary by M. and Mme. de Falbe, 1898
REFERENCE London 1862, no. 4357; London 1962, no. 27

The commemorative iconography of this box (laurel-entwined obelisk, medallic portrait of the Prince *etc.*) suggests that, like cats. 48 and 49, it was made for presentation. The fanciful architectural elements are closely parallelled on contemporary Parisian boxes and draw heavily on Meissonier's designs. The chasing may be attributable to Augustin Heckel. HR

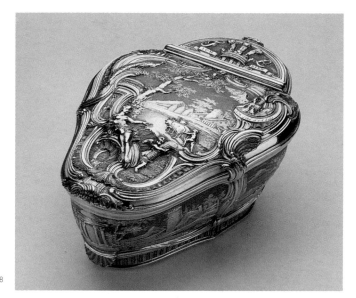

48

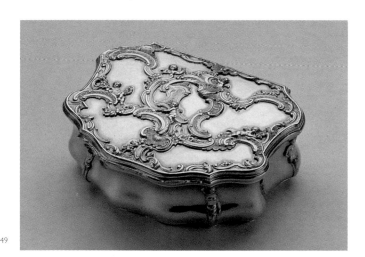

49

50

Melchior Baumgartner (1621–1686) of Augsburg, Charles Clay (died 1740) of London and others

51. *The Temple and Oracle of Apollo*, variously 1664, *ca.* 1740 and later

Silver-gilt, enamel and rock-crystal casket on ebony- and mahogany-veneered plinth with gilt-bronze mounts containing a clock and a barrel organ; the casket in glass case, 191.5 × 91 × 76 cm (75⅜ × 35¹³⁄₁₆ × 29¹⁵⁄₁₆ in.)
Marks: the casket signed under the lid by Melchior Baumgartner of Augsburg and dated 1664; the clock engraved on the backplate and signed on the dial by Charles Clay
RCIN 30037
PROVENANCE Acquired either by Frederick, Prince of Wales, *ca.* 1743–50, or by Augusta, Princess of Wales, 1759
REFERENCE Royal Archives 55461; Public Record Office LC11/37, qtr. to 10 October 1822; Haspels 1987, p. 187, pls. 259–60 and *passim*; Roberts 1995², pp. 58–59

Prince Frederick's love of music, memorably captured in Philippe Mercier's portrait of him and his sisters in concert (cat. 22), is well attested in his surviving accounts. The instruments in the Prince's various residences were regularly maintained by John Snetzler and others, and both the Prince and Princess enjoyed the vogue for music produced by weight-driven mechanical organs. The royal couple possessed at least two of these sophisticated toys: the so called *Temple and Oracle of Apollo*, and the *Temple of the Four Grand Monarchies of the World* (now lacking its organ and mechanical parts), purchased in 1743 and presently at Kensington Palace. Both were created by the clockmaker Charles Clay, who established something of a monopoly in this field. *The Temple of the Four Grand Monarchies* originally played music by Geminiani, Handel and Corelli; the *Temple of Apollo* plays ten tunes of which five correspond to settings specially arranged by Handel for the purpose, including airs from the operas *Xerxes*, *Arianna* and *Ottone*.

The first known description of the *Temple of Apollo* appears in a newspaper advertisement of 1743, three years after Clay's death, announcing its exhibition to the public by his widow. This indicates that the elaborate Augsburg casket then contained a gilt figure of Apollo (since lost), but reveals nothing about its provenance. The date at which the Temple entered the Prince and Princess's collection is equally unknown. If it was acquired at the time of the public exhibition, no bill has survived among the Prince's accounts. Alternatively, it may have been sold to Princess Augusta in 1759 by the clockmaker George Pyke, from whom an inconclusive bill for £94. 10s. survives. Later alterations by Rundell, Bridge & Rundell for George IV included placing a gilt-bronze group of St George and the Dragon, attributed to the 17th-century sculptor Francesco Fanelli, on the top of the casket and mounting eight gilt-bronze mask-and-scroll plaques on the central section housing the clock.

HR

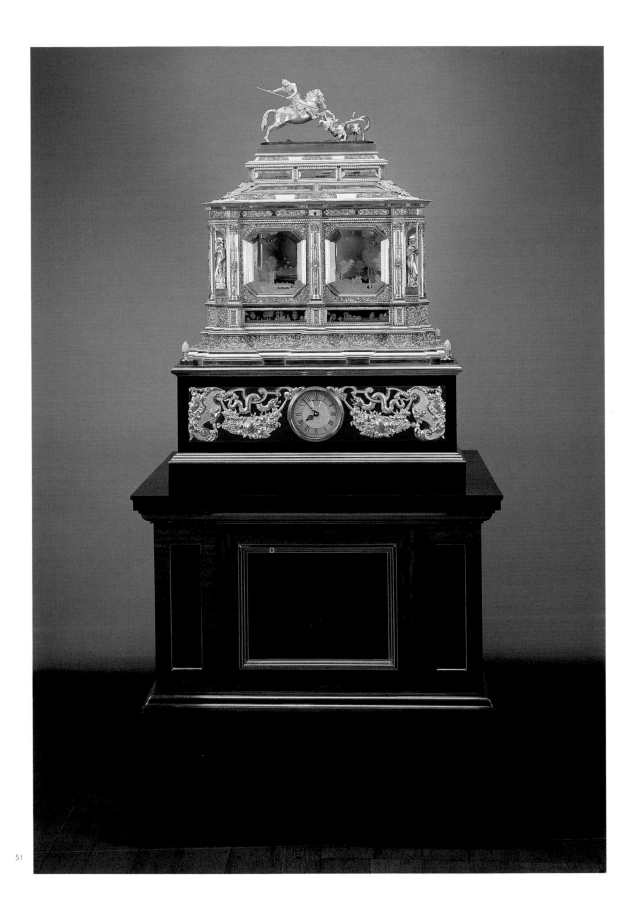

51

Attributed to Benjamin Goodison (*ca.* 1700–1767)

52. *A pair of giltwood stands*, 1732–33

Carved with female busts supporting an Ionic capital; portor marble tops; 144.8 × 41 × 41 cm (57 × 16⅛ × 16⅛ in.) and 145.4 × 41 × 41 cm (57¼ × 16⅛ × 16⅛ in.)
RCIN 1231.1-.2
PROVENANCE Probably supplied for the Apartment of Frederick, Prince of Wales at Hampton Court Palace, 1732–33
REFERENCE Public Record Office LC9/288, qtr. to Michaelmas 1733, Bill 85; Duchy of Cornwall, Household Accounts of Frederick Prince of Wales, Vouchers, vol. IV, f. 238, undated but *ante* 28 December 1733; Edwards and Jourdain 1955, pp. 45–46 and pl. 43; *King's Works*, V, 1976, pp. 180–81; *Dictionary* 1986, p. 353; Rorschach 1991, p. 242

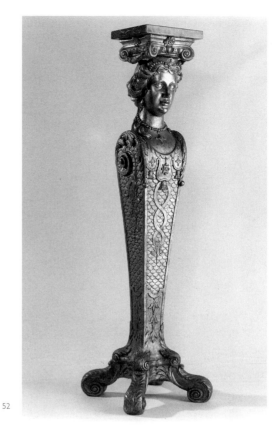

52

This pair of candelabra stands, differing in some of the carved detail, was almost certainly supplied with a second similar pair by the royal cabinet-maker Benjamin Goodison at a cost of £42 in 1732–33. They were intended for Prince Frederick's Apartment at Hampton Court, at the northern end of the east front of the Palace adjoining the Queen's State Apartment. Goodison's work in the Apartment, which included three mirrors carved with Prince of Wales feathers (cat. 53), was probably carried out under the general direction of William Kent, the architect chiefly concerned in alterations at Hampton Court in the years 1731–35. Although undocumented, Kent's involvement is especially likely in view of his appointment in 1732 to the post of Architect to the Prince of Wales; and both he and Goodison worked extensively together for the Prince at Kew, Carlton House and elsewhere.

Goodison's account, with which these stands have traditionally been identified, describes them as "carved & gilt Term Fashion". The Antique or Palladian origin of the design thus indicated evidently appealed to the Prince since he purchased two further sets, for Kew, at the same date. These were described as "4 Rich terms wth. Boys Heads & Ionick Capitalls ... very Rich" and "4 Rich Terms wth. Warriors heads & Dorick Caps ..." and cost £42 and £32 respectively. The Kew sets, which are untraced, were supplied by the carver John Boson (*ca.* 1705–43), one of Goodison's collaborators and, like him, a member of the Burlington-Kent circle. HR

53. *Two giltwood mirrors*, 1732–33

Each with bevelled plate, arched cresting incorporating Prince of Wales feathers and shaped base with brass sockets for two candle-branches; 109.5 × 72 × 5 cm (43⅛ × 28⅜ × 2 in.) and 108.5 × 71.5 × 5 cm (42¾ × 28⅛ × 2 in.)
RCIN 1304.1-.2
PROVENANCE as for cat. 52
REFERENCE Public Record Office, LC9/288, qtr. to Michaelmas, Bill 85; Edwards and Jourdain 1955, pp. 45–46 and pl. 40; *Dictionary* 1986, p. 353

53

These mirrors, together with one other *en suite*, are traditionally identified (like the stands, cat. 52) with an entry in Goodison's account of 1733 for "3 large Glass Sconces in carved & gilt frames wth. two wrot. Arms to Each", for which £27 was charged. A mirror shown in the Mercier portrait of Prince Frederick and his sisters (cat. 22) has also been identified with one of these. While the identification of these mirrors with the entry in Goodison's bill is likely to be correct, it is worth noting that among the quantities of carved giltwood furniture supplied

for the Royal Family in the 1730s Goodison also made at least ten other "sconces", similarly described and priced, for the Prince's use at Hampton Court and Kew.

Designers and artists working for Prince Frederick, notably William Kent, quickly recognized – and then exploited to the full – the decorative possibilities of the Prince of Wales's distinctive feathered badge, as seen on this mirror. The most impressive example is to be found on the stern of Prince Frederick's State Barge, designed by Kent and completed in 1732 (fig. 6, p. 14). HR

John Harman (active 1714–29)
54. *Pair of flintlock sporting guns*

Polished steel locks with waterproof pans, and walnut full-length stocks carved in low relief. Browned steel barrels. Silver mounts chased and engraved with trophies; side plates chased in low relief with a sportsman and dogs admiring dead game. Escutcheon plates surmounted by a lion's head and engraved with the arms of the Prince of Wales
Marks: Engraved on the pan with the maker's name: *JOHN HARMAN*
Overall length 132 cm (52 in.); barrel: 91 cm (36 in.)
RCIN 61489 (L398) and 61490 (L450)

David Columbell (active *ca.* 1720–63)
55. *Flintlock sporting gun*

Polished steel lock, walnut stock with removable butt; round, browned steel removable barrel covered in brown leather and held to the stock with three silver bands. Silver thumb-plate chased and engraved with military trophies. The heel decorated with scrollwork inlaid in silver wire
Engraved on the breech with the maker's name, *COLUMBELL*, and on the replacement lockplate [J]*OHN HARMAN*
Overall length 124.5 cm (49 in.); barrel 85 cm (33⅜ in.)
RCIN 61760 (L269)
PROVENANCE Made for Frederick, Prince of Wales, *ca.* 1730; George III; transferred from Augusta Lodge, Windsor, to Carlton House, 1822; Windsor Castle
REFERENCE Laking 1904, nos. 269 398, 450; Blackmore 1968, p. 47 (L398)

John Harman was an apprentice to the royal gun-maker John Shaw, and became free of the Gunmakers' Company in 1714. He is recorded as Gunsmith to the Prince of Wales in 1729, and these guns probably date from shortly after the Prince's arrival in England in that year. David Columbell was apprenticed in 1712 and worked at Westminster. Prince Frederick's arms also appear on a gun by Barbar at Windsor Castle (Laking 1904, no. 225). JM

54

55

George Augustus Frederick

(1762–1830)

CREATED PRINCE OF WALES

19 AUGUST 1762, AGED 1 WEEK;

PRINCE REGENT 1811–1820;

ACCEDED AS KING GEORGE IV 29 JANUARY 1820

Prince George, the eldest son of George III and Queen Charlotte, was born at Buckingham House on 12 August 1762, and created Prince of Wales a week later. His early education, in the company of his younger brother Frederick Augustus, was conducted in seclusion and according to his parents' strict morality. That his schooling was effective can be judged from his early fluency in French and Latin, but he and Prince Frederick soon got the better of their dull and ailing governor, Lord Holdernesse, whose poor health obliged him to spend long periods of recuperation on the Continent. On his resignation in 1776, Richard Hurd, Bishop of Worcester, was appointed Preceptor to the Prince of Wales, but with little more success.

In 1780, when he had reached eighteen, the Prince was established with his own household. Remaining under his parents' roof at Buckingham Palace, he nonetheless conceived a passion for the actress Mary Robinson, who extracted from him a promissory note for £20,000. The King secured her return of the Prince of Wales's love letters for £5000, and barred his son from attending the theatre, balls, assemblies or masquerades, an injunction which he ignored completely. Likewise, although his First Equerry, Lord Lake (see cat. 70), a man singled out by Wraxall among "pleasing exceptions" to a list of the Prince's companions "so little formed to elevate the mind or to improve the character",[1] warned him in 1781 to avoid politics and those who would take advantage of his good nature, the Prince formed friendships with the Opposition Whigs, Fox and Sheridan, that further distanced him from his father. In December 1785, he secretly and illegally married Mrs Maria Fitzherbert, a twice widowed Catholic, renouncing her in 1795 to marry his cousin Princess Caroline of Brunswick Wolfenbüttel.

When in 1783 it was necessary to provide the Prince with his own house, he was offered Carlton House in Pall Mall (fig. 20), which had latterly been the home of his grandmother the Dowager Princess Augusta. Despite expectations that he would receive an income of £100,000, Parliament was only prepared to grant him half that sum, but the Prince was entitled to the annual income of the Duchy of Cornwall (£12,000) and an *ex-gratia* sum of £30,000 in settlement of his debts. The Prince's lifelong disregard of budgets was established from October 1784, when his Treasurer Col. Hotham wrote, "It is with ... grief and vexation that I now see your Royal Highness ... totally in the hands, and at the mercy of your builder, your upholsterer, your jeweller and your tailor".[2] In that year, expenditure at Carlton House amounted to £147,293, against the £30,000 voted by Parliament for initial refurbishment; this pattern was repeated in successive years and on a far more spectacular scale, after his accession, at Buckingham Palace and Windsor Castle.

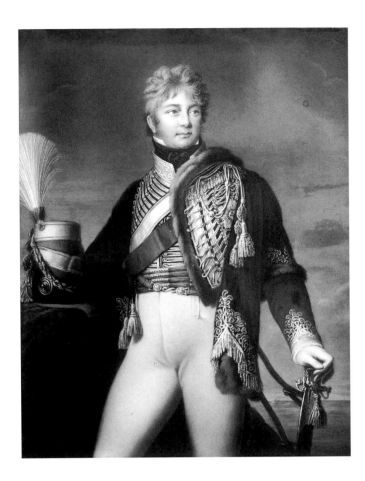

Fig. 19 Henry Bone after Elizabeth Vigée-Le Brun, *George IV when Prince of Wales*, enamel, *ca.* 1802–05 (The Royal Collection)

This chronic over-expenditure was fuelled by an insatiable love of display, and the term 'dandy' is quite inadequate for a man who would gild the rigging of his yachts, and insist that his letters be folded in the latest French manner. He seems to have seen himself as the central actor in the most costly of theatrical performances, whether the part was that of Prince, Regent or King. At Carlton House, the stage sets were constantly changing, thanks to the Prince's restless experiments with colour schemes and the energies of the decorators; Gaubert, Daguerre and Walsh Porter (figs. 21 and 22). For the fêtes held in honour of royal birthdays, military victories or state visitors, further temporary structures and settings would be created, most memorably on the night of 19 June 1811 (see cats. 100–08).[3]

The love of French art and fashion which is the most consistent thread in the Prince's activities as a collector may have been formed in part by his early friendship with the duc de Chartres, subsequently duc d'Orléans ('Philippe Egalité'), the richest man in France, who lived for long periods in London

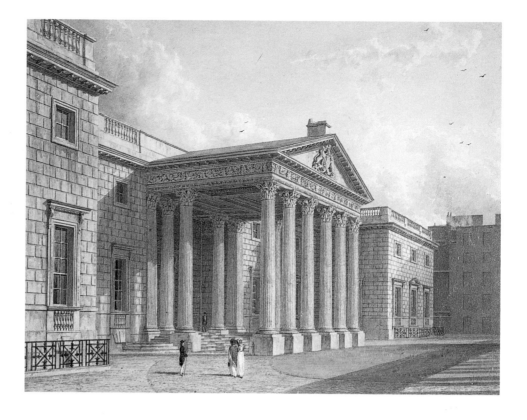

Fig. 20 William Westall, *Carlton House: the north front*, watercolour for *Pyne's Royal Residences*, April 1819 (The Royal Library, Windsor Castle)

in the 1780s. The Prince's architect Henry Holland looked to France for his inspiration, both in his work at Carlton House and in the Marine Pavilion at Brighton, and employed French assistants in his office. The Prince of Wales had himself painted by Mme Vigée-Le Brun (fig. 19) in the uniform of the 10th Light Dragoons.

If such francophilia in the heir to the British throne at a time of more or less continuous hostility between England and France might seem inappropriate, there was a distinct convergence in taste between the two countries at the end of the eighteenth century. Dominique Daguerre was the agent for Wedgwood in Paris as well as for Sèvres in London, and the chaste but extremely luxurious Louis XVI furniture of Georges Jacob and François Hervé (see cat. 96), also supplied to George IV's Whig friends the Dukes of Bedford and Devonshire, could have originated in either country. Others in the Prince's circle, notably Lord Yarmouth and Sir Harry Featherstonhaugh, shared the same taste and made purchases of French works of art on his behalf.[4]

Queen Charlotte was among the earliest collectors of Sèvres porcelain in England, and her eldest son's taste for Sèvres was lifelong and comprehensive. In 1784 the minister responsible for the factory, the comte d'Angiviller, sent him a large consignment of biscuit table decorations and tea-wares as a gift, to which the Prince responded with a substantial order. Other

purchases were made through *marchands-merciers* such as Dominique Daguerre, London auctioneers and dealers, and in Paris by the Prince's own employees, notably his Confectioner François Benois and the Clerk-Comptroller of the Kitchen, Jean-Baptiste Watier.

A close link exists between the Prince's Sèvres porcelain and his magnificent collection of Dutch and Flemish pictures (which numbered over 200 works by 1816). These pictures were obtained largely from French aristocratic collections, where such paintings often hung in proximity with Sèvres vases; the factory itself owned a collection of Dutch paintings and prints, which provided source material for the Sèvres painters.

The Prince's picture collection was tailored to his residences, and to specific settings within them. He acquired no 'capital' gallery pictures of the Italian Baroque, which were in relatively plentiful supply, because he had no picture gallery, and the old masters at Carlton House were displayed throughout the rooms in relatively sparse hangs. No pictures were hung at Brighton. Portraits and busts of his friends and of military heroes (by Gainsborough, Reynolds and Nollekens) were placed in the Drawing Rooms and in the Armoury. The Prince showed no appetite for historical portraits, but he was an avid collector of engravings of this kind.

Invoices in the Royal Archives show that Prince George spent far more on prints than on watercolours and drawings.

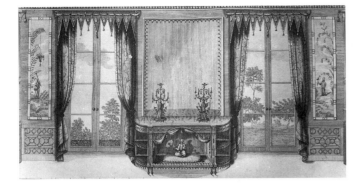

Fig. 21 T. Sheraton, *The Chinese Room, Carlton House*, engraving, 1793

Fig. 22 Charles Wild, *The Blue-Velvet Room, Carlton House*, watercolour, 1817 (The Royal Library, Windsor Castle)

His documented purchases began in 1783,[5] and continued in the 1790s with large consignments from Colnaghi, who occasionally also supplied frames and frequently bid for the Prince at auction; in May 1800 they acquired 133 portrait engravings at the sale of Sir William Musgrave's collection.[6] Apart from portraits, the Prince's collection embraced theatrical subjects, military uniforms, historical and contemporary reportage, and topography. The "curious" and "gay" prints that came from Colnaghi around 1799 are known only from the accounts, for immediately after George IV's death, "several drawers full of *Free* Prints and Drawings ... the Private Property of His late Majesty", were destroyed by order of one of his executors, Sir William Knighton.[7]

The Prince's collections are well documented from 1793, when an inventory was taken at Carlton House at the behest of Coutts bank, to whom he was substantially indebted, and from 1806 to 1830 in a series of volumes kept by the Prince's Inventory Clerk Benjamin Jutsham.

In November 1788 Sir William Hamilton sent the Prince a colossal antique head for display at Carlton House, no doubt in the expectation of further orders. The Prince, unlike the Dukes of Bedford and Devonshire, seems to have resisted the charms of ancient marbles, while succumbing wholeheartedly to the fabulous polish and sensuous lines of Canova's nudes.

In his letter of 12 November 1788,[8] Sir William advised the twenty-six-year-old Prince that "the only method [of acquiring a knowledge of the arts] is to examine with attention such works of art as are avowedly and undoubtedly of the first class and compare them with others that only pretend to be so". If his wider education may be counted a failure, this exhibition, and the Royal Collection as a whole, contains abundant evidence that he took this lesson to heart.

NOTES

1. Wraxall 1884, V, pp. 383–84.
2. Aspinall 1963, I, p. 164.
3. London 1991[3], pp. 29–31, 44–45.
4. In addition to London 1991[3], see also London 1966[1].
5. Invoice from Bretherton, Royal Archives 27679.
6. Royal Archives 27144.
7. Royal Archives, Vic.Add. T/73.
8. Aspinall 1963, I, p. 372, no. 298.

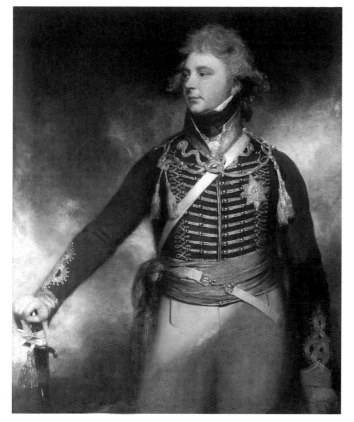

56

Thomas Gainsborough (1727–1788)

57. *The three eldest daughters of George III and Queen Charlotte*

Oil on canvas, 129.5 × 179.7 cm (51 × 70¾ in.)
RCIN 400206
PROVENANCE Painted for George, Prince of Wales, in 1783–84
REFERENCE Millar 1969, p. 40, no. 798; Walker 1985, I, p. 106; Cardiff 1990, no. 24; London 1994, no. 9

Charlotte, Princess Royal (1766–1828) stands between her sisters Princess Augusta (1768–1840) on the left and Princess Elizabeth (1770–1840), seated on the right. All had previously sat to Gainsborough for the series of bust portraits of the Royal Family painted at Windsor in 1782. Like his father, Prince George was an enthusiatic patron of Gainsborough, and at the time of the artist's death owed him £1,246. 10s. 6d.

Originally a full-length portrait, which cost £315, this painting was submitted to the Royal Academy in 1784. It caused a disagreement between the Hanging Committee and the artist, who thought it was hung too high for a portrait painted "in so tender a light". As a result, Gainsborough never showed at the Academy again. Prince George intended to hang it with other family portraits in the Saloon at Carlton House. It was later transferred to Windsor where, early in the reign of Queen Victoria, it was severely cut at the bottom and trimmed at the top, to be fitted into an overdoor.
MLE

Sir William Beechey (1753–1839)

56. *George IV when Prince of Wales*, 1803

Oil on canvas, 128.2 × 102 cm (50½ × 40 in.)
RCIN 400511
PROVENANCE Painted at the sitter's command for presentation to Edward, Duke of Kent, in 1803; George, Duke of Cambridge; his sale, Christie's, 11 June 1904, lot 73; purchased by Edward VII
REFERENCE Millar 1969, p. 8, no. 664; Walker 1985, I, p. 208; Cardiff 1990, no. 2; London 1991³, no. 106

Beechey became portrait painter to Queen Charlotte in 1793 and subsequently received numerous commissions from George III and the Prince of Wales. The first version of this portrait was the painter's diploma piece, which he presented to the Royal Academy on his election in 1798. The present work incorporates subtle alterations to bring the likeness up to date. It cost £84 plus ten guineas for the frame.

The Prince is wearing the uniform of the 10th Light Dragoons, of which he was appointed colonel in 1793. A similar jacket, made in 1800 by the tailor J.C. Frank, remains in the Royal Collection. Although forbidden active service, Prince George was fascinated by military affairs and immensely proud of his regiment.
MLE

Richard Cosway (1742–1821)

58. *George IV when Prince of Wales*

Watercolour on ivory; 3.3 cm (1¼ in.) diameter, oval
RCIN 420005
PROVENANCE George, Prince of Wales and thence to his sister Mary, Duchess of Gloucester (see cat. 59 below), by whom bequeathed to her niece, Queen Victoria
REFERENCE Millar 1986, pp. 586–92; Walker 1992, no. 176; Edinburgh 1995, no. 55

58

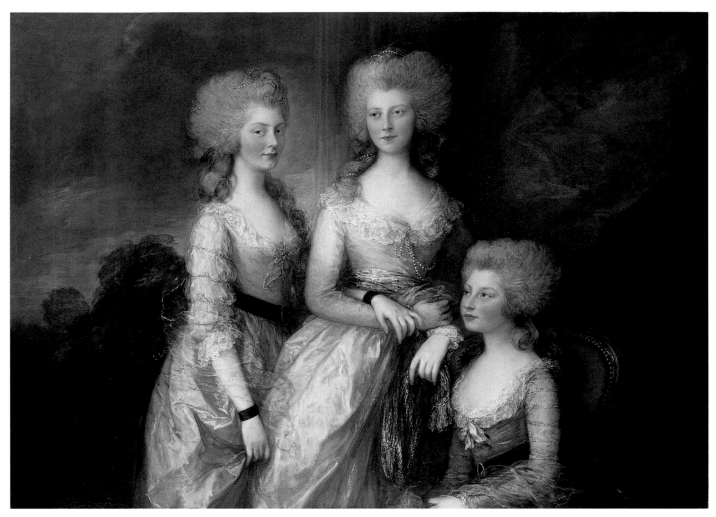

57

This work was almost certainly painted for the Prince of Wales himself, and is probably one of the thirty or so portrait miniatures listed in the accounts submitted by the artist up to 1795. The Prince attained his majority on 12 August 1783, and this miniature can be dated *ca.* 1783–84 on the basis of his appearance or, to be more precise, the trichological evidence. As a young man, Prince George wore a traditional wig, but began in 1782 to adopt a more fashionable look, allowing his natural hair to grow. As Lady Spencer wrote to the Duchess of Devonshire on 19 October 1782, "The Prince dresses his hair in a new way, flattish at the sides, frizzed and widish at each side and three curls at the bottom of this frizzing". This miniature is one of the earliest representations of the new coiffure which gradually became so windswept that it was satirized by artists such as James Gillray. At the start of the nineteenth century it was succeeded by a more restrained, clean-cut style, suitable for occasions when the Prince appeared in uniform.

Cosway had been appointed Principal Painter to the Prince of Wales, certainly by 1785, and frequently referred to this role with the elaborate signature *Serenissimi Walliae Principis Primarius Pictor* (as in cat. 60). Elected a Royal Academician in 1771, he was drawn to the attention of the Prince of Wales by his portrait of Mrs Fitzherbert. A collector and connoisseur in his own right, Cosway played an important role in

the various transformations of Carlton House until he fell from favour in 1811. Cosway's Anglo-Florentine wife, Maria, was also an artist and the couple lived in Pall Mall, at the centre of society. A dandy and somewhat eccentric, Cosway has recently been re-assessed as an artist of some significance.

CL

Richard Cosway
59. *Princess Mary, Duchess of Gloucester* (1776–1857)

Watercolour on ivory, 7.9 × 6.4 cm (3⅛ × 2½ in.), oval
RCIN 420647
PROVENANCE George, Prince of Wales
REFERENCE Walker 1992, no. 185; Edinburgh 1995, no. 116; New York 1996, no. 61

This miniature is a characteristic example of Cosway's mature style, with the head carefully delineated and warmly coloured while the drapery and cap are only schematically drawn. The figure is set against a cloudy background, which creates a sense of open space and animates

59

60

the portrait, making the characterization more vivid. Although this is probably complete, more finished copies of the image are recorded.

Commissioned by the Prince of Wales in 1792 for 30 guineas, this miniature is evidence of his close relationship with his sisters (see also cats. 57 and 60). Princess Mary was the fourth of the six daughters of George III and Queen Charlotte and was reputedly the most attractive. Like all her sisters, she had a secluded upbringing, but finally married her cousin, William Frederick, Duke of Gloucester (1776–1834) in 1816. CL

60. *Princess Sophia (1777–1848)*

Watercolour on ivory, 7.9 × 6.4 cm (3½ in.).
Signed and dated on the original backing: *R.dus Cosway./ R.A./ Primarius Pictor/ Serenissimi Walliae/ Principis/Pinxit/ 1792*
RCIN 420647
PROVENANCE George, Prince of Wales
REFERENCE Williamson 1897, p. 38; London 1970, no. 50; Millar 1977, pp. 131–32; Millar 1986, p. 587; Roberts 1987, pp. 65–88; Cazzulani and Stroppa 1989, fig. 22; Walker 1992, no. 186; Edinburgh 1995, no. 117; New York 1996, no. 60

The technique and treatment are similar to cat. 59, although the present miniature is more precisely handled in the sky and the dress. A key element in Cosway's miniatures is the use made of the ivory support, which when allowed to show through gives the image great luminosity. At least two variants of this portrait were made by Cosway.

Princess Sophia was the fifth daughter of George III and Queen Charlotte. She was the favourite sister of George, Prince of Wales, but was not physically strong, suffering from repeated bouts of ill health and eventually becoming blind towards the end of her life.

All the daughters of George III and Queen Charlotte were frequently depicted by leading artists of the time, including Gainsborough (see cat. 57), Hoppner and Beechey. They were encouraged by their mother to engage in various decorative arts, as well as drawing and printmaking. Formal art lessons were complemented by copying from items in the Royal Collection.
CL

61. *Princess Amelia (1783–1810)*

Watercolour on ivory mounted on card, 9.1 × 7.5 cm (3⁹⁄₁₆ × 3 in.), oval
RCIN 420003
PROVENANCE George, Prince of Wales; thence probably passing to the collection of his brother, the Duke of Sussex, whose daughter married as second wife Thomas Wilde (1782–1855), 1st Lord Truro, Lord Chancellor; sold Christie's, 11 May 1893, lot 39; bought for the Royal Collection
REFERENCE Williamson 1897, p. 78; London 1970, no. 52; London 1974, no. 168; Millar 1986, p. 587; Walker 1992, no. 187; Edinburgh 1995, no. 130; New York 1996, no. 71

Commissioned by George, Prince of Wales in 1795, this miniature is less finished that cats. 59–60, but emphasizes the charms of the youngest daughter of George III and Queen Charlotte. She is depicted here aged twelve. Cosway made another miniature of her in 1802 which is in the Victoria and Albert Museum. Perhaps the finest image of her in miniature was that executed in 1807 by Andrew Robertson, of which a replica dated 1811 is still in the Royal Collection.

Princess Amelia was the fifteenth and last child of George III and Queen Charlotte. On medical advice, she spent long periods away from court at Worthing and Weymouth. She never married and may have died of tuberculosis. Robertson praised her appearance: "... fine features, melting eye, charming figure, elegant, dignified, finest hair imaginable ...". CL

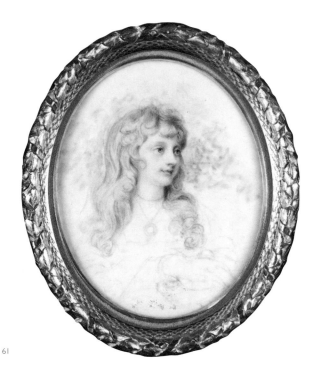

61

62

Anne Mee, née Foldsone (*ca.* 1770–1851)

62. *Princess Charlotte of Wales (1796–1817)*

Watercolour on ivory, 21.6 × 15.5 cm (8½ × 6⅛ in.)
RCIN 420197
PROVENANCE Painted for George IV when Prince Regent
REFERENCE Walker 1992, no. 856

The scale of this work is considerably larger than those attempted by earlier miniaturists, and is a conscious attempt to rival portraits in oils and thereby elevate the genre. Anne Mee was self-taught and exhibited at the Royal Academy between 1804 and 1837. Her early work was influenced by Cosway. She specialized in portraits of ladies, and was widely patronized. This portrait is immensely detailed, especially in the treatment of the accessories – the furnishings and the jewels. The ruff makes an interesting comparision with those worn by Isaac Oliver's female sitters (see cats. 3–4).

Princess Charlotte, the 'Daughter of England', was the daughter of George IV and Queen Caroline. She was engaged to William, Prince of Orange in December 1813, but the engagement was broken off on 16 June the following year. The prominence of the rings in this miniature evidently relates to that engagement, and Mrs Mee submitted her account in 1813/14. The artist seems to have retained the miniature until February 1816, when Princess Charlotte became engaged to Prince Leopold of Saxe-Coburg-Saalfeld and the portrait was returned to Carlton House. Following their marriage on 2 May 1816, the couple lived at Claremont, near Esher in Surrey. Princess Charlotte's death in childbirth on 6 November 1817 was the occasion for widespread mourning. CL

63. *Caroline, Duchess of Argyll (1774–1835)*

Watercolour on ivory, 20.5 × 14.7 cm (8⅛ × 5¾ in.)
RCIN 420781
PROVENANCE Painted for George IV when Prince Regent
REFERENCE Walker 1992, no. 858

This miniature is part of an extensive series titled *The Gallery of Beauties of George III*, commissioned by the Prince Regent, who also ordered elaborate frames (no longer surrounding the miniatures), presumably for display in Carlton House. The type of beauty and full-blown treatment of the figures indicate that, although the ladies belonged to the court of George III, Mrs Mee's commission was very much to the taste of his eldest son. The series was finished in 1814. The original list of sitters was longer than the seventeen portraits in the Royal Collection, and it is likely that the project was never completed.

There were two royal prototypes for Mrs Mee's *Gallery of Beauties*: the 'Windsor Beauties' by Sir Peter Lely (1662–65) and the 'Hampton Court Beauties' by Sir Godfrey Kneller (*ca.* 1691). Both sets, however, are oil paintings. During the early 19th century, similar undertakings were issued in book form or as engravings and, indeed, some of Mrs Mee's portraits for *The Gallery of Beauties* were engraved.

63

Bone was appointed Enamel Painter to George, Prince of Wales in 1801. He had a prolific output and exhibited frequently at the Royal Academy between 1781 and 1832, specializing in historical portraiture and copies after Old Masters and leading contemporary painters. George III and William IV also commissioned work from him. Several members of Bone's family were also miniaturists. The three enamels exhibited here were elaborately framed and fitted with specially locking 'windows' for display in the Prince of Wales's Private Bedroom at Carlton House.

This enamel is a partial copy after the full-length portrait by Hoppner painted for the Prince of Wales and still in the Royal Collection. Nelson, who is shown wearing the full-dress uniform of a Rear-Admiral with a view of the bombardment of Copenhagen in the background, sat for Hoppner in the summer of 1801, but the painting was not finished until 1805. It is regarded as one of the most accurate likenesses of Nelson, and was frequently copied and engraved. In the most widely circulated engraving, by Charles Turner (1806), the background is transformed into the Battle of Trafalgar. Prince George owned several impressions of this print (cat. 91).

Bone began the enamel in Hoppner's studio and exhibited it at the Royal Academy in 1805. A squared-up preparatory drawing is in the National Portrait Gallery. Hoppner's portrait and Bone's copy demonstrate George IV's admiration for the heroes in the war with Napoleon.
CL

The present sitter is not presented allegorically, but as a straightforward likeness with loose-fitting diaphanous drapery and curly hair in the Regency style – a Byronic form of beauty. The setting is a landscape with a column – more appropriate perhaps for a hothouse plant than an aristocratic lady. The modern equivalent is the fashion plate as evolved over the years in *Vogue, Vanity Fair, Harpers & Queen* and *Tatler*. Caroline, Duchess of Argyll was the daughter of the fourth Earl of Jersey. She married, first, in 1795 Henry, Lord Paget and, secondly, in 1810 the sixth Duke of Argyll.
CL

Henry Bone (1751–1834) after John Hoppner
64. *Horatio, 1st Viscount Nelson (1758–1805)*

Enamel, 21.1 × 17.0 cm (8½ × 6¾ in.)
Inscribed on the back: *Admiral Lord Viscount Nelson/ London April 1805/ Painted by Henry Bone A.R.A./ Enamel painter to His Royal Highness/ the Prince of Wales, after the Original/ by John Hoppner R.A. Portrait/ painter to His Royal Highness*
RCIN 406913
PROVENANCE George, Prince of Wales
REFERENCE Millar 1969, no. 849; Walker 1992, no. 782

64

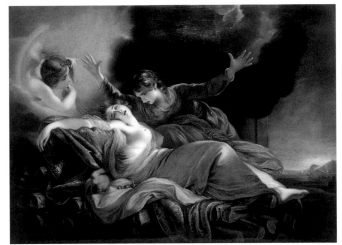

65

Henry Bone after Sir Joshua Reynolds

65. *The death of Dido*

Enamel, 25.0 × 33.3 cm (9⅞ × 13¼ in.)

Signed and dated lower right *H. Bone 1804.* Inscribed on the back *London April 1804/ retouched June 1804/ Painted for His Royal Highness the Prince of Wales/ by Henry Bone ARA Enamel Painter to H.R.H/ after the picture by the late Sir Joshua Reynolds/ painted in the year 1786 [sic], in the possession of the/ Most Noble the Marchioness of Thomond/ Size of the Picture 7 feet 10 inches by 4 feet 10/ N.B. On the left hand of the Iris are five fingers and a thumb*

RCIN 404284

PROVENANCE George, Prince of Wales

REFERENCE Millar 1969, no. 1029; Walker 1992, no. 790; London 1994, no. 29

The Prince of Wales acquired this enamel copy of one of Sir Joshua Reynolds's most famous narrative compositions several years before purchasing the painting itself at the sale of the Marchioness of Thomond at Christie's on 19 May 1821. The picture remains in the Royal Collection. Contrary to Bone's inscription, *The Death of Dido* was exhibited at the Royal Academy in 1781. It illustrates the account in Virgil's *Aeneid* of the death of the Queen of Carthage. Reynolds's composition exemplifies his theory of the Grand Style and was frequently copied in oils and engraved.

A squared-up preparatory drawing by Bone for this enamel is in the National Portrait Gallery. The enamel was exhibited at the Royal Academy in 1805.

CL

Henry Bone after Correggio

66. *Jupiter and Io*

Enamel, 24.0 × 15.6 cm (9½ × 6¼ in.)

Signed and dated lower left *H. Bone/ 1801.* Inscribed on the back *Painted by Henry Bone (Febr 1801)/ Enamel Painter to His Royal Highness/ the Prince of Wales, after a Copy/ by Henry Thomson from Correggio/ in the Imperial Gallery of the/ Belvedere at Vienna*

RCIN 404269

PROVENANCE George, Prince of Wales

REFERENCE Walker 1992, no. 787

The ultimate source for this enamel is a famous painting by Correggio in Vienna but, according to the inscription, Bone's immediate source was a copy by Henry Thomson (1773–1843), which cannot now be traced. Correggio was much admired during the late 18th and early 19th centuries. The tradition of English miniaturists making copies after major Old Masters dates back to the 17th century, when Peter Oliver, David des Granges and Thomas Flatman worked in this capacity for Charles I.

A squared-up preparatory drawing for the enamel is in the National Portrait Gallery. Bone exhibited his *Jupiter and Io* at the Royal Academy exhibition of 1801.

CL

66

67

68

Joseph Nollekens (1727–1823)

67–70. *Four busts from the Octagon Hall, Carlton House*

67. *Charles James Fox (1749–1806)*

Marble, 61 cm (24 in.) high, excluding socle
Incised on the back *Nollekens Ft.1808*
RCIN 35430
PROVENANCE Commissioned by the Prince of Wales; bill dated 22 March
1808, £126 (Royal Archives 26706); delivered March 1808
REFERENCE Smith 1827, p. 304; Cunningham 1830, III, pp. 170–71; London
1991³, no. 2

This is a repetition of Nollekens's second bust of Fox, made for the 5th
Duke of Bedford, which remains at Woburn Abbey. It was commis-
sioned by the Prince of Wales in memory of his long-standing friend
and political supporter, and stood alongside those of the two most
prominent Whig dukes (cats. 68 and 69). The first likeness, ordered in
1791 by the Empress of Russia, was one of the sculptor's greatest suc-
cesses. Nine examples of the present bust are known, of which this was
the third to be made.

The biographer Alan Cunningham criticized this bust as too lifelike:
"the head of Fox needed to be pared of certain marks of indulgence in
the cheeks and chin, and augmented a little in the forehead, to render
it worthy of art". According to Smith, Fox's forehead was indeed higher
in the death-mask taken by Nollekens than in either of the two busts.

68. *Francis Russell, 5th Duke of Bedford (1765–1802)*

Marble, 61.2 cm (24⅛ in.) high, excluding socle
Incised on the back *Nollekens Ft.1808*
RCIN 35412
PROVENANCE Commissioned by the Prince of Wales; bill dated 22 March
1808, £126 (RA 26706); received at Carlton House 7 November 1809
REFERENCE London 1984³, no. 29; Kenworthy-Browne 1995, pp. 63–64

This is the eleventh example of a likeness first exhibited in plaster at
the Royal Academy in 1801, and commissioned by Lady Holland. The
prime marble, also dated 1801, is at Melbury, Dorset. The present ver-
sion was supplied to the Prince together with its usual pendant, the
bust of Fox, and both commemorated his friendship with the sitters.

The 5th Duke had been responsible for the rebuilding of Woburn
Abbey by Henry Holland, the Prince of Wales's architect at Brighton
and Carlton House, and for laying out Russell and Tavistock Squares
on the family's London estate. He inaugurated the sculpture gallery at
Woburn, which eventually housed Canova's *Three Graces*. In Parliament
he was a disciple of Fox, and a member of the Prince's inner circle.

The Prince also acquired Nollekens's bust of John, 6th Duke of
Bedford, who succeeded on the death of his elder brother following an
accident on the tennis court.

69

70

69. *William, 5th Duke of Devonshire (1748–1811)*

Marble, 57.1 cm (22½ in.) high, excluding socle
Incised on the back *Nollekens Ft./1812*
RCIN 35410
PROVENANCE Commissioned by the Prince Regent; bill dated 13 April 1812,
£126 (RA 26710); received at Carlton House in April 1812

This bust of the 5th Duke of Devonshire, another of the eminent Whigs
in the Prince of Wales's circle, was created after his death, presumably
for Chatsworth, where the prime version remains. He was the least
accomplished of the four friends commemorated in the Octagon Hall.
The Duke's appearance is well known from his portraits by Batoni and
Reynolds, while Reynolds's portraits of his wife, Lady Georgiana
Spencer, and of his mistress Lady Elizabeth Foster, represent the other
members of a famous and enduring *ménage à trois*.

70. *Gerard, Viscount Lake (1744–1808)*

Marble, 56.5 cm (22¼ in.) high, excluding socle
Incised on the back *Nollekens Ft./1814*
RCIN 20747
PROVENANCE Commissioned by the Prince Regent; bill dated 5 July 1814,
£157 (Public Record Office LC11/17); received at Carlton House in July 1814
REFERENCE Smith 1827, pp. 38–39

A considerable pantheon of military figures was represented at
Carlton House in sculpture as well as paint, concentrated for the most
part in the Armoury. Viscount Lake of Dehli and Leswaree,
Commander-in-Chief in India in 1800, owed his place in the Octagon
Hall to his length of service in the Household of the Prince of Wales.
On its establishment in 1780 he was appointed First Equerry (holding
this position until his death) and Chief Commissioner of the Stables.
His brother, Warwick Lake, was a Gentleman of the Bedchamber and
advised the Prince on racing matters.

J.T. Smith described the origin of this likeness: "Mr Nollekens's
assistant attended him to cast the face of Lord Lake after his decease;
his Lordship's brother was then inconsolably pacing the room, but Mr
Nollekens shook him by the elbow, and applied to him for a little
sweet-oil, a large basin, some water, and pen, ink, and paper
Nollekens, after he had taken the mask, muttered the following soli-
loquy: 'Now, let us see, I must begin to measure him; where's my
callipers? I must take him from his chin to the upper pinnacle of his
head; I'll put him down in ink; ay, that will do; now I must have him
from his nose to the back part of his skull; well, now let's take his
shoulders; now for his neck; well, now I've got him all.'"

This suggests that the first example of this bust was made for Lake's
brother, but the present bust is the only version currently known.
JM

Rembrandt van Rijn (1606–1669)

71. *Christ and St Mary Magdalene at the tomb, 1638*

Oil on panel, 61 × 49.5 cm (24 × 19½ in.)
Signed indistinctly on the tomb on the right *Rembrandt f/ 1638*
RCIN 404816
PROVENANCE Painted for H.F. Waterloos, Amsterdam (?); Willem van der
Goes, Leiden; bought by Valerius Röver, Delft, 1721; sold by his widow to
Wilhelm VIII, Landgrave of Hesse-Kassel, 1750; removed to France in 1806;
Empress Joséphine Malmaison; sold by her heir Eugène de Beauharnais to the
dealer P.J. Lafontaine; purchased in part exchange by the Prince Regent, 9
November 1819
REFERENCE Fuseli 1830, pp. 92–93; Smith VII, 1836, p. 44, no. 103; Waagen
1854, p. 5; Hofstede de Groot VI, 1916, pp. 109–10; no. 142; London 1946, no.
333; London 1971, p. 29, no. 15; Millar 1977, pp. 146–47; White 1982, pp. lxix,
101–8, no. 161; London 1988, no. 35; Brown, Kelch and Van Thiel 1991, pp.
204–07

71

72

Mary Magdalene mistook the risen Christ for a gardener when she visited his tomb (John 20:11–18). A poem by Rembrandt's friend Jeremias de Decker, inspired by this painting and first published in 1660, is pasted to its back:

"When I read the story told us by St John/ And then view this artful scene,

Where, I wonder, was pen ever so truly followed/ By the brush, or lifeless paint so closely brought to life?

It is as if Christ is saying, "Mary, do not tremble,/ It is I, death has no part of your Lord".

She, believing this, and yet not fully,/ Likes to hover 'twixt joy and sorrow, fear and hope.

The grave rock raised towering to the sky by art's dictate/ And rich in shadows, lends spectacle and majesty

To the whole. Your masterly strokes,/ Friend Rembrandt, I first saw pass upon this panel;

Thus my pen could rhyme your gifted brush,/ And my ink extol your paints."

In a lecture delivered in 1801, the artist Henry Fuseli commented that Rembrandt: "possessed the full empire of light and shade ... in the cool of dawn, in the noon-day ray, in the livid flash, in evanescent twilight, and rendered darkness visible such were his powers of nature ... that the best cultivated eye, the purest sensibility, and the most refined taste dwell on them, equally enthralled". The Prince Regent would have appreciated the distinguished provenance of this cabinet painting, as well as its striking pictorial qualities. It was the last of three paintings by Rembrandt which he purchased and displayed at Carlton House. MLE

David Teniers the Younger (1610–1690)

72. *Peasants dancing outside an inn*

Oil on canvas, 135.7 × 205.4 cm (53¼ × 80¾ in.)
RCIN 406363
PROVENANCE Lubbeling collection; Randon de Boisset, his sale Paris 1777; M. Le Boeuf, his sale Paris 1783; Henry Hope, his sale Christie's, 6 April 1811, lot 58; purchased by the Prince Regent
REFERENCE Smith III, 1831, p. 313, no. 196; Waagen 1854, p. 12; Millar 1977, pp. 59, 100, 126, 147–48, 150–52; Reynolds 1975, pp. 109, 253; London 1991, no. 49; London 1991³, p. 27; Lloyd 1994, no. 13

Born in Antwerp, Teniers married the daughter of Jan Brueghel the Elder and like his father-in-law specialized in genre scenes of peasant life. In 1651 he was appointed court painter and art adviser to Archduke Leopold-Wilhelm at Brussels, on whose behalf he acquired pictures from the dispersed collection of Charles I. A highly prolific artist, Teniers became wealthy, purchased a country estate, and was ennobled in 1680.

During the 18th century Teniers's paintings were much sought after by British collectors, including Frederick, Prince of Wales and George III, while Sir Joshua Reynolds admired his drawing and Gainsborough made copies after his work. In 1831 the dealer John Smith observed, "No painter every exercised the pencil with greater freedom and address ... aided by a lively imagination". The Prince Regent purchased several paintings by Teniers. He was well represented at Carlton House, where this picture of the mid 1640s hung in the Bow Room on the principal floor, and appears in an engraving in W.H. Pyne's *History of the Royal Residences*, published in 1819. MLE

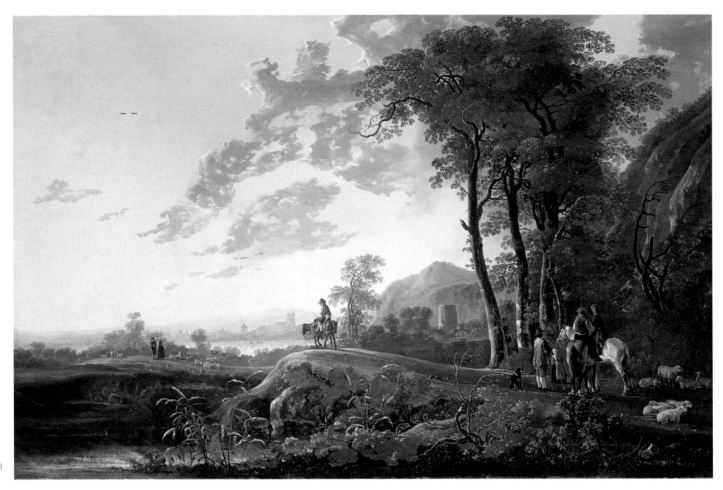

73

Aelbert Cuyp (1620–1691)

73. *An evening landscape with figures and sheep*

Oil on canvas, 101.6 × 153.6 cm (40 × 60½ in.)
Signed lower right *A cuÿp*
RCIN 405827

PROVENANCE J. van der Linden van Slingeland, his sale Dordrecht 1785;
bought Fouquet; Jan Gildemeester, his sale Amsterdam 1800; bought Telting;
Sir Thomas Baring; purchased with his collection by the Prince Regent in 1814
REFERENCE Smith V, 1834, p. 355, no. 244; Waagen 1854, p. 20; Hofstede de
Groot II, 1909, pp. 131–32, no. 432; London 1946, no. 391; London 1971, p. 22,
no. 17; Reiss 1975, pp. 10–12, 176, no. 133; Millar 1977, p. 147; White 1982, pp.
lix, 32–33, no. 35; London 1991[3], no. 44, p. xvi; Lloyd 1994, no. 14; Kriz 1997,
pp. 116–21

The atmospheric landscapes of the Dordrecht painter Aelbert Cuyp combine a classical structure reminiscent of Claude with naturalistic figures and animals in the Dutch tradition. From the mid 18th century his work was especially sought after by British collectors, and was highly influential upon painters such as J.M.W. Turner and A.W. Callcott. In 1816 the connoisseur Michael Bryan enthused: "Tuned to the harmony of colour, like the ear of a musician to sound, his eye appears to have been incapable of a discordant note".

In 1817 the fine group of works by Cuyp assembled by Noel Desenfans between 1780 and 1811 was put on public display at Dulwich Picture Gallery. The Prince Regent acquired at least nine paintings by or attributed to this fashionable artist. Modern scholarship on Cuyp began in 1834 with John Smith, who commented on this painting of the later 1650s: "The delightful appearance of a summer's evening illumines the scene. A charming example of art." By 1816 it hung with other Dutch paintings in the Bow Room on the principal floor of Carlton House.

MLE

74

Philips Wouwermans (1619–1668)

74. *The halt of a hawking party at a wayside inn*

Oil on panel, 57.8 × 62.2 cm (22¾ × 24½ in.)
Signed at lower left *PHW*, in monogram
RCIN 406736
PROVENANCE Jan Gildemeester sale, Amsterdam 1800; bought Labouchère;
P. de Smeth van Alphen sale, Amsterdam 1810; bought Texier; Philip Hill; his
(anonymous) sale, Christie's 26 January 1811, lot 39; bought by Lord Yarmouth
for the Prince of Wales
REFERENCE Smith I, 1829, pp. 270–71, 273, nos. 255, 263, and IX, 1842, p. 171,
no. 95; Waagen, II, 1854, pp. 18–19; Hofstede de Groot II, 1909, pp. 460, 468,
nos. 657, 684; London 1946, no. 303; White 1982, pp. li, lxi, lxiii, 151, no. 242;
London 1991³, nos. 144, 197

Active in his native Haarlem, Wouwermans specialized in small land-
scapes with horses. He was highly productive and immensely suc-
cessful, and his works remained much sought after by French and
German aristocratic collectors during the 18th century. Between 1810
and 1819 the Prince Regent added nine paintings to the works by
Philips Wouwermans previously assembled by James II and George III.

Smith considered this late work of around 1660 "an excellent pic-
ture, of superior quality". By 1816 it hung in the Blue Velvet Closet on
the principal floor of Carlton House, where it appears in an engraving
in W.H. Pyne's *History of the Royal Residences*, published in 1819. An
enthusiastic horseman, the Prince Regent also commissioned numer-
ous equestrian paintings by English artists, including George Stubbs
(see cat. 80) and Benjamin Marshall.
MLE

Gerard ter Borch (1617–1681)

75. *A gentleman pressing a lady to drink*

Oil on canvas, transferred from panel, 41.3 × 32.1 cm (16¼ × 12⅝ in.)
RCIN 404805
PROVENANCE Peilhon sale, Paris 1763; Abbé Le Blanc sale, Paris 1781;
bought by Lord Yarmouth for the Prince Regent; received at Carlton House on
9 May 1812
REFERENCE Smith IV, 1833, p. 126, no. 26; Waagen 1854, p. 7; Hofstede de
Groot V, 1913, pp. 33–34, no. 82; London 1946, no. 320; London 1971, p. 26, no.
64; White 1982, pp. 25–26, no. 28; Philadelphia 1984, pp. 147–48

Ter Borch was born in Zwolle, and in 1635 visited England, where his
uncle was engraver to Charles I. A portraitist and genre painter, he
settled in Deventer in 1654. His sitters included the Prince of Orange
and the delegates to the Congress of Munster in 1648. Writing in 1833,
Smith overlooked ter Borch's psychological penetration, observing,
"the production merely displays the ingenuity of a tasteful choice of
subject, and a skilful management in the colouring, effect, and
execution".

The model for the lady in this work of around 1660 was ter Borch's
step-sister, Gesina, who appears in several other genre scenes with
women drinking. In the 17th-century Netherlands, drinking undiluted
wine was considered shameful. After an unhappy affair, Gesina ter
Borch wrote a poem in praise of the soothing powers of wine: "Cruel
Venus I drive you out of my mind / And ease it with the wine. / The
noble sweet wine soothes the human heart / when drunk moderately
and enjoyed with good taste."

In 1816 this picture hung in the Ante-Room at Carlton House.
MLE

Adriaen van Ostade (1610–1685)

76. *The interior of a peasant's cottage*, 1668

Oil on panel, 46.7 × 41.6 cm (18⅜ × 16⅜ in.)
Signed over the fireplace on the right *Av. Ostade/ 1668*
RCIN 404814
PROVENANCE P. de Smeth van Alphen, his sale, Amsterdam 1810; bought
P.J. Lafontaine, his sale, Christie's, 12 June 1811, lot 59; but apparently bought
privately by Lord Yarmouth for the Prince Regent; received at Carlton House
13 June 1811
REFERENCE Smith I, 1829, p. 148, no. 146; Waagen 1854, p. 13; Hofstede de
Groot III, 1910, pp. 281–82, 379, nos. 460, 774a; London 1946, no. 325; London
1971, p. 26, no. 33; Millar 1977, p. 151, pl. XXXVI; White 1982, pp. lv, lviii, lxvi,
85, no. 132, p. 87; Philadelphia 1984, no. 91, pl. 29; London 1988¹, no. 46

Apparently a student of Frans Hals, Ostade worked in Haarlem and
specialized in small realistic peasant scenes. His earliest composition
with a tumbledown interior and a nursing mother is an etching dated
1647. A lost painting bore an inscription which elucidates this subject:
"we love our little child from the heart, and that is no trifle. Thus we
regard our miserable hovel as a splendid mansion".

75

George III owned pictures by Ostade, as did Lord Yarmouth, the Vice-Chamberlain of Prince George's household. The Prince purchased eight paintings by Ostade, most of which came with the Baring collection in 1814. Three, including the present work, hung in the Bow Room of Carlton House. Writing in 1829, Smith considered, "This excellent picture is remarkable for its brilliant display of chiaro-scuro, and its extraordinary power of colour. The window is indeed a magical deception in art. It might, however, be wished that the artist had not placed his point of sight so high, as it gives the appearance of an ascent to the apartment". Ostade presumably intended this perspectival device to add dignity to his subject.

MLE

Gerrit Dou (1613–1675)

77. *The grocer's shop: woman selling grapes*, 1672

Oil on panel, 48.7 × 37.9 cm (19¼ × 14 in.)
Signed at lower right *DDOV 1672*
RCIN 405542
PROVENANCE Comte de Choiseul, Paris, by 1754; Choiseul-Praslin sale, Paris, 1793; bought Paillet; purchased in Paris by William Buchanan, 1817; Thomas Thompson Martin, from whom purchased by the Prince Regent, 21 June 1817
REFERENCE Smith I, 1829, p. 8, no. 23; Waagen 1854, p. 6; Hofstede de Groot I, 1908, p. 409, no. 187; London 1946, no. 342; London 1971, pp. 30–31, no. 57; Millar 1977, pp. 146, 156; White 1982, pp. xxxix–xli, lxiii, lxviii–lxix, 36, 39–40, no. 46; Philadelphia 1984, pp. 184–85; London 1991³, no. 146, pl. XXXIII

The Leyden painter Gerrit Dou studied with Rembrandt and specialized in small, highly finished genre scenes. He painted numerous pictures of cooks and housewives at half length, surrounded by still-life objects, set within stone embrasures. Their activity is frequently interrupted by children – a theme which has been interpreted as contrasting innocence with experience. The bas relief of children playing with a goat, probably based upon a lost sculpture by François du Quesnoy, was a motif which appears frequently in his paintings.

Dou's paintings were prized by his contemporaries, and remained highly sought after through the eighteenth century. In 1829 John Smith observed: "He was a perfect master of all the principles of art; which, united with consummate skill and labour, enabled him to produce the most perfect specimens that ever came from the easel of a painter". In 1817 the Prince Regent declined William Beckford's enormous price of 3000 guineas for Dou's *Poulterer's shop*, now in the National Gallery, but paid the substantial sum of 1000 guineas for the present work. After its acquisition, it joined the display of Dutch paintings in the Bow Room at Carlton House.

MLE

76

77

78

Meyndert Hobbema (1638–1709)

78. *A watermill beside a woody lane*, 1665 or 1668

Oil on panel, 52.3 × 68.2 cm (24½ × 35¼ in.)
Signed at lower right *M Hobbema/ f 1665/8?*
RCIN 404577
PROVENANCE Sir Thomas Baring; purchased with his collection by the
Prince Regent in 1814
REFERENCE Smith VI, 1835, pp. 113, 155, no. 113; Waagen II, 1854, p. 21;
Hofstede de Groot IV, 1912, p. 380, no. 79; White 1982, p. 50, no. 68; Kriz 1997,
pp. 63, 121

A student of Jacob Ruisdael, Hobbema lived in Amsterdam and
specialized in landscapes. He is best known for his *Avenue at Middelharnis*
in the National Gallery, London. In 1668 he married and was appointed
wine gauger of the city; thereafter his artistic output greatly decreased.

Hobbema was little known during the 18th century, moving Smith
in 1835 to comment that his works were "held so cheaply by [his]
countrymen, that the speculator reaped an abundant harvest by their
importation to England". There he provided an influential model for
English Picturesque artists. Of the present work and another Hobbema,
also acquired by the Prince Regent in 1814, Smith remarked: "The usual
effect of sun and shade, so admirably blended in all his best works, lend
their aid ... to complete the charm of the scenes". In 1816 both pictures
hung in the Ante-Room at Carlton House. MLE

Elisabeth Vigée-Le Brun (1755–1842)

79. *Charles-Alexandre de Calonne (1734–1802), 1784*

Oil on canvas, 149.9 × 128.3 cm (59 × 50½ in.)
RCIN 406988
PROVENANCE Purchased by George, Prince of Wales, before 1806. In Carlton House in 1816
REFERENCE London 1946, no. 406; London 1966[1], no. 6; London 1979, no. 47; London 1988[1], no. 31; Vigée-Le Brun 1989, pp. 45–48, 253–54; Goodden 1997, pp. 33–35

One of the leading portraitists of the late 18th and early 19th centuries, Vigée-Le Brun left France at the Revolution, and visited many European courts, including Naples, Vienna and St Petersburg. In 1802–05 she was in London, where Prince George commissioned his own portrait from her as a gift for Mrs Fitzherbert (see fig. 19, p. 70). Vigée-Le Brun described the Prince as "... having gained too much weight for his age. Tall and well built, he had a fine face He wore a wig which was a veritable work of art; the hair was parted on the forehead after the fashion of the Apollo Belvedere and it suited him perfectly."

Charles-Alexandre de Calonne was Contrôleur-Général des Finances to Louis XVI. Unable to push through his plans for restoring solvency, he was dismissed in 1787 and retired to England where he became a supporter of the exiled French aristocracy, selling his extensive art collections in 1795 to finance their cause. His conviction that the French Revolution represented a threat to every established government was fully shared by Prince George.

The sitter is wearing the Order of the Saint-Esprit and carrying a letter addressed to Louis XVI. Dated August 1784, the charter of the Caisse d'Amortissement, which led to his downfall, rests on the table. In her *Memoirs*, the artist strongly denied rumours of an affair with Calonne: "Can you imagine that I, with my love of the picturesque, could ever a tolerate a wig?". K B

George Stubbs (1724–1806) with additions by François Boucher (1703–1789) and Claude-Joseph Vernet (1714–1789)

80. *Hollyhock*

Oil on canvas, 38.8 × 47.8 cm (15¼ × 19¼ in.)
RCIN 400034
PROVENANCE Commissioned by 2nd Viscount Bolingbroke in 1766; comte Jean du Barry, who had it 'embellished' by Boucher and Vernet; his son vicomte Adolphe du Barry; his sale, 21 November 1774, lot 20; purchased by M. Monet for 175 livres; E.M. Harrington; his sale Christie's 3 February 1810, lot 71; bought in at £16. 5s. 6d.; Colnaghi's, from whom purchased by George, Prince of Wales, 16 April 1810
REFERENCE Engraved by John Scott for *The Sporting Magazine*, 1803; London 1966[2], no. 37; Millar 1969, no. 1119; London 1984[2], no. 42

This equine portrait by England's most famous painter of horses was radically altered for the comte du Barry by the addition of a background and figures by two of the most fashionable painters in France. The subtlety and anatomical precision of Stubbs's handling does not sit well with the bucolic sweetness of Boucher's shepherd couple. Nevertheless, in 1803 this work moved the editor of *The Sporting Magazine* to enthuse, "The original painting ... is one of the most beautiful ever seen".

The other seventeen paintings by Stubbs in the Royal Collection all appear to have been commissioned by George, Prince of Wales, during the 1790s. Hollyhock was foaled in 1765, by Young Cade out of Cypron. Lord Bolingbroke purchased the colt at Windsor and had some success with him at Newmarket before selling him to Lord Rockingham. Prince George may have acquired this painting because Hollyhock had been bred by his great-uncle, the Duke of Cumberland, whose interest in racing he shared (see cat. 82).

The paucity of French pictures in Prince George's collection was probably the result of his emulation of the grandest 18th-century French interiors, in which apartments furnished with contemporary *boiserie* and furniture were hung with Dutch and Flemish cabinet paintings (see cats. 71–78). Watercolours of the interiors of Carlton House indicate that the Prince followed this practice. Also, much contemporary French art was too republican or Napoleonic for the Prince's taste. K B

David Wilkie (1785–1841)

81. *Blind Man's Buff, 1812*

Oil on panel, 63.2 × 91.8 cm (24⅞ × 36⅛ in.)
Signed, left of centre *David Wilkie. 1812*
RCIN 405536
PROVENANCE Painted for the Prince Regent in 1812–13
REFERENCE Waagen II, 1854, p. 25; Millar 1969, pp. xxxvii, 12, 137–38, no. 1175; Brown 1985, no. 2; Miles and Brown 1987, pp. 11–12, 131, 168–72; London 1991[3], nos. 154, 179

A portrait, history and genre painter, Wilkie trained in Edinburgh and moved to London in 1805. He became a favourite of the Prince Regent, who later remarked, "I can never have too many Wilkies in my collection". Appointed Limner to the King for Scotland in 1823, and Principal Painter to the King in 1830, he was knighted in 1836.

Blind Man's Buff was the first painting which the Prince commissioned from Wilkie, to accompany *The country choristers* by Edward Bird (1772–1819), purchased in 1810. He "let Wilkie make choice of the subject ... and fix his own price". It cost 500 guineas, and was exhibited at the Royal Academy in 1813. Benjamin West described it as "a youthful company playing at Blindmans Buff Life with mirth and good temper is seen in every group and in every figure – it places the painter in this class of Art preeminent to the Flemish schools". His patron Lord Mulgrave believed, "Wilkie would go beyond Teniers [and] Ostade" – also favourites of the Prince (see cats. 72 and 76). This painting hung in the Upper Ante-Room at Carlton House in 1819, when Wilkie provided it with a companion, *The penny wedding*.
M L E

80

81

82

Thomas Sandby (1721/23–1798) and Paul Sandby
(1730–1809)

82. *Ascot Heath races*

Watercolour with pen and ink on paper (two sheets), 49.5 × 91.4 cm
(19½ × 36 in.)

RL 14675

PROVENANCE Thomas Sandby; his sale, Leigh & Sotheby's, 18 July 1799, lot
11; Colnaghi; purchased by George, Prince of Wales, 1 August 1799, for 5
guineas

REFERENCE Oppé 1947, pp. 43–44, no. 147; Arts Council of Great Britain
1974, p. 153, no. 325; New Haven 1985, p. 56; Roberts 1995², pp. 17–21, 134–35,
no. 47

In 1741/42 Thomas Sandby moved from his native Nottingham to
London. After working as a draughtsman for the Ordnance Office, he
entered the service of William Augustus, Duke of Cumberland
(1721–1765), leaving his old post to his brother Paul. Shortly after the
Duke's appointment in 1746 as Ranger of Windsor Great Park, Thomas
became his Steward. Paul established a reputation as a watercolourist,
and in 1768 was appointed Chief Drawing Master at the Royal Military
Academy in Woolwich.

The design of this panoramic view of around 1765 is by Thomas
Sandby, with figures added by Paul, perhaps assisted by the sporting
artist Sawrey Gilpin (1733–1807). This watercolour illustrates the eques-
trian interests of the Duke of Cumberland, who had re-established
horse racing at Ascot, to the south-west of Windsor, in the late 1740s.
Prince George shared his great-uncle's interest in racing, and inherited
several of his equestrian portraits.

MLE

83

Paul Sandby

83. *The Dutch House (Kew Palace), from the north-east*

Watercolour with pen and pencil on paper, 36.1 × 69 cm (14¼ × 27⅛ in.)
RL 14712

PROVENANCE Colnaghi; purchased by George, Prince of Wales, 26 June
1804, for 7 guineas

REFERENCE Oppé 1947, p. 48, no. 160; Ball 1985, p. 214; New Haven 1985,
pp. 28–31, no. 24; Roberts 1995², p. 21

Paul and Thomas Sandby were founder members of the Royal
Academy, and Paul painted numerous views of Windsor. However, he
was not patronized by George III, possibly on account of the King's
poor relations with his younger brother Henry Frederick, Duke of
Cumberland (1745–1790), who continued to employ Thomas Sandby
as Steward. The great Sandby collection at Windsor was initiated in
1799–1812 by the Prince of Wales.

The early 17th-century Dutch House at Kew was a subsidiary royal
residence, used in conjunction with Richmond Lodge and the White
House, neither of which survive. The White House, which was located
opposite the Dutch House, had been the home of George III and his
parents. The King's mother continued to live there until her death in
1772, when the property passed to George III. In 1773 the Prince of
Wales and his brother Frederick, aged respectively eleven and ten,
were transferred to the Dutch House, which became known as the
Prince's House. In this watercolour they appear at the left, playing
with a cart, accompanied by their brothers William (1765–1837) and
Edward (1767–1820), their sister Charlotte (1766–1828) and a governess.

This drawing was engraved by Michelangelo Rooker for the
Virtuosi's Museum in 1776. It was one of the few framed watercolours
acquired by the Prince, and its purchase price of 7 guineas included a
"burnished gold frame", which has since disappeared.

MLE

84

Jacques-François-Joseph Swebach-Desfontaines
(1769–1823)

84. *The death of General Desaix at the Battle of Marengo,
1800–01*

Indian ink and blue and grey wash, heightened with white, on paper,
63 × 93 cm (24¹³⁄₁₆ × 36⅝ in.)
Signed, lower left *Swebach/ ano 9*
RL 16537
PROVENANCE Colnaghi; purchased by George, Prince of Wales,
30 November 1808, for 25 guineas
REFERENCE Blunt 1945, p. 80, no. 525; Chandler 1966, pp. 229–30, 278,
293–96; Haswell Miller and Dawnay 1970, I, pl. 241, and II, p. 170, no. 1937;
Wellington 1976, pp. 305–09

Born in Metz, Swebach exhibited battle scenes regularly at the Paris
Salon from 1788, and was principal painter at the Sèvres porcelain
factory 1802–13. This drawing is dated in the Republican 'Year IX',
which ran from 23 September 1800 until 22 September 1801.

Louis Desaix (1768–1800) became a brigadier general in 1793 and
achieved fame during the Egyptian Campaign of 1798–99. He was
killed on 14 June 1800 while leading the attack which defeated the
Austrian army at Marengo – the battle in North Italy which Napoleon
considered his finest victory. Desaix was admired as a paragon of
virtue, and his death moved Napoleon to write: "I am plunged into the
deepest grief for the man whom I loved and esteemed the most". This
purchase reflects the Prince of Wales's fascination with Napoleon and
his campaigns.
MLE

Robert Dighton (1752–1814)

85. *Robert Dighton Junior as a Private in The Prince of
Wales's Volunteers*, 1803

Watercolour, with touches of bodycolour, on paper, 36 × 25.5 cm
(14³⁄₁₆ × 10¹⁄₁₆ in.)
Signed, lower right *Dighton. 1803*; bottom right *Dighton. Junr. H-R-H- The
Prince of Wales. Volunteers*
RL 0858
PROVENANCE Colnaghi, purchased by George, Prince of Wales, 13 July
1806, for 2 guineas
REFERENCE Haswell Miller and Dawnay 1966 and 1970, pp. 87, 89, no. 718,
pl. 273; Thorne 1986, pp. 69–70

Dighton worked in London and Brighton, specializing in miniatures,
drawings and prints of actors and military subjects. He produced over
thirty drawings of British professional and volunteer soldiers for the
Prince of Wales.

The Prince of Wales's Volunteers was one of the numerous volun-
teer regiments raised around 1800. It existed from September 1803 until
after the Napoleonic Wars. The precise date of its disbandment is
unknown, and there is no descendant regiment. A friend of the Prince
of Wales, the MP, dramatist and businessman Miles Peter Andrews
(*ca.* 1742–1814) is described in the Volunteer Lists as its "Lieutenant
Colonel Commanding".
MLE

85

Dighton Jun.^r H.R.H. The Prince of Wales Volunteers.

87

86

88

89

Dirk Langendijk (1748–1805) and Jan Anthonie
Langendijk (1780–1818)
86–88. *Three drawings from a portfolio of studies of staff
and regimental uniforms of the Prussian army*

86. *Staff Officer of the Engineer Corps in Undress Order*,
1805

Watercolour, heightened with gold and silver on paper, 48 × 27 cm
(18⅞ × 10⅝ in.)
Signed, lower right *Dirk en Jan Antony Langendyk Dzn./ delineavit 1805*; on
verso *Staf officiers van het/ Ingenieur Corps*
RL 15761

87. *Officer of the 13th Cuirassiers (Garde du Corps,
Potsdam) in Review Order*, 1805

Watercolour, heightened with gold and silver on paper, 48 × 27 cm
(18⅞ × 10⅝ in.)
Signed, lower right *Dirk en Jan Antonij Langendyk Dzn./ delineavit 1805*; on
verso *Garde du Corps in Potsdam/ galla [sic] Uniform*
RL 15767

88. *Officer of the 2nd Hussars (Regiment von Gocking) in
Review Order*, 1806

Watercolour, heightened with gold and silver on paper, 48 × 27 cm
(18⅞ × 10⅝ in.)
Signed, lower right *Jan Antonij Langendĳk Dzn: delint/ 1806*; on verso *Husaaren
Officier, Regiment von Gocking/ zu Berlyn am Ersten Revue Tage*
RL 15723

PROVENANCE Purchased by George, Prince of Wales from Colnaghi. Cat. 87
is identifiable in an invoice of 28 December 1809, when it was purchased for 6
guineas
REFERENCE Haswell Miller and Dawnay 1966 and 1970, II, pp. 150–52,
nos. 1689, 1729, 1740; Chandler 1966, pp. 454–55; London 1991³, no. 109

The Rotterdam artist and engraver Dirk Langendijk and his son Jan
Anthonie specialized in battle scenes and uniform studies. The Prince
of Wales owned over four hundred of their drawings, including eighty-
five studies of Prussian military personnel. It is difficult to identify
individual drawings in Colnaghi's accounts; their prices varied from
5 to 7 guineas. Doubtless the addition of gold and silver paint, as here,
was thought to justify the high price (compare with cat. 85).

Dated from 1805 until 1809, most of these studies are based upon
the engraved plates in C.C. Horvath, *Uniformes de l'Armée prussienne
sous le règne de Fréderic-Guillaume III, roi de Prusse*, published at Potsdam
in 1804. Although it had declined considerably since the days of
Frederick the Great, the Prussian army was still widely regarded as the
finest in Europe until its defeat by Napoleon at the Battle of Jena in 1806.
The Prince of Wales also owned items of Prussian uniform and equip-
ment. MLE

90

Jan Anthonie Langendijk

89. *The disastrous explosion at Leyden, 12 January 1807*

Ink and watercolour on paper, 58.2 × 88.7 cm (22¹⁵⁄₁₆ × 36¹⁵⁄₁₆ in.)
Signed, at bottom right *Jan Anthony Langendyk dessiné sur le lieu le 13 Janvier 1807*
RL 15226; Van Puyvelde no. 259
PROVENANCE Colnaghi, purchased by George, Prince of Wales, 12 October 1807, for 25 guineas
REFERENCE Van Puyvelde 1944, pp. 43, 46, no. 259; Haswell Miller and Dawnay, II, 1970, p. 140, no. 1231/1

The Prince of Wales acquired over thirty of Langendijk's scenes of the wars in Holland and Belgium, produced in 1800–15. On 12 January 1807 a ship carrying 10,000 tons of gunpowder exploded in the Rapenburg canal at Leyden, causing considerable damage to the town. Both this drawing and a half-scale version, dated 14 January 1807 and also in the Royal Collection, bear inscriptions stating that they were made on the spot. The composition was engraved by the Rotterdam printmaker G. Kitsen. As Napoleon's brother Louis Bonaparte (1778–1846) had been crowned King of Holland in 1806, the disaster at Leyden was a setback for Britain's enemies. During the early 19th century, the widening circulation of newspapers stimulated an insatiable demand for illustrations of current events and celebrities from an increasingly news-hungry public (see also cat. 91). MLE

Valentine Green (1739–1813) after Johann Zoffany

90. *Mr Garrick and Mrs Pritchard in the Tragedy of Macbeth, Act II, Scene III*

Mezzotint, 45.5 × 55 cm (18 × 21⅝ in.), published 30 March 1776 by J. Boydell, Cheapside, London
RCIN 655013
PROVENANCE Purchased by the Prince of Wales from Colnaghi, 15 January 1810, for one guinea as "Mr Garrick and Mrs Pritchard in Macbeth"
REFERENCE Royal Archives 27496; Smith 1884, II, p. 554, no. 47, state I, London 1976, p. 45, no. 48

Green's mezzotint reproduces Zoffany's oil painting, executed at the time of the last performance (on 24 April 1768) of the celebrated tragic actress Hannah Pritchard (1711–1768), in her most famous role as Lady Macbeth. She played opposite David Garrick (1717–1779) as Macbeth at Drury Lane. The painting is in the collection of the Maharaja of Baroda.

By the late 1790s the firm of Colnaghi was supplying the majority of the prints and drawings delivered to Carlton House; they continued to be the major supplier throughout the Regency and following George IV's accession. Their first relevant account refers to their outstanding bill of £1,047 for goods delivered between 26 December 1797 and 9 April 1799 (Royal Archives 27094). Their assistance with mounting and organizing the Prince's collection probably commenced much earlier than 1813, when they first submitted invoices for "the arrangement of

His Royal Highness' collection of drawings and Prints": in September 1810 they had supplied "Two Solanders 1/2 bound Russia, to contain prints" for £3. 12s. 6d. (Royal Archives 27539). A large number of the smaller prints supplied by Colnaghi shortly before the Regency were destined for grangerized editions (of Grammont's *Memoirs*, and other works), "illustrated by His Royal Highness" (RA 27587). For this purpose cheap drawings, copying unavailable prints, were occasionally supplied. Colnaghi also provided prints and borders for the Prince's Print Room in January 1800 (RA 27125-27, 27129-31).

JR

Charles Turner (1773–1857) after John Hoppner

91. *Admiral Lord Nelson*

Mezzotint, 64 × 41.8 cm (25¼ × 16½ in.), published 9 January 1806 by Colnaghi & Co., 23 Cockspur Street, London

RCIN 659361

PROVENANCE Purchased by the Prince of Wales from Colnaghi, 27 January 1806, for 2 guineas as "A portrait of Lord Nelson by Hoppner – proof"

REFERENCE Royal Archives 27329, 27624; McKay and Roberts 1914, pp. 182–83; Millar 1969, no. 849 and pl. 180

Hoppner was employed by the Prince of Wales from *ca.* 1790 to 1807. As its title inscription states, this print was copied from a portrait of Horatio Nelson (1758–1805) in the collection of the Prince of Wales. This remains in the Royal Collection, as does a miniature after it by Henry Bone (cat. 64). In the background of the oil, Nelson's victorious bombardment of Copenhagen in 1801 is shown. Nelson presumably sat to Hoppner soon after returning to England in July 1801; an engraved copy of the portrait, by H. Meyer, was published on 21 December 1802.

Hoppner's bill of 6 January 1806 to the Prince of Wales includes his fee for a full-length portrait of Nelson. Three days later, this mezzotint was published. In the background of the print the bombardment of Copenhagen is replaced by the Battle of Trafalgar. Nelson became a national hero following his death aboard the *Victory* in the course of the battle on 21 October 1805. He was buried at St Paul's Cathedral on 9 January 1806. Turner's mezzotint was put in hand soon after Nelson's death, and was published on the day of his funeral. According to Hoppner's biographer, "the rush for proofs was so great that they were sold before they passed through the drying press".

In view of the Prince's close association with the print, it is perhaps surprising that he had to buy an impression. He may have received complimentary copies before purchasing a further impression on 29 January 1806, less than three weeks after its publication. On 16 January the Prince had purchased from Ackermann "1 Proof Impression of Lord Nelson's Monument" (with frame) together with "A representation of Lord Nelsons Car, Do. of the Banners, Do. of the Coffin" for just over £7. JR

91

Niccolò Schiavonetti (1771–1813) after Henry Singleton

92. *The last effort and fall of Tipu Sultan*

Engraving, trimmed within the platemark, 58.2 × 69.6 cm (23 × 27½ in.), published 15 August 1802 by Messrs Schiavonetti, 12 Michaels Place, Brompton, and Anthony Cardon, 31 Clipstone Street, Fitzroy Square, London

RCIN 750589a

PROVENANCE Purchased, with its companion piece (RCIN 750588), by the Prince of Wales from Colnaghi, 15 August 1802, for 7 guineas as "A pair the Fall of Tippoo proofs"

REFERENCE Royal Archives 27202; Forrest 1970, pp. 351–52; Buddle 1989, p. 57; London 1991³, p. 48

At the assault on Seringapatam on 4 May 1799, Tipu Sultan, 'the Tiger of Mysore' (1753–1799), was finally vanquished by the British forces. He is shown here, bare-headed, to left of centre. The identities of the other figures are indicated in the published key (also incorporating an explanation concerning the companion print, *The surrender of two sons of Tippoo Sultaun*; RCIN 750589b). However, the figure to Tipu's right is merely described as "Soldier who killed Tippoo".

The print, which was "Dedicated by Permission to the ... Court of Directors of the United East India Company" by the publishers, was purchased by the Prince of Wales on the day of its publication from

92

his chief print supplier, Colnaghi. It depicts a key event in the Fourth Mysore War, three years prior to the publication of the print. Cat. 92 is one of four scenes from the war depicted by Henry Singleton, who never visited India but based his compositions on secondary sources. The series of reproductive prints published by Schiavonetti and Cardon was only one of a number produced at the time.

The prices paid by the Prince for individual prints – whether fine modern works or old rarities – were often higher than those for water-colours. His expenditure of 7 guineas on the pair of Tipu prints equalled the sum paid for Sandby's *The Dutch House* (cat. 83), but the cost of the latter included the frame. However, the Prince of Wales was prepared to pay large sums for military watercolours – as well as prints. Hence the large sums paid for the works by Swebach and Langendijk shown here (cats. 84, 86–88).

Prince George was an avid collector of relics of the Tiger of Mysore, and the Armoury at Carlton House included eleven items from the Sultan's palace at Seringapatam.

JR

Pierre-Philippe Thomire (1751–1843)
93. *Gilt bronze mantel clock*, ca. 1805

Apollo in his chariot drawn by four horses over the arc of heaven, on red griotte marble base; the later movement by B.L. Vulliamy, 75 × 78 × 26 cm (29½ × 30¾ × 10¼ in.)
Marks: The movement signed by Vulliamy and numbered 1223
RCIN 2764
PROVENANCE Purchased by the Prince of Wales from "Mr. Boileau" (possibly J.-J. Boileau) and received at Carlton House 2 May 1810
REFERENCE Jutsham I, p. 119, II, p. 66; Harris, de Bellaigue and Millar 1968, p. 169; Ottomeyer and Pröschel 1986, I, p. 355; de Bellaigue 1990, p. 16, note 42

It is not surprising that such an exuberant object, in Thomire's showiest manner, should have appealed to the Prince of Wales, nor that versions and variants of this spirited design found their way into the collections of other monarchs: examples are to be noted in Vienna, St Petersburg and Madrid. The "Boileau" from whom the Prince purchased the clock may have been Jean-Jacques Boileau, the artist-designer working for Daguerre at Carlton House in the 1780s and again for Morel and Seddon

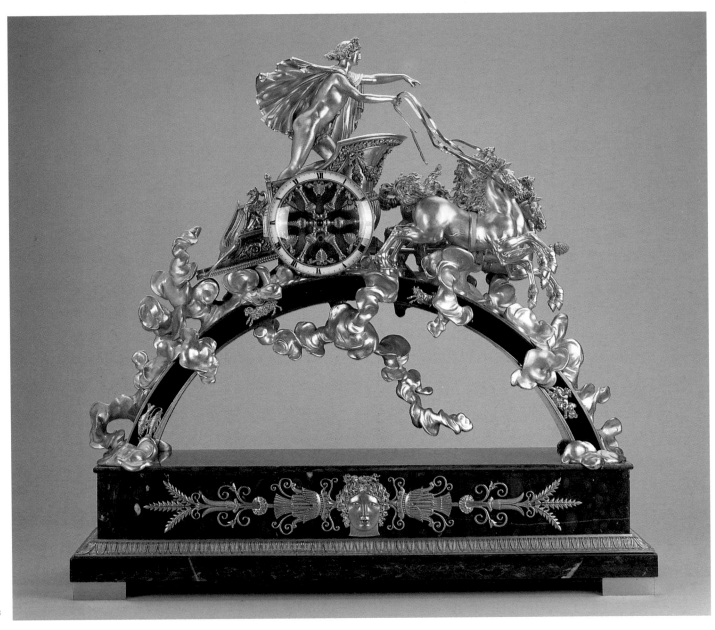

93

at Windsor in the 1820s. If so, Boileau can only have been acting as middleman: the Prince bought directly from Thomire on a number of occasions. On delivery, the Prince's clock was placed in the Crimson Drawing-room, where it was supplanted within two years by one of two equally elaborate figural clocks, either the *Oath of the Horatii* by Claude Galle or the *Rape of the Sabines* by Thomire, both of which were *in situ* by 1812.

The *Apollo* clock was sent to Royal Lodge at Windsor in 1824 and by 1834 it had been transferred to Brighton Pavilion, where its original Thomire movement, described by B.L. Vulliamy as "good for nothing", was replaced.

HR

Adam Weisweiler (1744-1820)

94. *Pier table*, ca. 1787–90

Veneered with ebony, mounted with gilt bronze and inset with mirror panels; shelves and top of red griotte marble; 91 × 175 × 52.7 cm (35¹³⁄₁₆ × 68⁷⁄₁₆ × 20¾ in.)

Marks: stamped *A. WEISWEILER*

RCIN 13

PROVENANCE Supplied by Dominique Daguerre *ca.* 1787–90 for the Chinese Drawing Room, Carlton House

REFERENCE de Bellaigue 1967, p. 524 and fig 34; London 1991³, pp. 18–20, 23 and no. 55

94

95

This console, together with a companion table mounted with Chinese caryatid figures, a set of chairs by François Hervé (cat. 96), two pairs of candelabra (cat. 95) and a clock, formed the principal furnishings of the Chinese Room on the basement floor of Carlton House, created by Holland and Daguerre *ca.* 1787–90. This pioneering scheme was the forerunner of a series of increasingly elaborate interiors of exotic inspiration created for the Prince, which culminated at Brighton Pavilion in the 1820s. The relative restraint of this first scheme, which may be seen in Thomas Sheraton's engravings of 1793 (see fig. 21, p. 72), was more than offset by the inventive exuberance and extraordinary finesse of the furniture. The console for example, essentially a standard Louis XVI furniture type deriving from the *commode à encoignures*, is given – under Daguerre's direction – a distinctive and exotic *enjolivement* with dragons, peacocks, tasseled drapery and bamboo mounts in the most avantgarde Parisian taste.

By 1811 the Chinese Drawing Room had been dismantled and the principal furnishings relocated on the floor above in the Rose Satin Drawing Room. This scheme, recorded by Pyne in *ca.* 1817, was again changed in 1819 when all the remaining *chinoiserie* furniture and mounted oriental porcelain at Carlton House was sent to Brighton. It was at this date that copies of cat. 96 and its companion (now at Buckingham Palace) were made by Edward Bailey prior to installation in the Music Room Gallery at Brighton. HR

French

95. *Pair of gilt bronze four-light candelabra, ca.* 1787–90

Each with a female Chinese musician painted in colours, 78.7 × 34 × 21.6 cm
(31 × 13⅜ × 8½ in.)
RCIN 4246

PROVENANCE Supplied by Dominique Daguerre *ca.* 1787–90 for the Chinese Drawing Room, Carlton House
REFERENCE Public Record Office LC11/39, qtr. to 5 April 1823; de Bellaigue 1967, p. 523 and fig. 33; Verlet 1987, figs. 97 and 167; London 1991³, pp. 18–20 and no. 57

Together with another pair, these candelabra formed part of the original furnishings of the Chinese Drawing Room at Carlton House (see cats. 94 and 96). Daguerre's role in the supply of the furniture was paramount: the highly fashionable *chinoiserie* pieces, including these candelabra, are likely to have been created to his specific order and imported from Paris direct. Daguerre's extensive connections with bronze-makers are not sufficiently fully documented to make a reliable attribution, though the *bronzier* François Rémond was his principal supplier at certain periods and is known to have worked in this idiom. Pierre Verlet has tentatively identified two objects for which Rémond may well have made *chinoiserie* mounts and which were supplied by Daguerre to the Garde Meuble in 1785.

When the majority of *chinoiserie* objects remaining at Carlton House were transferred to Brighton Pavilion in 1819, these candelabra were placed (with cats. 94 and 96) in the Music Room Gallery. In 1823 the painted decoration on all four candelabra was added by Robert Jones at a cost of £29. 8s.

HR

François Hervé (active *ca.* 1781–96)
96. *Two giltwood armchairs*, 1790–92

Pierced frames surmounted by a seated Chinaman; upholstered in modern yellow satin; 102.9 × 59.7 × 62.5 cm (40½ × 23½ × 24⅝ in.)
RCIN 481

PROVENANCE Part of a suite supplied for the Chinese Drawing Room at Carlton House in 1790
REFERENCE de Bellaigue 1967, pp. 520, 523 and fig. 31; *Dictionary* 1986, pp. 423–24; London 1991³, pp. 18–20 and no. 54

These chairs, like the Weisweiler table and candelabra (cats. 94 and 95), were made for the Chinese Drawing Room at Carlton House. The suite to which they belong consists of six side chairs, four armchairs and four bergères and was made in 1790 by François Hervé, of 32 Johns Street, Tottenham Court Road. In 1792 the seated Chinese figures were added by Hervé. The total cost of £880. 11s. included three trial chairs for the Prince's approval, gilding by Sefferin Nelson and upholstery in yellow satin by Robert Campbell (the material supplied by Ibbetson, Barlow & Clarke) as well as loose covers. The subsequent history of the suite repeats that of cats. 94 and 95.

Little is known of Hervé. His name, his association with the Anglo-French circle of Gaubert, Holland and Daguerre (principally at Chatsworth, Carlton House and for the Duke of York), and a number of French constructional features in his documented chairs all point to a French origin, though there is no certainty of that. The most remarkable feature of these chairs is the extent of the piercing in the frames (seats, backs and arm-supports), a technical feat without direct parallel in either French or English chair-making and one which no doubt contributed to their very high cost. HR

96

97

Martin Carlin (*ca.* 1730–1785)
97. *Cabinet*, *ca.* 1783

Veneered with tulip-, purple- and box-wood, with two doors enclosing three
drawers, set with two oval and eight rectangular Sèvres porcelain plaques and
with gilt bronze mounts; white marble top, 95.9 × 152.4 × 50.8 cm (37¾ × 60 ×
20 in.)
Marks: stamped four times *M. CARLIN JME*; the oval plaques with blue
interlaced *LL*s, marks of the flower-painter E.-F. Bouillat and gilder J.-P.
Boulanger; the rectangular plaques with purple interlaced *LL*s enclosing date
letters *ff* (for 1783) and mark of gilder H.-F. Vincent *jeune*, one with inscription
naming Vincent Taillandier (as border painter)
RCIN 21697
PROVENANCE Probably supplied by Dominique Daguerre *ca.* 1785–90 for
Carlton House
REFERENCE Royal Archives, Box 3/154; London 1979, no. 39; Verlet 1987,
p. 320, figs. 352, 355

The date of acquisition of this exceptionally refined and sumptuous
piece of furniture is unknown, though it seems to have been at
Carlton House by 1792, when the Coutts Inventory was drawn up as
part of the process of dealing with the Prince's debts and staving off
his creditors: the "Salloon" on the top floor of the house – part of the
Prince's own suite of rooms – contained "A beautiful Commode
enrich'd with the Seve porcelain & Or Molu" beneath a pier glass 142
cm (56 in.) wide, a description which may refer to this piece. It is a clear
indication of the Prince's fondness for a type of furniture considered
highly fashionable in France but appreciated only by a small number
of connoisseurs in England at that date.

Furniture mounted with Sèvres porcelain plaques was the preserve
of the Prince's principal furniture adviser Dominique Daguerre: when
he succeeded his cousin and partner S.-P. Poirier in 1777, he also
succeeded to Poirier's virtual monopoly over the purchase of plaques
of this kind from the Sèvres factory. The factory records indicate that
ten plaques corresponding to those on the Prince's cabinet were
supplied to Daguerre in the second half of 1783. The delicate frieze
mount, which appears on other pieces of furniture supplied by
Daguerre, has been attributed to the *bronzier* François Rémond.
HR

103

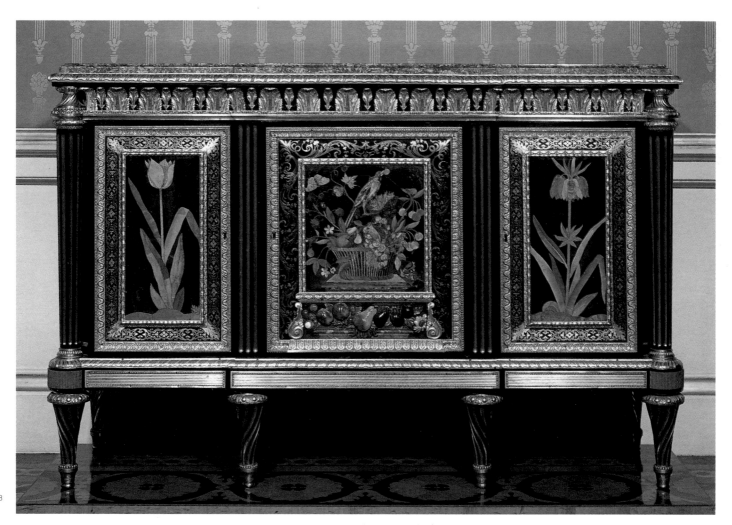

98

Adam Weisweiler (1744–1820)

98. *Cabinet, ca.* 1785–90

With three doors, veneered in ebony and inset with *pietra dura* panels
bordered with Boulle marquetry and with gilt bronze mounts; brocatello
marble top, 100 × 150 × 49 cm (39⅜ × 59¹⁄₁₆ × 19⁵⁄₁₆ in.)
Marks: stamped indistinctly *A. WEISWEILER*
RCIN 2593
PROVENANCE Plausibly identified with a purchase by the Prince of Wales at
Dominique Daguerre's sale of imported stock, Christie's, 25 March 1791, lot 59
(110 guineas); probably the "Superb Commode" recorded in the Council
Chamber at Carlton House in 1793
REFERENCE Harris, de Bellaigue, Millar 1968, pp. 140–43; London 1991³, no.
28; Paris 1994, no. 523; de Bellaigue 1995, p. 176; Sargentson 1996, p. 47, pl. 14

Dominique Daguerre, the celebrated Parisian *marchand-mercier*, was
employed as furniture supplier and interior decorator at Carlton House
from 1787 to 1795. He came from Paris at the Prince's invitation to
work at Carlton House with the architect Henry Holland, and in the
eight and a half years of their collaboration – effectively almost a
partnership – architect and decorator totally transformed the rambling

old house which the Prince had inherited from his grandmother
Augusta, Princess of Wales. The combination of Daguerre's stylish
opulence and Holland's classical restraint produced some of the most
perfect and refined Anglo-French interiors ever realised in England.
Without doubt, the Gallic references in Holland's architecture were
enhanced and complemented by a string of purchases in the most up-
to-date Parisian taste, made by the Prince either directly from Daguerre
or through the salerooms (by which means Daguerre traded exten-
sively in the 1790s). These included furniture by Martin Carlin (see
cat. 97), bronzes by Gouthière and Rémond (see cat. 99), clocks by
Sotiau, Manière and Lépine and seat furniture by Georges Jacob.

The Weisweiler cabinet, which incorporates large flat panels of early
17th-century Florentine *pietra dura* and relief panels probably made at
the Gobelins in the late 17th century, would certainly have been made
under Daguerre's supervision. His stock included a quantity of such
panels ready to be made up and a number of similarly decorated pieces
by or attributed to Weisweiler are known. These include a cabinet now
in the Swedish Royal Collection, probably acquired from Daguerre in
the early 1790s; another in the J. Paul Getty Museum; and a pier table
now at Buckingham Palace supplied by Daguerre to the Princess of
Salm in the late 1780s. H R

99

François Rémond (*Maître ciseleur-doreur* 1774)
99. *Pair of gilt and patinated bronze candelabra, ca. 1785–90*

For three lights, each with three satyresses and camel's-head candle branches, 69 × 38.5 × 30 cm (27⅛ × 15⅛ × 11¹³⁄₁₆ in.)
RCIN 39216
PROVENANCE Probably supplied by Dominique Daguerre *ca.* 1785–90 for Carlton House
REFERENCE Royal Archives 25099; Baulez 1987, pp. 37–39

This model of candelabra, of which other versions and variants are known, was first supplied by the *bronzier* François Rémond for the *cabinet turc* of the comte d'Artois at Versailles on 28 November 1783. The name of the designer is unknown, though J.-D. Dugourc has been suggested by Baulez. The lavishly decorated *cabinet*, the second Turkish scheme created for the King's brother within six years, was provided with an elaborate suite of gilt furniture by Georges Jacob; for the huge sum of 28,500 *livres* (later reduced by half), Rémond supplied a clock case and five pairs of candelabra. Two of the pairs of candelabra, decorated with stems of maize, were acquired by George IV in 1820.

The date of the Prince's acquisition of these extraordinarily *à la mode* objects is not known, but they may have formed part of Daguerre's first wave of sales to the Prince in the late 1780s. They were recorded in the "Blew Room" in 1792. Surprisingly, there is no indication that the Prince planned a Turkish room at Carlton House in emulation of French examples. HR

Rundell, Bridge & Rundell, various makers
100–07. *Silver gilt from the Prince Regent's 'Grand Service', 1802–11*

100. *Two-handled oval salver*

Engraved with the Royal Arms at the centre; pierced, continuous and repeating border cast with confronted panthers and vases among scrolling vines, with four, repeated Bacchic masks; two loop handles cast as garlands of flowers, each mounted with two ram's-head cornucopiae. One of a pair; 58.4 × 69.8 cm (23 × 27½ in.)
Marks: Hallmark for London 1809–10 and maker's mark of Benjamin II Smith and James III Smith
RCIN 51494.2 (GV 250)

101. *Tureen, cover and stand*

The circular bowl with two plaques of sacrifices cast in low relief, and a winged Egyptian head below each; the handles in the form of winged goddesses of fertility (Diana of the Ephesians) with castellated tiaras; domed cover with entwined serpent handle; resting on a spiral-fluted socle with 4 sphinx supports on the angles; the stand cast and chased with a band of rosettes and lozenges, supported on 4 animal feet. From a set of 4 large and 4 small tureens. Tureen and cover height 36.7 cm (14⁷⁄₁₆ in.); width 43.3 cm (17¹⁄₁₆ in.); depth 32 cm (12⅝ in.); stand diameter 47.5 cm (18¹¹⁄₁₆ in.)
Marks: Hallmark for London 1803–04 and maker's mark of Paul Storr
RCIN 51695.4.a-d (GV 232)

102. *Two four-light candelabra*

Engraved with the Royal Arms, each on three lion's legs spaced by classical female masks; the trumpet stems with three addorsed female heads supporting three detachable S-shaped branches and a central candle-holder; the branches cast and chased with acanthus foliage, lion mask paterae and dolphin terminals. From a set of 12 (part of a larger group of 24 made in stages, 1804–12); overall height 64 cm (25⅜ in.)
Marks: Hallmark for London obscured, and maker's mark for Paul Storr
RCIN 50827.13-.14 (GV 14)

103. *Two salts*

Each in the form of a triton bearing away a nautilus shell; the shells, with later liners, rest on irregular oval bases cast and chased with waves. Originally gilt in two colours. From a set of 24, 10 × 11.8 × 6.2 cm (3¹⁵⁄₁₆ × 4⅝ × 2½ in.)
Marks: Hallmark for London 1810, and maker's mark of Paul Storr
RCIN 50825.1-.2.a-b (GV 196)

100

101

102

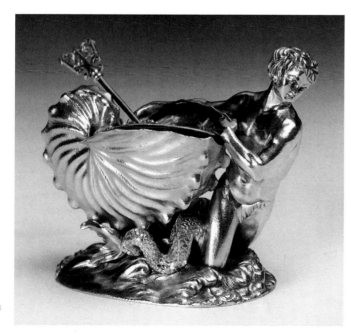

103

104. *Two wine-glass coolers*

Cylindrical form with a double lip; the sides cast with low reliefs on a matted ground, depicting Jupiter and Ganymede, and Hebe and a hippocamp; the sides cast with tritons supporting the lip. From a set of 24 made in stages, 1805–12; 10.3 × 15.3 cm (4¹⁄₁₆ × 6 in.)
Marks: Hallmark for London 1805–06 and 1810–11 and maker's mark for Benjamin II and James III Smith; stamped on the base *RUNDELL BRIDGE ET RUNDELL AURIFICES REGIS ET PRINCEPIS WALLIAE LONDINI FECERUNT*
RCIN 51298.1 and .9 (GV196)

105. *Two sauceboats, covers and stands*

Inverted helmet shape, with domed lids and cone finials; the sides cast with 'Egyptian' winged-disc motifs, and with winged masks below the spout and handle; rising double-serpent handles with hooded dog's head terminals and bud finials; supported on 3 animal legs with cloven hoofs, on oval stands. From a set of 12; 22.9 × 22.6 × 14.5 cm (9 × 8⅞ × 5¹¹⁄₁₆ in.)
Marks: Hallmark for London 1804–05 and maker's mark for Digby Scott and Benjamin II Smith
RCIN 51688.4–.5 (GV 224)

106. *Two sugar or cream vases, covers and stands*

Engraved with a closed crown and the Prince of Wales's feathers; the vases in the form of round, two-handled urns, chased with a broad band of scrolling foliage around the centre, alternating acanthus at the neck and gadrooning in the lower part; on circular bases with radiating palm leaves, resting on 4 feet. Glass liners; 20.2 × 15 cm (8 × 5¹⁵⁄₁₆ in.)
Marks: Hallmark for London 1806–07 and maker's mark for Benjamin II Smith and James III Smith
RCIN 51465.9 and .10 (GV 121)

107. *Two soup plates*

Engraved with the Royal Arms and the Prince of Wales's motto; slightly scalloped borders cast with reeding entwined with fruiting vines and with shell motifs at intervals. From a total of 6 dozen soup plates and 24 dozen table plates; diam. 27.5 cm (10¹³⁄₁₆ in.)
Marks: Hallmark for London 1805–06 and maker's mark of Digby Scott and Benjamin II Smith
RCIN 51854.5 and .72 (GV 189)

PROVENANCE Purchased by the Prince Regent, 4 June 1811
REFERENCE Royal Archives 26284–87; Jones 1911, pp. 162, 164, 166, 188, 216; Schroder 1988, pp. 358–63, no. 95; London 1991³, nos. 85, 91, 93–95, 100; Paris 1994, nos. 179, 180; New York 1997, no. 7

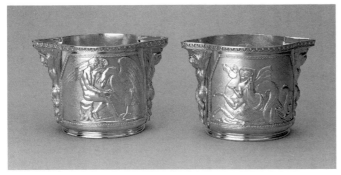

104

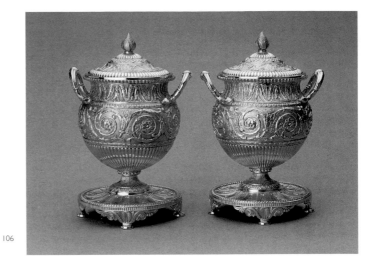

106

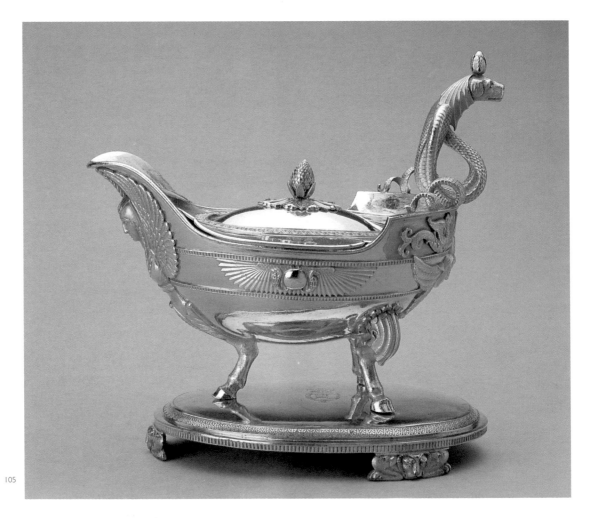

105

107

The firm of Rundell, Bridge & Rundell, goldsmiths and jewellers, enjoyed the quite exceptional patronage of not only the Prince of Wales but also George III and Queen Charlotte, the Duke of Cumberland, the Duke of York and other members of the Royal Family. While they are best known for the dining and display silver made for them by master silversmiths such as Paul Storr, they also sold quantities of much older silver and precious objects, as well as bronzes, to the Prince of Wales.

This selection of plate illustrates the aspect of the Prince's life at Carlton House that most frequently featured in the contemporary press: the fêtes and banquets held on royal anniversaries or in honour of a state visitor or military or naval success. All the pieces appear in the very extensive invoice totalling £61,340.1s. 2d. submitted on 4 June 1811 by Rundells, and were doubtless part of the display of plate mounted at Carlton House for the fête on the King's birthday on 19 June (a few months after the Prince's installation as Regent), which was attended by 3,000 guests. The contents of this bill constitute the greater part of what became known as the Grand Service, and the selection exhibited here shows several of its characteristics. All of the dining and display plate supplied in 1811 was gilt (both the new and the older pieces), indicating a desire to achieve a 'unity of grandeur' in the Carlton House buffet displays.

In style, the Grand Service was all-embracing. While taking account of the latest Neoclassical trends in England and especially France, it subsumed, and was to some extent influenced by, the plate supplied to Frederick, Prince of Wales by George Wickes in the 1740s. While some of the pieces, such as the sumptuous oval salvers (cat. 100) or the Piranesian sugar vases (cat. 106) were relatively standard contemporary designs, the service included some of the most expressive productions in the revived Egyptian style, including the sauce boats by Scott and Smith (cat. 105) and most notably the 'Ephesian Diana'

tureens by Paul Storr (cat. 101). The form of these grand objects was derived from a French tureen by Henri Auguste already in the Royal Collection. A design by Jean-Jacques Boileau (see cat. 93) now in the Victoria and Albert Museum may also be related to their production. The Egyptian motifs were selected from such engraved works as Vivant Denon's *Voyage dans la Basse et la Haute Egypte* (1802), and Percier and Fontaine's *Recueil de décorations intérieures* (1801). A further set of these tureens was supplied to the Prince Regent's brother, Ernest, Duke of Cumberland, who was among the several other clients who possessed examples of the caryatid candelabra (cat. 102), which were made with slight modifications over ten years.

Contemporary English modellers and sculptors such as John Flaxman and Edward Hodges Baily were employed by Rundells to produce designs and plaster models. Although they are described in the 1811 bill as "very finely executed from the antique", the 'triton' salts (cat. 103) were designed by Baily, closely following a bronze by William Theed the Elder, *Thetis bringing from Vulcan the armour of Achilles* (Royal Collection, on loan to Wrest Park, Bedfordshire). In large numbers their *mouvementé* forms enlivened the dining table in the same way as biscuit porcelain figures and groups, and they epitomize the watery, nautical theme that pervades Rundells' productions in the years after Trafalgar. The 'Neptune' centrepiece by Crespin (cat. 45) was extended by marine embellishments added by Rundells to the base (not exhibited) to form part of the Grand Service.

JM

Rundell, Bridge & Rundell, unknown maker
108. *Centrepiece*

Gilt bronze; the pierced, domed cover surmounted by a cast and chased canopic jar with the lotus-bud finial of Isis; four double-scrolled candle branches to hold eight candles, mounted to a ring with the signs of the Zodiac cast in low relief, supported by four winged female Egyptian figures, each holding a bowl of produce; at the centre, a figure of the bull Apis on a rectangular draped altar applied with Egyptian masks, standing on a matted and engraved circular platform. The shaped base with four expressed corners with cast figures of chimeras, all standing on paw feet; 80.2 × 48 × 47.5 cm (31 9/16 × 18 7/8 × 18 11/16 in.)
RCIN 50419
PROVENANCE Purchased by the Prince Regent on 4 June 1811, £504. 19s. 0d (including ebony stand)
REFERENCE Royal Archives 26285; Curl 1982, pl. 147; Paris 1994, p. 305, no. 181

The Grand Service included a number of designs executed in ormolu as opposed to silver gilt. This object is described in Rundells' bill of 1811 as "A large and very superb ormoulu Temple, gilt all over, with figures supporting Branches for lights, chimeras on the base, with dome top". Like the set of ormolu candelabra with addorsed Egyptian figures derived from Piranesi (Royal Collection on loan to Brighton Pavilion), the centrepiece, of which neither the maker nor designer have been identified, shows a serious attempt to reproduce Egyptian designs, in this case probably an amalgam of Montfaucon's *L'Antiquité expliquée* and the works of Piranesi and Vivant Denon.

JM

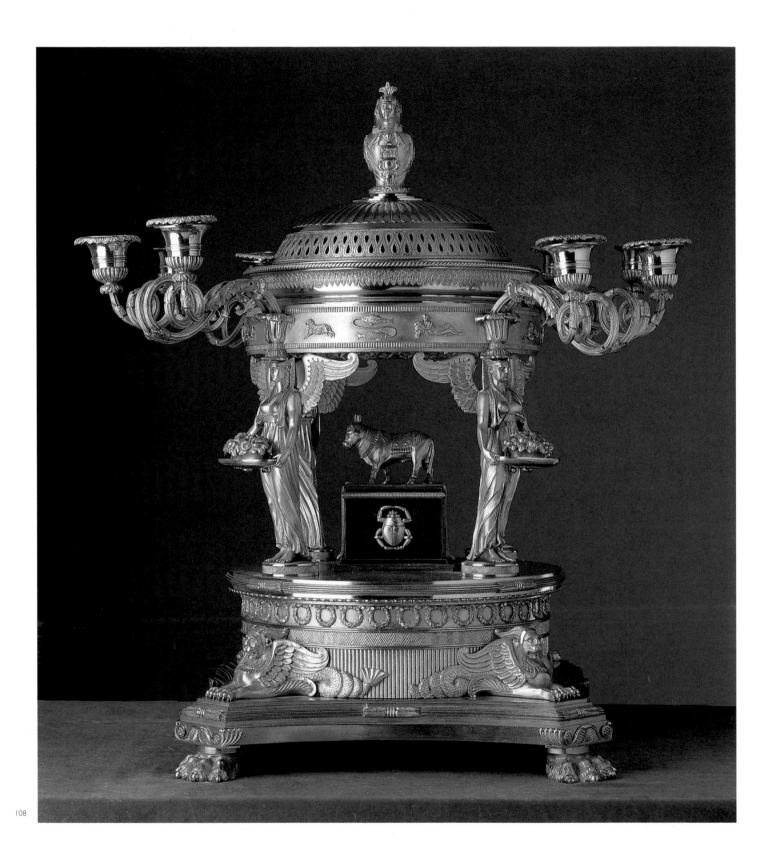

Sèvres

109. *Pieces from a dinner and dessert service*, 1776–83

Soft-paste porcelain, *bleu céleste* ground, painted in enamels with fruit and
flowers, and gilded
Two sugar basins and covers, 11 × 23.5 × 15.5 cm (4⁵⁄₁₆ × 9¼ × 6⅛ in.); one *seau
crennelé* (monteith), dated 1782, 13.2 × 29.7 × 20.8 cm (5³⁄₁₆ × 11¹¹⁄₁₆ × 8³⁄₁₆ in.);
two half-bottle (liqueur decanter) coolers, 15.2 × 20.3 × 15.5 cm (6 × 8 × 6⅛ in.);
four plates, dated 1779, 1781 and 1782, height 2.9 cm × diam. 24.5 cm
(1⅛ × 9⅝ in.); one *pot à oglio* (round tureen and cover), 25.8 × 29.7 × 23.8 cm
(10³⁄₁₆ × 11¹¹⁄₁₆ × 9⁵⁄₁₆ in.); stand, dated 1776, 6.5 × 46 × 36.6 cm (2⁹⁄₁₆ × 18⅛ ×
14⁷⁄₁₆ in.); two mustard pots, 9 × 8.5 × 6.2 cm (3⁹⁄₁₆ × 3⁷⁄₁₆ × 2½ in.); two *pots à jus*
(pots for meat juices), dated 1777, 7.7 × 8 × 6.2 cm (3¹⁄₁₆ × 3⅛ × 2½ in.)
Marks: Interlaced *LLs* and date letter painted in blue, painters' and gilders'
marks, incised letters, on most pieces
RCIN 58500.3 and .5.a-b; 59372.2, 59275.1 and .3; 59298.29, .39, .78 and .100;
59296.2.a-b; 59297.1; 59278.1 and .2.a-b; 59282.1 and .8.a-b
PROVENANCE Given by Louis XVI to the Duchess of Manchester, 1783; sold
through the London auctioneer Harry Phillips to the Prince of Wales, about
March 1802
REFERENCE Royal Archives 25268r (bill); de Bellaigue 1977; London 1979,
no. 1

George Montagu, 4th Duke of Manchester (1733–1788) was appointed
ambassador to the Court of Versailles in April 1783. Having negotiated
the peace treaties with Britain's enemies which concluded the War of
American Independence, he was presented with a diamond-studded
gold box by Louis XVI. His wife received a service of Sèvres porcelain,
valued at 21,080 *livres* (then worth about £670). This comprised a dinner
and dessert service of 283 pieces, and a further 106 pieces of biscuit
porcelain sculpture for table decoration. In 1802 the Duchess sold the
service to the Prince of Wales for £840, plus 5% commission. It now
lacks the porcelain sculpture, which may have been retained by the
Duchess.

The service was largely assembled from pieces already in stock at
Sèvres, mostly made in 1776 and 1782–83. With its sinuous forms,
turquoise-blue ground, richly tooled gilding and exuberant bouquets
of flowers and fruit, the service is in the late Louis XV style of that
decade, not entirely abandoned at Sèvres until after the Revolution.
Particularly prized by British collectors, Louis XV Sèvres was to be
much imitated by British manufacturers from the early 19th century
(see cats. 153–54). OF

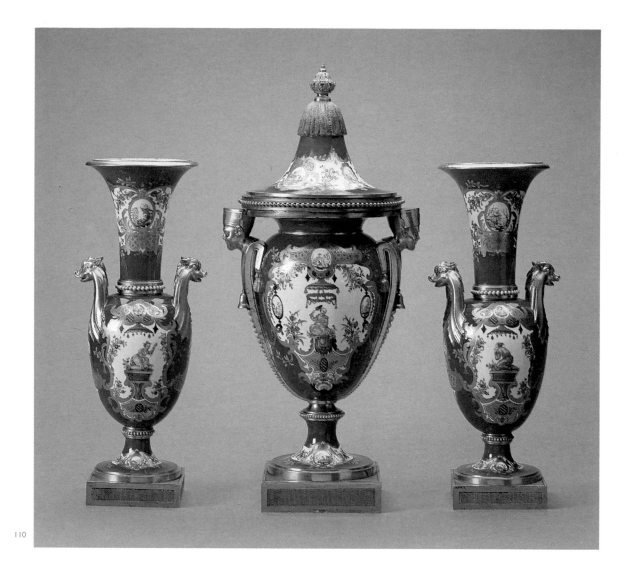

110

Sèvres

110. *Garniture of three vases, collectively known as vases chinois*, 1780

Hard-paste porcelain, brick red ground, reserves painted in polychrome enamels with festoons of flowers and with Chinese figures and buildings, gilded and silvered, and with gilt bronze mounts. Centre vase, 50 × 30 × 16 cm (19^{11}/$_{16}$ × 11^{13}/$_{16}$ × 6^{5}/$_{16}$ in.); flanking vases, 38.3 × 22.5 × 18.9 cm (15^{1}/$_{16}$ × 8^{7}/$_{8}$ × 7^{7}/$_{16}$ in.)

Marks: Interlaced *LLs* and *CC* for 1780, below a crown, painted in red; artist's mark, a branch, attributed to Nicolas Schrade

RCIN 36075.a-b; 36076.1 and .2.a-b

PROVENANCE Sold to an unidentified purchaser in January 1781, and acquired by the Prince Regent from the Parisian dealer P.J. Lafontaine in 1818

REFERENCE London 1979, nos. 39 and 40; London 1991³, nos. 155 and 156

Unlike the other pieces of Sèvres exhibited here, this garniture is made of hard-paste porcelain, produced alongside the older and more costly soft-paste body from 1769. The pure white colour of the porcelain contrasts sharply with the vivid red ground. It is among the earliest examples of this Neoclassical design, which was modelled late in 1779 or in 1780. The ground colours and painted *chinoiseries* recall Meissen porcelain of the 1730s. However, the sources are French. The twelve miniature scenes in the roundels are copied from engravings after Jean Pillement, and three of the figures in the main reserves are probably taken from Gabriel Huquier, *Second livre de cartouches chinois*

For the Prince's taste for *chinoiserie*, see cats. 94–95. He owned numerous oriental vases, many with European gilt bronze mounts, as well as an unrivalled collection of Sèvres garnitures. Placed on cabinets and pier tables, these porcelains were an important element in room decoration, linking the furniture to the pictures or tapestry above. Sent initially to the Brighton Pavilion, this garniture was at Carlton House by 1826. OF

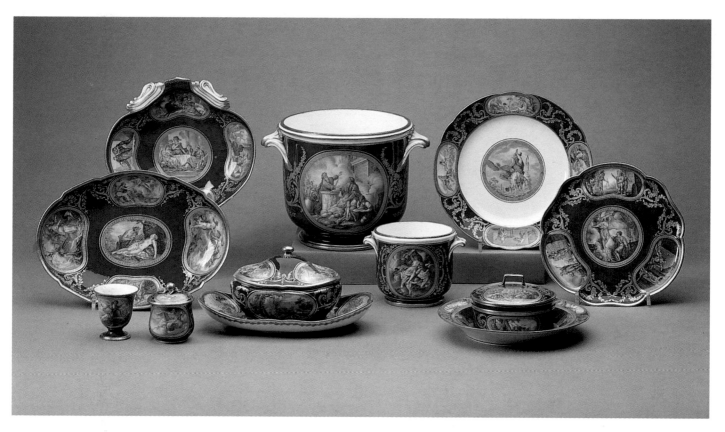

111

Sèvres

111. *Pieces from a dinner and dessert service, 1783–93*

Soft-paste porcelain, *beau bleu* ground, painted in enamels with classical scenes, and gilded

Four plates, diam. 24.2 cm (9⁹⁄₁₆ in.); central reserves only (i) 1785, *Death of Eurydice*; (ii) 1786, *Rape of Proserpine*; (iii) 1788, *Metamorphoses of Myrrha*; (iv) 1788, *Harmonia*. Two large bottle coolers, 18.7 × 25.6 × 20.4 cm (7³⁄₈ × 10¹⁄₁₆ × 8¹⁄₁₆ in.); (i) 1788, *Telemachus and Temosirius* and *Telemachus and Mentor*; (ii) 1789, *Triumphs of Bacchus* and *Cippus addressing the Romans*. Two wine-glass coolers, height 10.7 × 14.8 × 12 cm (4³⁄₁₆ × 5¹³⁄₁₆ × 4¹¹⁄₁₆ in.); (i) 1785, *Sisters of Phaeton transformed into poplars* and *Nyctimene becoming an owl*; (ii) 1786, *Rape of Ganymede* and *Rape of Orithyia*. Shell dish, 5.5 × 22 × 22.3 cm (2¹⁄₈ × 8⁵⁄₈ × 8³⁄₄ in.), 1790, *Idomeneus tries to detain Telemachus*. One oval dish, 4.2 × 26.8 × 19.4 cm (1⁵⁄₈ × 10⁹⁄₁₆ × 7⁵⁄₈ in.), 1786, *Endymion*. Three ice-creams cups, 6.4 × 7.2 × 5.8 cm (2⁷⁄₁₆ × 2¹³⁄₁₆ × 2¹⁄₄ in.), 1789. Their tray, 2.5 × diam. 21 cm (1¹⁄₁₆ × 8¹⁄₄ in.), 1786, *Pygmalion*. One sugar basin and cover, 11 × 23.3 × 15 cm (4⁵⁄₁₆ × 9¹⁄₈ × 5⁷⁄₈ in.), 1785, *Autumn* and *Summer*. Two butter dishes and covers, 8.4 × diam. 20 cm (3⁵⁄₁₆ × 7⁷⁄₈ in.); (i) 1785, *Spring* and *Orpheus*; (ii) 1787, *Venus*; six *pots à jus* (pots for meat juices), 7.5 × 7.7 × 6 cm (2¹⁵⁄₁₆ × 3 × 2⁵⁄₁₆ in.), 1789

Marks: Interlaced *LL*s and date letter in blue; painters' and gilders' marks, incised letters

RCIN 58027.1, .8, .25 and .40; 58038.1 and .3; 58035.6 and .7; 58030.2; 58031.2; 58045.1, .10 and .11; 58029.3; 58032.1.a-b; 58033.1 and .2.a-b; 58043.1, .3-.7.a-b

PROVENANCE Commissioned by Louis XVI, 1783; sold by the Revolutionary Government 1794; bought by the Prince of Wales from Robert Fogg, 1810 and 1811; Carlton House

REFERENCE Royal Archives 26402, 26397; London 1979, no. 2, de Bellaigue 1986, nos. 28, 46, 99, 100; 108 and 127, 42 and 60; 146; 51; 130–31, 133; 66; 40; 36 and 79; 88–93; London 1991³, no. 105; Versailles 1993, nos. 110–37

This service was commissioned by Louis XVI in 1783 for his own use. The timetable for its production, drawn up by the King himself, extended until at least 1803. Piece for piece, it was also to be the most expensive service yet made at Sèvres (the plates cost 480 *livres* each, compared to 36 *livres* for those of the Manchester service; see cat. 109). By the time of the King's execution in 1793, 198 pieces had been completed, almost half the intended total. 124 of these, already delivered to Versailles, were auctioned by the Revolutionary Government, and were sold to the Prince of Wales in 1811 by Treuttel & Würtz of Paris for £1,973. 4*s*. 8*d*. The sale was arranged through the London dealer Robert Fogg, who had previously sold the Prince another twelve pieces from the service which had remained at Sèvres until 1809.

The Louis XVI service is decorated with episodes from classical mythology and history, within dark blue grounds, and elaborate gilding of arabesques and foliage. The scenes in the reserves were mostly copied from engravings, including recent editions of Ovid's *Metamorphoses* and Fenelon's *Télémaque*. They were extremely time-consuming and difficult to paint, requiring at least three muffle-kiln firings, which is why production was only about twenty pieces a year.

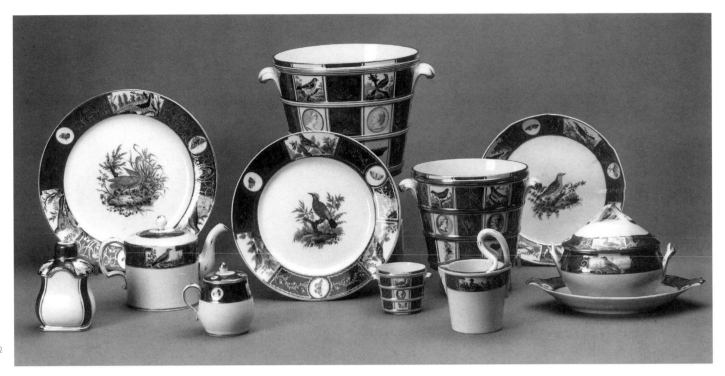

112

Eight figure-painters were employed on them at various times. The service was intended by Louis XVI as a showpiece, and was probably never used.

OF

Tournai

112. *Pieces from a dinner, dessert, breakfast, tea and coffee service, ca.* 1787

Soft-paste porcelain, painted in enamels and gilded.

Two large plates, 3.6 × diam. 27.3 cm (1^{7}/$_{16}$ × 10^{3}/$_{4}$ in.); twelve small plates, 2.9 × diam. 23 cm (1^{1}/$_{8}$ × 9^{1}/$_{16}$ in.); large bottle cooler, 18 × 26 × 21 cm (7^{1}/$_{16}$ × 10^{1}/$_{4}$ × 8^{1}/$_{4}$ in.); two smaller bottle coolers, 14 × 20 × 16.7 cm (5^{1}/$_{2}$ × 7^{7}/$_{8}$ × 6^{9}/$_{16}$ in.); five glass coolers, 6 × 8.2 × 6.7 cm (2^{3}/$_{8}$ × 3^{1}/$_{4}$ × 2^{5}/$_{8}$ in.); two sugar basins, covers and stands, 17 × 17.7 × 12 cm (6^{11}/$_{16}$ × 6^{15}/$_{16}$ × 4^{11}/$_{16}$ in.); two mustard pots, 9 × 9 × 6.8 cm (3^{9}/$_{16}$ × 3^{9}/$_{16}$ × 2^{11}/$_{16}$ in); cylindrical teapot, 12 × 18 × 10.4 cm (4^{3}/$_{4}$ × 7^{1}/$_{16}$ × 4^{1}/$_{8}$ in.); pear-shaped teapot, 14.7 × 19.3 × 12.4 cm (5^{3}/$_{4}$ × 7^{5}/$_{8}$ × 47/8 in.); two jugs, 18.6 × 16 × 11.1 cm (7^{5}/$_{16}$ × 65/16 × 4^{3}/$_{8}$ in.); one cream jug, 14 × 11.5 × 9.2 cm (5^{1}/$_{2}$ × 4^{9}/$_{16}$ × 3^{5}/$_{8}$ in.); two tea caddies, 11.5 × 7.6 × 5.1 cm (4^{9}/$_{16}$ × 3 × 2 in.); three coffee cans, 6.6 × 9 × 6.9 cm (2^{9}/$_{16}$ × 3^{1}/$_{4}$ × 2^{11}/$_{16}$ in.); three saucers, 3.2 × diam. 14 cm (1^{1}/$_{4}$ × 5^{1}/$_{2}$ in.)

Marks: Inscribed with the names of birds in black; incised marks
RCIN 36946.11-.12; 36949.12, .14, .33-.35, .71, .80, .95, .109, .120, .147, .148; 58438.9; 58160.4-.5; 33370.9, .22-.24, .27; 36944.3-.4.a-c; 58163.1-.2.a-b; 33369.3; 58164.a-b; 33669.1-.2; 33374.2; 33666.3-.4.a-b; 58159.5, .6, .8; 33671.3, .7, .10
PROVENANCE Commissioned by the duc d'Orléans in 1787; bought by the Prince of Wales from Robert Fogg, 1803 and 1806; Carlton House
REFERENCE Royal Archives 26350, 26375; Soil de Moriamé 1910, pp. 203–06; Jottrand 1972; London 1979, no. 4; Dawson 1980; Hall 1986

Philippe, duc d'Orléans (1747–1793), an opponent and distant cousin of Louis XVI, commissioned this service not from the French royal factory at Sèvres, but from one of its rivals, the porcelain factory at Tournai in Belgium. The reserves are enamelled with birds copied from the comte de Buffon's *Histoire Naturelle*. This vast encyclopaedia did much to popularize the study of natural history, and the nine volumes on birds (1770–83) were used regularly as a source at Sèvres from 1779. The birds depicted on the pieces exhibited are too numerous to list here. All are named in distinctly unscientific French; for example, "*oiseau mouche huppé à gorge topase/ cayenne*" and "*Hirondelle-de-mer, apellée l'épouventale*". The source for the border design of birds in shaped rectangular reserves alternating with roundels is the Sèvres 'Le Fevre' service of 1784 .

Orléans was a frequent visitor to London in 1783–85, and a crony of the Prince of Wales. He also commissioned a Sèvres service of Buffon birds for the wife of his London agent. His vast Tournai table service, which comprised 1603 pieces costing 60,148 *livres*, was dispersed during the Revolution, and is now scattered among many collections. Over 600 pieces were bought by the Prince of Wales (as Sèvres) from Robert Fogg in 1803 and 1806 for a total of £1,447. 15s. 6d.

OF

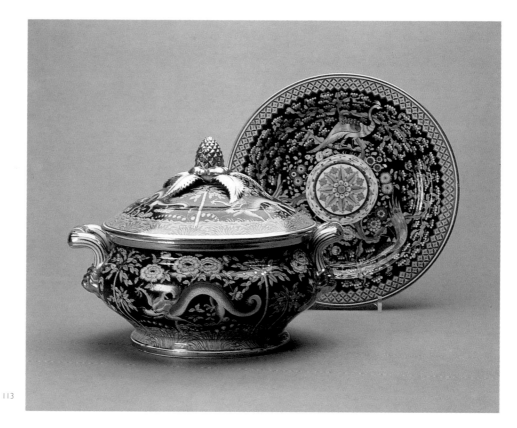

113

H. & R. Chamberlain, Worcester

113. *Pieces from a dinner and dessert service, 1807–16*

Hybrid paste porcelain, painted in enamels and gilded. Large tureen and
cover, 24 × 32.2 × 26.5 cm (9⁷⁄₁₆ × 12¹¹⁄₁₆ × 10⁷⁄₁₆ in.); stand, height 4.8 × diam.
30.7 cm (2 × 12¹⁄₁₆ in.); small tureen, cover and stand, 14.5 × 19.8 × 11 cm
(5¹¹⁄₁₆ × 7³⁄₄ × 4⁵⁄₁₆ in.); six plates, 4.5 × diam. 23.2 cm (1³⁄₄ × 9¹⁄₈ in.); two large
plates, 3.7 × diam. 28.3 cm (1⁷⁄₁₆ × 11¹⁄₈ in.)

Marks: *Chamberlains/ Worcester/ & New Bond Street/ London/ Royal Porcelain
Manufacturers* printed in red under a crown (large tureen and stand, one large
plate); *Chamberlains/ Worcester* painted in red script (all other pieces)
RCIN 58403a-c; 58405.1a-c; 58401.5, .8, .21, .30-.31, .36; 58402.1 and .4

PROVENANCE Delivered to Carlton House from 1811

REFERENCE Royal Archives 26398, 26431; Binns 1865, pp. 162–66; Godden
1982, p. 101; Fox 1992, pp. 515–17; Sandon 1993, pp. 269–70

This wildly eclectic service was ordered by the Prince while on a visit
to Worcester in September 1807, during which he toured the Cham-
berlain factory and granted it the title of 'Porcelain Manufacturers to
His Royal Highness the Prince of Wales'. He had previously bought
porcelain from the London showrooms of the rival Worcester firm of
Flight & Barr, which held his father's warrant, and this was the first
major commission secured by Humphrey and Robert Chamberlain's
factory, which had broken away from Flight's in 1788.

The dessert service, delivered in July 1811, cost a startling £806. 8s.
It was unusually large, comprising 96 plates costing £3. 3s. each, and
a further 48 with basket rims, together with 32 dishes, 6 ice-cream pails
and 4 cream bowls. Each piece was decorated with a different design,
described in Chamberlain's bill as "copied from fine old India and
other China" and selected by the Prince from a specially prepared
pattern-book. The dinner service, of "fine old patterns", was completed
in July 1816. It included "12 Dozen Dinner plates all different £453
12s" and "6 Rich Soup Tureens and Stands £144", as well as 12 sauce
tureens at 10 guineas each. A 72-place breakfast service was not
supplied until October 1816, and the final cost was over £4000.

The Chamberlain 'Harlequin' service is typical of the English table
porcelains the Prince bought at this period for use rather than display.
Many pieces are richly decorated with oriental or 'Japan' designs, and
these can be compared with the "Dinner & Dessert Service & Tea and
Coffee Service ... painted Chinese Temple & rich burnished Gold Mosaic
border" supplied by the Staffordshire firm of Davenport in 1807. Others
demonstrate the wide range of ground colours and subject-matter in
the Chamberlain factory's repertoire. OF

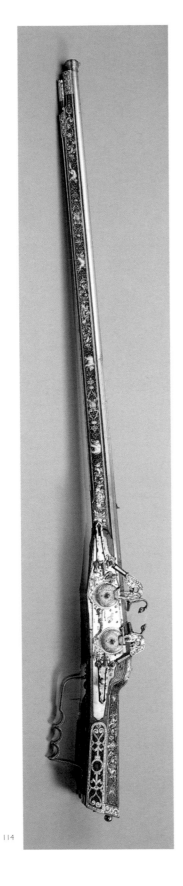

114

German

114. *Superimposed charge wheel-lock rifle*, 1606

Partly octagonal barrel, walnut stock with a butt-trap, inlaid with stag's horn and mother-of-pearl engraved with strapwork, caryatid figures, foxes, wild boar, bears, elephants, winged horses and masks. Double steel lock engraved with monstrous heads, cherubs and scrolls. Overall length 113 cm (44⅜ in.); barrel 106 cm (41¾ in.)

Marks: Dated on the barrel, *1606*; stamped twice with the maker's mark (Støckel 5511), and engraved on one of the bone inlays with the mark *HF*, for the stockmaker Hans Fleischer

RCIN 61101

PROVENANCE Bought from Colonel Benningson in 1807; Carlton House; transferred to Windsor Castle

REFERENCE *Carlton House Arms Cat.*, no. 1871; Laking 1904, no. 347; Blackmore 1968, pp. 44–45, no. L347

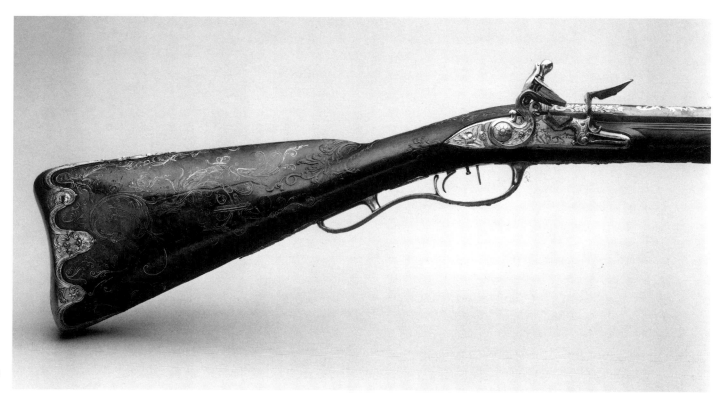

115

Jacob Walster (active *ca.* 1750–80)

115. *Flintlock sporting rifle (Pirschbüchse), ca.* 1765

Removable, blued and partly gilt iron barrel, one third octagonal and formed
in a twisted heart-section for the remaining length; half-length walnut stock,
carved with a sea-monster's head at the comb and a griffin's head behind the
cheekpiece; the butt inlaid with floral swags and dragon's heads in silver wire;
the steel lock chased with a Roman trophy on a gold ground, and with a
cherub offering a bird to a dog. Overall length 117.5 cm (46¼ in.); barrel 69 cm
(27 in.)

Marks: Signed in inlaid gold letters either side of the backsight *Walster/ A
Saarbruck*, which is also engraved on the lockplate

RCIN 61100

PROVENANCE Carlton House; transferred to Windsor Castle

REFERENCE *Carlton House Arms Cat.*, no. 749; Laking 1904, no. 401; London
1991[3], no. 118

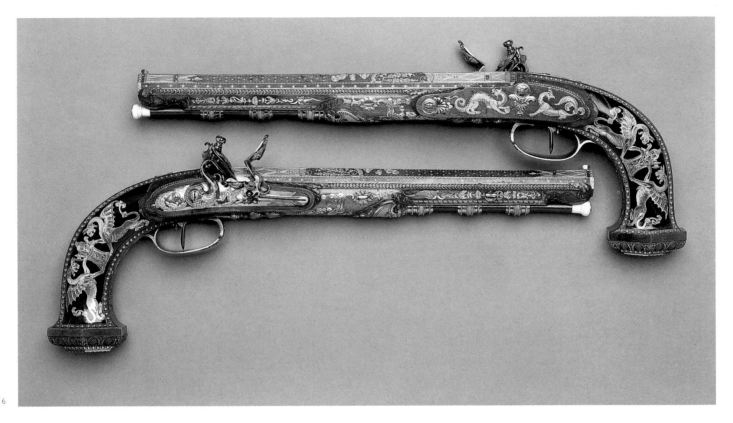

116

Nicolas-Noël Boutet (1761–1833)
116. *Pair of flintlock pistols, ca.* 1802

Walnut stocks, almost entirely covered with carved or inlaid decoration. The
butts veneered with ebony, inlaid with engraved silver griffins supporting a
helmeted bucranium trophy, and edged with boxwood balls; burnished steel
and engraved locks and trigger guards partly inlaid with gold; octagonal,
blued and rifled barrels, powdered with gold stars at the centre, inlaid with
gold at the muzzle and breech. Overall length 39.5 cm (15⁹⁄₁₆ in.); barrels
26.9 cm (10⁹⁄₁₆ in.)
Marks: Struck on the breech with a gold-lined *poinçon* with the maker's name,
Boutet and *contrôleur*'s marks
RCIN 61152.1-.2
PROVENANCE Presented to the Prince of Wales by the Marquis Wellesley in
May 1810
REFERENCE *Carlton House Arms Cat.*, no. 2045; Laking 1904, no. 497; London
1991³, no. 122

117. *The Sword of the Prince of the Peace, ca.* 1802

Gold cross hilt; pommel in the form of two addorsed lion-heads and quillons
formed as eagles with outstretched wings holding thunderbolts in their claws,
lapis lazuli grip; straight, watered steel blade engraved with the arms of
Godoy on one side
Marks: on the blade: *Manufac Impériale./ Versailles,/ Entreprise/ Boutet*; three
other marks

Overall length 84.7 cm (33⅜ in.); blade 68.1 cm (26¹³⁄₁₆ in.). Wooden scabbard
covered with mother of pearl and mounted in gold.
RCIN 61169.a-b
PROVENANCE Presented to Don Manuel de Godoy (1767–1851), the Prince of
the Peace, by Napoleon I; sold by the Supreme Junta of Seville in 1809;
purchased by the Marquis Wellesley, by whom presented to the Prince Regent
in 1811
REFERENCE *Carlton House Arms Cat.*, no. 2115; Laking 1904, no. 653; London
1991³, no. 136; Norman (forthcoming), E55

118. *Baldrick for a sword, ca.* 1802

Leather shoulder-belt covered with crimson velvet, the outer face covered by
33 rectangular pierced and enamelled gold plaques. The larger plaques, which
are edged with pierced laurel branches, contain elaborate trophies of war, the
sciences, arts and agriculture. The smaller plaques, which are arranged
transversely in trios, include symbols of Hercules, laurel and oak branches,
Roman swords, laurel wreaths, stars, and badges of the Order of the Eagle.
The lunette-shaped gold mounts at the ends are enamelled deep blue and set
with gold eagles on a trophy of flags
Overall length 148.6 cm (58½ in.); width 6.7 cm (2⅝ in.)
PROVENANCE Presented by Napoleon I to Manuel de Godoy, the Prince of
the Peace, with the sword (cat. 117); presented to the Prince Regent in 1813 by
Lord Fife
REFERENCE *Carlton House Arms Cat.*, no. 2359; Laking 1904, no. 654; London
1991³, no. 137; Norman (forthcoming), E655

117

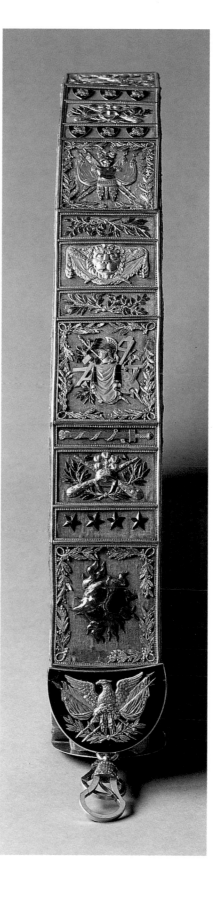

118

119

119

English

119. *Sabretache, ca. 1800*

For the 10th Light Dragoons; brown and red leather, covered with leopardskin, with chequered gold lace border and the cypher *GP* reversed in silver wire and spangles, below the Prince of Wales's feathers. 38 x 31 cm (14^{15}⁄$_{16}$ x 12^{3}⁄$_{16}$ in.)

PROVENANCE Made for George, Prince of Wales
REFERENCE *Carlton House Arms Cat.*, no. 111; Laking 1904, no. 823; London 1991³, no. 111; Arch (forthcoming), no. S4

English (Cuff & Son)

120. *Sabretache, ca. 1800*

For the 10th Light Dragoons; black leather covered with black velvet, with a border of gold lace and spangles, and in the centre the cypher *CP* superimposed on a trophy of arms below the Prince of Wales's feathers; motto *PRO GLORIA ET PATRIA* applied below the trophy; 35 x 31.8 cm (13^{3}⁄$_{4}$ x 12^{1}⁄$_{2}$ in.)

PROVENANCE Made for George, Prince of Wales
REFERENCE *Carlton House Arms Cat.*, no. 108; Laking 1904, no. 817; Arch (forthcoming), no. S1

The Prince of Wales maintained an interest in arms, uniforms and militaria throughout his life. Disqualified as heir to the throne from actual military service, his enthusiasms were channelled into the design of uniforms (see cat. 56) and the collecting and arrangement of historic arms and armour.

When first established in the 1790s, the Armoury occupied a single room at Carlton House, but it was repeatedly extended and rehoused. The collection ran to 3300 items by 1826, including sporting guns and ethnographic curiosities. On the disestablishment of Carlton House, the new armouries designed by Nash at Buckingham Palace were deemed inadequate by Jutsham to hold even a third of the collection, and it was sent to Windsor Castle.

This selection illustrates some of the more important groups in the collection. The magnificent German rifle (cat. 114) is one of a number purchased from Col. Benningson in 1807. The Prince shared a taste for richly decorated antique arms with his friends Sir Samuel Rush Meyrick of Goodrich Court, Herefordshire (who advised on the displays at Windsor Castle), and Sir Walter Scott, whose collection complemented the antiquarian interiors at Abbotsford. Curiosities were also highly prized: the German rifle (cat. 115) has a heart-shaped barrel – an undoubted technical masterpiece but, as Laking observed, "as a weapon of precision it leaves much to be desired".

The establishment of a manufactory of swords and firearms at Versailles in 1793 was due to the entrepreneur Nicolas-Noël Boutet (1761–1833). The Prince Regent's preoccupation with the personal treasures of his defeated opponents, such as the relics of Tipu, Sultan of Mysore (see also cat. 92), and the tremendous Sèvres porcelain Table of the Great Commanders (now at Buckingham Palace) is represented here by the luxurious sword and belt presented by Napoleon to his Spanish ally Don Manuel de Godoy, possibly in 1802.
JM

120

Albert Edward

(1841–1910)

CREATED PRINCE OF WALES,

8 DECEMBER 1841, AGED 4 WEEKS;

ACCEDED AS KING EDWARD VII,

22 JANUARY 1901

The eldest son of Queen Victoria and Prince Albert, Albert Edward was born at Buckingham Palace on 9 November 1841 and was created Prince of Wales on 4 December. With the help of their counsellor Baron von Stockmar, the royal couple submitted their son to an idealistic, isolated and rigorous private education. The Queen found her nine-year-old son "... has such affectionate feeling – great truthfulness and great simplicity of character". The Prince, exhausted by relentless instruction, often rebelled. In 1859 he became an undergraduate at Oxford, transferring to Cambridge in 1861. He married Princess Alexandra of Denmark on 10 March 1863, and they moved into their London residence, Marlborough House (which had been assigned to the Prince in 1860), and into Sandringham House, set in a Norfolk estate of 7000 acres, which had been purchased for him the previous year (figs. 25 and 26). Both residences were refurnished by Holland & Sons (see cat. 146) and Sandringham was entirely remodelled and enlarged from 1867 to 1870.

The Prince lacked the literary or intellectual interests of his parents, but had a quick, trained eye and an instinct for what pleased him. He later averred that he did not know much about art, but claimed a flair for arrangement. As the leader of what became known as the Marlborough House set, he prided himself on being well informed. His engagement diaries of the 1870s and 1880s show concentrated bursts of visiting artists' studios and private views – a habit that had been drummed into him during his educational visit to Rome in 1859 (figs. 23 and 24). His *cicerone* during the visit, the veteran sculptor John

Fig. 23 Greco-Roman objects collected by Albert Edward, Prince of Wales, in 1859 (Swiss Cottage Museum, Osborne, Isle of Wight)

Fig. 24 *The Prince of Wales at Miss Hosmer's studio*, from *Harper's Weekly*, no. 3, 7 May 1859

Fig. 25 The Saloon, Sandringham, 1889
(Royal Photograph Collection, Windsor Castle)

Fig. 26 The Entrance Hall, Marlborough House, photographed by
Walery, *ca.* 1890s (Royal Photograph Collection, Windsor Castle).
The Gobelins tapestry of *Mahommed Ali's massacre of the Mamelukes at
Cairo* was presented by the French Emperor

Gibson, led him to nearly fifty artists' studios in twelve half-
days. Acquisitions resulted from the young Frederic Leighton
(cat. 124), whom he liked immediately and who became a
trusted friend, and Harriet Hosmer (cat. 140), whom he was also
later to meet, at a ball in Boston.

It is perhaps the international flavour of his adult life that
most distinguishes Prince Albert Edward from all his pre-
decessors. Although the Prince Consort's men had kept him on
a short rein during the Roman visit, his tours of North
America (1860), the Levant (1862), Egypt (1862), India (1875)
and numerous European forays allowed ample scope for his
favourite pursuits in high society (fig. 27), the theatre, the
parade ground or the hunting field, and each resulted in
significant artistic acquisitions. The photographer Francis
Bedford accompanied the Middle East tour of 1862 (see cats.
175–84) and on his return the Prince commissioned Carl Haag's
richly evocative and highly wrought watercolours (cats.
127–29). Haag was also the designer of the Turkish Smoking
Room at Marlborough House, where divans, ottomans, gilt
metal basins and perfume-burners were disposed round a
marble fountain beneath a 'stalactite' ceiling, and the oriental
flavour of the house was intensified by the addition of the
Indian Room in 1878 (see cats. 155–64, fig. 28).

The Prince was an enthusiast for the succession of inter-
national exhibitions that followed his father's Great Exhibition
of 1851, attending those at Paris (1869 and 1878) and Vienna
(1873) as well as the 1862 International Exhibition and the 1886
Colonial and Indian Exhibition in London (of which he was
president).

Topography consequently accounts for a large proportion
of the Prince's collection, particularly in watercolour by Lear,
Pritchett and Simpson, or Continental artists including
Chevalier (cats. 136–37), Haag (cats. 127–29) and Preziosi (cat.
132). The visits also furnished the libraries at Marlborough
House and Sandringham with some of the outstanding illus-
trated books of the time, such as David Roberts's *The Holy Land*,
Lear's *Ionian Islands* and *Corsica*, and practically the complete
work of John Gould.

Prince Albert Edward's collection was almost entirely con-
temporary. He had no appetite for Old Masters, and his circle
does not seem to have been aware of, let alone to have appre-
ciated, the artistic avantgarde. Three hundred paintings were
listed at Sandringham and Marlborough House in the cata-
logue of 1877 drawn up by Alan Summerly Cole (son of Sir
Henry Cole).

Despite his talent for friendship, portraiture was mainly lim-
ited to members of the Prince's family. Large portraits of his
children were commissioned from the German Carl Bauerle,
and there were several works by the Danish court painter
Laurits Tuxen (see cat. 122). The work of French artists includes
the bewitching portrait of Princess Alexandra of 1900 by
Benjamin Constant, and the extraordinary portrait of the Prince
himself by Bastien-Lepage (cat. 121). There were notable gifts:
a fine early portrait by Watts of Lady Holland was bequeathed
by the sitter, and Landseer gave his self-portrait with dogs, *The
connoisseurs*. Far more of his friends were remembered through
the new art of photography, of which the Prince was himself
a serious amateur practitioner.

Fig. 28 The Indian Room, Marlborough House, photograph, *ca.* 1898

Fig. 27 The Prince of Wales in the costume of a Grand Prior of the Order of Malta, on the occasion of the Devonshire House Ball, photograph by Lafayette, 1897 (Royal Photograph Collection, Windsor Castle)

Animals played an important part in the lives of both the Prince and the Princess, and from Landseer there also came the 1866 pastel *Children of the mist, Dunrobin* (a picture of deer), and a large canvas, *The Arab tent*, which the Prince bought and hung in the Dining-room at Sandringham. The finest of his sporting paintings, portraits of his winning race horses Persimmon and Diamond Jubilee by the Munich artist Emil Adam, were presented to the Jockey Club, while his successful racing yacht, R.Y.S. *Britannia*, was depicted in action in a contrasting pair of paintings by Wyllie, and in watercolour and oils by Eduardo de Martino, the Neapolitan successor to Sir Oswald Brierly as Queen Victoria's Marine Painter in Ordinary.

Female beauty, such an enthusiasm in life, was perhaps what caught the Prince's eye more than anything in a work of art. The female form was well represented not only in paintings, such as those included here by Gustave Doré (cat. 126) and Prinsep's *The Roum-i-Sultana* (cat. 125), but also in sculpture. On his second visit to Rome in 1872, the Prince had bought a marble *Nymph* from the Scot Lawrence Macdonald, and a *Venus and Cupid* by Macdonald's son Alexander, which was to stand in the Hall at Marlborough House. A small marble nymph by Boehm, for which Katherine Walters, the courtesan known as 'Skittles', had modelled, was enshrined in a niche in the Library.

Prince Albert Edward's early sculptural acquisitions were in the Neoclassical tradition of John Gibson favoured by his father. There were numerous small commissions to the sculptors who counted amongst the Prince's friends, such as his half-cousin Count Gleichen, Lord Ronald Gower (younger son of the Duke of Sutherland) and the Austrian-born Emil Fuchs. In later years the Prince was a regular buyer of small bronzes from the leading exponents of the 'New Sculpture', including Frederick Pomeroy, Jules Dalou (cat. 144), Bertram Mackennal (cat. 145), Thomas Brock and Alfred Gilbert. For all that Princess Alexandra, and her sculptor sister-in-law Princess Louise, may have done to secure the commission, it was the Prince of Wales who in 1892 ordered from Gilbert what is for many the greatest ensemble of late nineteenth-century British sculpture, the tomb of the heir presumptive, the Duke of Clarence and Avondale, in the Albert Memorial Chapel at Windsor.

Jules Bastien-Lepage (1848–1884)

121. *Albert Edward, Prince of Wales*, 1879

Oil on panel, 43.4 × 35.2 cm (17⅛ × 13⅞ in.)
Inscribed by the artist and dated *SON ALTESSE ROYALE MONSEIGNEUR LE PRINCE DE GALLES/ par J. BASTIEN-LEPAGE. LONDRES 1879*
RCIN 402333
PROVENANCE Probably Alexandra, Princess of Wales; claimed by Emile Lepage, 1885; Mathieu Goudchaux, from whom acquired by the French Government; presented by Prime Minister Edouard Daladier to HM King George VI on the occasion of his state visit to France, 1938
REFERENCE *The Times*, 5 June 1880, p. 5; Bashkirtseff 1890, p. 159; Jopling 1925, p. 212; Blanche 1937, p. 68; Millar 1977, p. 205, pl. 232; McConkey 1978, p. 372, ill. 44; McConkey 1984, pp. 103–07; Aubrun 1985, no. 227, pp. 162–63; McConkey 1987, pp. 20–21, 65–66

The Prince of Wales was a great admirer of the actress Sarah Bernhardt, who visited London in 1879 (see cat. 143). She had promised a sitting to the young Bastien-Lepage and probably encouraged the Prince to do likewise.

The commission proved problematic. The Prince sat to the artist seven times at Marlborough House in July 1879. Bastien-Lepage wrote to a friend: "He poses badly, but I believe that the portrait is going well, he appears happy and is interested in my work". A further six sittings took place in Paris in March 1880. There followed a dispute as to whether Bastien-Lepage had presented the portrait to the Princess of Wales. The Princess seems to have owned it until 1885 when, following its exhibition in Paris, it was claimed by the dead artist's brother.

Both the Prince's and Bernhardt's portraits were exhibited in London in 1880. The *Times* critic described that of the Prince as "a fantaisie" and an artist recalled that "it has the air of a Holbein". In size, inscription and in the precision of handling of the figure, the portrait is greatly indebted to 16th-century models, and may have been intended to draw parallels with Holbein's well known portraits of Henry VIII.
CN

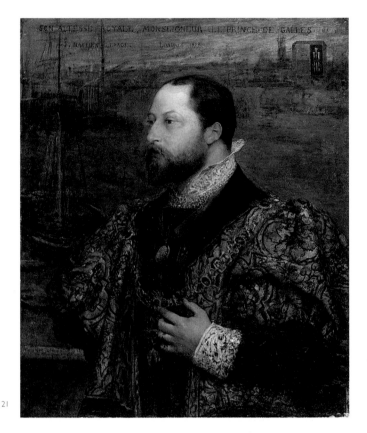

121

Laurits Regner Tuxen (1853–1927)

122. *The family of the King and Queen of Denmark*, 1885

Oil on canvas, 74.6 × 105.4 cm (29⅜ × 41½ in.)
Signed and dated *L. Tuxen 1885*
RCIN 402341
PROVENANCE Painted for Alexandra, Princess of Wales, 1885
REFERENCE Millar 1977, p. 206; Frederiksborg 1990, pp. 20–21, 37–39, 54, 64–68, no. 49; Millar 1992, pp. 68–73, 261–63, 267–69, no. 785, pl. 685; Edinburgh 1997, pp. 108–09, no. 43

122

This is a reduced-scale version of a monumental portrait group by the Danish painter Tuxen, commissioned by Louise, Queen of Denmark in 1883, which is now at Christiansborg Castle in Copenhagen.

Princess Alexandra of Denmark (1844–1925) married the Prince of Wales in 1863. Her family, also linked by marriage with the royal families of Greece and Russia, assembled at annual reunions at Fredensborg Castle, north of Copenhagen. This work commemorates "an extra-large gathering" to celebrate Queen Louise's sixty-fifth birthday in 1882. The principal sitters are, from the left, the Prince (seated,

123

wearing the red jacket of the Danish Hussars) and Princess of Wales, the Duke and Duchess of Cumberland (at the back), the King and Queen of Denmark (both seated), the Tsar and Tsarina, the Danish Crown Prince and Princess (seated), and the King and Queen of Greece.

Tuxen worked from photographs and large oil life-studies which he made in London, St Petersburg and Gmunden. At Windsor, in March 1885, he showed a sketch of the composition to Queen Victoria, who considered it "charming, & very cleverly grouped". The artist subsequently undertook a series of monumental commissions for the British Royal Family, beginning with the family of Queen Victoria in 1887, and continuing until the reign of King George V.

MLE

George Loring Brown (1814–1889)

123. *The bay and city of New York (New York at sunrise)*, 1860

Oil on canvas, 169.1 × 305.3
Signed and dated *Geo. L. Brown./ N. York/ 1860*
RCIN 402263

PROVENANCE Purchased from the artist by Henry Ward Beecher (1813–1887) and a group of New York businessmen, by whom presented to Albert Edward, Prince of Wales, October 1860

REFERENCE *The Crayon*, October 1860, p. 289; *The Times*, 30 May 1861, p. 10; Woods 1861, pp. 376–77, 404–05; *Art-Journal* 1861, p. 191; Tuckerman 1870, p. 354; *The Art Review*, 1 May 1871, pp. 3–4; Cole 1877, p. 82, no. 1225; Manchester 1973, pp. 20–23; Millar 1977, p. 205, pl. 234

Brown studied in Boston and Paris, and achieved success painting views of Italy from 1840 until his return to New York in 1859. Discovering there the immense landscapes by Frederic Church (1826–1900), he resolved to remake his reputation exhibiting similarly monumental pictures of New York, the White Mountains and the Niagara Falls.

Brown's panorama of New York depicts the Hudson river and the west side of southern Manhattan, Upper Bay and Staten Island, out to the Atlantic. The view is taken after sunrise from a romanticized Hoboken Heights. During the Prince of Wales's visit to New York in October 1860, the *Times* correspondent described west Manhattan as "a long, low mass of red brick houses, with hosts of shipping on the

124

water". The Prince, who arrived by sea at the southernmost tip of Manhattan, and later departed up the Hudson river, had first-hand knowledge of the landscape depicted in his picture.

The picture was shown at the French Gallery, London, in May 1861, together with its companion *The Crown of New England*, which the Prince purchased in July. Both paintings subsequently hung at Sandringham.

CN

Frederic, Baron Leighton of Stretton (1830–1896)
124. *Nanna (Pavonia)*, 1859

Oil on canvas, 59.4 × 51.1 cm (23⅜ × 20⅛ in.)
Signed and dated *L 59*
RCIN 404570
PROVENANCE Purchased from the artist by George de Monbrison; from whom acquired by the Prince of Wales, 1859
REFERENCE Cole 1877, p. 58, no. 966; Barrington 1906, II, pp. 40–41; Magnus 1964, pp. 127–28; Ormond 1975, pp. 41–42, pl. 57, no. 46; Millar 1977, p. 206; Millar 1992, pp. 160–64, no. 452, pl. 386; London 1996[2], pp. 111–13, no. 15

Leighton studied in Florence and Frankfurt and worked in Rome before settling in London. His reputation was established in 1855 when his first Royal Academy exhibit, *Cimabue's Madonna carried in procession*, was purchased by Queen Victoria for £630. Elected President of the Academy in 1878, Leighton received a baronetcy in 1886, and the unique distinction for an artist of a peerage shortly before his death.

Nanna Risi, the mistress and model of the German painter Anselm Feuerbach (1829–1880), sat frequently to Leighton in Rome in 1858–59. In this and another portrait, her head is framed by a peacock feather fan (*pavonia* in Italian). Prince Albert Edward saw the present work in Leighton's studio in Rome on 24 February 1859: "I admired three beautiful portraits of a Roman woman each representing the same person in a different attitude". Shortly after his visit, Leighton wrote, "George de Monbrison has very kindly consented to give up his Nanna to the Prince, but is evidently sadly disappointed – so much so, that I have written to offer to ... copy it for him". This copy is now at Leighton House. The present work was shown at the London International Exhibition in 1862, and was subsequently provided with a companion by Leighton, titled *Bianca*.

The artist became a friend of the Prince of Wales. In 1874 he superintended the decoration of the most elaborate of the Marlborough House balls, at which the Prince appeared dressed as Charles I, proving himself (according to *The Times*) "well descended from Kings whose Courts have never been wanting in splendour".

MLE

Valentine Cameron Prinsep (1838–1904)
125. *The Roum-i-Sultana*

Oil on canvas, 112.2 × 142.5 cm (44¼ × 56⅛ in.)
RCIN 402441
PROVENANCE Purchased from the artist by the Prince of Wales, 1879
REFERENCE London 1977[2], no. 14; London 1985[2], pp. 199–200, no. 20; Millar 1992, pp. 209–15, no. 566, pl. 484

Val Prinsep was born in Calcutta, where his father was a member of the Council of India, and educated in England. A prominent socialite, he married the daughter of the Liverpool shipowner and art patron F.R. Leyland, and was a friend of Lord Leighton. In 1870 he sold his first painting to the Prince of Wales, who often visited his studio. Prinsep returned to India in 1876 with a commission for the monumental *Imperial Assemblage held at Delhi, 1 January 1877*, which he completed in 1880 (The Royal Collection, St James's Palace).

This subject was suggested by a visit made by the artist in 1877 to the palace of the Moghul Emperor Akbar (1542–1605) in Agra. When

125

exhibited at the Royal Academy in 1879, its label explained: "At Futtehpore-sikri there is a vast palace ... wherein are many pavilions, in which dwelt the wives of the emperor. One, curiously carved all over with delicate patterns, was said to have been inhabited by the European wife of the emperor, and still goes by the name of Roum-i-Sultana's Palace."

The *Roum-i-Sultana* is a comparatively decorous contribution to the genre of harem scenes, often including European women, inaugurated by Ingres. Renoir's *Parisian women in Algerian dress* was rejected by the Paris Salon in 1872.

MLE

Gustave Doré (1832–1883)

126. *La Nymphe et la source*, 1868/74

Oil on panel, 81 × 54.6 cm (31⅞ × 21½ in.)
Signed and dated *G. Doré/ 1868/ 1874*
RCIN 402307
PROVENANCE Unrecorded, but presumably Albert Edward, Prince of Wales
REFERENCE Roosevelt 1885, pp. 387, 427, 486; Valmy-Baysse 1930, ill. p. 285; Millar 1977, p. 206, pl. 236; Millar 1992, pp. 60–61; Clapp and Lehni 1992, pp. 225–26, 242–43; Swansea 1994, n.p.

The Prince of Wales owned a number of Doré's works. The present painting, although signed and dated 1868 and 1874, is not listed in the 1877 catalogue of the Prince's collection.

La Nymphe was apparently begun in 1868, the year of Doré's first visit to London for the opening of the Doré Gallery. The artist became well known for the vast religious paintings he exhibited there and for

126

127

his illustrations for Jerrold's book *London: A Pilgrimage*. Though he was a brilliant draughtsman and illustrator, Doré's artistic training was slight. The present painting may be intended to symbolize Youth awakening to Beauty. It appears to have been reworked with more vivid greens, presumably in 1874. The subject reappears in a painting, drawing and plaster related to Doré's sculpture *La Mort d'Orphée*.

The sociable Doré was a friend of the Prince of Wales, who presented him to Queen Victoria in 1875, and both of them purchased works from the Doré Gallery. The Prince's equerry, Christopher Teesdale, was also a good friend of the artist, and was bequeathed two prime works by him. Teesdale may possibly have left this and other pictures to the Prince on his death in 1893.

CN

Carl Haag (1820–1915)

127. *Agyle Agha*, 1859

Watercolour and bodycolour, main sheet 49.4 × 34.2 cm (19½ × 13½ in.); with addition of paper strips made up to 51 × 35.6 cm (20⅛ × 14 in.)
Signed and dated *Carl Haag 1859*
Inscribed on verso of frame, by the artist: *The celebrated Bedawee Sheik Aghile Agha who was honoured by a visit from H.R.H. the Prince of Wales in his encampment near Monte Tabor in the year 1862, by Carl Haag RWS 1900*
RL S 362
PROVENANCE Presented by the artist to the Prince of Wales as a birthday present on 7 November 1899
REFERENCE Millar 1995, pp. 386, 397, no. 2313

Born in Bavaria, Haag studied drawing in Germany before visiting London in 1847, where he attended the Royal Academy Schools. He was then appointed court painter to Ernest II, Duke of Saxe-Coburg (1818–1893), the elder brother of the Prince Consort. He gave Queen Victoria drawing lessons during the 1850s, and was invited to Balmoral in 1853.

The artist travelled extensively in the Middle East during the 1850s. During a visit to Syria in 1859, he visited the camp of Sheikh Agyle

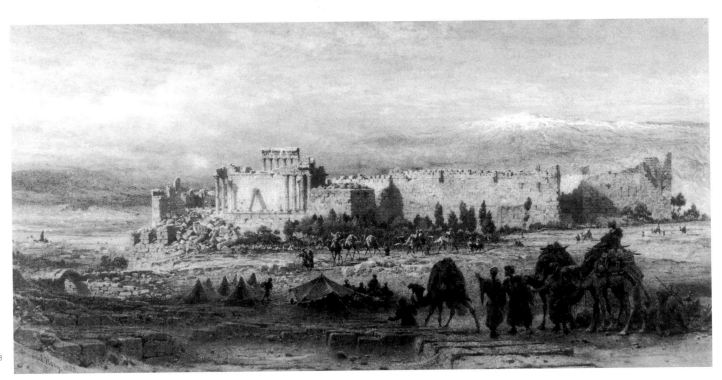

128

Agha (Akil Aga), a mercenary leader in the Egyptian service. The Sheikh wrote his signature in the right-hand corner of the picture, but proved a poor sitter, and the figure and costume were completed from another model. Emily Beaufort, who accompanied Haag, described Agyle Agha's "sleek fat face, with his small sunken eyes, low forehead and thick lips, – smooth but repulsive", an assessment much at variance with that of the Prince of Wales three years later (see cat. 129).

MLE

Carl Haag

128. *Encampment of the Prince of Wales at Baalbek, May 1862*, 1863

Watercolour and bodycolour, 30.5 × 61 cm (12 × 24 in.)

Signed and dated *C. Haag. 1863*

RL S 364

PROVENANCE Purchased from the artist with cat. 129 by the Prince of Wales for 100 guineas on 23 August 1863

REFERENCE Millar 1995, p. 396, no. 2310

The Prince of Wales visited Baalbek in the Lebanon during 3–5 May 1862, on his tour of Egypt and the Holy Land (see also cats. 175–84). Its 2nd-century Roman temples of Jupiter and Bacchus had enjoyed celebrity since the Renaissance, but were severely damaged by an earthquake in 1759. They remained a picturesque wilderness of fallen blocks during the second half of the 19th century, although increasingly visited by tourists.

Haag had visited Baalbek in November 1858, and made studies which he later worked up as pictures. He recalled that "The colouring of these ruins is one of Baalbec's chief beauties, purple and gold and lilac!" The Prince saw Haag's sketches in July 1862, shortly after his own return from the Levant, and commissioned this watercolour. Based upon a sketch made on 12 November 1858, from the Greek convent where the artist had stayed, it was begun on 20 December 1862 and finished the following month.

MLE

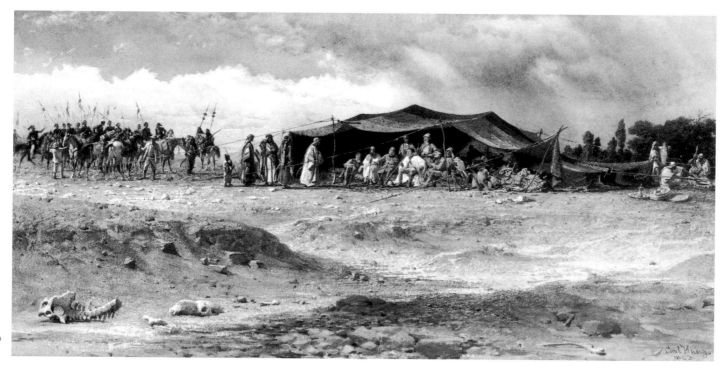

129

129. *Visit of the Prince of Wales to Agyle Agha, 19 April 1862, 1863*

Watercolour and bodycolour, 31 × 61.3 cm (12¼ × 24¼ in.)
Signed and dated *Carl Haag/ 1863*
Inscribed on back of frame: *His Royal Highness the Prince of Wales on a Visit to Aghile Agha, the famous Bedawee Sheikh, in his Encampment near Mont Tabor by Carl Haag, Ida Villa, 7 Lyndhurst Road, Hampstead. 1863*
RL S 363
PROVENANCE As for cat. 128
REFERENCE Millar 1995, pp. 396–97, nos. 2311, 2312

On 19 April 1863, during the Prince of Wales's tour of Egypt and the Holy Land, his party halted between Tabor and Tiberias to visit the encampment of Agyle Agha (see cat. 127). The Prince recalled in his diary, "He is a celebrated man in Syria, & protected the Christians during the recent massacres [1860]. He is a tall, good looking man & he and his brother received us in their tent ... Agyle Agha gave us luncheon, which was placed before us in wooden dishes, & we had to eat it with our fingers à l'Arabe. I gave him a revolver before leaving with which he was very much pleased"

Haag had made studies of Agyle Agha's camp during his own visit between 29 July and 3 August 1859. He began this watercolour on 1 May 1863 and completed it in July. A compositional study for this work was purchased for the Royal Collection in 1982.
MLE

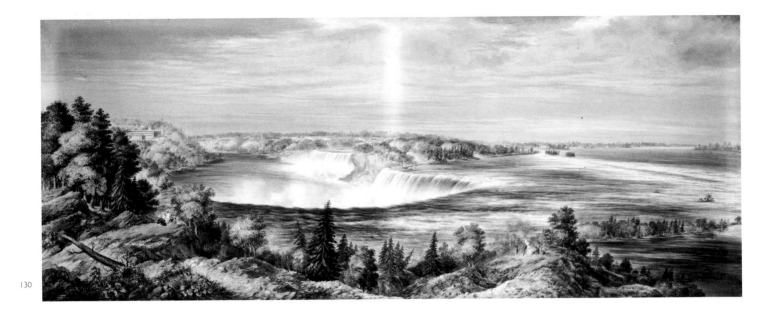

130

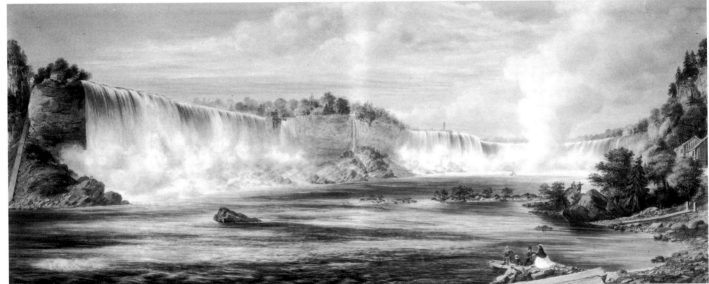

131

132

Washington F. Friend (*ca.* 1820–1891)

130. *Niagara Falls seen from above*

Watercolour and bodycolour, 63.5 × 152.8 cm (25 × 60⅛ in.)
Signed *W.F. Friend*
RL 21529

131. *Niagara Falls seen from below*

Watercolour and bodycolour, 63.2 × 153 cm (24⅞ × 60 in.)
Signed *W.F. Friend*
RL 21530

PROVENANCE Purchased from the artist by Queen Victoria as a gift for the Prince of Wales for 20 guineas in May 1865
REFERENCE Cole 1877, nos. 932–33; Magnus 1964, pp. 36–37; Millar 1995, pp. 339–40, nos. 2005–06

Friend was born in Washington DC. He secured backing to paint a panorama of Canada and the United States in 1849. This was exhibited, with vocal and orchestral accompaniment, in North America and England during the early 1850s. The panorama received considerable acclaim, and in 1854 the *Art-Journal* advised that its "various views of Niagara alone reward a visit".

Queen Victoria had purchased four drawings of Canada from Friend in 1853, and the Prince of Wales noted in his diary on 11 February 1865 that the artist had showed him "some very good drawings of his of Canada". Two months later the Queen saw the drawings of Niagara Falls, which had been made for the Prince.

Niagara Falls, on the river of the same name separating Canada from the United States, are one of the greatest natural spectacles in North America. Friend's watercolour of the Falls from above depicts the view from the Canadian, left bank; that from below shows the view from the American, right bank. Between July and November 1860 the Prince of Wales had made a state visit to Canada, followed by a private visit to the United States (see cat. 123). On 15 September the Prince visited Niagara to watch a performance by the French acrobat Blondin, and had to be prevented from accepting an invitation to cross the Falls in a wheel-barrow on a tight-rope. MLE

Amadeo, 5th Count Preziosi (1816–1882)

132. *Constantinople: the Sweet Waters of Europe*, 1869

Watercolour over pencil, 46.5 × 68.5 cm (18¼ × 27 in.)
Signed and dated *Preziosi/ 1869*
RL S 251
PROVENANCE Probably acquired by the Prince of Wales in 1869
REFERENCE Millar 1995, pp. 704–05, no. 4419

The artist trained as a lawyer before studying painting in his native Malta and Paris. He settled in Constantinople in 1842, and was described in *The Illustrated London News* of 16 July 1859 as "the well known artist of Oriental subjects". During his first visit to Constantinople in 1862 the Prince of Wales bought an album of his works. On 8 April 1869, during his second visit to the city, he visited "Preziosi's charming little rooms, full of knick-knacks and sketches".

'The Sweet Waters of Europe' was the name of a valley outside Constantinople which served as a place of resort, especially during the summer months. Prince Edward visited the area, and wrote to his mother: "... there were a great many people in caiques and on the shore We saw a great many Turkish ladies – who looked very picturesque – in their bright dresses – & many very handsome ones with such dark eyes – & their faces are now very easily seen – as their veils are of the very thinnest muslin or gauze." MLE

133

Count Mihály von Zichy (1827–1906)

133. *Scenes at Sandringham House*, 1875

Pencil with watercolour, bodycolour and bronze paint on buff paper,
75.6 × 53.5 cm (29¾ × 21 in.)
Signed and dated *Zichy 1875* (bottom right)
Inscribed: *November/ SANDRINGHAM/ 1874* (centre)
RL S 270
PROVENANCE Acquired by the Prince of Wales
REFERENCE Millar 1995, pp. 947, 951–52, no. 6042

After studies at Pest and Vienna, the Hungarian painter and illustrator Zichy moved to St Petersburg, where he became court painter to the Tsar in 1859. The Prince of Wales sat to him in November 1866, while visiting Russia for the marriage of his sister-in-law to the Tsarevich Alexander. In 1871–74 the Prince invited Zichy to stay, on several occasions, at Abergeldie and Sandringham. He owned over twenty drawings by the artist and an album of photographs of his paintings.

At top centre, this sheet depicts a view of Sandringham with the Prince's arms, flanked by vignettes of the Prince at a card game and a piano duet. In the centre is a view of the Saloon at teatime, above a figure with skittles and billiard cues. At the lower left is the Dining-room, with the Princess of Wales leaving the table; at the lower right is the Bowling Alley with the Princess arriving. A vignette of a game of billiards appears at the bottom centre. Most of the people represented are identified in a key on the back of the frame.

In the winter of 1872 a visitor to Sandringham observed, "We all sit in the hall before dinner; dine at 8 at a round table ... the Princess ... and Miss Knollys play the piano very prettily ... and then we have a rubber and go to the bowling alley or billiard room at 10."
MLE

John Axel Richard Ber (1853–1906)

134. *Three days at Sandringham*, 1887

Watercolour and bodycolour on buff paper, 71.1 × 50.8 cm (28 × 20 in.)
Signed, dated and inscribed: *3 jours à/ Sandringham/ Jan/ 1887 Ill. par Ber*
RL S 271
PROVENANCE Acquired by the Prince of Wales
REFERENCE Hibbert 1976, pp. 94–95; Millar 1995, pp. 90–91, no. 231

Ber was born in Stockholm, and worked in America and at the Russian court. He stayed at Sandringham from 29 January 1887, and witnessed the partridge shooting on 31 January and 1 February.

This sheet depicts scenes from life at Sandringham. At top left is the Prince of Wales's piper, D. Mackay. At upper centre is a vignette of the Princess of Wales with Princess Maude and Princess Victoria, with a shooting marquee at the right. At upper left the Prince and several companions are depicted from behind, with the entrance front of Sandringham; at upper right the Prince appears with M. de Falbe, Lord Alcester and the Hon. W. Craven, all of whom are out shooting. Canon Duckworth is depicted at lower left, flanking vignettes of ladies seated, and figures playing skittles. The figure bearing a label *Dernière jour/ de Chasse* at lower left is a Chinese bronze, acquired at Peking in 1869 by Admiral Sir Henry Keppel, and brought in 1870 to Sandringham, where

134

it remains. A vignette of figures out shooting appears at the bottom, centre right.

The Prince of Wales was passionately fond of shooting, and the estate at Sandringham was well stocked with game birds, hares and rabbits. An observer described a shoot: "... a terrific fusillade ensues, birds dropping down in all directions, wheeling about in confusion between the flags and the guns, the survivors ... escaping into the fields beyond. The shooters then retire to another line of fencing, making themselves comfortable with camp-stools and cigars until the birds are driven up as before, and so through the day, only leaving off for luncheon in a tent brought down from Sandringham." A day's shooting could yield as many as 3000 birds. During the shoot on 31 January and 1 February, 333 and 211 partridges were shot.

MLE

Sir Oswald Walters Brierly (1817–1894)

135. *RYS Hildegarde winning the Queen's Cup at Cowes 1877*, 1878

Watercolour and bodycolour over pencil, stretcher 67.5 × 102 cm
(26⅝ × 40¼ in.)
Signed and dated *O.W. Brierly. 1878*
RL S 351
PROVENANCE Acquired by the Prince of Wales
REFERENCE Hough 1992, p. 229; Millar 1995, pp. 132–33, no. 488

Brierly trained as an artist and studied navigation and naval architecture before becoming an illustrator for *The Illustrated London News* during the Crimean War. He accompanied the Prince and Princess of Wales to the Levant in 1868, was appointed Marine Painter to Queen Victoria in 1874, and was Marine Painter to the Royal Yacht Squadron.

The Prince of Wales had been introduced to yacht racing as a boy, when in 1851 he witnessed the schooner *America* win the first America's Cup. However, he did not start racing himself until 1876, when he purchased RYS *Hildegarde*, a 205-ton schooner, built for cruising two years earlier. The Prince was on board when the *Hildegarde* won the Queen's Cup at Cowes on 7 August 1877. Thereafter, he became an enthusiastic yachtsman and regularly attended the Cowes Regatta. His involvement with yachting, as Commodore of the Royal Yacht Squadron and the Royal Thames Yacht Club and President of the Yacht Racing Association, enhanced the prestige of the sport.

MLE

136

137

Nicolas Chevalier (1828–1902)

136. *Buda-Pest: looking east along the River Danube*, 1873

Watercolour and bodycolour, 40.5 × 81 cm (16 × 31⅞ in.)
Signed and dated *N. Chevalier 1873*
RL S 21513

137. *Buda-Pest: looking west along the River Danube*

Watercolour and bodycolour, 41 × 81.5 cm (16⅛ × 32⅛ in.)
RL S 21512

PROVENANCE Purchased from the artist by the Prince of Wales, 1873
REFERENCE Magnus 1964, p. 126; Gerszi and Gonda 1994, pp. 134–35; Millar 1995, pp. 189–90, 200–01, nos. 1011–12

Chevalier was born in St Petersburg and studied in Munich and London before working as a lithographer and illustrator in Australia. In 1869–70 he accompanied the Prince of Wales's younger brother, Alfred, Duke of Edinburgh (1844–1900) on a cruise from Australia via Tahiti, Japan, China and India to Ceylon. Chevalier subsequently moved to London and exhibited a series of watercolours of the countries visited.

Between 23 April and 22 May 1873 Chevalier accompanied the Prince of Wales to Austria-Hungary to attend the International Exhibition at Vienna. The Prince's party visited Budapest on 11–14 May as guests of the Archduke Joseph.

Following the Hungarian uprising in 1848 and the foundation of the Austro-Hungarian monarchy in 1867, Buda and Pest became two of the fastest growing cities in Europe, and were amalgamated in 1872 as Buda-Pest (Budapest). These two watercolours form an almost continuous panoramic view of the Danube, looking across the river from Pest to Buda, from Gellért Hill in the east (cat. 136) across Castle Hill and the royal palace to the Széchenyi Chain Bridge in the west (cat. 137). In the foreground is the embankment with the docks of the Danube Steamboat company.

MLE

138

139

Angelos Giallina (Yiallinas; 1857–1939)

138. *Corfu, with Mon Repos on the left*, 1890

Watercolour, 47 × 91.8 cm (18½ × 36³⁄₁₆ in.)
Signed and dated *Giallina 90*
RL S 127
PROVENANCE Possibly acquired by Alexandra, Princess of Wales
REFERENCE Millar 1995, p. 351, no. 2065

The Greek landscape painter Angelos Giallina was born in Corfu, and
worked there and in Athens. He decorated the Villa Achilleion on
Corfu for the Empress Elizabeth of Austria, and worked for King
George I of Greece (1845–1913), the brother of the Princess of Wales (see
also cat. 122). Princess Alexandra visited an exhibition of Giallina's
work in London in 1891, and reputedly took an interest in his work
while visiting Corfu on the Royal Yacht in 1899.

One of the most beautiful of the Greek Islands, Corfu was a Venetian
possession until 1797, and was administered by Great Britain from

1815 until 1864, when it was ceded to Greece together with the other
Ionian Islands. Mon Repos was a Greek royal palace; it appears in
several other watercolours of Corfu by Giallina in the Royal Collection.
MLE

139. *Athens, the Acropolis at sunset*

Watercolour, 47 × 91.4 cm (18½ × 36 in.)
Signed and dated *Giallina 90*
RL S 128
PROVENANCE As for cat. 138
REFERENCE Millar 1995, pp. 131, 351, 410, no. 2061

Largely constructed during the 5th and 4th centuries BC, the Acropolis
is one of the most spectacular sites surviving from classical antiquity;
its immense historical and cultural significance ensured that Athens
became the capital of modern Greece on its foundation in 1832. The
Prince of Wales first visited the Acropolis in May 1862 (see cat. 184).

140

141

The following year, shortly after the Prince's marriage to Princess Alexandra of Denmark, her brother was elected King of Greece. The Prince and Princess of Wales visited Athens in April 1869, and the Prince returned in 1875.

MLE

Harriet Goodhue Hosmer (1830–1908)

140. *Puck*

Marble, 85 × 42 × 50 cm (33½ × 16½ × 19¹¹⁄₁₆ in.)
RCIN 10568
PROVENANCE Purchased from the artist by the Prince of Wales, February 1859
REFERENCE Cole 1877, no. 752; Carr 1912, pp. 163, 184–85, 278, 343–44; Sherwood 1991, pp. 115–27

This spirited figure of a winged child sitting on a giant toadstool was purchased by the eighteen-year-old Prince of Wales on a visit to the artist's studio in Rome, and counts among his earliest independent acquisitions. The Prince had been forbidden by his father from purchasing works of art on what was an educational tour, and *Puck* was apparently paid for out of his own pocket-money.

Having studied anatomy at St Louis, Missouri, Harriet Hosmer travelled to Rome in 1852 and joined the studio of John Gibson, before setting up on her own. Gibson, who had advised Prince Albert on the acquisition of suitable sculpture for Osborne, was charged with escort-

ing the Prince of Wales to meet the leading members of the Roman artistic community. The visit to Hosmer's studio was described and illustrated in *Harper's Weekly* of 7 May 1859 (see fig. 24, p. 122).

This figure was Hosmer's first and greatest commercial success. Fifty marble examples were produced, and sold at $1000 each.

The Prince kept his in his rooms at Frewin Hall, Oxford, during his time as an undergraduate at Christ Church, shortly after his return from Rome. In 1862 it was shown at the London International Exhibition alongside the works of John Gibson, and by 1871 it occupied pride of place in the centre of the Drawing Room at Sandringham. The Prince subsequently met the sculptress in America, and in the 1870s purchased a version of her life-size *Sleeping faun* (no longer in the Royal Collection). JM

Federico Gaetano Villa (1837–1907)

141. *La benda d'Amore (Cupid's blindfold)*, 1880

Marble, height 129.5 cm (51 in.)
Incised on the base: *F.G. VILLA/ MILANO*
RCIN 7755
PROVENANCE Acquired by the Prince of Wales by 1889
REFERENCE Gubernatis 1889, pp. 547–48

It seems likely that the Prince of Wales first encountered this group at the Vienna Universal Exhibition of 1873, which he visited in his capacity as President of the British Section. Bedford Lemere's photo-

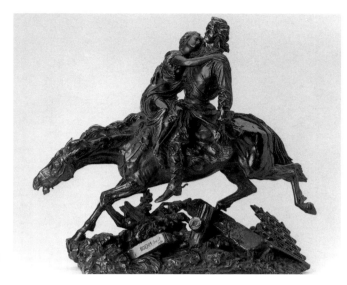

142

143

graphs of the Drawing Room at Sandringham show that by 1889 Villa's group had supplanted Harriet Hosmer's *Puck* (cat. 140) in the centre of the room.

Villa was born in Rome but made his name in Milan and Naples, where a marble of the present group was shown in 1877. A contemporary critic in the *Emporio Pittoresco* heaped praise on the group for its ability to speak in equal measure to the head and the heart, and cloaked this vision of a playful girl preparing for a risqué parlour game in the language of gods and mortals.

Another example of the group, dated 1876, was acquired by the railroad magnate Henry E. Huntington and remains in his garden at San Marino, California.　JM

Sir Joseph Edgar Boehm (1834–1890)

142. *Wilhelm and Lenore*, 1871

Bronze, 45.7 × 51 × 14 cm (18 × 20 × 5½ in.)
Incised on a gravestone in the base: *BOEHM.fecit/ 1871*
RCIN 7977
PROVENANCE Acquired by the Prince of Wales by 1877
REFERENCE Cole 1877, no. 1545; Stocker 1988, pp. 310–11

Of the forty works by the Austro-Hungarian emigré Boehm in the Royal Collection, this early and ambitious bronze, cast from a terracotta model exhibited in 1867, is outstanding in quality. Its subject is taken from a ballad of 1774 by Gottfried Bürger (1747–1794): when the victorious Crusaders return home, Lenore is dismayed that Wilhelm, her betrothed, is not among them. Unsure whether he is dead or unfaithful, she despairs of ever seeing him again. Then one midnight she wakes to the sound of a horseman dismounting outside. It is the ghost of Wilhelm, who carries her off into the night; as she pleads with him, he urges the horse on. Boehm has chosen the moment as Wilhelm's body reverts to a skeleton, before the horse and its riders are swallowed up by an open grave.

The legend had been interpreted by the previous generation of French Romantic artists, and Boehm seems indebted to earlier sculptors such as Antoine-Louis Barye, whose work he would have known from three years spent in Paris in 1859–62. Such imagery was out of date by 1867, and the terracotta was greeted by critical silence at the Royal Academy. Its exact subject had been forgotten by 1877, when the bronze was listed at Marlborough House as "a wounded soldier on a horse, bearing away a woman".

Boehm's first works for the Royal Family date from 1869, including the life-size marble statue of Queen Victoria in the Grand Vestibule at Windsor Castle, and an equestrian group of Princess Louise, the Queen's fourth daughter, who became Boehm's first pupil in sculpture. JM

Sarah Bernhardt (1844–1923)

143. *Inkwell (Autoportrait en Chimère/Autoportrait en Chauve-Souris)*, 1880

Bronze, 31 × 35.5 × 31 cm (12¼ × 14 × 12¼ in.)
Signed on the side of the base *SARAH : BERNHARDT*
RCIN 7275
PROVENANCE Presented by the artist to the Prince of Wales
REFERENCE Magnus 1964, pp. 153, 299; Los Angeles 1980, no. 28; Wildenstein 1984, pp. 5, 15; Gold and Fizdale 1992, pp. 152–53, 190

From the time of her first performances in London in 1879, when the Comédie Française took over the Gaiety Theatre, Sarah Bernhardt captivated the Prince of Wales. During the season she held an exhibition of her paintings and sculpture in Piccadilly. The *vernissage* was attended by actors, artists such as Leighton and Millais, the Prime Minister Mr Gladstone and the Prince and Princess of Wales. Bernhardt later complained that the Prince prevented her from learning her lines by prolonging the evening until 1.20 am.

This extraordinary object is loosely descended from grotesque bronze inkwells of the Italian Renaissance. About ten were cast by Thiébaut Frères in 1880, and the artist presented them as souvenirs (Mrs Patrick Campbell was another recipient). The Prince's example was placed prominently behind the desk in his study at Marlborough House, although it was evidently not used for its ostensible purpose.

Sarah Bernhardt had studied painting with her lover Gustave Doré and with Alfred Stevens, and sculpture with the *animalier* François Pompon. She first exhibited as a sculptor in 1872. Although an amateur, her ambitions reached far beyond the modelling of small bronzes. She managed to secure for herself the commission for an over-life size group of *Le Chant*, for the façade of Charles Garnier's new Monte Carlo casino, persuading Doré to produce its pendant, *La Danse*.
JM

144

Jules Dalou (1838–1902)

144. *La Vérité méconnue (Truth unrecognized)*

Bronze, 22.5 × 19 cm (8¾ × 7½ in.)
Incised on the base: *DALOU and SUSSE Fes Edrs*; founder's stamp on base:
SUSSE FRERES EDITEURS/ PARIS
RCIN 7587
PROVENANCE Probably acquired by Edward VII after 1901
REFERENCE Heim/Mallett 1965 no. 29; Beattie 1983, pp. 14–24; Cadet 1996, p. 47

Dalou held office under the Paris Commune of 1871. At the outset of the Third Republic he fled to England under the patronage of Alphonse Legros and George Howard, later Earl of Carlisle. In London he taught at the National Art Training School and established his reputation. Through the agency of Princess Louise, Duchess of Argyll (herself a sculptor), he obtained a commission for the large terracotta group in the Queen's Private Chapel at Windsor commemorating her five grandsons who did not survive infancy (1878). He returned to Paris in 1890.

Of all Dalou's small bronzes of female nudes dating from the 1890s, this is perhaps the best known. It was first produced around 1890, and subsequently cast in bronze in two smaller sizes (of which this is the larger) by Susse Frères, and in Sèvres biscuit porcelain. *La Vérité méconnue* is exceptional for the impenetrable solidity of the form, and for the attribute of a discarded mirror, symbolic of Truth spurned or ignored. The edition in the smallest size was issued in support of the defence of captain Alfred Dreyfus during the famous trial of 1894–1899.

Edward VII had already known the sculptor while Prince of Wales. Dalou's terracotta of a nursing mother, dated 1874, recorded at Sandringham in 1877, is no longer in the Royal Collection.
JM

Sir Edgar Bertram Mackennal (1863–1931)

145. *Salome*

Bronze, on a marble base, height (excluding base) 29.2 cm (11½ in.)
Incised on base: *B.MACKENNAL/ LONDON/ SALOME* and *HOHWILLER-
FONDEUR* (foundry)
RCIN 7964
PROVENANCE Acquired by the Prince of Wales
REFERENCE Beattie 1983, pp. 246–47

The story of the biblical anti-heroine Salome (Mark 6:14-28) had
attracted artists since the 1850s, notably the French painters Gustave
Moreau and Odilon Redon. Most treatments represent either her dance
or her final embrace of John the Baptist's severed head, but this work
eschews narrative in favour of a defiant and highly charged standing
figure.

This small bronze was exhibited at the Royal Academy in 1897, and
sold for 20 guineas in an edition of 25. The presence of a cast at
Marlborough House at this time calls to mind the occasional tensions
that existed between the Prince of Wales's court and that of St James's.
Five years earlier, Oscar Wilde's *Salome* had been banned from the
West End by the Lord Chamberlain. After a Paris performance in 1893,
The Times declared the play "an arrangement in blood and ferocity,
morbid, bizarre, repulsive and very offensive in its adaptation of scrip-
tural phraseology to situations the reverse of sacred". Despite the
Prince's close friendship with Sarah Bernhardt (see cat. 143), for whom
the central role had been written, he did not intervene on her behalf,
as he had done when *La Dame aux camélias* was threatened with the
same fate in 1881.

Mackennal came to London in 1882 from his native Melbourne, and
studied in Paris under Rodin. He exhibited a number of small statuettes
but is chiefly known for his public sculpture and memorials, notably
that of Edward VII in St George's Chapel, Windsor, for which he was
knighted.

JM

Holland & Sons

146. *Writing table*, 1863

Oak and walnut with tapering, fluted legs, a frieze of scrolling foliate inlay
running across the drawers and a narrow shelf raised on gilt-bronze brackets
with a brass trellis back. The writing surface veneered in burr walnut; 99.5 ×
122 × 65.5 cm (39 x 48 × 25¾ in.)
Stamped on the top edge of one drawer front: *HOLLAND & SONS*
RCIN 7724
PROVENANCE Supplied for Sandringham in April 1863
REFERENCE Joy, *Holland*, ch. 9

145

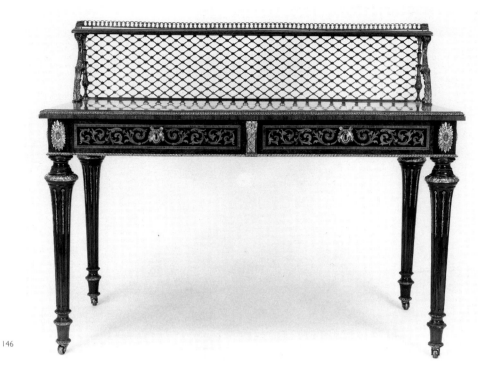

146

The London firm of Holland & Sons enjoyed a steady stream of large-scale commissions for royal residences, both official and private, beginning with Osborne House in the mid 1850s and including Buckingham Palace and Balmoral.

From 1860, when they were paid £1155 for furnishing his rooms at Oxford, their leading royal patron was the Prince of Wales. The present table was part of the thorough re-furnishing of the old house at Sandringham (which was not remodelled until 1867–70) with suites of furniture in graded qualities, from mounted and inlaid pieces such as this for the drawing rooms to painted deal for the servants' bedrooms. The total cost was £2,551. 17s. 0d. It is notable that the gilt bronze ornaments for this table, at £19. 12s., were rather more expensive than the cabinet work, for which £12. 5s. was charged.

Beginning in the same year, Holland supplied a much larger and grander order for Marlborough House, at a cost of £15,895. 10s. 1d. The firm was able to offer the Prince a complete service. His elaborate Turkish Room, with its marble "fountain in the eastern style", was entirely fitted out by their craftsmen, and it was Holland who provided the temporary furnishings for the fêtes at Marlborough House, including bandstands, staging, and the hire of Persian carpets.
JM

Unknown maker
147. *Circular table*, mid 19th century

Parquetry top arranged with concentric bands of shaped samples of exotic woods, of which many are end-grain (including coconut and date palms, tropical walnut, box and *lignum vitae*) on a base of Indian laurel; the centre inlaid with the Prince of Wales's feathers, crown and Garter collar in engraved ivory, surrounded by a garland of oak-leaves tied with a ribbon; the edge applied with batons of exotic woods between ebony bands. The stand veneered in ebony and with gilt-bronze mounts. Height 74 cm (29⅛ in.); diam. 135.2 cm (53¼ in.)
RCIN 7182
PROVENANCE Made for the Prince of Wales

The place of origin of this very distinctive table is unknown. It was at Sandringham by 1871, when it appeared in photographs of the Saloon. The base, which is probably English, resembles those of tables sold in London by the dealer Edward Holmes Baldock and based on the designs of Richard Bridgens. If the top is contemporary, it may be associated with the Prince of Wales's birth in 1841. It is equally possible that the table top came from one of the international exhibitions attended by the Prince, where not only arts and manufacturer's but the natural products of undeveloped countries were shown and judged for their usefulness and value. The woods included here may be from more than one part of the world, and cabinet-makers such as the Estonian-born Johann Martin Levien, who established a workshop in New Zealand, often mingled the exotic woods of more than one continent.
JM

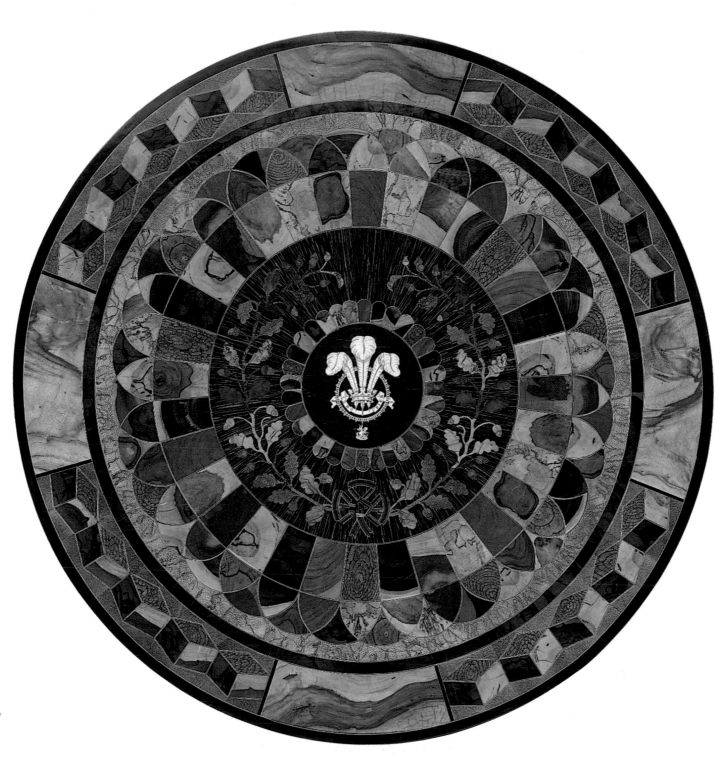

Carl Fabergé (active 1896–1908)

148. *Cigarette case*

Two-colour gold and dark-blue *guilloché* enamel set in rose diamonds with a snake; 9.6 × 7 × 1.7 cm (3¹³⁄₁₆ × 2¾ × ¹¹⁄₁₆ in.)
Marks: Moscow gold mark of 56 *zolotniks* for 1896–1908
RCIN 40113
PROVENANCE Presented to the Prince of Wales by Mrs George Keppel; given back to her by Queen Alexandra in 1911 as a memento, and returned by Mrs Keppel to Queen Mary in 1936
REFERENCE London 1995³, handlist no. 502

This case is one of the most stylish and original pieces of Fabergé in the Royal Collection, displaying to great advantage the firm's outstanding technical expertise and highly developed sense of design. It was probably given to the Prince by Mrs Keppel – herself an avid collector of Fabergé – shortly after the commencement of their liaison in 1895.

The Prince and, particularly, the Princess of Wales were both collectors of Fabergé, the Princess concentrating with enthusiasm on flowers and animals, the Prince on functional pieces such as photograph frames and desk accessories. They shared this passion with their Danish and Russian relations, with whom they regularly exchanged gifts of Fabergé from the 1890s onwards. As King and Queen they indulged this taste further, though neither of them appears to have liked – or acquired – the very elaborate or heavily jewelled pieces (for example Easter eggs) traditionally exchanged by members of the Russian royal family.
HR

149. *Oval strut frame holding photograph of the Princess of Wales, ca. 1890*

Gold and orange *guilloché* enamel, ivory back; 6.5 × 5.4 × 5.2 cm (2⁹⁄₁₆ × 2⅛ × 2¹⁄₁₆ in.)
Marks: workmaster *M.E. Perchin*; gold mark of 56 *zolotniks* for before 1896
Photograph by Alice Hughes
RCIN 23306
PROVENANCE Presumably acquired by the Prince or Princess of Wales *ca.* 1898, the date of the photograph
REFERENCE London 1995³, handlist no. 174

150. *Frame holding painted miniature of Tsarina Maria Feodorovna by Zehndorf, ca. 1895*

Four-colour gold and violet *guilloché* enamel; 9 × 7.8 × 7.3 cm (3½ × 3¹⁄₁₆ × 2⅞ in.)
Marks: workmaster *M.E. Perchin*; gold mark of 56 *zolotniks* for before 1896, *FABERGÉ* (in Cyrillic)
RCIN 40107
PROVENANCE Probably acquired by the Prince or Princess of Wales *ca.* 1895
REFERENCE London 1995³, handlist no. 248

The miniature is based on a photograph of the Tsarina (sister of the Princess of Wales) by Pasetti of 1894.
HR

151. *Strut frame holding coloured photograph of Albert Victor, Duke of Clarence and Avondale, ca. 1890*

Gold and red *guilloché* enamel; 4.9 × 5 × 2.5 cm (1¹⁵⁄₁₆ × 2 × 1 in.)
Marks: workmaster *K.O. Pihl, Moscow*; gold mark of 56 *zolotniks* for before 1896
RCIN 40225
PROVENANCE Presumably acquired by the Prince or Princess of Wales *ca.* 1890, the probable date of the photograph
REFERENCE London 1995³, handlist no. 171

The Duke of Clarence, eldest son of the Prince of Wales, died unexpectedly at Sandringham in 1892.
HR

152. *Strut frame holding photograph of the Prince of Wales, ca. 1896*

Nephrite, three-colour gold, silver gilt, cabochon rubies and rose diamonds; the back of mother of pearl; 3.3 × 3.5 × 3.6 cm (1⁵⁄₁₆ × 1⅜ × 1⁷⁄₁₆ in.)
Marks: workmaster *J.V. Aarne*; silver mark of 88 *zolotniks* for 1896–1908
Photograph by W. Kuntze Müller
RCIN 40237
PROVENANCE Presumably acquired by the Prince or Princess of Wales *ca.* 1896, shortly after the probable date of the photograph
REFERENCE London 1995³, handlist no. 347

148–152

153

Minton

153. *Candelabrum*, 1864

Bone china, painted and gilded. The raised, pierced basket surrounded by six branches rising from a ring, supported by three crouching female scroll-terms in biscuit, and with three naturalistic shell dishes set into the base; the dishes painted with a crowned cypher of Prince Albert Edward and Princess Alexandra formed in garlands of flowers; 55.5 × 38 × 43 cm (21¾ × 15 × 17 in.)
Marks: printed factory mark; date mark for 1864
RCIN 58229

154. *Pieces from a dessert service*, 1863

Bone china, *bleu celeste* ground with floral reserves and gilded swags of oak foliage. Two round tazzas on double-scroll tripod bases studded with painted profile heads imitating antique cameos; diam. 16.4 × 26 cm (6¼ × 10¼ in.). Cylindrical ice-pail and cover, with square handles and looped knob to the cover; fitted with a liner; 23 × 24.5 cm (9¼ × 9½ in.). Comport stand, of shaped oval outline, supported by two biscuit figures of putti united by gilt swags, and with a pair of billing doves; 16.5 × 25 × 16 cm (6⅜ × 9⅞ × 6¼ in.). Six plates; diam. 24.7 cm (9¾ in.). Four menu-holders; height 9.7 cm (3¾ in.)
Marks: impressed Minton mark; date marks for 1862–63; all the pieces bear the printed mark of the retailer Thomas Goode & Co, and the underglaze 'ermine' mark denoting a special soft glaze.

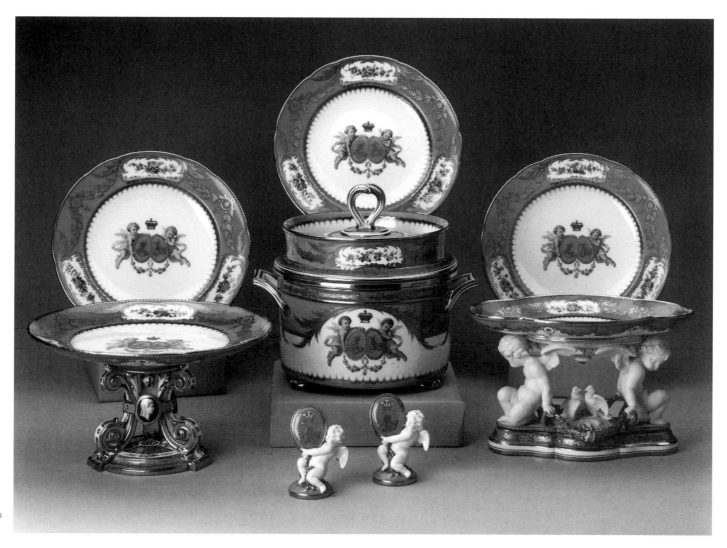

154

RCIN 7456.3-4; 7547.1a and .2.b-c; 7454; 7452.13, .18, .56, .61–.62, .68; 7462.5, .7-.9

PROVENANCE Commissioned by the Prince of Wales
REFERENCE Rayner 1977, p. 8

The dessert service with two putti holding *AE* cyphers for Albert Edward and Alexandra dates from 1863 and contained over 130 pieces. A drawing survives in the Royal Library for a plate from the service to which the candelabra belong, with the cypher rendered in flowers.

Herbert Minton (1793–1858) was one of the great entrepreneurs of the 19th century, whose wares were prominently shown at the major international exhibitions. Much of his output was inspired by works of the past, whether 'encaustic' floor tiles, French Renaissance enamels, maiolica or 'Palissy' wares. These pieces belong to a series of ambitious Minton services which imitate Sèvres porcelain of the later 18th century (such as the Manchester service, cat. 109). In particular, the fictive cameos on the stands of the tazzas are derived from the service commissioned from Sèvres by Catherine the Great of Russia in 1776. Queen Victoria, who purchased a *bleu celeste* service from Minton in

1851, lent important pieces from George IV's Sèvres collection to the Manchester 'Art Treasures' Exhibition of 1857 and the International Exhibition of 1862, and a representative selection remained on loan at South Kensington until 1887.

The Prince of Wales shared his mother's enthusiam for Minton's productions. Another dessert service, with reproductions of paintings by Landseer, is at Sandringham, and garnitures of vases, large jardinières and stools furnished many of the rooms at Marlborough House.
JM

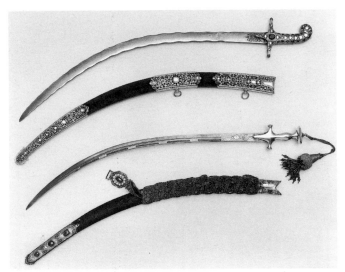

155–156

157

158

155–64. *Arms and objects of art presented by the Princes and Nobles of India*

155. *Sabre (shamsher) and scabbard*

Watered steel blade with waved edge; gold hilt encrusted with diamonds, rubies and emeralds, with a tassel of pearls, emeralds and rubies; wooden scabbard covered with purple velvet and with similarly jewelled, pierced gold mounts. Overall length 101.4 cm (40 in.)
Marks: hilt with a Hindu inscription
Presented by the Maharaja of Kashmir
RCIN 11410 (MH 94)

156. *Sabre (talwar) and scabbard*

Watered steel, grooved blade; iron hilt with disc pommel overlaid with gold; leather scabbard with enamelled gold mounts set with cabochon emeralds and rubies, and with a mother-of-pearl handled scabbard knife; gold-embroidered belt with cabochon ruby pendant surrounded by pearls. Overall length 127.6 cm (50¼ in.).
Marks: in the cartouche on the blade the koranic *Victory comes from God*; on the flat of the blade *Mir Ali Murad Khan Talpur*, which has been inscribed over the erased name of another Talpur ruler; on the back of the blade *Sohrab Khan Bahadur Talpur*
Presented by Mir Ali Murad Khan of Khairpur
RCIN 11283 (MH 228)

157. *Punch dagger (katar)*

Broad steel blade with two deep grooves on each side; gold grips and side-bars, set with diamonds, rubies and emeralds. Overall length 39.4 cm (15½ in.)
Marks: on the forte of the blade *H.R.H.Prince of Wales, Rutlam A.D. 1876*
Presented by the Maharaja of Rutlam
RCIN 11284 (MH 55)

158. *Punch dagger (katar)*

Broad steel blade with two deep grooves on each side; gold grips and side-bars set with diamonds, rubies and emeralds. Overall length 41 cm (16 in.)
Presented by the Raja of Ramnagar
RCIN 11287 (MH 50)

159. *Dagger and sheath*

Steel blade with two shallow grooves on each side, partly overlaid with gold, and filled at the centre with a row of loose pearls; enamelled gold hilt set with diamonds in floral patterns; wooden sheath covered with blue velvet, with enamelled gold mounts set with diamonds. Overall length 40.6 cm (15¾ in.)
Marks: inscribed in Persian *work of Ibrahim 1877*
Presented by the Maharaja of Bharatpore
RCIN 11289 (MH 96)

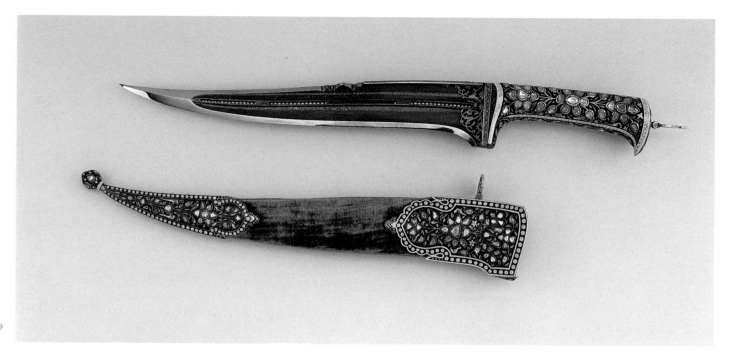

159

160

160. *Shield*

Silver, partly gilt, with translucent *champlevé* enamel in several colours; pierced and enamelled gold bosses, tear-shaped motifs and crescent, all set with diamonds; blue-enamel border set with diamonds. Diam. 48 cm (18¾ in.)
Presented by the Maharaja of Kashmir
RCIN 11278 (MH 104)

161. *Pair of bottles*

Gold; of bulbous form with segmental sides; with rows of ducks, projecting *makara* heads and parrots. Possibly Punjab. Overall height 28.2 cm (11 in.)
RCIN 11362 (MH 251–52)

162. *Spice box*

Gold; divided into four lobed segments, with an embossed and chased cover, 8.3 × 8.6 × 8.6 cm (4¼ × 3⅜ × 3⅜ in.)
From a Durbar set of ten pieces presented by the Maharaja of Mysore
RCIN 11464 (MH 291)

163. *Dish*

Gold, decorated overall with translucent, *champlevé* enamels in red, green and white. Diam. 32.3 cm (12¾ in.)
Presented by the Maharaja of Jaipur
RCIN 11469 (MH 288)

161

162

164. *Rose-water stand (attar-dan)*

Gold, with translucent *champlevé* enamels in red, green and white; pierced foliate rim with suspended pearls; hinged lotus-bud centre, secured by a catch beneath the tray; six legs, set with diamonds; 10.2 × 15 cm (4 × 6 in)
Presented by the Maharaja of Jaipur
RCIN 11423 (MH 106)

PROVENANCE Presented to the Prince of Wales by the Princes and Nobles of India, 1875–76
REFERENCE Marlborough House 1898, nos. 50, 55, 94, 96, 104, 106, 228, 251–52, 288, 291; Magnus 1964, pp. 132–42

The Prince of Wales's tour of India in 1875–76 was a great diplomatic success, followed within a year by the proclamation of Queen Victoria as Empress. Arriving at Bombay in November 1875, the Prince travelled the length of the Subcontinent from Ceylon to Nepal, often in great state. In Benares, for example, he was carried to the palace in a golden palanquin. There was a gruelling round of official duties at receptions, military reviews, investitures and the opening of public buildings, but also ample time for the pursuit of tigers, cheetahs and elephants.

The diplomatic climax of the tour was reached at Calcutta, where the Prince held a Durbar in the Throne Room of the Viceroy's house, and it was here that many of the finest presentations were made by the assembled Maharajas. The gifts were mainly weapons or gold and enamelled vessels, and included both contemporary (cat. 155) and historic (cat. 156) pieces. The enamelled dish presented by the Maharaja of Jaipur (cat. 163) was said to be the largest ever made there, and to have taken four years to produce. A lavishly cased marine chronometer bearing the cypher of Queen Victoria and the Maharaja of Kashmir sold at Christie's in London in 1996 (26 November, lot 386) may be an example of the Prince's reciprocal gifts.

Even before the presents had left Bombay on HMS *Serapis* in March 1876 for the return journey, the Prince had telegraphed for arrangements to be made to show the collection at the India Museum in South Kensington. It was then shown at Bethnal Green in 1877, at the Paris International Exhibition of 1878, and in York in 1881, before returning to Marlborough House later that year. The most precious pieces, including those shown here, were installed in a series of pollard-oak cabinets inlaid with holly, and fitted with electric lighting of the Prince's own devising. The cabinets and their contents were moved *en bloc* to Buckingham Palace on his accession in 1901.

An illustrated catalogue was published in two volumes, for Marlborough House (1898) and Sandringham (1910), where the less precious weapons were displayed as trophies in the Ballroom. Whilst observing in his introduction to the first volume that "the interest of His Royal Highness in the Collections is inexhaustible", Sir John Birdwood of the India Office stressed their importance not only in diplomatic relations, but as models for designers and manufacturers in Europe.
JM

167

171

Roger Fenton (1819–1869)

165–74. *A selection of prints from Photographic Views and Portraits of the Crimean Campaign, 1855*

165. *Lieutenant-General Sir Harry David Jones (1791–1866)*

Albumen print, 19.2 × 15.2 cm (6¼ × 7¾ in)
RPC no. 16

Sir Harry Jones served in the Royal Engineers and was severely wounded in the unsuccessful assault on the Redan on 18 June 1855. He returned to England where the Prince of Wales met him on in December 1855. His ADC, Lieutenant John Cowell, was appointed tutor to Prince Alfred in 1856, and later became Master of the Royal Household.

166. *Mr Angell, Postmaster, mounted*

Albumen print, 18.4 × 15.7 cm (6¼ × 7⅜ in.)
RPC no. 76

Fenton was on friendly terms with postal staff in the Crimea, and sometimes went riding with Mr Angell.

167. *Captain Halford ready for duty*

Albumen print, 17.2 × 16 cm (6⅜ × 6⅞ in.)
RPC no. 125

Captain Charles Halford was an officer in the 5th (The Princess Charlotte of Wales's) Regiment of Dragoon Guards.

168. *Railway officials*

Albumen print, 18.7 × 16.5 cm (6½ × 7½ in.)
RPC no. 140

The Crimean railway was built during the war to carry military supplies. The railwaymen shown are Edgar Swan, assistant engineer; J. Cadell, assistant surgeon; H.B. Middleton, assistant cashier; Albert Howes, surgeon, and J.R. Kellock, assistant engineer.

169. *Old Post Office, Balaklava*

Salted paper print, 20 × 25.2 cm (10⅛ × 7⅛ in.)
RPC no. 244

Among the first photographs which Fenton took after arriving in the Crimea was one of the post office, and he made good use of it thereafter in sending photographs back to England.

170. *The quarries and aqueduct, Valley of Inkermann*

Albumen print, 18.4 × 15.7 cm (10⅛ × 7⅛ in.)
RPC no. 250

The Prince of Wales visited Inkermann and the heights overlooking the Tchernaya Valley on 13 April 1869.

171. *Sir John Campbell with the remains of the Light Company of the 38th*

Salted paper print, 13.3 × 23.9 cm (9½ × 5⅜ in.)
RPC no. 265

General Sir John Campbell (1816–1855) was killed during the assault on the Redan. During his visit in 1869, the Prince of Wales saw his grave. He later commented on the enormous loss of life in the conflict: "for what? for a political object".

174

172. *Colonel Shadforth and the 57th Inkermann in the distance*

Albumen print, 18.6 × 23.5 cm (9½ × 7⅜ in.)
RPC no. 266

Lieutenant-Colonel Thomas Shadforth commanded the 57th Regiment of Foot, and was killed during the attack on the Redan. Colour Sergeant George Cumming later wrote to his widow that he had been "... our father & friend, and ... never did I see more genuine grief amongst a body of men, than what was seen in the 57th Regt. for the poor Colonel".

173. *Balaklava from Guards Hill*

Albumen print, 24.2 × 33.5 cm (13⅜ × 9⅝ in.)
RPC no. 274

The Prince of Wales visited Balaklava on 14 April 1869, writing later to Queen Victoria that "... the harbour ... is much narrower than I expected – & it is incredible to believe that 200 ships were lying there during the war".

174. *Cavalry Church Parade*

Salted paper print, 26.8 × 34.9 cm (14 × 10⅝ in.)
RPC no. 287

In a letter home, written on 4 April 1855, Fenton wrote, "I have been travelling about with the van in the Guards' and Cavalry camp getting some interesting views ... the distances are so great and the ravines so numerous, that it takes the best part of the day to go round".

PROVENANCE Purchased by the Prince of Wales, 1856
REFERENCE Royal Archives, Queen Victoria's Journal 1855; Prince of Wales's Diary 1854–56; Vic.Add.MSS A/3/132, 133, F3/21, 22 ; Lee 1925, pp. 136, 298–99, Gernsheim 1954, pp 52, 58, 88–89; Cooke 1997, figs. 15, 20

Roger Fenton undertook his Crimean project under the patronage of the Queen and Prince Albert. When the results were exhibited in 1856 the Prince of Wales visited the exhibition twice, and his name appears in the list of subscribers in the catalogue, together with his parents, Napoleon III, and many others.

The Crimean War fired the imagination of the young Prince, who was of an age to be impressed by military matters and knew relatives, friends and members of the Royal Household who were on active service in the Crimea. He regularly accompanied his parents on visits to hospitals, and reviews, inspections and the presentation of medals, and also saw James Robertson's Crimean photographs in February 1856. His diaries for 1854–56 contain many references to the war, and he was taken to see "the Diorama of the Seat of War" in June 1854, the "Picture Model of the Town and Forts of Sebastopol" in June 1855, and "the battle of the Alma" at Burford's Panorama in April 1856. On 30 March 1855 the Royal children "drew some things for the Patriotic Fund", to be exhibited and sold in aid of the war, and on 13 November 1855 they "saw a Russian dog that was taken at Sebastopol", whose portrait remains in the Royal Photograph Collection.

The Prince of Wales listened eagerly to officers returning from battle; for example, on 23 July 1856, "I had a long talk with Gen. Windham, he told me that he had been in all the battles & all the assaults that had taken place in the Crimea". His cherished ambition to enter the Army, starting at the lowest rank, was out of the question, but his wish to visit the Crimea was finally realised in April 1869, when the Prince and Princess of Wales went there during their tour in Egypt

175

179

and Turkey. He was deeply moved by the former battle sites as well as by the kindness of the Russian officers who accompanied them.

Fenton's photographs were kept in three portfolios. In 1902, the Prince, by then King Edward VII, requested that these be gone through and any duplicates removed. These were apparently bound as the volume titled *Crimean Portraits. Photographed by Fenton*, which contains 31 portraits and groups of officers, at least twelve of whom the Prince had met in 1855 and 1856. In addition, the King possessed an album of twelve photographs of Sebastopol by G. Shaw Lefevre, as well as 21 views taken in the Crimea during his visit in 1869.
FD

Francis Bedford (1816–1894)

175–84. *A selection of photographs from His Royal Highness The Prince of Wales's Tour in the East, 1862*

175. *Albanians at Durazzo, 22 February*

Albumen print, 20.1 × 24 cm (7⅞ × 9½ in.); incl. mount: 47 × 58.3 cm
(18½ × 23 in.)
RPC no. 3; Bedford no. 128

The Prince of Wales described a hunting party at Durazzo in his diary on 22 February 1862: "We had an escort of Albanians with their long guns, fez & white petticoats or kilts wh. had a very picturesque effect".

176. *Excavated temple at the base of the Sphinx, Ghizeh, 4 March*

Albumen print, 24.5 × 29.6 cm (9⅝ × 11⅞ in.); incl. mount 47 × 58.3 cm
(18½ × 23 in.)
RPC no. 17; Bedford no. 15

The Prince wrote in his diary on 4 March, "We visited the 'Spynx' [*sic*] just before sunset, wh. is also very curious and interesting – We had a charming little encampment just below the Pyramids where we slept for the night".

177. *Pyramids of Cheops and Cephrenes, Ghizeh, 5 March*

Albumen print, 23.5 × 28.8 cm (9¼ × 11⅜ in.); incl. mount 47 × 58.3 cm
(18½ × 23 in.)
RPC no. 20; Bedford no. 13

Bedford's view imbues the Pyramids with the atmosphere experienced by the Prince at Ghizeh on the evening of 4 March: "They quite exceeded my expectations, and are certainly wonderful mementoes of our forefathers". The following morning he followed the itinerary in *Murray's Hand-Book*, and wrote in his diary, "... before the sun rose we started to ascend the first & principal Pyramid ... the ascent is rather tedious & difficult, but you are rewarded by a fine view".

178. *Monolithic shrine in the Temple of Edfou, 14 March*

Albumen print, 28.7 × 23.2 cm (11⅜ × 9⅛ in.); incl. mount 58.3 × 47 cm
(23 × 18½ in.)
RPC no. 31; Bedford no. 26

At the Temple of Edfou, the Prince wrote on 14 March, "... it is considered the finest in Egypt, & [I] studied it excessively, & we went all over it – Mr. Bedford ... took some very successful views".

184

179. *In the Hall of Columns, Karnak, 16 March*

Albumen print, 28.8 × 23.4 cm (11⅜ × 9¼ in.); incl. mount 58.3 × 47 cm (23 × 18½ in.)
RPC no. 35; Bedford no. 29?

On 16 March, the Prince wrote, "After breakfast we rode to Karnak, to see the celebrated temples there – ... I won't describe the temples, as in Murray's Handbook there are such detailed accounts". *Murray's Hand-Book* for 1880 describes how, originally, in the Hall of Columns, "light only penetrated ... through the sort of clerestory, remains of which may still be seen". Bedford's photograph captures this light effect.

180. *The Vocal Memnon, Thebes, 17 March*

Albumen print, 29.1 × 23.8 cm (11½ × 9⅜ in.); incl. mount 58.3 × 47 cm (23 × 18½ in.)
RPC no. 40; Bedford no. 39

Murray's Hand-Book describes how "The easternmost of the two sitting colossi was once a wonder of the ancients" on account of the metallic ring, like a harpstring breaking, which it made when touched by the light of the rising sun.

181. *Bethlehem from the roof of the Convent, 3 April*

Albumen print, 22.7 × 28.8 cm (8⅞ × 11⅜ in.); incl. mount 47 × 58.3 cm (18½ × 23 in.)
RPC no. 79; Bedford no. 69?

On 3 April the Prince recorded that his party visited the Church of the Nativity in Bethlehem and a convent, most likely Mar Saba, from which the Prince noted that they "had a fine view from the top".

182. *The Golden Gate, Jerusalem, 9 April*

Albumen print, 23.8 × 28.9 cm (9⅜ × 11⅜ in.); incl. mount 47 × 58.3 cm (18½ × 23 in.)
RPC no. 89; Bedford no. 60

Roberts's *Holy Land* of 1855 dates this massive double gateway, projecting from the eastern wall near the Great Mosque, to around AD 136 during Hadrian's rebuilding of Jerusalem.

183. *Tower of Galata and part of Turkish Burial Ground, Constantinople, 21 May*

Albumen print, 23.6 × 28.6 cm (9¼ × 11¼ in.); incl. mount 47 × 58.3 cm (18½ × 23 in.)
RPC no. 147; Bedford no. 142

The Tower of Galata was originally built in 1348 by the Genoese merchant community in Constantinople. It commands one of the best panoramic views of the city.

184. *Portions of the frieze of the Parthenon, Athens, 31 May*

Albumen print, 16.8 × 29.1 cm (6⅝ × 11½ in.); incl. mount 47 × 58.3 cm (18½ × 23 in.)
RPC no. 173; Bedford nos. 165/167?

These three sections show, from left to right, sacrificial cattle, deities and water-bearers, from the north and east sides of the frieze depicting the Greater Panathenaic festival. This exquisite image reveals Bedford's remarkable skill in the photography of works of art.

PROVENANCE Made for the Prince of Wales, 1862
REFERENCE Royal Archives, Prince of Wales's Diary 1862; Roberts 1855–56; Murray and Wilkinson 1867, pp. 164, 335; Murray 1880, pt. 2, p. 497; Budge 1895, pp. 300, 329; Murray 1900, p. 100; Murray 1905¹, pp. 16–17; Murray 1905², p. 317; London 1910, pls. 26, 42; Dimond and Taylor 1987, pp. 17, 43, 51–55, 80, 118–26, 215; Lee 1927, I, pp. 130–37; Gernsheim 1987, pp. 128, 160–63; Ayliffe 1994, p. 124; Hamber 1996, pp. 42, 83, 297, 377–78, 385, 401

From February to June 1862 the Prince of Wales undertook a tour of Egypt and Palestine (see cats. 128–29) in accordance with the wishes of his late father, the Prince Consort. He was accompanied by the photographer Francis Bedford, who had previously undertaken projects for the Royal Family.

Like his brothers and sisters, the young Prince of Wales had been coached in photography, and had some success taking portraits in the 1850s. This gave him an understanding and judgement of the new art, and encouraged him, like his father, to attend exhibitions and purchase photographs, and to patronize photographers and photographic societies. He received the lavishly illustrated three-volume set of David Roberts's *Holy Land* as Christmas presents from his grandmother the Duchess of Kent in 1855–57, which may have inspired an interest in the ancient sites and their monuments. The lithographs after Roberts's views were produced by Day & Son, the company for which Bedford had worked before following his photographic career.

Bedford's 180 photographs capture the monumentality of the ancient sites and, at times, are permeated by dramatic light effects which call to mind the religious purpose of the Prince's tour. In his diary of 1862 the Prince commended the quality of Bedford's work and his choice of views. Following his return to England, his photographs were favourably received, both by the Queen and the photographic press, when they were displayed at the German Gallery in London.

HG

Charles
Philip Arthur George

(born 1948)

CREATED PRINCE OF WALES,

26 JULY 1958, AGED 9;

INVESTED 1 JULY 1969, AGED 21

Prince Charles's interest in collecting has evolved in parallel with his development as a watercolour artist. After tuition from Robert Waddell at Gordonstoun, in the early 1970s he discussed the technique of watercolour painting with the artist Edward Seago. In the years after his marriage (1981) he received further tuition from John Ward, Bryan Organ and Derek Hill. When The Prince of Wales asked Hill to advise him on the formation of a collection of his own, the artist suggested that the distinguished collector, patron and art historian Sir Brinsley Ford would be better placed to perform this task.

The Prince of Wales first visited Sir Brinsley's London home in July 1985, and returned in November of the same year to inspect a small collection of works by British artists assembled for his approval. As well as paintings by Peter Greenham and Jane Dowling, there were works by rising young British artists. Fourteen paintings, by nearly all of the artists invited to submit works, were subsequently acquired by The Prince (including cats. 194, 201 and 209); Hugh Buchanan, one of the artists represented, was subsequently commissioned to paint interiors at various royal residences (cats. 189–93). Sir Brinsley also first recommended the work of Emma Sergeant (cats. 230–34) to The Prince and advised him on portrait painters, exhibitions to be visited, and so on.

Many of the artists who subsequently accompanied The Prince on his travels were first introduced to him by Sir Brinsley. The idea of inviting an artist to join him on tour began with the visit to Italy in 1985 when John Ward accompanied the royal party for part of the voyage. As Prince Charles explained in 1989, "It is such a good way of providing a record, adding to the Royal Collection, obtaining some tips on painting, and meeting another artist, that I cannot resist it!" In addition, it is an admirable way of supporting young artists.

With increased confidence in his own taste, and proficiency in watercolour painting, The Prince's collection has continued to grow. The works that he acquires are generally on a small scale and demonstrate his awareness of the skill in the handling of paint, colour, light, design and perspective required of the artist. The following selection is typical of the wider collection: traditional figurative painting; topographical and architectural subjects and landscapes; still lifes and portraits. The Prince of Wales's selection for 'The Discerning Eye' exhibition at The Mall Galleries in 1997 demonstrated these characteristics.

The pictures and other works of art in The Prince's collection are used to furnish both his London apartment at St James's Palace and his country home, Highgrove House near Tetbury in Gloucestershire, purchased by the Duchy of Cornwall in 1980. The new garden at Highgrove has provided the setting

Fig. 29 Tom Wood, *HRH the Prince of Wales*, oil on canvas, 1989 (Private Collection, on loan to the National Portrait Gallery, London)

for some fine pieces of sculpture, and also for the specially commissioned garden furniture made to the designs of Julian and Isabel Bannerman and of the architect Leon Krier (cats. 252, 255–56).

In The Prince's residences, the works of art from his own collection hang against a backdrop of older paintings, furniture and decorative arts from the Royal Collection. On the formation of The Royal Collection Trust in 1993, HM The Queen appointed The Prince of Wales the first Chairman of the Trust. The Prince's interest in architecture led to a series of Architectural Summer Schools, held annually since 1989, and to the establishment in 1993 of The Prince of Wales's Institute of Architecture. The Prince is an Honorary Royal Academician and an Honorary Member of the Royal Institute of Painters in Watercolour and the Royal Watercolour Society.

Fig. 30 Aerial view of Highgrove, photograph by Andrew Lawson, 1996

185

Diana Armfield (born 1920)

185. *Through the gateway, Highgrove*, 1988

Oil on board, 29 × 21.3 cm (11⅜ × 8⅜ in.)
Signed *DMA*

186. *Kitchen garden in April, Highgrove*, 1988

Oil on board, 26.5 × 25.6 cm (10⅝ × 10⅛ in.)
Signed *DMA*

187. *View out of the Drawing-Room window, Highgrove,*
1988

Oil on board, 34.8 × 29.9 cm (13¾ × 11⅝ in.)
Signed *DMA*
Inv. 124/B

PROVENANCE Commissioned by The Prince of Wales, 1988

188. *Blossom and cabbages in mid May, Highgrove*, 1988

Oil on board, 29 × 23.5 cm (11½ × 9¼ in.)
Signed *DMA*
Inv. 125/B

PROVENANCE Presented by the artist to The Prince of Wales, 1989
REFERENCE (cats. 185–88) Halsby 1995, pp. 73–75

Diana Armfield studied at Bournemouth School of Art, the Slade School of Fine Art and the Central School of Arts and Crafts, London; in 1949 she married the artist Bernard Dunstan. From 1959 she was on the staff of the Byam Shaw School. She has exhibited at the Royal Academy since 1965 and has held regular solo exhibitions in London (at Browse & Darby); she has also received commissions from the National Trust's Foundation for Art and the Contemporary Art Society for Wales.

The artist's work was first admired by The Prince of Wales at an exhibition at the New English Art Club in 1988. In September 1988 Armfield visited Highgrove to discuss the commission for two views of the kitchen garden. In the following spring the artist painted the above four views, of which the Prince purchased three; the fourth was a gift from the artist.

JR

Hugh Buchanan (born 1958)

189. *The Library, Balmoral Castle*, 1986

Watercolour over pencil, 37.3 × 56 cm (14⅝ × 22⅛ in.)
Signed and dated *Buchanan 86*
Inv. 077/B
REFERENCE Petworth 1994, no. 3

190. *The Ballroom, Balmoral Castle*, 1986

Watercolour over black chalk, 27.3 × 37 cm (10¾ × 14⅝ in.)
Signed and dated *Buchanan 86*
Inv. 068/B

191. *The Saloon, Sandringham House*, 1987

Watercolour over pencil, 37.6 × 56.1 cm (14⅞ × 22⅛ in.)
Signed and dated *Buchanan 87*
Inv. 080/B

PROVENANCE Commissioned by The Prince of Wales, 1986

192. *Hall table (with broken polo sticks), Highgrove*, 1994

Watercolour over pencil, 43.4 × 37.8 cm (17⅛ × 14⅞ in.)
Signed and dated *Buchanan 94*

193. *The Drawing-Room, Highgrove*, 1994

Watercolour and bodycolour over black chalk, 56.8 × 38.2 cm (22⅜ × 15⅛ in.)
Signed and dated *Buchanan 94*

PROVENANCE Commissioned by The Prince of Wales through the Francis Kyle Gallery, 1994

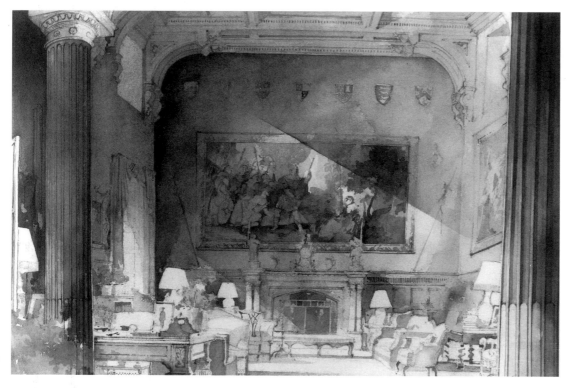

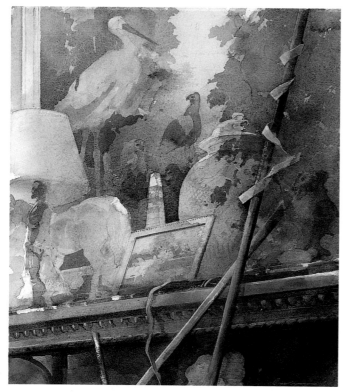

The Royal Collection contains several series of watercolours recording the interiors and exteriors of the different royal residences from the early 19th century to the 1960s. These views of Balmoral, Sandringham and Highgrove were commissioned by The Prince of Wales as part of this tradition.

Hugh Buchanan was awarded a travel scholarship following his studies at the Edinburgh College of Art; this enabled him to visit the Middle East, Northern Italy and the Balkans and confirmed his interest in architecture. Since 1981 he has undertaken several commissions to record country-house interiors for the National Trust. The City of Edinburgh purchased Buchanan's painting of the gates of Hopetoun House at his degree show, and presented it to The Prince and Princess of Wales as a wedding present. In 1986 he was commissioned by Prince Charles to paint a view in the gardens at Frogmore House, Windsor, as a sixtieth-birthday present for HM The Queen. The Balmoral interiors were painted in October 1986; those of Highgrove followed six years later.

JR

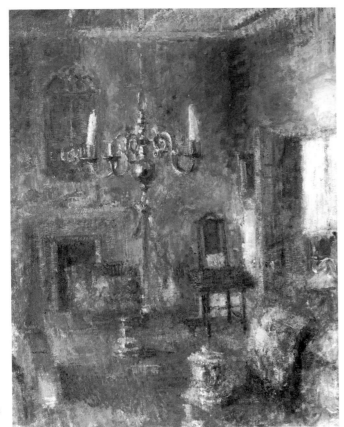

194

Edmund Fairfax-Lucy (born 1945)

194. *The brass chandelier no. 3*

Oil on canvas, laid down on board, 50.7 × 40.6 cm (20 × 16 in.)
Inv. 029/B
PROVENANCE Purchased by The Prince of Wales, 1985

This was one of the fourteen paintings acquired by The Prince of Wales in November 1985. In the words of the artist, "The painting was the third of five that I painted of this chandelier around that time. I had bought the chandelier, which was made *ca.* 1900, and had hung it in the dining room that I use, at Charlecote. (The three red tapestry chairs are adapted from 18th-century library chairs and the silver-covered cup is dated 1703. The blue ribbon with glass ball as with everything else in the picture was assembled by me in the 1980s.) This painting was, as I remember, much the most loose in the handling of the paint of any of the five versions." The painting was incomplete at the time of its acquisition. When the finished picture was delivered in February 1986, Sir Brinsley Ford commented that "Fairfax-Lucy has, in my opinion, greatly enriched his painting ... by adding a sparkle to the silver on the table, adding highlights to the chandelier and colour to the tops of the chairs which are up against the table. I really do think it is a ravishing picture, and hope it gives you, Sir, as much pleasure as it does me."

After training at the City and Guilds and the Royal Academy Schools, Edmund Fairfax-Lucy has exhibited widely and has received commissions from the National Trust's Foundation for Art. In 1974 he succeeded his father as 6th Baronet. He accompanied The Prince on his tour to Brazil in April 1991. JR

Susannah Fiennes (born 1961)

195. *Turbanned head*, 1995

Watercolour, 28.8 × 21 cm (11⅜ × 8¼ in.)
Signed and dated *S Fiennes '95/Oman*

196. *Single standing figure*, 1995

Watercolour, 34.1 × 24.2 cm (13⅜ × 9½ in.)
Signed and dated *S Fiennes '95/Oman*

PROVENANCE Painted during the royal visit to Oman, October 1995

After training at the Slade School of Fine Art (1979–83), Susannah Fiennes has travelled and exhibited her work widely. Her first solo exhibition was held in 1992 and in the following year she received the BP Travel Award, which funded a prolonged visit to China. She also teaches art. Her work was brought to the attention of The Prince of Wales by Emma Sergeant (see cats. 230–34). Fiennes accompanied The Prince of Wales on his official visits to Oman in October 1995, and to Hong Kong in June–July 1997.

197. *Christopher Patten leaving Hong Kong*, 1998

Oil on canvas, 37.5 × 50 cm (14¾ × 19¾ in.)
Signed and dated *S. F. '98*

198. *HMY Britannia in Hong Kong Harbour*, 1997

Watercolour and bodycolour on grey paper, 22.6 × 30 cm (8⅞ × 11¾ in.)
Signed and dated *S. Fiennes 29th June '97*

199. *Two yachtsmen on HMY Britannia*, 1997

Each, watercolour, 29.5 × 13 cm (11⅝ × 5⅛ in.)
Each signed and dated *S. Fiennes '97*

PROVENANCE Painted during the royal visit to Hong Kong, June/July 1997
REFERENCE Mitchell 1997

The Prince represented The Queen at the Independence celebrations in Hong Kong in the summer of 1997. The Royal Yacht *Britannia* sailed to Hong Kong to serve as the base for the royal party. Christopher Patten was the last British Governor of Hong Kong and on 1 July 1997 he and his family left the former British Protectorate on board HMY *Britannia*. Patten is here shown leaning over the railings on the deck of *Britannia*, looking back at Hong Kong. A portrait drawing by Fiennes of Patten, made at the time of this visit, is on loan to the National Portrait Gallery, London.
JR

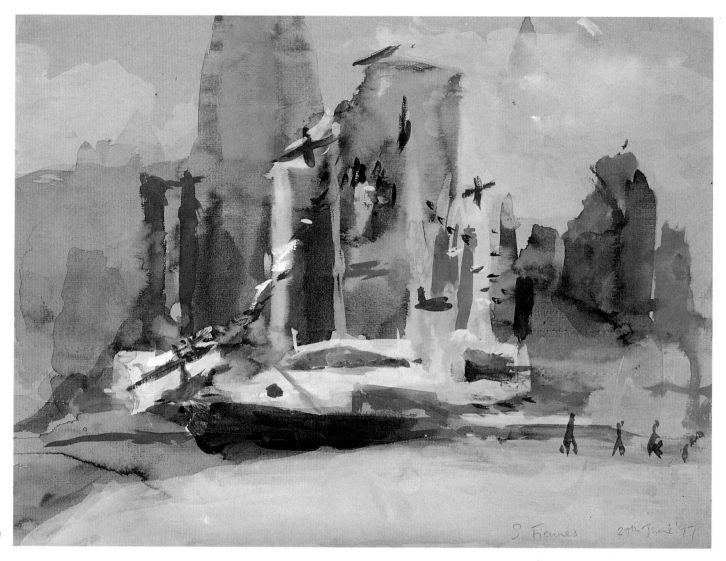

198

200

Neil Forster (born 1939)

200. *Willie Potts, RVM*

Pastels on grey paper, 38.2 × 35.5 cm (15⅛ × 14 in.)
Signed *Neil Forster*
PROVENANCE Commissioned by The Prince of Wales

Neil Forster won a scholarship to the Byam Shaw School of Art from
his secondary school, Bradfield College. Since his childhood, spent in
India, he has travelled widely and has worked in Spain, Ireland, Kuwait
and the United States. His one-man exhibitions have included por-
traits, studies of animals (especially horses and dogs) and landscapes.
The sitter was stalker/gamekeeper on the Balmoral Estates from 1972
until his retirement in 1995.
JR

Emily Gwynne-Jones (born 1948)

201. *The artist's father, Allan Gwynne-Jones*

Oil on board, 24.4. × 19.5 cm (9⅝ × 7⅝ in.)
Inv. 181/B
PROVENANCE Purchased by the Prince of Wales, 1985
REFERENCE London 1984[3], no. 2

This portrait of the artist Allan Gwynne-Jones (1892–1982), DSO, RA,
by his daughter is one of a number painted in the late 1970s, when his
eyesight was failing. Others show him writing (exhibited at the Royal
Academy, 1978) and with his easel (Brinsley Ford collection). An early
self-portrait of Allan Gwynne-Jones is in the Tate Gallery. His portrait
of *Emmy as a bridesmaid*, 1956, showing the artist of this picture at the
age of eight, is in the Glynn Vivian Art Gallery, Swansea.

 Emily Gwynne-Jones is the only child of the artists Allan Gwynne-
Jones and Rosemary Allan. She trained at the Royal Academy Schools,
the Royal College of Art and in Paris and now lives in Suffolk.
JR

201

Tom Hallifax (born 1969)

202. *Derek painting in his pinny*, 1995

Oil on board, 49 × 61 cm (19⅜ × 24 in.)
Signed and dated *TH/ 95* and inscribed: *Derek painting in his pinny/ at St
Columbs, Oct 1995*
PROVENANCE Commissioned by The Prince of Wales, 1995

Derek Hill (see cat. 203) recommended Tom Hallifax to The Prince of
Wales as an accomplished portrait painter. The sitter is depicted at
work in his studio at St Columb's, Donegal.

 Hallifax studied History of Art at the University of St Andrews
before taking a degree in Fine Art at the University of Ulster, Belfast.
He accompanied The Prince on his official visit to the United States of
America and Hong Kong in November 1994.
JR

Derek painting in his pinny,
at St Columbs, Oct 1995

203

Derek Hill (born 1916)

203. *Sir Brinsley Ford*

Oil on canvas, 60 × 50 cm (23⅝ × 19⅝ in.)
Signed *DH*
PROVENANCE Commissioned by The Prince of Wales, 1987

This portrait was commissioned in the course of a dinner of the Society of Dilettanti, of which the Prince was elected an Honorary Member in 1985. He mentioned to Derek Hill that he wished to commission a portrait of Brinsley Ford. The painting was completed following five sittings during December 1987. The sitter commented on the completed painting: "I was pleased that [Hill] had attenuated my fingers to El Greco-ish, Aubrey Beardsley-ish proportions. Less pleased that he had attenuated my nose for though long, it is not quite as long as Derek has made it".

Sir Brinsley Ford (born 1908) has encouraged numerous British artists, many of whom he has introduced to Prince Charles. Several of these artists (including Hugh Buchanan, Edmund Fairfax-Lucy, Derek Hill, Peter Kuhfeld and Martin Yeoman) were also involved in the National Trust's Foundation for Art, of which Sir Brinsley was first Chairman. In 1987 he suggested artists who might be commissioned by the Royal Collection to produce a new series of portrait drawings of members of the Order of Merit.

Hill began his artistic career as a stage designer, following studies in Munich, Paris, Vienna and Russia. In 1953–55 and 1957–58 he was Art Director at the British School at Rome. In addition to advising The Prince of Wales on his own watercolour painting, Hill has accompanied him on private visits to Turkey, Italy, France and Eire. He has portrayed Prince Charles on several occasions; his first portrait was painted in 1971 for Trinity College, Cambridge. In 1988 Hill was commissioned to draw Lord Olivier for the Royal Collection's Order of Merit portrait series.
JR

204. *Sir Laurens van der Post*

oil on canvas, 38.3 × 39.3 cm (15⅛ × 15½ in.)
Signed *DH*
Inv. 012/B
PROVENANCE Commissioned by The Prince of Wales, 1987
REFERENCE Paris 1997, no. 13

This portrait was commissioned in 1987, soon after The Prince of Wales had visited the Kalahari desert with the celebrated author Sir Laurens van der Post (1906–1996). Throughout his long life Sir Laurens was active as a writer, farmer, soldier, explorer and conservationist, based chiefly in his native South Africa. He had served under Lord Mountbatten in the 1940s and first met Prince Charles around thirty years later. From the mid 1970s The Prince of Wales and Sir Laurens were regular correspondents and close friends: they spent five days together in the Aberdare Mountains in Kenya in 1976. Sir Laurens was godfather to Prince William of Wales.
JR

204

205

Henry Koehler (born 1927)

205. *Paddy holding Reflection and Mexico (1)*

Oil and charcoal on paper, 28 × 35.5 cm (11 × 14 in.)
Signed *Henry Koehler*
Inv. o89/B

Paddy Whiteland was already employed as groom at Highgrove when
the estate was purchased by The Prince of Wales. He is shown here
holding two of The Prince's hunters. In his Introduction *to Highgrove:
Portrait of an Estate* (1993), The Prince described Paddy as "horseman,
survivor and influence at Highgrove for forty-seven years ... one of
'Nature's Gentlemen' His rugged features and twinkling eyes are
one of the most welcoming features of Highgrove and his Irish stories
are famous ... one of the most loyal people I have ever met." He died
in February 1997.

206. *Paddy Whiteland with Reflection*

Oil and charcoal on paper, 28 × 35.5 cm (11 × 14 in.)
Signed *Henry Koehler*
Inv. o87/B

207. *Dennis Brown picking a cauliflower at Highgrove*

Oil and charcoal on paper, 35.5 × 28 cm (14 × 11 in.)
Signed *Henry Koehler*
Inv. o82/B

Dennis Brown has been a gardener at Highgrove since 1985. He
specializes in growing organic fruit and vegetables.

208. *Michael Fawcett polishing HRH's boots*

Oil and charcoal on paper, 35.5 × 28 cm (14 × 11 in.)
Signed *Henry Koehler*
Inv. o88/B

Michael Fawcett was a footman at Buckingham Palace until his appoint-
ment as valet to The Prince of Wales in 1983. In 1997 he became Deputy
Personal Assistant to The Prince.

PROVENANCE Commissioned by The Prince of Wales, 1986

In 1985 the Prince of Wales asked Brinsley Ford to suggest an artist who
could paint Paddy Whiteland with one or two of his horses, "rather
along the same lines as Stubbs painted the grooms as well as the
horses". The American Henry Koehler was subsequently introduced
to The Prince by Lord King of Wartnaby.
J R

210

211

Peter Kuhfeld (born 1952)

209. *Jemimah*

Oil on canvas, 45 × 35 cm (17⅝ × 13¾ in.)
PROVENANCE Purchased by The Prince of Wales, 1985

Jemimah Kuhfeld (born 1980) is the artist's daughter.

210. *Prince William of Wales*

Oil on canvas, 51.5 × 38.3 cm (20¼ × 15⅛ in.)
Signed *Kuhfeld*
Inv. 118/B
PROVENANCE Commissioned by The Prince of Wales, 1986

Portrait of the elder son of The Prince, born on 21 June 1982.

211. *Prince Harry of Wales*

Oil on canvas, 51.5 × 39.5 cm (20¼ × 15½ in.)
Signed *Kuhfeld*
Inv. 117/B
PROVENANCE Commissioned by The Prince of Wales, 1986

Portrait of the younger son of The Prince, born on 15 September 1984. The Prince commissioned portraits of Princes William and Harry early in 1986 and sittings took place later that year and the summer of 1987.

212. *The Capitol at Dougga, Tunisia*

Oil on board, 28.5 × 23 cm (11¼ × 9⅛ in.)
Signed *Kuhfeld*
Inv. 46/B
PROVENANCE Painted during the royal visit to Tunisia, March 1990

213. *Young girl in blue dress, Umuagbai village*

Oil on board, 24 × 18 cm (9½ × 7⅛ in.)
Signed *Kuhfeld*
Inv. 121/B

214. *The Durbar at Maiduguri, Nigeria*

Oil on canvas, 82.5 × 106.5 cm (32½ × 42 in.)
Signed *Kuhfeld*
Inv. 47/B

217

215. *Chief in a beaded cap and red robe*

Oil on board, 25 × 17.5 cm (9⅞ × 6¾ in.)
Signed *Kuhfeld*
Inv. 43/B

216. *War canoes, Port Harcourt*

Oil on board, 32 × 27 cm (12¾ × 10⅝ in.)
Signed *Kuhfeld*
Inv. 122/B

PROVENANCE Painted during the royal visit to Nigeria, March 1990

217. *Morning in the Hatakeyama, Tokyo*

Oil on canvas, 31.5 × 44.5 cm (12⅜ × 17½ in.)
Signed *Kuhfeld*
Inv. 44/B

PROVENANCE Painted during the royal visit to Japan, November 1990, and presented by the artist to The Prince of Wales as a birthday gift in the same month

REFERENCE (cats. 212, 214–215, 217) London 1991⁴, nos. 37, 38, 41, 42

The circumstances in which this work was painted are described in an inscription by The Prince, on the back of the frame: *This is by the artist I took to Japan at the time of the Emperor's enthronement. It is of the inside of a traditional Japanese house where we had lunch.*

219

218. *Rynek Stavego Minster, Warsaw*

Oil on board, 37 × 44.7 cm (1½ × 17⅝ in.)
Signed *Kuhfeld*
PROVENANCE Painted during the royal visit to Poland, May 1993

In September 1985 Sir Brinsley Ford invited Peter Kuhfeld to submit some of his paintings for consideration by Prince Charles, suggesting that he should include some portraits of his daughters as a demonstration of his abilities in painting children. This resulted in the acquisition of cat. 209, and the commissioning of cats. 210–11. Subsequently Kuhfeld painted The Prince's portrait (in Garter robes) and accompanied him to Italy and Tunisia, and Nigeria and Cameroon, in March 1990; to Japan in November 1990, and to Poland in May 1993.

Peter Kuhfeld studied painting at Leicester Polytechnic and at the Royal Academy Schools. He won the Royal Academy silver medal for drawing in 1979 and was awarded the Richard Ford scholarship in 1981, which enabled him to study in Spain. He has worked for the National Trust Foundation for Art since its commencement in 1986. Kuhfeld's portrait drawing of Lord Menuhin is part of the Royal Collection's Order of Merit series.
JR

Binny Mathews (born 1960)
219. *Tea bowl at Mixbury*, 1989

Oil on canvas, 33 × 30.5 cm (13 × 12 in.)
Signed and dated *Binny Mathews 1989*
Inv. 177/B
PROVENANCE Purchased by The Prince of Wales from Henry Wyndham Fine Art, 1989
REFERENCE London 1989, no. 59

Binny Mathews received her artistic training at Farnham School of Art. She has exhibited since 1980, and has taught at the London College of Printing and at Heatherley School of Fine Art. In 1989 she won the Elizabeth Greenshield Foundation Award for figurative painting.

This still life was painted during a break in a portrait sitting with Mrs Ben Collins: the porcelain bowl is depicted in the room in which the sitting was taking place.
JR

John Napper (born 1916)
220. *Saucepan and lemons (the blue still life)*

Watercolour, 50 × 60.3 cm (19⅝ × 23¾ in.)
Signed and dated *JN* [in monogram]/ *JOHN NAPPER*/ *1987*
PROVENANCE Purchased by The Prince of Wales from the Gillian Jason Gallery, 1993
REFERENCE London 1988², no. 21; London 1993, no. 33

221. *Corner of my table no. 6*

Watercolour, 22.2 × 44.4 cm (8¾ × 17½ in.)
Signed and dated *JN* [in monogram]/ *JOHN NAPPER*/ *1990*
PROVENANCE Purchased by The Prince of Wales from the artist, 1996

One of a series of still lifes entitled *Corner of my table*, the first of which was painted in 1985. The artist's materials depicted in this painting include museum paste (a paper glue), oil of cloves (used as a preservative when making *gesso*) and a large jar of wood ash (for mixing with distilled water to make a lye, for cleaning painted surfaces).

222. *Allegory, Paris exposed*

Oil on canvas, 61 × 73.5 cm (24 × 28⅞ in.)
Signed and dated *JN*/ *JOHN NAPPER*/ *1991*
PROVENANCE Purchased by The Prince of Wales through the Albemarle Gallery, 1993
REFERENCE London 1991⁵, no. 8; Machynlleth 1993, no. 34

"This painting is one of a number of works based on mythological themes. It depicts the infant Paris, exposed by Agelaus on Mount Ida. Some say that he was nurtured by a she-bear, others that it was the goat Amaltheia who suckled the child. In this painting, Clee Hill in Shropshire stands in for Mount Ida and Agelaus and his family are seen by the side of a church, which was inspired by a drawing made in Italy in 1959. The atomic powerhouse in the distance is a pictorial symbol

222

of energy, the energy that underlies all myths" (letter from the artist, 19 February 1998).

223. *Corner of my table no. 20: green pencils*

Watercolour, 24.3 × 34.8 cm (9⅝ × 13¾ in.)
Signed *JN* [in monogram]/ *1994*
PROVENANCE Purchased by The Prince of Wales from the artist, 1996

In recent years Prince Charles has made regular annual purchases of paintings by John Napper, whose work he first encountered in 1987. The artist was trained by his father and then at the Dundee School of Art and the Royal Academy Schools. He served as War Artist to Ceylon Command 1943–44. From 1949 to 1957 he taught life-painting at St Martin's School of Art, London. Napper spent the following decade in France and was appointed visiting Professor of Fine Arts at the University of Southern Illinois, 1968–69. Since 1971 he has lived near Ludlow in Shropshire. Napper's portrait of HM The Queen (1953) hangs at the Walker Art Gallery, Liverpool. In 1996 he painted a portrait of Prince Charles.

All Napper's watercolours are painted in pure watercolour, without bodycolour or pencil. He writes, "None of them have any trace of pencil, as I think that any preliminary 'drawing' in pencil always makes the final result look 'dirty'. To begin with, all 'drawing' is done with a brush and thin light grey watercolour."
JR

224

225

Michael Noakes (born 1933)

224. *HM The Queen*, 1972–73

Oil on board, 72.4 × 49.5 cm (28½ × 19½ in.)
Signed and dated *Michael Noakes/ 1972–3*
PROVENANCE Purchased by The Prince of Wales, 1974
REFERENCE London 1982, no. 137; London 1986, no. 18

225. *HM Queen Elizabeth The Queen Mother*, 1973

Oil on board, 50.8 × 38.7 cm (20 × 15¼ in.)
Signed and dated *Michael Noakes/ 1973*
PROVENANCE As for cat. 224
REFERENCE Windsor, Guildhall, 1990

Both portraits are studies painted in connection with the group portrait commissioned by the Corporation of the City of London to commemorate the Queen's Silver Wedding Anniversary (20 November 1972), when the Royal Family lunched at the Guildhall. The group portrait includes seven members of the Royal Family, together with the Lord Mayor and Lady Mais.

The portraitist and landscape painter Michael Noakes trained at the Royal Academy Schools. The Guildhall portrait was his first royal commission; since then he has painted individual portraits of The Queen for Manchester Town Hall (1977) and for The Queen's Lancashire Regiment. He has portrayed Queen Elizabeth for London University, for RADAR and for the opening of the Overlord Embroidery; and The Prince of Wales for 2nd KEO Gurkhas and for the Royal College of Psychiatrists. Noakes has contributed two drawings to the Royal Collection's Order of Merit series.
JR

Bryan Organ (born 1935)

226. *Study for a portrait of Harold Macmillan*, 1980

Watercolour and bodycolour with pen and ink on graph paper, 42 × 47.6 cm (16½ × 18¾ in.)
Signed, dated and inscribed *Bryan Organ/ study for HM – Jan 1980*
PROVENANCE Gift from the artist to The Prince of Wales, 1981

This portrait study was presented in the course of the artist's work on The Prince's own portrait (now National Portrait Gallery, London). An oil portrait of Harold Macmillan (1894–1986; Prime Minister 1957–63; created Earl of Stockton; OM, PC) was commissioned in 1980 by the University of Oxford, of which Macmillan was Chancellor; a

226

second version was purchased by the National Portrait Gallery. In the year that this portrait was drawn the Highgrove estate was purchased from Maurice Macmillan, the sitter's eldest son, as The Prince of Wales's country residence.

Bryan Organ trained at Loughborough College of Art (where he later taught) and at the Royal Academy Schools. He has received numerous portrait commissions. In addition to Prince Charles, his sitters have included the Princess of Wales (1981; National Portrait Gallery), Princess Margaret (1969; Lincoln's Inn), Prince Philip (1983; National Portrait Gallery). Organ drew Sir Sidney Nolan for the Royal Collection's series of portraits of members of the Order of Merit.
JR

Andrew Ratcliffe (born 1948)

227. *HRH The Prince of Wales*, 1985

Oil on canvas, laid on board, 91.5 × 71 cm (36 × 28 in.)
Signed and dated *ANDREW RATCLIFFE/ 1985*
Inv. 242/B

228. *Preparatory study (profile) for the portrait of The Prince of Wales*

Watercolour over pencil, 36.8 × 28 cm (14½ × 11 in.)
Signed *Andrew Ratcliffe*
Inv. 092/B

227

229. *Preparatory study (three-quarter face) for the portrait of The Prince of Wales*

Watercolour over pencil, 38.8 × 28 cm (15¼ × 11 in.)
Signed *Andrew Ratcliffe*
Inv. 086/B

PROVENANCE Commissioned by The Prince of Wales, 1985

Andrew Ratcliffe was born in Lancashire and received his training at Burnley and Canterbury College of Art. He has described the circumstances in which this portrait was made: "I wrote to The Prince in 1981, and subsequently met with him and showed him some of my work. On following visits I did some pencil studies of HRH and the Prince William aged about six months. HRH suggested some sittings for a painting and these took place at the end of 1985 at Kensington Palace. As the painting took shape, and we were both happy with it, it became clear that he wished to acquire it." In 1986 the painting and the preparatory sketches were exhibited at the National Portrait Gallery, London. Eight years later Ratcliffe painted another portrait of The Prince, for the Palace of Westminster. He has drawn Sir Andrew Huxley for the Royal Collection's Order of Merit series.
JR

231

Emma Sergeant (born 1959)

230. *Head study, Egypt*

Black pencil, 19.7 × 14.3 cm (17⅞ × 5¾ in.)
Signed and dated *ES/ 95*

This head was drawn, from imagination, at the British Embassy, Cairo. The artist describes the subject as "a mummy of my choice".

231. *Two head studies, Egypt*

a) Black pencil, 19.7 × 14.3 cm (17⅞ × 5¾ in.)
Signed and dated *ES/ 95/ Cheikh el Balad*
b) Black pencil, 19.7 × 14.3 cm (17⅞ × 5¾ in.)
Signed and dated *ES/ 95/ Cheikh el Balad*
PROVENANCE (cats. 230–31) Drawn during the royal tour of Egypt, March 1995

The wooden figure of *Cheikh el Balad* was drawn in the Egyptian Museum of Antiquities in Cairo.

232. *President Akayev of Kyrgyzstan*

Black chalk, 19.8 × 14.3 cm (17⅞ × 5¾ in.)
Signed and dated *ES/ 96*

Askar Akayev, elected first President of the Republic of Kyrgyzstan in October 1991, was re-elected in December 1995. This portrait was drawn during a meeting between the President and The Prince of Wales at the Presidential Guest House, Bishck, Kyrgyzstan, on Saturday 9 November 1996.

233. *Three female studies, Central Asia*

a) Conté crayon, 19.8 × 14.3 cm (17⅞ × 5¾ in.)
Signed and dated *ES/ 96*
b) Conté crayon, 19.8 × 14.3 cm (17⅞ × 5¾ in.)
Signed *ES/ 96*
c) Conté crayon, 19.8 × 14.3 cm (177/8 × 5¾ in.)
Signed and dated *ES/ 96*

The left-hand figure was selling entry tickets and postcards when the royal party visited the Tamarlaine Museum during the visit to Uzbekistan (9–12 November 1996). The figure on the right, inscribed *Leena*, was an university student at the time of the visit to Turkmenistan. She assumed the role of dancing girl to welcome The Prince to her college.

234. *Two head studies, Central Asia*

a) Conté crayon, 19.7 × 14.3 cm (17⅞ × 5¾ in.)
Signed and dated *ES /96*
b) Conté crayon, 19.7 × 14.3 cm (17⅞ × 5¾ in.)
Signed and dated *ES/ 96*; inscribed *The Mufti*
PROVENANCE (cats. 232–34) Drawn during the royal tour of Central Asia, 1996. The royal party visited His Grace The Mufti at Barahkhan Madrassah, Tashkent, Uzbekistan on 12 November 1996

The work of Emma Sergeant was introduced to The Prince of Wales by Brinsley Ford in April 1986, when he acquired her *Study for Milapote II*. Subsequently she accompanied The Prince on his official tours of Egypt and Morocco in 1995, and of Central Asia in 1996. Sergeant's drawing of Lord Todd is part of the Royal Collection's Order of Merit series. In 1994 she painted a portrait of the Duke of York.

237

The artist studied at the Camberwell School of Arts and Crafts and at the Slade School of Fine Art. After winning the National Portrait Gallery's Portrait Award in 1981 she painted Lord David Cecil and Laurence Olivier for the Gallery. She has held one-woman shows since 1984 and in 1985–86 visited the Northwest Frontier Province of Pakistan, painting Afghan refugees.
JR

John Sergeant (born 1937)

235. *Sandringham House – weighing machine*

Watercolour and pen and ink, 21.4 × 29 cm (8½ × 11½ in.)
Signed and dated *John Sergeant/ 23 April 1989*; inscribed *Sandringham*
PROVENANCE Presented by the artist to the Prince of Wales, 1989

236. *Prague skyline with the dome of Sv Mikulas, Mala Strana*

Pencil, pen and ink, watercolour and bodycolour, 15.4 × 46.7 cm (6⅛ × 18½ in.)
Signed and dated *John Sergeant/ Prague 1991*
Inv. 186/B

237. *Prague: Hradčany*

Pen and ink, watercolour and bodycolour, 15.5 × 47.5 cm (6⅛ × 18¾ in.)
Signed and dated *John Sergeant/ Prague 1991*
Inv. 185/B
PROVENANCE (cats. 236–37) Drawn on the royal visit to Czechoslovakia, May 1991

238. *Teapot with lustre cup*

Watercolour and bodycolour over pencil, 31.5 × 23.1 cm (12⅜ × 9⅛ in.)
Inv. 234/B
PROVENANCE J.S. Maas & Son; purchased by the Prince of Wales, November 1992

238

John Sergeant studied at Canterbury College of Art. After meeting John Ward in 1958, he entered the Royal Academy Schools and won the Drawing Prize in 1962. In the early 1980s he undertook a number of commissions for interior views. In 1987 he contributed to the National Trust exhibition at Agnew's entitled 'The Long Perspective', where his work was noticed by Prince Charles. Two years later Sergeant was commissioned to contribute drawings to The Prince's book, *A Vision of Britain*. He accompanied Prince Charles on his official visit to Czechoslovakia in May 1991. Sergeant's portrait of Sir Frederick Ashton is part of the Royal Collection's Order of Merit series.
JR

239

John Ward (born 1917)

239. *The Dining-room in HM Yacht Britannia*

Watercolour over pencil, 23 × 31.3 cm (9⅛ × 12⅜ in.)
Signed *John Ward*
Inv. 222/B
PROVENANCE Painted on the royal visit to Italy, April–May 1985

This watercolour was one of a series painted by John Ward while on board *Britannia* in 1985; he had been invited to accompany The Prince and Princess of Wales on part of their Italian tour, specifically to assist with The Prince's own watercolour painting. Ward was first introduced to the Royal Family through The Queen's Private Secretary, Sir Michael Adeane. In 1962–63 he painted a series of watercolours of Balmoral for The Queen and in 1981 he was commissioned by The Prince of Wales to make watercolours of the Royal Wedding; he later painted the christenings of Princes William (1982) and Harry (1985). Ward's oil portraits of the Princess of Wales (cat. 240) and The Princess Royal followed in 1984 and 1987–88. He has also drawn Sir Isaiah Berlin and Sir John Gielgud for the Royal Collection's Order of Merit series.

Ward studied at the Hereford School of Arts and Crafts and at the Royal College of Art before enlisting with the Royal Engineers in 1939. After the war he was active as an illustrator, working for *Vogue* from 1948, the year of his first one-man exhibition. He soon established a reputation as a portraitist and became a Member of the Society of Portrait Painters in 1954. Two years later he was elected to the Royal Academy but resigned in 1997. He was appointed CBE in 1985 and has been involved with the National Trust's Foundation for Art since its inception.

A painting by Ward's daughter, Celia, was purchased by Prince Charles in 1986. For the artist's son, Toby Ward, see below. The Royal Yacht *Britannia* was decommissioned in December 1997.
JR

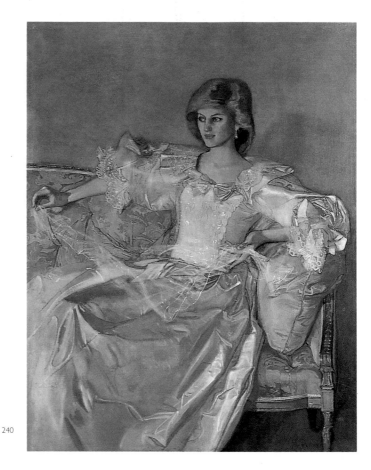

240

240. *HRH The Princess of Wales, 1984*

Oil on canvas, 15 × 122 cm (62¼ × 48 in.)
Signed and dated *John Ward '84*
PROVENANCE Commissioned by the Prince of Wales
REFERENCE Ward 1991, p. 78

In his recent book the artist describes this commission: "When I was asked to paint this portrait I was immensely pleased and flattered. A glorious subject. The wedding dress was chosen by mutual consent. A preliminary pencil study was made and squared up on the canvas, which was loosely pinned on to the stretcher with plenty of overlap for extension should it be needed.

"The portrait was painted at Kensington Palace, where the windows and ceilings are low, and so it was best to paint sitting – risky for so large a canvas, but best for light. With the elaborate dress and the simplicity of the shape of the couch I eliminated all background – a rich tapestry hung behind the Princess. It was wonderful to attempt so splendid a subject."

The painting was completed in 1984. It shows the Princess of Wales in the dress designed by David and Elizabeth Emanuel for her marriage to The Prince of Wales on 29 July 1981. The painting hung at Kensington until the Princess's death in late August 1997. This is the first time it has been exhibited. JR

241a

241b

Toby Ward (born 1965)

241. *Two sketchbooks from the Gulf Tour, November 1993*

a) Sunday 6 November
left: *A slight hitch, the battery was flat*
right: *RAF Lyneham by 10 am. Coffee in the VIP lounge*
Pen and ink and watercolour, 10.5 × 15 cm (4¼ × 5⅞ in.)
b) Friday 11 November
The orchestra of HMY Britannia playing at night, in the United Arab Emirates
Pen and ink and watercolour, 10.5 × 15 cm (4¼ × 5⅞ in.)
PROVENANCE Drawn during the royal tour to the Gulf, November 1993

Toby Ward trained at the City and Guilds of London Art School after serving in the Royal Welch Fusiliers. His earliest artistic training was received from his father, John Ward (see cats. 239–40). Ward's talent as an illustrator has been employed in a number of commissions for pictorial records, from the National Trust, UN Forces and the Royal Opera House, and he was invited to accompany The Prince of Wales on his official visit to the Persian Gulf in November 1993. The two sketchbooks shown here document different episodes of the tour, from the journey to the airport to state occasions in the Gulf States.

Ward is also active as a portrait painter and in 1996 won the Richard Ford Award to travel to Madrid. JR

242

244. *Mahlamba Ndlopfu, lunch with President Mandela, 1997*

Red chalk, 19 × 14 cm (7½ × 5½ in.)
Inscribed *Mahlamba Ndlopfu, Pretoria/ Robbie Wraith. 1 Nov. 1997*

245. *The Spice Girls in concert in aid of the Nations Trust, Johannesburg, 1997*

Pen and ink and watercolour, 12.7 × 19 cm (5 × 7½ in.)
Signed and dated *Robbie Wraith 1997*

246. *Fugitives' drift, 1997*

Watercolour over pencil, 14 × 19 cm (5½ × 7½ in.)
Inscribed *Fugitives Drift. 2 Nov. 1997/ Robbie Wraith*

247. *Helicopter to Dukuduku, 1997*

Pen and ink and watercolour, 19 × 14 cm (7½ × 5½ in.)
Inscribed *In the helicopter to DukuDuku/ Robbie Wraith 1997*

248. *Cape Town, 1997*

Pen and ink with watercolour and sepia wash, 19 × 14 cm (7½ × 5½ in.)
Inscribed *Cape Town, 1997/ Robbie Wraith*

249. *Crossroads, Cape Town (4 November 1997)*

Pen and ink and watercolour, 21 × 14.5 cm (8¼ × 5¾ in.)
Inscribed *Crossroads/ Capetown 1997 Robert Wraith*

250. *Johannesburg (5 November 1997)*

Pen and ink and watercolour, 21 × 14.5 cm (8¼ × 5¾ in.)
Inscribed *Johannesburg/ 1997/ Robert Wraith*

PROVENANCE Drawn during the royal tour of South Africa, 1997

The studies shown here belong to a series of 35 made by Robert Wraith in October and November 1997, when he accompanied The Prince of Wales on his official tour of South Africa and Swaziland. The study of President Nelson Mandela, elected President of South Africa in May 1994, was made during an official luncheon.

From 1969 Robert Wraith studied for several years with Pietro Annigoni in Florence. In 1995 Wraith was elected to the Royal Society of Portrait Painters and has won the Elizabeth Greenshield Award (twice), a John Player Portrait prize and a Hunting Group prize. He was recommended to The Prince of Wales as a possible 'travelling artist' by John Ward and accompanied the Prince of Wales on his official tour of South Africa and Swaziland in November 1997. A portrait of HM The Queen commissioned by Shell UK was completed in May 1998. JR

242. *Menu card of the 45th birthday dinner of The Prince of Wales, November 1993*

Watercolour and pen and ink, 35 × 22.6 cm (13¾ × 8⅞ in.)
Inscribed *Menu created and cooked by Antonio Carluccio and drawn by Toby Ward*
PROVENANCE Presented by the artist to The Prince of Wales, November 1993

The design and content of the menu reflects The Prince's love of Italy. The birthday dinner party took place at Highgrove immediately after the Gulf tour. JR

Robert Wraith (born 1952)

243. *Coronation of King Letsie III, Lesotho, 1997*

Pen and ink and watercolour, 19 × 14 cm (7½ × 5½ in.)
Inscribed *The Coronation of King Letsie III/ Lesotho 31st October 1997/ Robbie Wraith*

248

251

Martin Yeoman (born 1953)

251. *Young Omani boy*

Pen and oak-gall ink, brown and black chalk, 23.8 × 17.5 cm (9⅜ × 6⅞ in.)
Signed *Yeoman*; inscribed *Young Omani boy/ Wadi Bani Kahlid/ 1987*
Inv. 070/B
PROVENANCE Drawn for The Prince of Wales

Prince Charles first met Martin Yeoman in April 1986, and purchased a number of the artist's paintings. The following November Yeoman accompanied The Prince on his tour of the Gulf States (Oman, Qatar, Bahrain, Saudi Arabia).

This portrait was made from life during Yeoman's second visit to the Gulf, early in 1987. This visit was made at the Prince's request, in the company of Stephen Day, Middle East Adviser to the Prince.

Yeoman was also present on The Prince's private visit to Hong Kong in 1989 and on the tour to India and Nepal in February 1992. In 1988 he drew Sir Alan Hodgkin for the Order of Merit series. His drawings of the grandchildren of HM The Queen were commissioned by the Royal Household in 1992 as a gift to Her Majesty on the 40th anniversary of her accession (exhibited National Portrait Gallery, 1993).

Yeoman studied at the Royal Academy Schools, and has exhibited since 1976. He was one of the young artists who inspired the National Trust's Foundation for Art and was elected to the Royal Society of Portrait Painters in 1990. He has recently turned to etching and sculpture.
JR

252

Julian Bannerman (born 1951) and Isabel Bannerman (born 1962)

252. *'Sun' garden bench*

Oak, 148 × 200 × 70 cm (58¼ × 79¾ × 27½ in.)

PROVENANCE Gift from Sun Life Assurance to The Prince of Wales, December 1996, at the time of the opening of their new headquarters in Bristol

Two great benches were conceived as integral parts of the Oak Temples within the new Hosta garden and 'Stumpery' in the woodland garden at Highgrove. These are sited at opposite sides of a grassy glade, "a place to stop and contemplate. It was therefore decided that some seats should be made to go inside the Temples – but they had to be as singular as the place itself". The benches were designed in the tradition of 18th-century garden furniture (in the grottos and hermitages of William Kent and Thomas Wright) which "look as though nature had produced the cabriole legs or fantastic detail, without artifice". In the event, the designers discovered that the creation of furniture, "... which looks both elegant and at one with nature ... [and

of] things which look as if they were grown and not carved, is actually far harder than it would seem" (information from the designers). The benches were carved by Ray and Giles Coggins and Anthony Griffiths.

Julian and Isabel Bannerman have worked together on garden and building restoration and design since 1982. Projects have included the maze, grotto and hermitage at Leeds Castle and the rock- and water-garden, rockery and dairy garden at Waddesdon Manor. Their garden designs were awarded gold medals at Chelsea Flower Show in 1993 and 1994. JR

253

254

Angela Conner

253. *HRH The Prince of Wales*, 1995

Bronze, 48.5 × 32 × 22 cm (19⅛ × 12⅝ × 8⅝ in.)
Signed *1995 2/10 Conner*
PROVENANCE Commissioned by the Duke of Devonshire, by whom
presented to The Prince of Wales, November 1995

This bronze resulted from a commission from the Duke of Devonshire
for a clay portrait bust of the Prince, cast in an edition of ten. Sittings
took place at Birkhall, Windsor Castle and Chatsworth, the Duke's
home. The first cast is at Chatsworth; the second was presented to the
Prince. Others are at the London headquarters of the National Trust
and at The Prince of Wales's Institute of Architecture.

Angela Conner sold her first piece of sculpture at the age of eight.
She worked as an illustrator and journalist in New York and then spent
nine months as an apprentice to Barbara Hepworth. She has exhibited
widely and has won numerous prizes, particularly for public sculpture.
In addition to portrait busts, she has created a number of structures
incorporating stone and moving water.
JR

Nicholas Dimbleby (born 1946)

254. *Greenman relief*, 1995

Bronze relief, 98 × 69 × diam. 7 cm (38½ × 27¼ × 2¾ in.)
Signed *ND 1 /10 /95*
PROVENANCE Commissioned by The Prince of Wales, 1995
REFERENCE Hong Kong 1995, no. 16

This relief was commissioned by Prince Charles for the walled garden
at Highgrove. It is inscribed *Genius Loci* (the spirit of the place) and
features the face of a Greenman, whose physical forms merge with the
natural forms of leaves and branches. The Greenman is a woodland
spirit of fertility and protection. He is shown awaking from sleep.
Although a pagan god, he is often to be seen entwined with foliage on
bosses and carvings in churches. The fountain at the base of the relief
relates to an actual fountain at Highgrove and was included following
discussions with the Prince. This relief is the first of an edition of ten.
Following its exhibition in December 1995, a further cast was pur-
chased for the Peak Café in Hong Kong.

Nicholas Dimbleby was trained at Edinburgh College of Art, Gold-
smith's College of Art and the Central School of Art and Design,
London. He has exhibited regularly since 1976 and his work includes
numerous pieces of figurative sculpture, notably portraits of his father,
Richard Dimbleby, for BBC Television Centre and Westminster Abbey.

255

256

Recent public commissions are Sylvia Plath (for Smith College, USA), James Cook (in Great Ayton, Yorkshire) and Duke Ellington (for Soho Square). JR

Leon Krier (born 1946)

255. *Garden seat with double back support*

Teak, 75.5 × 65 × 57 cm (29¾ × 25⅝ × 22½ in.)
PROVENANCE Commissioned by The Prince of Wales, 1995
REFERENCE *Perspectives on Gardens*, 1997, pp. 18–19

256. *Garden seat with single back support*

Teak, 72 x 80.5 x 70 cm (28⅜ x 31⅝ x 27½ in.)
PROVENANCE Commissioned by The Prince of Wales, 1996

The architect Leon Krier has described the circumstances surrounding the commission of the four chairs and bench that he designed for the garden at Highgrove: "HRH The Prince of Wales, having seen the catalogue of my furniture produced by Giorgetti (Italy), asked me to do sketches for garden seats and benches. Over the summer of 1994 I produced 11 doodles from which HRH chose 4. These 4 have been made by the furniture maker, Stephen Florence, at the rate of one per year." At the same time, Krier also produced the Poundbury bench (1996) and *Hortus* garden-chair designs (1997), which he describes as 'family' relations in character and construction. These were also produced by Stephen Florence, who works in Carmarthenshire. Krier has designed furniture for Giorgetti since 1991.

Krier was born in Luxembourg and studied in Stuttgart. From 1968 to 1974 he collaborated with James Stirling. His publications include *Architecture + Urban design 1967–1992* (1992) and *Architecture – Choice or Fate* (1998). In 1985 Krier sent The Prince material concerning his master-plan for the Federal City in Washington. They met the following

year, at the 'Real Architecture' exhibition, where Krier's plan for Spitalfields, London, was shown. Thereafter, the Prince has regularly sought Krier's advice on architecture and urbanism, and in 1988 Krier was invited by the Duchy of Cornwall to produce a master-plan for the Poundbury development outside Dorchester, Dorset; he has supervised the execution of the plan since construction commenced in 1994. JR

László Marton (born 1925)

257. *The little princess*

Bronze on marble plinth, height 63 cm (24⅞ in.)
PROVENANCE Presented by the artist to The Prince of Wales, 5 July 1993
REFERENCE Kratowill 1992

This figure is a portrait of Marton's eldest daughter. It was modelled in 1972 and served as the basis for a large-scale bronze figure (height 170 cm; 66¹⁵⁄₁₆ in.) on the Duna Corso, Budapest, completed in 1990. Another small bronze of *The little princess* (no. 1 of the edition) is in the Hungarian National Gallery, Budapest. The Prince of Wales's cast is the second of the edition. JR

258. *Torsion, 1993*

Carrara marble on green marble base, height 54 cm (21¼ in.)
Signed and dated on base *Marton L '93*
PROVENANCE Presented by the artist to The Prince of Wales, 1995
REFERENCE Tasnádi (ed.) 1996

Marton studied at the School of Applied Arts and the Academy of Fine Arts in Budapest. He has received numerous awards, including the Outstanding Artist Prize of the Hungarian People's Republic and the Order of Merit of the Hungarian Republic's Officer's Cross. There are

259

257

permanent exhibitions of his work in Budapest, Szigliget and Tapolca (his home town).

The Prince of Wales first encountered Marton's work during his visit to Hungary in 1990. Five years later, the Prince opened the first exhibition of Marton's work in England, at the Hannah Peschar Gallery and Sculpture Garden, Ockley, Surrey. Also in 1995, the sculptor modelled a portrait bust of Prince Charles, with the aid of photographs. *Torsion* was included in the 1995 exhibition, which had been shown at the Dominikanus Kerengó of the Budapest Hilton earlier in the same year. J R

David Wynne (born 1926)

259. *The goddess of the woods*

Bronze on marble base, height 55.5 cm (21⅞ in.)

PROVENANCE Preparatory maquette for the marble figure commissioned by The Prince of Wales, 1990

REFERENCE Wynne 1993, pp. 107–13, 116, 118

The commission for the large marble figure (106.5 cm; 41¹⁵⁄₁₆ in. high, of *rosso orbico* marble), for the woodland garden at Highgrove, followed a visit by The Prince of Wales and David Wynne to Tresco Abbey in 1990. The sculptor's marble figure entitled *Gaia* had recently been installed there and inspired the Prince to commission a similar figure for his own garden. Of the large-scale figure the sculptor wrote, "This carving was commissioned for a specific place in a quiet woodland garden, within an oak grove. The figure was to be similar in feeling to Gaia on Tresco, calm and still." The model for the Highgrove figure was Joanna Leighton. A second bronze maquette was exhibited by the sculptor at The Mall Galleries, London, in 1997.

David Wynne decided to become a sculptor in 1949 after studying zoology at Cambridge University and serving in the Royal Navy. He was encouraged in this decision by Jacob Epstein and received lessons from George Ehrlich. Wynne is best known for his freestanding sculpture (particularly animals: his *Boy with a Dolphin* is on the Thames Embankment) and for his portraits. In 1973 he sculpted a bronze head of The Prince of Wales in his investiture coronet; his bronze bust of HM The Queen (Royal Collection) was modelled in the same year.

In his foreword to a recent book on Wynne's work, Prince Charles describes the sculptor as "... a remarkable man with a remarkable, God-given talent for extraordinarily sensitive sculpture". J R

Appendix

PRINCELY HOUSES

Henry, Prince of Wales

RICHMOND PALACE, SURREY

The riverside palace granted to Prince Henry by James I in 1610 was substantially as built by Henry VII between 1497 and 1501, on the site of the ancient royal manor of Sheen. The royal lodgings were contained in a tall central block, articulated by numerous domed towers (see fig. 13, p. 23), with the remaining accommodation arranged around two courts on the landward side. In 1611 Salomon de Caux prepared designs for ornamental waterworks for the Office of the Prince's Works, but these were superseded by a far more elaborate scheme by Gostantino de' Servi for fountains, grottos, summer houses and galleries, and a colossal figure three times the size of the giant *Appennino* created by Giambologna for Francesco de' Medici at Pratolino. None of these works seems to have been started by the time of the Prince's death in 1612, when Richmond was made over to his younger brother, the future Charles I. The palace was demolished under the Commonwealth.
REFERENCE *King's Works*, IV, Part II, 1975, pp. 231–332; Strong 1986, pp. 107–08; Thurley 1993, pp. 27–32

ST JAMES'S PALACE, LONDON

St James's Palace was originally built by Henry VIII between 1531 and 1541 on the site of a medieval leper house. Apartments in the palace were given to Prince Henry by his father James I in 1604, following the precedent set by Henry VIII in lodging his own son Edward VI there. From 1604 until 1612 there were numerous additions in connection with the Prince's enthusiasms, including an indoor riding school, duck houses, a pheasantry, an "Artillarie house", and a richly decorated library for the reception of the Lumley-Arundel collection (see cat. 16). It was at St James's, the Prince's winter palace, that many of his finest pictures and works of art were kept, and in 1609–10 the Tudor long gallery was refurbished to accommodate them. Although Inigo Jones was appointed architect to Prince Henry in 1609, he does not seem to have been responsible for these projects, which were undertaken by the Office of the King's Works.
REFERENCE *King's Works*, IV, Part II, 1975, pp. 244–46

Frederick, Prince of Wales

CARLTON HOUSE, LONDON

Carlton House was first built in 1709 for Henry Boyle, Lord Carleton, at the eastern end of what had been the garden of St James's Palace (on what is now Waterloo Place). It was inherited in 1725 by Carleton's nephew Richard, 3rd Earl of Burlington, who put it at the disposal of his mother, the dowager Countess. Lady Burlington sold the house and its twelve-acre garden in 1733 to Prince Frederick (he had begun to use the house a year earlier), who employed William Kent to remodel the house to designs by Henry Flitcroft. Kent's work in the garden seems to have been the first appearance of his naturalistic style of landscaping. At its centre was an octagonal 'saloon', erected in 1735, and resembling Burlington's Chiswick House in miniature; externally a double stone staircase with busts by Rysbrack in niches to either side and, within, bold plasterwork by Isaac Mansfield and rich giltwood furniture by Benjamin Goodison.
REFERENCE Rorschach 1985, pp. 128–44
[see below under George, Prince of Wales]

KEW HOUSE (THE WHITE HOUSE), SURREY
A large Palladian house with a central, pedimented block of five bays, engaged two-bay blocks at either side, and long, single-storey wings at the ends, the White House (so called because of the colour of its austere stucco façade) was built to William Kent's designs between 1731 and 1735, on the site of a much smaller brick house leased for Prince Frederick in 1730. It stood opposite the seventeenth-century gabled brick house known as the Dutch House, which had been acquired by Frederick's mother, Queen Caroline, in 1728. The new house was fitted up by the same craftsmen whom the Prince employed on the garden saloon at Carlton House, here working on a far grander scale, with deep plaster cornices by Isaac Mansfield, and gilt furniture and carvings by Boson and Richards. These were combined with the contents of the old house, which the Prince had acquired from Lady Elizabeth St André in 1731. The White House was demolished in 1802–03.
REFERENCE *King's Works*, V, 1976, pp. 227–28; Rorschach 1985, pp. 144–75; Desmond 1995, p. 29; Harris 1996

CLIVEDEN, BUCKINGHAMSHIRE
Standing on a spectacular site on a cliff above the Thames at Taplow, Cliveden was built in the 1670s by the 2nd Duke of Buckingham, and remodelled by the Earl of Orkney in the early 1700s to designs by Thomas Archer. The house and its riverside demesne were leased by Prince Frederick from Lord Orkney's daughter in 1737, and remained in regular use until his death in 1751. Payments in the Prince's accounts to the carver and gilder Paul Petit for very sumptuous picture frames appear to apply to Cliveden, but the Prince made almost no architectural changes. It was here in 1741 that an elaborate outdoor entertainment, *The Masque of Alfred*, was staged for Frederick, with music by Thomas Arne and words by James Thomson, David Mallet and Lord Lyttelton. It celebrated the Patriot King who ruled by consent, the ideal with which the Prince of Wales was identified by his political supporters.
REFERENCE Rorschach 1985, pp. 184–91; National Trust 1994, pp. 12–19; Crathorne 1995, pp. 52–67

PARK PLACE, BERKSHIRE
A few miles from Cliveden, upstream on the Thames at Henley, Park Place was leased by the Prince of Wales from Lord Archibald Hamilton, who had built it soon after 1719. Lord Archibald was the Earl of Orkney's younger brother, and his wife Jane was the Prince's mistress and a member of the Princess' household from 1736. Prince Frederick does not seem to have left any mark on the house or grounds, using it purely for outdoor recreation. The estate was subsequently developed as a picturesque landscape by Henry Seymour Conway, who purchased it in 1752, after the Prince's death.
REFERENCE Millar 1963, p. 181; Rorschach 1985, pp. 181–83

NORFOLK HOUSE, LONDON
On the east side of St James's Square and close to Carlton House, Norfolk House was built (as St Albans House) by the Earl of St Albans in 1665–67, the first house to be erected in the Square. It was acquired for the 8th Duke of Norfolk in 1722. In 1737, following their ejection from St James's Palace by George II, the Prince of Wales and Princess Augusta took a lease from the 9th Duke, and it was here that the future King George III was born in the following year. Although Prince Frederick spent £2,500 on repairs, the house was still in a very poor state when he surrendered the lease in 1741, and it was completely reconstructed to designs by Matthew Brettingham between 1748 and 1751. This house was demolished in 1938.
REFERENCE *Survey of London*, XXIX, 1960, pp. 187–89; Rorschach 1985, pp. 175–77

LEICESTER HOUSE, LONDON
Built between 1631 and 1635 on what is now the north side of Leicester Square by Robert Sidney, 2nd Earl of Leicester (died 1677), Leicester House was a substantial thirteen-bay mansion with a hipped roof and a walled forecourt. Frederick, Prince of Wales took a fourteen-year lease in 1743, moving from the dilapidated Norfolk House, and it became his main London residence, just as it had served his mother and father from 1717 to 1727, after they had been dismissed from St James's Palace by George II. The Prince took great pleasure in the exchange of paintings and furniture between Leicester House and Carlton House, but among the fixtures here were the two huge canvases by Wootton, *The Siege of Lille* and *The Siege of Tournay*, in elaborate frames carved by John Boson and gilded by Paul Petit, which were hung on the staircase. This house was demolished *ca.* 1791–92.
REFERENCE Millar 1963, p. 182; *Survey of London*, XXIX, 1966, pp. 441–55; Rorschach 1985, pp. 177–80

George, Prince of Wales

CARLTON HOUSE, LONDON
[see above under Frederick, Prince of Wales]
Occupied by Augusta, Dowager Princess of Wales, until 1772, Carlton House was granted to her grandson George, Prince of Wales, in 1783, still essentially in the form it had assumed under Prince Frederick's architects in the 1730s, but by now much built-against to either side. Initial repairs were made under Sir William Chambers, but he was immediately succeeded by Henry Holland, under whom the first significant additions and alterations were made, including the creation of a proper entrance front on the north (Pall Mall) side (completed in 1794), and the Hall, Vestibule and Staircase, all in a French-inspired, Neoclassical taste. It was always a disadvantage that the house was built across a considerable slope, with a low-ceilinged basement floor on the garden front only, and Holland's work resolved several problems of internal planning. Holland was also in charge of the creation in 1795 of an apartment for the new Princess of Wales and her entourage. From 1804 to 1812, further transformations were made, much influenced by Walsh Porter, a connoisseur and friend of the Prince, who introduced the architects James Wyatt (1804–05) and Thomas Hopper (1805–12). During this period the most spectacular of the principal rooms were created, including the Crimson Drawing-room (1806), the Circular Dining-room (1807) and the Gothic Conservatory (1807–09). The Prince's decorators, principally Guillaume Gaubert and Dominique Daguerre, were engaged almost continuously on re-workings of decorative schemes; not only were wall hangings, paint colours and upholstery repeatedly changed, but even such features as chimneypieces were frequently moved, as many as five times, during the Prince's occupancy. The constant remodelling, often with undue haste, contributed to structural defects which led to the demolition of the house in 1827 under John Nash, and the re-incorporation of many of its contents and fittings in George IV's new state apartments at Windsor Castle and Buckingham Palace.
REFERENCE *King's Works*, VI, 1973, pp. 307–22; Stroud 1966, pp. 61–85; London 1991[3], *passim*

BRIGHTON PAVILION, SUSSEX
The Prince of Wales first visited Brighton in his twenty-second year, 1783, staying with his uncle the Duke of Cumberland, ostensibly for the benefit of his health. He acquired his own seaside establishment shortly afterwards, when his Clerk of the Kitchens, Louis Weltje, rented a farmhouse for him on

the Steine in the centre of the town. This was developed from 1787 by Henry Holland into a Marine Pavilion, with a central rotunda and two wings. Following the Prince's diversions into *chinoiserie* at Carlton House in the 1790s, there are tentative designs by Holland dating from 1801 for 'Chinese' embellishments on the exterior. However, the first fully-blown *chinoiserie* designs are by the firm of Crace for interior decorations in 1802, and for the exterior, by William Porden and Humphry Repton, in 1805. As it appears today the Pavilion is entirely as rebuilt under John Nash between 1815 and 1823, embracing many of the ideas of the earlier designs.

REFERENCE Morley 1984

Albert Edward, Prince of Wales

MARLBOROUGH HOUSE, LONDON

Built from 1709 to 1711 for John Churchill, Duke of Marlborough to designs by Sir Christopher Wren, Marlborough House stands on ground formerly occupied by the friary associated with Inigo Jones's Queen's Chapel at St James's. The staircase was decorated with views of the Duke's military triumphs by Louis Laguerre. Between 1771 and 1774 Sir William Chambers made a number of alterations for the 4th Duke of Marlborough. His family's lease expired in 1824. The first royal occupant was Prince Leopold of Saxe-Coburg-Saalfeld (1824–31), followed by Queen Adelaide (1837–49). After her death it was variously used as a museum for objects from Sir Henry Cole's Department of Practical Art, for the Normal Training School of Art, and as a home for surplus pictures from the National Gallery. In 1859 it was made available to the Prince of Wales on his coming-of-age and large-scale improvements were made under Sir James Pennethorne. Special attention was paid to the dining and reception rooms, and a new library. On the Prince's accession in 1901 several of his rooms, including the Indian Room and his study, were moved *en bloc* to Buckingham Palace.

REFERENCE Beavan 1896; Tyack 1992, pp. 232–41

SANDRINGHAM, NORFOLK

The Sandringham estate, near King's Lynn in Norfolk, was purchased in February 1862 in fulfilment of the wish of the recently deceased Prince Albert that the Prince of Wales should have a private country house on reaching the age of twenty-one. The house had been built in the late eighteenth century, and as soon as the Prince took up residence with his new bride Princess Alexandra in March 1863 it was found to be too small. The architect A.J. Humbert, who had worked for Prince Albert at Frogmore, and at Whippingham on the Osborne estate, produced designs for additions, but these were rejected in favour of total rebuilding in the 'Jacobethan' style between 1867 and 1873. Internally, the main rooms were baronial in character (but with a lighter approach to decoration in the drawing rooms), and there was also a bowling alley with *chinoiserie* murals. Further extensions, including a ballroom, were added in 1881–84 by a Norfolk architect, Col. Robert Edis. On the estate the Prince indulged to the full his love of shooting and established the Sandringham Stud, where his racehorses (including the winners of the 1896 and 1900 Derby) were bred.

REFERENCE Cole 1877

Charles, Prince of Wales

HIGHGROVE

The design of Highgrove, a compact stone house built between 1796 and 1798 for a Gloucestershire landowner, John Paul Esq., near Tetbury, has been attributed to Anthony Keck (1726–1797), who built the orangery at Margam in 1787–90. The house and 300 surrounding acres were acquired by the Duchy of Cornwall in 1980 from the late Maurice Macmillan. A pediment and balustrade were added to the house in 1987 by the architect Peter Falconer, based on suggestions by the artist Felix Kelly, and further embellishments were designed by William Bertram. The Prince of Wales's other improvements have been the development of the garden, and the conversion of the farmland to an organic regime.

REFERENCE HRH The Prince of Wales and Clover 1993

CONTRIBUTORS TO THE CATALOGUE

KB Kathryn Barron, FD Frances Dimond, MLE Mark Evans,
OF Oliver Fairclough, HG Helen Gray, CL Christopher Lloyd,
JM Jonathan Marsden, CN Charles Noble, HR Hugh Roberts,
JR Jane Roberts, BW Bridget Wright

The contributors wish to acknowledge the assistance of Mr De Witt Bailey (cats. 54–55, 114–16), Mr John Collins (cats. 17–18, 44), Dr Richard Edgcumbe (cats. 48–50), Mr John Kenworthy-Browne (cats. 67–70), Mr A.V.B. Norman (cats. 19, 117–18), Mr Peyton Skipwith (cat. 145), Dr Susan Stronge (cats. 155–64) and Mr Philip Ward-Jackson (cat. 142).

REFERENCES

MANUSCRIPTS IN ROYAL COLLECTIONS

Carlton House Arms Cat., 'A Catalogue of Arms. The Property of HRH The Prince of Wales at Carlton House', from the late 18th century to 1827

JUTSHAM I, 'An Account of Furniture &c. Received and Deliver'd by Benjamin Jutsham at Carlton House', 31 December 1806 21 June 1816 (receipts); 7 January 1807–October 1820 (deliveries)

JUTSHAM II, 'Ledger of furniture &c received by Benjamin Jutsham', 23 June 1816–7 December 1829

JUTSHAM III, 'Ledger of furniture &c delivered by Benjamin Jutsham', 23 October 1820–4 February 1830

PRINTED SOURCES

ALLEN 1987 B. Allen, *Francis Hayman*, New Haven and London 1987

ALTICK 1985 R.D. Altick, *Paintings from Books: Art and Literature in Britain, 1760–1900*, Columbus 1985

ARCH (forthcoming) N. Arch, *Arms and Armour in the Collection of Her Majesty The Queen: Uniforms and Militaria* (forthcoming)

ARTS COUNCIL 1974 Arts Council of Great Britain, *British Sporting Painting 1650–1850*, exh. cat., London 1974

ASPINALL A. Aspinall, *The Correspondence of George, Prince of Wales 1770–1812*, 8 vols., London 1963–1971

AUBRUN 1985 M.-M. Aubrun, *Jules Bastien-Lepage 1848–1884*, n.p. 1985

AUERBACH 1961 E. Auerbach, *Nicholas Hilliard*, London 1961

AVERY AND RADCLIFFE 1978 C. Avery and A. Radcliffe, edd., *Giambologna: Sculptor to the Medici*, exh. cat., London, Edinburgh and Vienna 1978

AYLIFFE 1994 R. Ayliffe, M. Dubin and J. Gawthrop, *Turkey, The Rough Guide*, London 1994

BALL 1985 J. Ball, *Paul and Thomas Sandby*, Cheddar 1985

BARR 1980 E. Barr, *George Wickes, Royal Goldsmith 1698–1761*, London 1980

BARRINGTON 1906 E. Barrington, *Life, Letters and Work of Frederic Leighton*, 2 vols., London 1906

BASHKIRTSEFF 1890 M. Bashkirtseff, *Journal*, London 1890

BAULEZ 1987 C. Baulez, 'Le Goût Turc', *L'Objet d'Art*, no. 2, December 1987, pp. 35–42

BAYNE-POWELL 1985 R. Bayne-Powell, *Catalogue of Portrait Miniatures in the Fitzwilliam Museum, Cambridge*, Cambridge 1985

BEATTIE 1983 S. Beattie, *The New Sculpture*, London 1983

BEAVAN 1896 A.H. Beavan, *Marlborough House and its Occupants, Present and Past*, London 1896

DE BELLAIGUE 1967 G. de Bellaigue, 'The Furnishings of the Chinese Drawing Room, Carlton House', *The Burlington Magazine*, September 1967, pp. 518–28

DE BELLAIGUE 1977 G. de Bellaigue, 'A Diplomatic Gift', *The Connoisseur*, CXCV, 1977, pp. 92–99

DE BELLAIGUE 1986 G. de Bellaigue, *Sèvres Porcelain in the Collection of Her Majesty the Queen: The Louis XVI Service*, Cambridge 1986

DE BELLAIGUE 1990 G. de Bellaigue, 'The Crimson Drawing Room, Carlton House', *Furniture History*, 1990, pp. 10–19

DE BELLAIGUE 1995 G. de Bellaigue, 'Daguerre and England' in *Bernard Molitor*, exh. cat., Luxembourg 1995

BINNS 1865 R.W. Binns, *A Century of Potting in the City of Worcester, being the History of the Royal Porcelain Works from 1751 to 1851*, London 1865

BIRRELL 1986 T.A. Birrell, *English Monarchs and their Books* (Panizzi Lectures, 1986), London 1987

BLACKMORE 1968 Howard L. Blackmore, *Royal Sporting Guns at Windsor*, London 1968

BLANCHE 1937 J.-E. Blanche, *Portraits of a Lifetime*, London 1937

BLUNT 1945 A. Blunt, *The French Drawings in the Collection of His Majesty The King at Windsor Castle*, Oxford and London 1945

BLUNT 1976 A. Blunt, 'The Massimi Collection of Poussin Drawings in the Royal Library at Windsor Castle', *Master Drawings*, XIV, 1976, pp. 3–31

BOISCLAIR 1986 M. Boisclair, *Gaspard Dughet. Sa vie et son œuvre (1615–1675)*, Paris 1986

BRIGSTOCKE 1996 H. Brigstocke, 'Nicolas Poussin', *The Dictionary of Art*, London 1996, XXV, pp. 385–97

BROWN 1991 C. Brown, J. Kelch and P. van Thiel, *Rembrandt: the Master and his Workshop*, exh. cat., New Haven and London 1991

BROWN 1985 D.B. Brown, *Sir David Wilkie*, exh. cat., Ashmolean Museum, Oxford, 1985

BRUSSELS 1980 Brussels, Palais des Beaux-Arts, *Bruegel: Un dynastie des peintres*, exh. cat. 1980

BUDDLE 1989 A. Buddle, 'The Tipu Mania: narrative sketches of the conquest of Mysore', in *India: a Pageant of Prints*, ed. P. Rohatgi, Bombay 1989

BUDGE 1895 E.A. Budge, *The Nile, Notes for Travellers*, London 1895

BUTTERY 1987 D. Buttery, 'The Picture Frames of Paul Petit, and Frederick, Prince of Wales', *Apollo*, CXXVI, July 1987, pp. 12–15

CADET 1986 P. Cadet, *Susse Frères: 150 Years of Sculpture*, Paris 1996

CAMPBELL 1985 L. Campbell, *The Early Flemish Pictures in the Collection of Her Majesty The Queen*, Cambridge 1985

CARDIFF 1991 Cardiff, National Museum of Wales, *The Royal Collection Paintings from Windsor Castle*, exh. cat. 1991

CARR 1912 C. Carr, ed., *Harriet Hosmer: Letters and Memories*, New York 1912

CASTIGLIONE 1994 B. Castiglione, trans T. Hoby and ed. V. Cox, *The Book of the Courtier*, London and Vermont 1994

CAZZULANI AND STROPPA 1989 E. Cazzulani and A. Stroppa, *Maria Hadfield Cosway: Biografia, diari e scritti delle fondatrice del Collegio delle Dame Inglesi in Lodi*, Orio Litta 1989

CHANDLER 1966 D.G. Chandler, *The Campaigns of Napoleon*, New York 1966

CLAPP AND LEHNI 1992 Clapp and N. Lehni, 'Une introduction à la sculpture de Gustave Doré', *Bulletin de la Société de l'Histoire de l'Art français, Année 1991*, 1992

CLAYTON 1995 M. Clayton, *Poussin: Works on paper*, exh. cat., London 1995

COLE 1877 A.S. Cole, *A Catalogue of the Works of Art at Marlborough House, London, and at Sandringham, Norfolk, belonging to their Royal Highnesses the Prince and Princess of Wales*, London 1877

COOKE 1997 B. Cooke, *The Grand Crimean Central Railway*, 1997

COOMBS 1997 D. Coombs, 'The Garden at Carlton House of Frederick Prince of Wales and Augusta Princess Dowager of Wales', *Garden History*, XXV, no. 2, 1997, pp. 153–77

COPENHAGEN 1988 Copenhagen, Rosenborg etc, *Christian IV and Europe*, exh. cat., ed. S. Heiberg, 1988

CRATHORNE 1995 J. Crathorne, *Cliveden, the Place and its People*, London 1995

CUNNINGHAM 1830 A. Cunningham, *The Lives of the Most Eminent British Painters, Sculptors and Architects*, 5 vols., London 1830

CURL 1982 J.S. Curl, *The Egyptian Revival*, London 1982

CUST 1918 L. Cust, 'The Lumley Inventories', *The Walpole Society*, vol. 6, 1918, pp. 15–35

DAVENPORT 1896 C. Davenport, *Royal English Bookbindings*, London 1896

DAWSON 1980 A. Dawson, 'The Eden service: Another Diplomatic Gift', *Apollo*, CXI, 1980, pp. 288–97

DESMOND 1995 R. Desmond, *Kew: the History of the Royal Botanic Gardens*, London 1995

DICTIONARY 1986 *Dictionary of English Furniture Makers 1660–1840*, edd. G. Beard and C. Gilbert, Leeds 1986

DIMOND AND TAYLOR 1987 F. Dimond and R. Taylor, *Crown and Camera*, Harmondsworth 1987

EDINBURGH 1965 Edinburgh, Scottish Arts Council Gallery, *British Portrait Miniatures*, exh. cat. 1965

EDINBURGH 1975 Edinburgh, Scottish Arts Council Gallery, *A Kind of Gentle Painting. Miniatures by the Elizabethan Court Artists Nicholas Hilliard and Isaac Oliver*, exh. cat. 1975

EDINBURGH 1995 Edinburgh, Scottish National Portrait Gallery, and London, National Portrait Gallery, *Richard and Maria Cosway. Regency Artists of Taste and Fashion*, exh. cat. 1995

EDINBURGH 1997 Edinburgh, Scottish National Portrait Gallery, *The Face of Denmark*, exh. cat. 1997

EDMOND 1983 M. Edmond, *Hilliard and Oliver: The Lives and Works of Two Great Miniaturists*, London 1983

EDWARDS 1948 R. Edwards, 'Mercier's Music Party', *The Burlington Magazine*, XC, 1948, pp. 308–12

EDWARDS AND JOURDAIN 1955 R. Edwards and M. Jourdain, *Georgian Cabinet-Makers*, rev. edn., London 1955

EHRMANN 1979 J. Ehrmann, 'Hans Vredeman de Vries', *Gazette de Beaux-Arts*, XCIII, 1979, pp. 13–26

ERTZ 1979 K. Ertz, *Jan Brueghel der Ältere*, Cologne 1979

FARINGTON *The Diary of Joseph Farington* (ed. K. Cave), XIII, New Haven and London 1985

FINSTEN 1981 J. Finsten, *Isaac Oliver*, 2 vols., London and New York 1981

FLETCHER 1895 W.Y. Fletcher, *English Bookbindings in the British Museum*, London 1895

FOISTER 1983 S. Foister, *Drawings by Holbein from the Royal Library, Windsor Castle*, London 1983

FOOT 1993 M.M. Foot, *Studies in the History of Bookbinding*, London 1993

FORREST 1970 D. Forrest, *Tiger of Mysore. The Life and Death of Tipu Sultan*, London 1970

FORSTER 1848 H.R. Forster, *The Stowe Catalogue, priced and annotated*, London 1848

FOX 1992 C. Fox (ed.), *London – World City 1800–1840*, New Haven 1992

FRANKFURT 1988 Frankfurt, Schirn Kunsthalle, *Guido Reni und Europa*, exh. cat. 1988

FREDERIKSBORG 1990 Frederiksborg, Nationalhistoriske Museum, *Laurits Tuxen Portraetter og historiemalerier*, exh. cat. 1990

FRIEDLÄNDER 1929 W. Friedländer, 'The Massimi Poussin Drawings at Windsor', *The Burlington Magazine*, LIV, 1929, pp. 116–28 and 252–58

FUSELI 1830 H. Fuseli, *Lectures on Painting*, London 1830

GERNSHEIM 1954 H. and A. Gernsheim, *Roger Fenton, Photographer of the Crimean War*, London 1954

GERNSHEIM 1987 H. and A. Gernsheim, *The Rise of Photography, 1850–1880*, London 1987

GERSON AND TER KUILE 1960 H. Gerson and E.H. Ter Kuile, *Art and Architecture in Belgium 1600 to 1800*, Harmondsworth 1960

GERSZI AND GONDA 1994 T. Gerszi and Z. Gonda, *Nineteenth-Century German, Austrian and Hungarian Drawings from Budapest*, Alexandria VA 1994

GODDEN 1982 G.A. Godden, *Chamberlain-Worcester Porcelain*, London 1982

GODFREY 1994 R.T. Godfrey, *Wenceslaus Hollar*, New Haven and London 1994

GOLD AND FIZDALE 1992 A. Gold and R. Fizdale, *The Divine Sarah*, London 1992

GOODDEN 1997 A. Goodden, *The Sweetness of Life. A Biography of Elisabeth Louise Vigée Le Brun*, London 1997

GRANDJEAN 1975 S. Grandjean, K. Aschengreen Piacenti, C. Truman, A. Blunt, *Gold Boxes and Miniatures of the Eighteenth Century: The James A. de Rothschild Collection at Waddesdon Manor*, Fribourg 1975

GRIMWADE 1969 A. Grimwade, 'Crespin or Sprimont? An unsolved problem of Rococo silver', *Apollo*, August 1969, pp. 126–28

GUBERNATIS 1889 A. de Gubernatis, *Dizionario degli artisti italiani viventi*, 1889

HALE 1990 J.R. Hale, *Artists and Warfare in the Renaissance*, New Haven and London 1990

HALL 1986 M. Hall, 'The Chartres Forth service, Philippe Egalité's lavish gift', *Apollo*, XCIII, 1986, pp. 386–89

HALSBY 1995 J. Halsby, *The Art of Diana Armfield*, Newton Abbot 1995

HAMBER 1996 A. Hamber, *A Higher Branch of Art*, Amsterdam 1996

HARRIS 1970 J. Harris, *Sir William Chambers*, London 1970

HARRIS 1996 J. Harris, 'Sir William Chambers and Kew Gardens', in J. Harris and M. Snodin (edd.), *Sir William Chambers, Architect to George III*, exh. cat., Somerset House, London, 1996, pp. 55–67

HARRIS, DE BELLAIGUE, MILLAR 1968 J. Harris, G. de Bellaigue, O. Millar, *Buckingham Palace*, London 1968

HASPELS 1987 J.J.L. Haspels, *Automatic Musical Instruments, their Mechanics and their Music 1580–1820*, Koedijk 1987

HASWELL MILLAR AND DAWNAY 1966 AND 1970 A.E. Haswell Miller and N.P. Dawnay, *Military Drawings in the Collection of Her Majesty The Queen*, 2 vols., London 1966 and 1970

HEIM / MALLETT 1965 Galerie Heim/Mallett at Bourdon House, *Jules Dalou (1838–1902)*, exh. cat. 1965

HELD 1982 J. Held (edd. A.W. Lowenthal, D. Rosand and J. Walsh), *Rubens and his Circle: Studies by Julius S. Held*, Princeton 1982

HIBBERT 1976 C. Hibbert, *Edward VII*, London 1976

HILLIARD 1983 N. Hilliard (edd. A.F. Kinney and L.B. Salamon), *Nicholas Hilliard's Art of Limning*, Boston 1983

HIND 1955 A. Hind, *Engraving in England in the Sixteenth and Seventeenth Centuries, Part 2. The Reign of James I*, Cambridge 1955

HOBSON 1940 G.D. Hobson (ed.), *English Bindings in the Library of J.R. Abbey*, London 1940

HOFSTEDE DE GROOT C. Hofstede de Groot, *A Catalogue Raisonné of the Works of the Most Eminent Dutch Painters of the Seventeenth Century*, 8 vols., London 1908–27

HOLLSTEIN 1997 F.W.H. Hollstein, *Dutch and Flemish Etchings, Engravings and Woodcuts 1450–1700*, XLVII, *Vredeman de Vries* (comp. P. Fuhring, ed. Ger Luijten), Parts I and II, Rotterdam 1997

HOLMES 1893 R.R. Holmes, *Specimens of Royal, Fine, and Historical Bookbinding Selected from the Royal Library, Windsor Castle*, London 1893

HOLMES 1906 R.R. Holmes, 'The English Miniature Painters Illustrated by Works in the Royal and Other Collections, III: Isaac Oliver', *The Burlington Magazine*, IX, 1906, pp. 22–29

HONG KONG 1995 Hong Kong, Sai Kung, *Nicholas Dimbleby. Sculpture by the South China Sea*, exh. cat. December 1995

HOPE 1913 W.H. St John Hope, *Windsor Castle: an Architectural History*, 2 vols., London 1913

HOUGH 1992 R. Hough, *Edward and Alexandra*, London 1992

HOWARTH 1997 D. Howarth, *Images of Rule, Art and Politics in the English Renaissance*, Berkeley 1997

INGAMELLS AND RAINES 1978 J. Ingamells and R. Raines, 'A Catalogue of the Paintings, Drawings and Etchings of Philip Mercier', *The Walpole Society*, vol. 46, 1978, pp. 1–70

JONES 1911 A. Jones, *The Gold and Silver of Windsor Castle*, London 1911

JOPLING 1925 L. Jopling, *Twenty Years of My Life*, London 1925

JOTTRAND 1972 M. Jottrand, 'Porcelaines de Tournai. Les services du duc d'Orléans et de Mgr de Salm-Reifferscheid', *Cahiers de Mariemont*, III, 1972, pp. 53–57

JOY, HOLLAND E.T. Joy, *Holland & Sons: A Victorian Furnishing Firm* (unpublished typescript, Victoria and Albert Museum, Department of Furniture & Interior Design)

KENWORTHY-BROWNE 1995 J. Kenworthy-Browne, 'The Sculpture Gallery at Woburn Abbey and the Architecture of the Temple of The Graces', in *The Three Graces*, exh. cat., Edinburgh 1995

KERSLAKE 1977 J. Kerslake, *National Portrait Gallery: Early Georgian Portraits*, 2 vols., London 1977

KING'S WORKS *The History of the King's Works* (ed. H.M. Colvin), vols. 1–6, London 1963–82

KRATOWILL 1992 M. Kratowill, *Marton László*, Budapest 1992

KRIZ 1997 K.D. Kriz, *The Idea of the English Landscape Painter*, New Haven and London 1997

LAKING 1904 G.F. Laking, *The Armoury of Windsor Castle*, London 1904

LARSEN 1988 E. Larsen, *The Paintings of Anthony Van Dyck*, 2 vols., Freren 1988

LEE 1925 S. Lee, *King Edward VII. A Biography*, I, London 1925

LEVEY 1991 M. Levey, *The Later Italian Pictures in the Collection of Her Majesty The Queen*, Cambridge 1991

LIVERPOOL 1977 *Walter Art Gallery: Foreign Catalogue*, Liverpool 1977

LLOYD 1994 C. Lloyd, *The Queen's Pictures: Old Masters from the Royal Collection*, London 1994

LONDON 1862 London, South Kensington Museum, *Special Loan Exhibition of Works of Art*, exh. cat., June 1862

LONDON 1910 London, British Museum, *The Sculptures on the Parthenon*, London 1910

LONDON 1935 London, Royal Academy, *Commemorative Catalogue of the Exhibition of British Art 1934*, exh. cat. 1935

LONDON 1946 London, Royal Academy, *The King's Pictures*, exh. cat. 1946

LONDON 1947 London, Victoria and Albert Museum, *Nicholas Hilliard and Isaac Oliver*, exh. cat. 1947

LONDON 1953[1] London, Royal Academy, *Flemish Art 1300–1700*, exh. cat. 1953

LONDON 1953[2] London, Royal Academy, *Kings and Queens*, exh. cat. 1953

LONDON 1956 London, Royal Academy, *British Portraits*, exh. cat. 1956

LONDON 1960 London, Royal Academy, *Italian Art and Britain*, exh. cat. 1960

LONDON 1962 London, Queen's Gallery, *Treasures from the Royal Collection*, exh. cat. 1962

LONDON 1966[1] London, Queen's Gallery, *George IV and the Arts of France*, exh. cat. 1966

LONDON 1966[2] London, Queen's Gallery, *Animal Painting: Van Dyck to Nolan*, exh. cat. 1966

LONDON 1968 London, Queen's Gallery, *Van Dyck, Wenceslaus Hollar and The Miniature – Painters at the court of the early Stuarts*, exh. cat. 1968

LONDON 1969 London, Hayward Gallery, *The Art of Claude Lorrain*, exh. cat. 1969

LONDON 1970 London, Queen's Gallery, *Gainsborough, Paul Sandby and Miniature Painters in the Service of George III and his Family*, exh. cat. 1970

LONDON 1971 London, Queen's Gallery, *Dutch Pictures from the Royal Collection*, exh. cat. 1971

LONDON 1972 London, Tate Gallery, *The Age of Charles I. Painting in England 1620–1649*, exh. cat. 1972

LONDON 1974 London, Queen's Gallery, *George III Collector and Patron*, exh. cat. 1974

LONDON 1976 London, National Portrait Gallery, *John Zoffany 1733–1810*, exh. cat. 1976

LONDON 1977[1] London, Queen's Gallery, *The Queen's Pictures*, exh. cat. 1977

LONDON 1977[2] London, South London Art Gallery, *Val Prinsep*, exh. cat. 1977

LONDON 1978 London, Queen's Gallery, *Holbein and the Court of Henry VIII*, exh. cat. 1978

LONDON 1979 London, Queen's Gallery, *Sèvres Porcelain from the Royal Collection*, exh. cat. 1979

LONDON 1980 London, Kenwood House, The Iveagh Bequest, *Gaspard Dughet called Gaspar Poussin 1615–75. A French Landscape painter in seventeenth century Rome and his influence on British art*, exh. cat. 1980

LONDON 1982 London, Queen's Gallery, *Kings and Queens*, exh. cat. 1982

LONDON 1983 London, Victoria and Albert Museum, *Artists of the Tudor Court*, exh. cat. 1983

LONDON 1984[1] London, Victoria and Albert Museum, *Rococo: Art and Design in Hogarth's England*, exh. cat. 1984

LONDON 1984[2] London, Tate Gallery, and Yale Center for British Art, New Haven, *George Stubbs, 1724–1806*, exh. cat. 1984

LONDON 1984[3] London, Contemporary Portrait Society, *Military Portraits*, exh. cat. 1984

LONDON 1984[4] London, Museum of London, *Paintings, Politics and Poster: Samuel Whitbread II and British Art*, exh. cat. by S. Deuchar, 1984

LONDON 1985[1] London, National Army Museum, *Soldiers then in Battle*, exh. cat. 1985

LONDON 1985[2] London, Hayward Gallery, *Renoir*, exh. cat. 1985

LONDON 1986 London, National Portrait Gallery, *Elizabeth II: Portraits of Sixty Years*, exh. cat. 1986

LONDON 1988[1] London, Queen's Gallery, *Treasures from the Royal Collection*, exh. cat. 1988

LONDON 1988[2] London, Albemarle Gallery, *John Napper: Recent Paintings*, exh. cat. 1988

LONDON 1989 London, Henry Wyndham Fine Art, *British Contemporary Paintings and Watercolours*, exh. cat. 1989

LONDON 1990 London, Queen's Gallery, *A Royal Miscellany from the Royal Library*, Windsor Castle, exh. cat. 1990

LONDON 1991[1] London, National Maritime Museum, *Henry VIII: A European Court in England*, exh. cat. 1991

LONDON 1991[2] London, National Gallery, *The Queen's Pictures*, exh. cat. 1991

LONDON 1991[3] London, Queen's Gallery, Carlton House: *The Past Glories of George IV's Palace*, exh. cat. 1991

LONDON 1991[4] London, Agnew's, *Peter Kuhfeld – Recent Paintings*, exh. cat 1991

LONDON 1991[5] London, Albemarle Gallery, *John Napper: Recent Paintings*, exh. cat. 1991

LONDON 1992 London, J.S. Maas & Son Ltd., *John Sergeant, Recent Works*, exh. cat. 1992

LONDON 1993 London, Gillian Jason Gallery, *John Napper: Notes for a Modern Mythology*, exh. cat. 1993

LONDON 1994 London, Queen's Gallery, *Gainsborough and Reynolds. Contrasts in Royal Patronage*, exh. cat. 1994

LONDON 1995[1] London, National Gallery, *In Trust for the Nation: Paintings from National Trust Houses*, exh. cat. 1995

LONDON 1995[2] London, Tate Gallery, *Dynasties: Painting in Tudor and Jacobean England 1530–1630*, exh. cat. 1995

LONDON 1995[3] London, Queen's Gallery, *Fabergé*, exh. cat. 1995

LONDON 1996[1] London, National Gallery, *Making and Meaning: Rubens's Landscapes*, exh. cat. 1996

LONDON 1996[2] London, Royal Academy, *Frederic Leighton*, exh. cat. 1996

LONG 1929 B. Long, *British Miniaturists*, London 1929

LOS ANGELES 1980 Los Angeles County Museum; Minneapolis Institute of Arts; Indianopolis Museum of Art, *The Romantics to Rodin. French Nineteenth-Century Sculpture from North American Collections*, exh. cat. 1980

LUDLOW 1994 Ludlow, *John Napper*, exh. cat. 1994

MCCLURE 1992 I. McClure, 'Henry, Prince of Wales on Horseback', in *The Art of the Conservator*, ed. A. Oddy, London 1992, pp. 59–72

MCCONKEY 1978 K. McConkey, 'The Bougereau of the Naturalists: Bastien Lepage and British Art', *Art History*, I, no.3, September 1978, pp. 371–82

MCCONKEY 1984 K. McConkey, 'After Holbein: A Study of Jules Bastien-Lepage's Portrait of the Prince of Wales', *Arts Magazine*, October 1984, pp. 103–07

MCCONKEY 1987 K. McConkey, *Edwardian Portraits: Images of an Era of Opulence*, Woodbridge 1987

MCGRATH 1997 E. McGrath, *Corpus Rubensianum*, Part 13 (1), *Subjects from History*, 2 vols., London 1997

MACGREGOR 1983 A. MacGregor (ed.), *Tradescant's Rarities*, Oxford 1983

MACGREGOR 1989 A. MacGregor (ed.), *The Late King's Goods*, London and Oxford 1989

MCKAY AND ROBERTS 1914 W. McKay and W. Roberts, *John Hoppner, R.A.*, London 1914

MACHYNLLETH 1993 Machynlleth, Powys, Tabernacle Cultural Centre, *John Napper: Paintings 1983–1993*, exh. cat. 1993

MAGNUS 1964 P. Magnus, *King Edward the Seventh*, London, 1964

MANCHESTER 1961 Manchester, City Art Gallery, *German Art 1400–1800*, exh. cat. 1961

MANCHESTER 1965 Manchester, City Art Gallery, *Between Renaissance and Baroque: European Art 1520–1600*, exh. cat. 1965

MANCHESTER 1973 Manchester NH, Currier Gallery of Art; Burlington, Robert Hull Fleming Museum; Ithaca, Herbert F. Johnson Museum, *George Loring Brown: Landscapes of Europe and America 1834–1880*, exh. cat., ed. T. Leavitt, 1973

MANWARING 1925 E.W. Manwaring, *Italian Landscape in Eighteenth Century England. A Study Chiefly of the Influence of Claude Lorrain and Salvator Rosa on English Taste 1700–1800*, New York 1925

MARLBOROUGH HOUSE 1898 *Catalogue of the Collection of Indian Arms and Objects of Art ... at Marlborough House*, London 1898

MÉROT 1987 A. Mérot, *Eustache Le Sueur 1616–1655*, Paris 1987

MILES AND BROWN 1987 H.A.D. Miles and D.B. Brown, *Sir David Wilkie of Scotland*, North Carolina Museum of Art, Raleigh, exh. cat. 1987

MILLAR 1960 D. Millar, 'Abraham Van der Doort's Catalogue of the Collections of Charles I', *The Walpole Society*, vol. 37, 1995

MILLAR 1963 O. Millar, *The Tudor, Stuart and Early Georgian Pictures in the Collection of Her Majesty The Queen*, 2 vols., London 1963

MILLAR 1969 O. Millar, *The Later Georgian Pictures in the Collection of Her Majesty The Queen*, 2 vols., London 1969

MILLAR 1977 O. Millar, *The Queen's Pictures*, London 1977

MILLAR 1986 O. Millar, 'George IV when Prince of Wales: his debts to artists and craftsmen'. Documents for the History of Collecting: 2, *The Burlington Magazine*, CXXVIII, 1986, pp. 586–92

MILLAR 1992 O. Millar, *The Victorian Paintings in the Collection of Her Majesty The Queen*, 2 vols., Cambridge 1992

MILLAR 1995 D. Millar, *The Victorian Watercolours and Drawings in the Collection of Her Majesty The Queen*, 2 vols., London 1995

MITCHELL 1997 S. Mitchell, 'The Sun Sets on Hong Kong', *Country Life*, 17 July 1997, pp. 74–77

MOORE 1996 A. Moore (ed.), *Houghton Hall: The Prime Minister, The Empress and the Heritage*, exh. cat. London 1996

MORLEY 1984 J. Morley, *The Making of the Royal Pavilion, Brighton*, London 1984

MURRAY 1900 A.S. Murray, *The Sculptures of the Parthenon*, London 1900

MURRAY 1880 J. Murray, *A Handbook for Travellers in Egypt*, 2 pts., London 1880

MURRAY 1905¹ J. Murray, *A Hand-Book for Travellers in Constantinople, Bursa, and the Troad*, London 1905

MURRAY 1905² J. Murray, *A Handbook for Travellers in Greece*, London 1905

MURRAY AND WILKINSON 1867 J. Murray and I. Gardner Wilkinson, *A Handbook for Travellers in Egypt*, London 1867

MURRELL 1983 J. Murrell, *The Way How to Lymne*, London 1983

NATIONAL TRUST 1994 The National Trust, *Cliveden*, London 1994

NATIONAL TRUST 1997 The National Trust, *Stowe Landscape Gardens*, London 1997

NEW HAVEN 1985 New Haven, Yale Center for British Art, *The Art of Paul Sandby*, exh. cat. 1985

NEW YORK 1996 New York, Metropolitan Museum of Art; Los Angeles, Huntington Library; Richmond, Virginia Museum of Fine Arts, and London, The Queen's Gallery, *Masterpieces in Little. Portrait Miniatures from the Collection of Her Majesty Queen Elizabeth II*, exh. cat. 1996

NEW YORK 1997 New York, Christie's, *Antiquity Revisited: English and French Silver-Gilt from the Collection of Audrey Love*, exh. cat. 1994

NIXON 1953 H.M. Nixon, *Twelve Books in Fine Bindings from the Library of J.W. Hely-Hutchinson*, Oxford (Roxburghe Club) 1953

NIXON 1978 H.M. Nixon, *Five Centuries of English Bookbinding*, London 1978

NORMAN (forthcoming) A.V.B. Norman, *Arms and Armour in the Collection of Her Majesty Queen Elizabeth II*, vol. I, forthcoming

OPPÉ 1947 A.P. Oppé, *The Drawings of Paul and Thomas Sandby in the Collection of His Majesty the King at Windsor Castle*, London 1947

OPPÉ 1950 A.P. Oppé, *English Drawings (Stuart and Georgian Periods) in the Collection of His Majesty the King at Windsor Castle*, London 1950

ORGEL AND STRONG 1974 S. Orgel and R. Strong, *Inigo Jones: The Theatre of the Stuart Court*, 2 vols., London, Berkeley and Los Angeles 1974

ORMOND 1975 L. and R. Ormond, *Lord Leighton*, London 1975

OTTOMEYER AND PRÖSCHEL 1986 H. Ottomeyer and P. Pröschel, *Vergoldete Bronzen. Die Bronzearbeiten des Spätbarock und Klassizismus*, 2 vols., Munich 1986

PARIS 1985 Paris, Institut Néerlandais, *Le Héraut du dix-septième siècle: Dessins et gravures de Jacques de Gheyn II et III*, exh. cat. 1985

PARIS 1994¹ Paris, Louvre; Ottawa, Musée des Beaux-arts du Canada; Vienna, Kunsthistorisches Museum, *Egyptomania: L'Egypte dans l'art occidental 1730–1930*, exh. cat. 1994

PARIS 1994² Paris, Grand Palais, *Le Soleil et l'étoile du Nord. La France et la Suède au XVIIIe siècle*, exh. cat. 1994

PARIS 1997 Paris, Unesco, *Derek Hill at Unesco*, exh. cat. 1997

PARKER 1945 K.T. Parker, *The Drawings of Holbein at Windsor Castle*, Oxford and London 1945

PEMBROKE 1968 Sidney, 16th Earl of Pembroke, *A Catalogue of the Paintings and Drawings at Wilton House*, London and New York 1968

PEPPER 1984 D.S. Pepper, *Guido Reni*, Oxford 1984

PERSPECTIVES 1997 *Perspectives on Gardens*, June/July 1997, pp. 18–19

PETWORTH 1994 Petworth House, Sussex, and Francis Kyle Gallery, London, *Hugh Buchanan. Watercolours 1984–1994*, exh. cat. 1994

PHILADELPHIA 1984 Philadelphia, Museum of Art, *Masterpieces of Seventeenth Century Dutch Genre Painting*, exh. cat. 1984

PILGER 1974 A. Pigler, *Barockthemen*, 3 vols., Budapest 1974

PIPER 1963 D. Piper, *Catalogue of Seventeenth-Century Portraits in the National Portrait Gallery*, Cambridge 1963

POSNER 1971 D. Posner, *Annibale Carracci*, 2 vols., London 1971

PRAGUE 1997 Prague, Prague Castle, *Rudolf II and Prague: The Court and the City*, exh. cat., edd. E. Fuciková et al., 1997

VAN PUYVELDE 1944 L. van Puyvelde, *The Dutch Drawings in the Collection of His Majesty The King at Windsor Castle*, London and Oxford 1944

RAYNER 1977 P.M. Rayner, *Thomas Goode of London 1827–1977*, London 1987

REID 1993 J. Davidson Reid, *Classical Mythology in the Arts*, 2 vols., New York and Oxford 1993

REISS 1975 S. Reiss, *Aelbert Cuyp*, London 1975

REYNOLDS 1952–54 G. Reynolds, 'Portraits by Nicholas Hilliard and his Assistants of King James I and his Family', *Walpole Society*, vol. 34, 1952–54, pp. 14–26

REYNOLDS 1983 G. Reynolds, 'The English Miniature of the Renaissance: A Rediscovery Examined', *Apollo*, CXVII, 1983, pp. 308–11

REYNOLDS 1988 G. Reynolds, *English Portrait-Miniatures*, 2nd. edn. Cambridge 1988

REYNOLDS (forthcoming) G. Reynolds, *The Sixteenth- and Seventeenth-Century Miniatures in the Collection of Her Majesty The Queen* (forthcoming)

REYNOLDS 1975 J. Reynolds (ed. R.R. Wark), *Discourses on Art*, New Haven and London 1975

RICHARDSON 1725 J. Richardson, *An Essay on the Theory of Painting*, London 1725

ROBERTS 1855–56 D. Roberts, *David Roberts' Holy Land*, 3 vols., London 1855–56

ROBERTS 1987 J. Roberts, *Royal Artists from Mary Queen of Scots to the Present Day*, London 1987

ROBERTS 1995[1] H.A. Roberts, 'So Beautiful a Style', *Country Life*, 23 November 1995, pp. 58–59

ROBERTS 1995[2] J. Roberts, *Views of Windsor: Watercolours by Thomas and Paul Sandby*, exh. cat., London 1995

ROOSEVELT 1885 B. Roosevelt, *Gustave Doré*, London 1885

RORSCHACH 1985 K. Rorschach, *Frederick, Prince of Wales (1707–1751) as a patron of the visual arts*, PhD thesis, Yale University, 1985

RORSCHACH 1989–90 K. Rorschach, 'Frederick, Prince of Wales (1709–1751) as Collector and Patron', *Walpole Society*, vol. 55, 1989–90, pp. 1–76

ROSENBERG AND PRAT 1994 P. Rosenberg and L.A. Prat, *Nicolas Poussin 1594–1665: Catalogue raisonné des dessins*, 2 vols., Milan 1994

RÖTHLISBERGER 1961 M. Röthlisberger, *Claude Lorrain. The Paintings*, London 1961

ROWLANDS 1985 J. Rowlands, *Holbein*, Oxford 1985

ROYAL COLLECTION 1990 Royal Collection, *A Souvenir Album of Flowers from the Royal Collection*, exh. cat. 1990

RUSSELL 1987 F. Russell, 'King George III's picture hang at Buckingham House', *The Burlington Magazine*, CXXIX, 1987, pp. 524–31

SANDON 1993 J. Sandon, *The Dictionary of Worcester Porcelain, I, 1751–1851*, Woodbridge 1993

SARGENTSON 1996 C. Sargentson, *Merchants and Luxury Markets*, London 1996

SCARISBRICK 1986 D. Scarisbrick, 'Anne of Denmark's Jewellery: the Old and the New', *Apollo*, CXXXIII, 1986, pp. 228–36

SCHRODER 1988 T. Schroder, *The Gilbert Collection of Gold and Silver*, Los Angeles 1988

SCOTT-ELLIOTT AND YEO 1990 A.H. Scott-Elliott and E.Yeo, 'Calligraphic Manuscripts of Esther Inglis (1571–1624): a Catalogue', *Papers of the Bibliographical Society of America*, vol.84, March 1990, pp. 12–86

SEELEY 1744 B. Seeley, *A Description of the Gardens of the Lord Viscount Cobham at Stow in Buckinghamshire*, Buckingham 1744

SHAW 1937 W.A. Shaw, *Three Inventories of Pictures in the Collections of Henry VIII and Edward VI*, London 1937

SHERWOOD 1991 D. Sherwood, *Harriet Hosmer, American Sculptor 1830–1908*, Columbia and London 1991

SMITH 1884 J.C. Smith, *British Mezzotinto Portraits*, London 1884

SMITH 1827 J.T. Smith, *Nollekens and His Times*, London 1827

SMITH 1829–42 J. Smith, *A Catalogue Raisonné of the Works of the Most Eminent Dutch, Flemish and French Painters*, 9 vols., London 1829–42

SMITH AND BENGER 1928 E. Smith and F. Benger, *The Oldest London Bookshop: a History of Two Hundred Years*, London 1928

SOIL DE MORIAMÉ 1910 E.-J. de Soil de Moriamé, *Les Porcelaines de Tournay*, Tournai 1910

SPENCER 1988 T.J.B. Spencer (ed.), *Shakespeare's Plutarch*, London 1964

STOCKER 1988 M. Stocker, *Royalist and Realist: the Life and Work of Sir Joseph Edgar Boehm*, New York and London 1988

STRONG 1964 R. Strong, 'The Elizabethan Malady: Melancholy in Elizabethan and Jacobean Portraiture', *Apollo*, LXXIX, 1964, pp. 264–69

STRONG 1969[1] R. Strong, *The English Icon: Elizabethan and Jacobean Portraiture*, London 1969

STRONG 1969[2] R. Strong, *National Portrait Gallery, Tudor and Jacobean Portraits*, 2 vols., London 1969

STRONG 1983 R. Strong, *The English Renaissance Miniature*, London 1983

STRONG 1986 R. Strong, *Henry Prince of Wales and England's Lost Renaissance*, London 1986

STROUD 1966 D. Stroud, *Henry Holland, his Life and Architecture*, London 1966

SURVEY OF LONDON London, Greater London Council, *The Survey of London*, XXIX, 1966

SWANSEA 1964 Swansea, Glynn Vivian Art Gallery, *Gustave Doré: A Studio Insight*, exh. cat., intro. by R. Paisey and J. Williamson, 1994

TASNÁDI 1966 A. Tasnádi (ed.), *The Sculptures of Marton László*, 1996

THORNE 1986 R.G. Thorne, *The House of Commons 1790–1820*, III, London 1986

THURLEY 1993 S. Thurley, *The Royal Palaces of Tudor England*, New Haven and London 1993

TIGHE AND DAVIS 1858 R.R. Tighe and J.E. Davis, *Annals of Windsor*, 2 vols., London 1858

TREVOR ROPER 1976 H. Trevor Roper, *Princes and Artists*, London 1976

TUCKERMAN 1870 H.T. Tuckerman, *Book of the Artists: American Artist Life, comprising Biographical and Critical Sketches of American Artists: Preceded by an Historical Account of the Rise and Progress of Art in America*, New York and London 1870

TYACK 1992 G. Tyack, *Sir James Pennethorne and the Making of Victorian London*, Cambridge 1992

VALMY-BAYSSE 1930 J. Valmy-Baysse, *Gustave Doré*, Paris 1930

VAN DER DOORT 1960 A. Van der Doort, ed. O. Millar, *Abraham Van der Doort's Catalogue of the Collections of Charles I*, *The Walpole Society*, vol. 37, 1960

VERLET 1987 P. Verlet, *Les Bronzes dorés français*, Paris 1987

VERSAILLES 1993 Versailles, Musée National des Châteaux de Versailles et de Trianon, *Versailles et les tables royales en Europe, XVIIème–XIXème siècles*, exh. cat. 1993

VERTUE G. Vertue, *Notebooks*, vols. I–VI with index, *The Walpole Society*, vols. 18, 20, 22, 24, 26, 29 and 30, 1930–55

VIGÉE-LE BRUN 1989 E. Vigée-Le Brun, trans. S. Evans, *The Memoirs of Elisabeth Vigée-Le Brun*, London 1989

WAAGEN 1854 G.F. Waagen, *Treasures of Art in Great Britain*, II, London 1854

H.R.H THE PRINCE OF WALES AND CLOVER 1993 H.R.H. The Prince of Wales and Charles Clover, *Highgrove, Portrait of an Estate*, London 1993

WALPOLE 1849 H. Walpole, edd. J. Dallaway and R.N. Wornum, *Anecdotes of Painting in England*, 3 vols., London 1849

WALPOLE 1928 H. Walpole, ed. J. Dallaway, *Anecdotes of Painting in England*, 5 vols., London 1928

WALKER 1985 R. Walker, *National Portrait Gallery: Regency Portraits*, 2 vols., London 1985

WALKER 1992 R. Walker, *The Eighteenth and Early Nineteenth Century Miniatures in the Collection of Her Majesty The Queen*, Cambridge 1992

WARD 1991 John Ward, *The Paintings of John Ward*, Newton Abbot 1991

WATERHOUSE 1960 E.K. Waterhouse, 'Poussin et l'Angleterre jusqu'en 1744', *Actes du colloque international Nicolas Poussin*, ed. A. Chastel, Paris 1960, II, pp. 283–96

WATSON AND AVERY 1973 K. Watson and C. Avery, 'Medici and Stuart: a Grand Ducal Gift of "Giovanni Bologna" Bronzes for Henry Prince of Wales (1612)', *The Burlington Magazine*, CXV, 1973, pp. 493–507

WELLINGTON 1976 The Duke of Wellington, 'Two War Artists under Napoleon and the Tsar', *The Connoisseur*, CXCIII, 1976, pp. 300–09

COLE 1997 A. Wells-Cole, *Art and Decoration in Elizabethan and Jacobean England: The Influence of Continental Prints, 1558–1625*, New Haven and London 1997

WHINNEY 1971 M. Whinney, *English Sculpture 1720–1830*, London (Victoria and Albert Museum) 1971

WHITE 1982 C. White, *The Dutch Pictures in the Collection of Her Majesty The Queen*, Cambridge 1982

WILDENSTEIN 1984 Wildenstein & Co., New York, *Sarah Bernhardt and her World*, exh. cat. 1984

WILLIAMSON 1897 G. Williamson, *Richard Cosway R.A. and his Wife and Pupils: Miniaturists of the Eighteenth Century*, London, 1897; 2nd. edn. London 1905

WILKS 1987 T.V. Wilks, *The Court Culture of Prince Henry and his Circle*, unpublished D.Phil. thesis, Oxford 1987

WILKS 1997 T.V. Wilks, 'Art collecting at the English court from the death of Henry, Prince of Wales to the death of Anne of Denmark', *Journal of the History of Collections*, IX, no 1, 1997, pp. 31–48

WINDSOR 1990 Windsor, Guildhall, *90 Memorable Years*, exh. cat. 1990

WINTER 1947 C. Winter, 'Hilliard and the Elizabethan Miniature', *The Burlington Magazine*, LXXXIX, 1947, pp. 175–83

WINTER 1948 C. Winter, 'The British School of Miniature Portrait Painters', *Proceedings of the Royal Academy*, XXXIV, 1948

WOODS 1861 N.A. Woods, *The Prince of Wales in Canada and the United States*, London 1861

WRAXALL 1884 N. Wraxall, *The Historical and the Posthumous Memoirs of Sir Nathaniel William Wraxall, 1772–1784*, ed H.R.Wheatley, 5 vols., 1884

WYNNE 1993 D. Wynne, ed. J. Stone, *The Sculpture of David Wynne, 1974–1992*, London 1993

YORK 1969 York, City Art Gallery, and London, Kenwood House, *Philip Mercier*, exh. cat. 1969

YOUNG 1937 Sir G. Young, *Poor Fred, the People's Prince*, London 1937

INDEX OF ARTISTS AND SITTERS